# PHOTOJOURNALISM
## THE VISUAL APPROACH

# PHOTOJOURNALISM
## THE VISUAL APPROACH

## FRANK P. HOY

Walter Cronkite School of Journalism and Telecommunication
Arizona State University

Prentice-Hall
Englewood Cliffs, New Jersey 07632

**Library of Congress Cataloging-in-Publication Data**

Hoy, Frank P.
  Photojournalism: the visual approach.

  Bibliography: p. 253
  Includes index.
  1. Photography, Journalistic.   I. Title.
TR820.H65   1986       778.9′907      85-28177
ISBN 0-13-665548-3

Cover design: Joe Curcio
Cover Photos—Top left: AP/Wide World;
top right: © Bill Beall
Manufacturing buyer: Harry P. Baisley

Printed in the United States of America

10  9  8  7  6  5  4  3  2

ISBN  0-13-665548-3    01

Prentice-Hall International (UK) Limited, *London*
Prentice-Hall of Australia Pty. Limited, *Sydney*
Prentice-Hall of Canada Inc., *Toronto*
Prentice-Hall Hispanoamericana, S.A., *Mexico*
Prentice-Hall of India Private Limited, *New Delhi*
Prentice-Hall of Japan, Inc., *Tokyo*
Prentice-Hall of Southeast Asia Pte. Ltd., *Singapore*
Editora Prentice-Hall do Brasil, Ltda., *Rio de Janeiro*
Whitehall Books Limited, *Wellington, New Zealand*

To my wife and friend, Mary Ellen, whose great encouragement, love, and professional help made this book possible and for Kathleen, Philip, Kevin, and Sean, who made it worthwhile.

*The author gratefully acknowledges the following contributors to the half-title and chapter-opening pages:*

Half-title page—Top & bottom left: Wally McNamee, *Washington Post*, middle, bottom & top right: Wally McNamee, *Newsweek*.

Chapter 1—Top left: Robert Hoy; top right: Don Stevenson, *Mesa Tribune*; middle right: David Longstreath; bottom: Dorothea Lange, Library of Congress.

Chapter 2—Top: *National Geographic Society*, bottom left: Kent Seivers; bottom right: *Claremont Courier*.

Chapter 3—Top left & right: John Faber, NPPA.

Chapter 4—Top: Ann Bailie, *Clarion-Ledger*; bottom-right: *Washington Post*.

Chapter 5—Top: Jim Witmer, *Troy Daily News*; bottom left: April Saul; middle right: Dick George, Phoenix Zoo; bottom right: *Washington Post*.

Chapter 6—Top left: Andy Arenz; middle left: Kent Seivers; bottom left: Wally McNamee, *Newsweek*; right: Brian Drake, *Longview Daily News*.

Chapter 7—Top: Chick Harrity, Associated Press; middle left: George Tames, *New York Times*; bottom left: Wally McNamee, *Washington Post*; bottom right: *Washington Post*.

Chapter 8—Top left: David Longstreath, *Daily Oklahoman*; top right: Richard Marshall, *Ithaca Journal*; bottom left: Michael Okoniewski; middle: Brian Drake, *Longview Daily News*; middle right: John Faber; bottom right: Mathew Lewis, *Washington Post*.

Chapter 9—Top left: Brian Drake, *Longview Daily News*; bottom: *Washington Post*.

Chapter 10—Top (3) & bottom left: John Faber.

Chapter 11—Top right: Robert Townsend; bottom: David Longstreath.

Chapter 12—Top: Andy Arenz; bottom: Bill Greene, *Patriot-Ledger*.

Chapter 13—Top left: Dick George, Phoenix Zoo; top right: Robert Hoy; bottom: David Longstreath.

Chapter 14—John Metzger, *Ithaca Journal*.

Chapter 15—Top left: Mark Damon, *Ithaca Journal*; top & middle right, bottom left: *Washington Post*; bottom right: Kent Seivers.

Chapter 16—Top left: John H. Sheally II, *Virginian-Pilot & Ledger-Star*; bottom left: Jim Witmer, *Troy Daily News*; bottom right: Tim Koors, *Phoenix Gazette*.

Chapter 17—Top left: Francis Benjamin Johnston, Library of Congress; right (3): John Faber.

Chapter 18—Top left: John Faber; top right & bottom: Don Stevenson, *Mesa Tribune*.

Chapter 19—Top: Bill Greene, *Patriot-Ledger*; bottom left: Bernie Boston, *Los Angeles Times*.

Chapter 20—Top left: The White House, Washington, D.C.; middle left: United Press International; top right: Brian Brainerd; bottom: Don Stevenson, *Mesa Tribune*.

Chapter 21—Bill Beall, *Washington Daily News*.

# CONTENTS

CONTENTS

# PREFACE

The hallmark of photojournalism is belief in the photograph as an active, firsthand observation of life and a report to others. All the photojournalists quoted in this book share the desire to see and report life firsthand.

When you choose a camera to communicate, you choose to make a statement about what you *see*. When you pick up your camera, you take on the responsibility to communicate what you see honestly. The material becomes fresh, new, *yours*. You are no longer a passive observer of life but an active, alert, interested, visual communicator.

Moreover, you choose communication that goes beyond self-expression. Whether you shoot pictures for a high school newspaper or yearbook, a weekly or a large metropolitan daily newspaper, or some type of magazine, you engage in communicating with a mass audience.

In a word, you have chosen photojournalism.

This book is dedicated to the basic principles of that profession, which has been practiced for over half a century by men and women on newspapers, magazines, and in television. The basics of this tradition have always been a solid study of content and technique.

I believe this study begins with the single black-and-white picture with caption. With a mastery of this basic unit, you have the essentials. Even today, with technology continually changing the gadgetry and nomenclature of our lives, the single image accompanied by words of explanation remain and *will* remain the core of visual communication. Recognizing this, as the 1980s bring further progress with the electronic cameras for still photography, you will have the knowledge and skill to incorporate new visual media into your style of reporting to your audience.

As you will see, change has always been a vital part of photojournalism, and the best of the new photojournalists have always learned the old ways first and then adapted them to the challenges of the present.

*Frank Hoy*

# ACKNOWLEDGMENTS

This book would not have been possible without the generosity of many true professionals who gave of time, photos, and moral support—I thank them all:

Wally McNamee of *Newsweek,* who has graciously contributed quotes and photos to this book and friendship over the years.

John Faber, historian of the National Press Photographers Association, who responded to every request with a generosity that matches his reputation.

David Longstreath, Associated Press, Oklahoma City, who contributed so much in photos, quotes, and moral support.

Dr. Douglas Anderson, Professor of Journalism and Dr. Eldean Bennett, Director of the Walter Cronkite School of Journalism and Telecommunication, both at Arizona State University, for advice, encouragement, and support.

Dr. John Ahlhauser, University of Indiana; John Thomas Allen, *The Washington Post;* Ann Bailie, Graphics Editor, *The Long Beach Press-Telegram;* Tony Berardi, *The Chicago American;* Morris Berman, NPPA; Bernie Boston, *The Los Angeles Times;* Hal Buell, Assistant General Manager, Newspictures, AP; Rich Clarkson, *The Denver Post* and *National Geographic;* Joseph Costa, NPPA; Mark Damon; Max Desfor, *U.S. News & World Report;* Brian Drake, freelance photographer; Arnold Drapkin, *Time;* Arthur Ellis, retired, *The Washington Post;* Peter Ensenberger, *Arizona Highways;* Ken Feil, Picture Editor, *The Washington Post;* Dr. Mario Garcia, *Contemporary Newspapers Design;* Robert Gilka, *National Geographic;* James Gordon, editor, *News Photographer;* Chick Harrity, *U.S. News & World Report; The Ithaca Journal* staff; Max Jennings, Executive Managing Editor, *The Mesa Tribune;* Tim Koors, *The Phoenix Gazette;* Emory Kristof, *National Geographic;* Mathew Lewis, Assistant Managing Editor of Photography, *The Washington Post;* Bob Lynn, Graphics Director, *The Virginian-Pilot* and *Ledger-Star;* Ted Majeski, Vice President, Executive Editor of Newspictures, UPI; Richard Marshall; Andrew "Buck" May, NPPA; John Metzger; Clement Murray, *The Philadelphia Inquirer;* Mary Ann Nock, Photo Editor, *The Phoenix Gazette;* April Saul, *The Philadelphia Inquirer;* Prof. William Seymour, West Virginia University; Peter Schwepker, *The Arizona Republic;* Ernie Sisto, *The New York Times;* Don Stevenson, Graphics Director, *The Mesa Tribune;* and George Tames, *The New York Times.*

My thanks to all the photographers whose work appears in these pages.

Finally, thanks to Stephen Dalphin, Editor, Maria Chiarino, Managing Editor, and their colleagues for the true making of this book.

Many interviews and photos were gathered through grant support from Faculty Grants and Sponsored Projects, Arizona State University, for which I am grateful.

F.P.H.

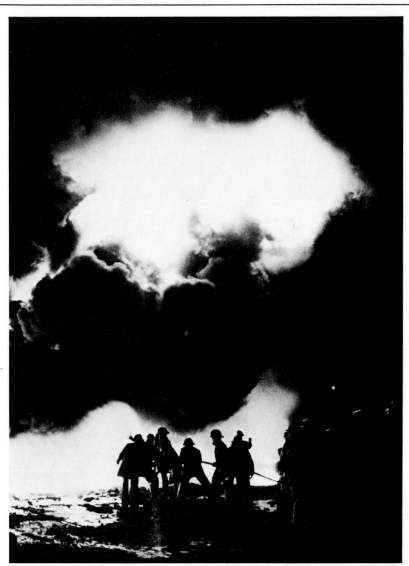

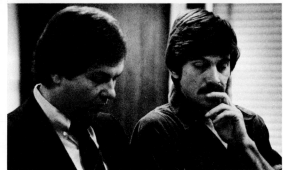

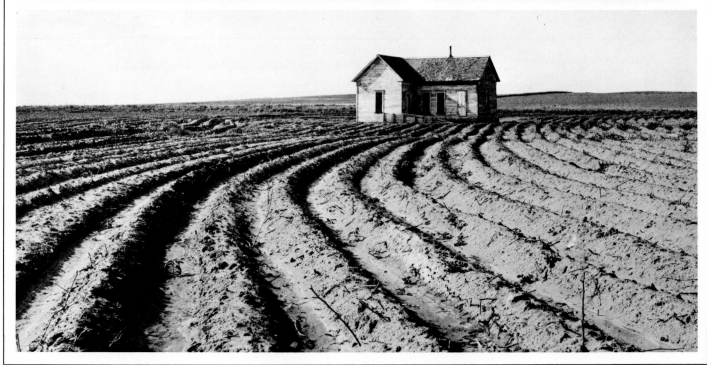

# 1. PHOTOJOURNALISM IN PERSPECTIVE

*"We're not in the business of pleasing ourselves with our photographs. The purpose is to communicate something to others."* Rich Clarkson, *National Geographic*

Clarkson's remark puts photojournalism in perspective for our study. Once you decide to study photojournalism, you enter into a field that has a strong tradition of communicating "something"—the news—to "others"—the public. Thus, it stands apart from general photography. It borrows from photography and written journalism to become something special. Like the art photographer, the photojournalist uses artistic techniques to produce striking images. At the same time, the photojournalist is also a reporter responsible for informing the public. He or she must blend these two media to produce a report of high quality and become a journalist with a camera.

Photojournalists report all manner of news. In a year-end issue on news photographs, *Time* magazine once wrote, "More and more, history is recorded through pictures, and in the past two decades there has been scarcely an event worth noting that has not been photographed from a dozen different angles. Centuries from now, those images will be as vivid and immediate as they are now." Most of these events aren't earthshaking, as most photojournalists cover local news events. But the good photojournalist always feels that he or she is covering an event worth reporting to the public (Fig 1.1).

In fact, the subject matter of photojournalism runs the gamut of our existence. Brian Lanker, a freelance photographer for *Sports Illustrated* and *Life* magazine, won the 1972 Pulitzer Prize in Features for his photos of a baby's birth. The same year a violent photograph from Viet Nam won in the news category. Lanker said, "I'm glad it happened with the story it did. . . . I think that says something about . . . where good photographs are, where things are happening, where life is going on."

As a member of what *Time* magazine called a "visual generation," you probably already own some sort of camera, so you may have more background for understanding photojournalism than you think. You probably have some experience in communicating through photography, whether through taking family snapshots, pursuing photography as a hobby, studying photography in high school or college, or working on a school paper or yearbook. Any of these experiences can form a beginning for a study of photojournalism.

## SNAPSHOTS

If you are like most of us, your first experience with photography was taking snapshots of friends or family. This was fun and there was no need to do more than point and shoot. The snapshots were often out of focus, poor in technical quality, or had no composition in the accepted sense, but they were still cherished for what they communicated (Fig 1.2).

The snapshot stage is so personal that any serious criticism is answered with a shrug, a laugh and a "so what?" Here is where we can truly say, "This is what I wanted." The audience for these snapshots is friends or family, and even the fuzziest shots still conjure up memories and are considered a success. They are just shots snapped instantly and taken for pleasure.

At first, such rudimentary experience with a camera may appear of little value. But, as you take snapshots, you learn that using a camera—aiming, shooting, and composing without worry—can be fun. Some of the best photojournalists are good because they learned to make technically excellent photographs with the enjoyment and spontaneity of the snapshooter.

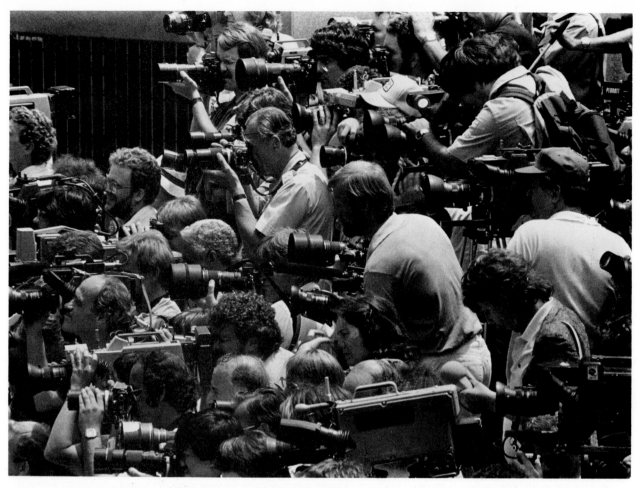

Figure 1.1: Photojournalists report all manner of local and national news. Here are some of the many who covered the 1984 Democratic National Convention in San Francisco. Photo by Tim Koors.

Figure 1.2: Snapshots are fun photos that conjure up memories. George Eastman introduced the Kodak in the late 1880s and by the 1930s the family snapshot was practically an American folk art.

# ADVANCED AMATEUR PHOTOGRAPHY

You may have stopped at that snapshot stage. However, like many others, you may have gone on to a higher stage: the hobby, or advanced amateur, stage. There are millions of amateurs who love photography enough to buy an advanced camera and to build a darkroom. If you are at this stage, you can attest to the amount of time and money involved in perfecting your camera and darkroom skills.

This stage is represented by the view stated in Kodak's *The Joy of Photography* that "the world of photography is a personal one. We take pictures to express our feelings about people, nature and the world around us." At this stage, you have probably spent quite a bit of time in the darkroom developing and printing. The purpose of your shooting is to please yourself and to communicate to a small circle of friends, perhaps fellow photographers or family. Any criticism at this stage can usually be answered with something like the snapshooter's "This is what I wanted." Many fine photographs are produced at this level of what is called personal or expressive photography (Fig. 1.3).

With the experience you have gained at this stage, you should be well-versed in darkroom and camera technique and can start becoming a people-oriented photojournalist rather than a self-expressive photographer. You can now concentrate your experience and perception in a definite direction.

**Figure 1.3: Advanced amateur photography allows us to express ourselves about the world.**

Figure 1.4: Art photography can be highly subjective and personal.

# ART PHOTOGRAPHY

You may have gone beyond these two stages and have entered into the serious art photography stage. If so, you may consider yourself a photographic artist, may have taken art courses, and may be building a portfolio. Having studied the craft seriously, you may be forming a definite personal style, and you probably view your work as a personal vision. If you are like the majority of art photographers at this stage, you concentrate on photographs of abstract designs, clouds, trees, and shadows (Fig 1.4). You rarely take a picture of people.

Although criticism of your work at this stage is taken more seriously than before, any criticism still takes into consideration your personal interpretation. With a serious view toward your work you can answer criticism as before: "This is what I wanted."

Such an answer to criticism at this stage is still valid. After all, your work up to now has been highly subjective, and you have the right to express yourself without a lot of rules and outside interference. Such a self-expressive approach is summed up by Phil Davis in his book, *Photography*:

> . . . nobody can presume to tell you what you have to like, therefore, nobody can tell you that a photograph you like is "bad" or that one you don't like is "good."

We all need to have strong personal opinions and we *must* stick to them if we are to progress. Believe in your work enough to question anyone who arbitrarily judges your works as "good" or "bad" because they are supposedly experts.

# PHOTOJOURNALISM

The art photography stage is excellent background for photojournalism, provided that you develop an awareness of your *audience*. As Brian Lanker said:

> Sure, I consider myself an artist. But I don't consider myself someone who is trying to convey my innermost emotions and feelings with my photographs. Because then . . . after two or three years of looking at my photographs, people know everything about me, but very little about their community. . . .

With your willingness to experiment, you have developed your aesthetic sense. Now you can combine that with reporting skill.

If you have worked for a high school or college newspaper, yearbook, or a professional newspaper, you have experienced decisions made under pressures of deadlines, space limitations, and the need to communicate to a broad audience. In photojournalism, there *are* hard and fast rules of "good" or "bad," and self-expression *per se* is discouraged. The picture editor can and does presume to tell us that photographs we like are not publishable and, therefore, "bad" for the purpose intended. It happens everyday.

If you have practiced photojournalism, you may be prepared for criticism that can be disconcerting to others who view photography as self-expression or art. On the other hand, this could be a disadvantage to your learning, for if you have experience on a publication, you might need to add aesthetics to a technical approach to your work. View the world with an artistic eye, add the news angle, and you can produce fine photographs that also report.

Experience on the snapshooter, advanced-amateur, or art-photographer levels provides important elements for the photojournalist. These include:

- freedom
- technical ability
- aesthetic sensitivity
- energy and ethics
- intellectual curiosity

This blend could produce a modern photojournalist. It describes the attitude of the majority of successful photojournalists today. Most would agree with the advice of Associated Press photojournalist David Longstreath: "There is always something new to learn in photojournalism, so keep trying something new and stay enthusiastic about your work. Never lose your enthusiasm."

## PHOTOJOURNALISM: A CLEAR COMMUNICATION

Photojournalism encompasses a broad variety of word and picture reporting. The term itself is fairly new. In the early days, photographers were "news photographers," "press photographers," or "magazine photographers." According to Del Borer of Eastman Kodak, it was not until the 1940s that the term *photojournalism* was coined by Professor Cliff Edom of the University of Missouri to describe the type of word-and-picture integration he was teaching. Through his lectures, writings, and work at the Missouri Photo Workshop, Edom popularized the word in its present meaning. Wilson Hicks, Picture Editor of *Life* magazine from 1937 until the late 1950s gave a detailed definition of photojournalism in 1952 in his classic book, *Words and Pictures:*

> This particular coming together of the verbal and visual mediums (sic) of communication is, in a word, photojournalism. Its elements used in combination do not produce a third medium. Instead they form a complex in which each of the components retains its fundamental character, since words are distinctly one kind of medium, pictures another.

According to Hicks, the result of this photojournalism is a combination of words and pictures that produces a "oneness of communicative result" (Fig. 1.5) when combined with the reader's educational and social background.

There are eight general characteristics of photojournalism:

First, photojournalism is communication photography. The communication can express a photojournalist's view of a subject, but the message communicates more than personal self-expression.

The aim of the photojournalist is to communicate a clear message so the viewer can understand the situation quickly. The power of a great photograph is the power of an immediately understood message. The simpler the composition, (Fig. 1.6) the better the photograph. If, as Tim Koors of the *Phoenix Gazette* thinks, a photojournalist can create a bond between the readers and the subject, then he or she has done the job right. Belief in clear communication is the cornerstone of photojournalism as a profession.

Second, the medium of photojournalism will be assumed to be the print medium—wire services, newspapers, and newsmagazines. This now means ink on paper, but electronics will play an increasingly important role in this work, since there is a constant need

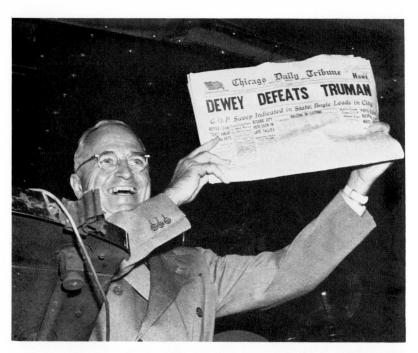

Figure 1.5: This 1948 Pulitzer prize photo by Frank Cancellare remains a classic political photograph of the upset Presidential election victory by underdog Harry Truman. UPI/Bettmann Archive.

Figure 1.6: Photojournalism means clear photographic messages that communicate to an audience. Photo by Clement Murray.

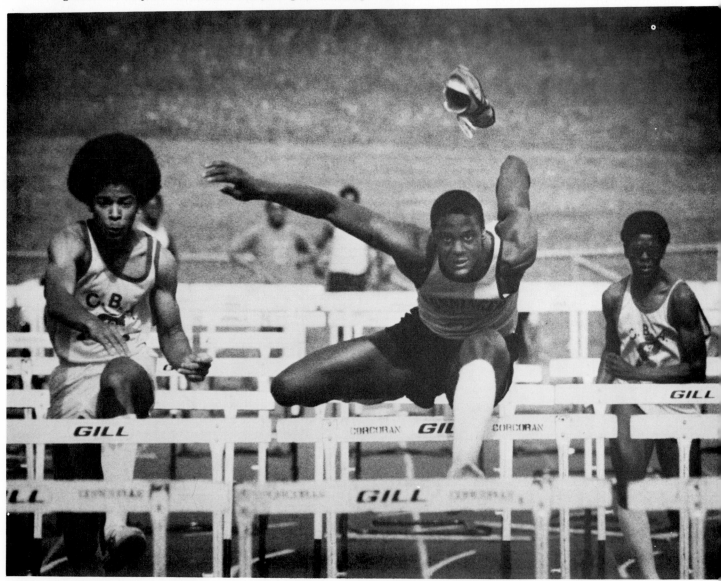

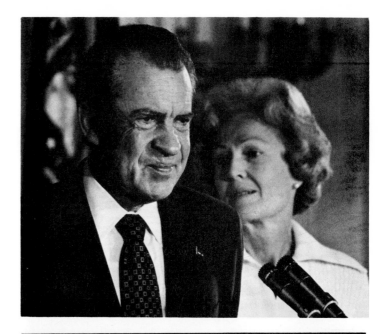

**Figure 1.7: Photojournalism reports news effectively enough to make readers wish they had been there. Here AP photographer Chick Harrity captured the pathos of President Nixon's last day in the White House. AP photo.**

for "news" pictures at every level of circulation, from the smalltown weekly, to the huge metropolitan daily, or international wire service.

Third, photojournalism *reports.* All the effort, talent and skill of the photojournalist are aimed at reporting some aspect of the news. Chick Harrity, longtime *Associated Press* photographer now at *U. S. News & World Report,* says you should report news so readers wish they had been there (Fig. 1.7).

Fourth, photojournalism communicates by integrating words and pictures. The balance between them is flexible but even in the heavily visual photographic essay, words are needed to complete the message. For a subject that needs an explanatory text, of course, words lead the way. The photojournalist should know which should predominate—words or pictures.

In this book, every photographer is viewed as a photojournalist—in other words, a person who always combines words and pictures to report. On a newspaper, photographers rarely write full stories because of tight deadlines. But you should *always* gather pertinent information (names and so on) that can be used in a cutline or caption. Many newspaper and wire service photographers also write full captions that are published or sent on the wire with their pictures.

This emphasis on the complete report means that words must be added to the photograph no matter how effective it is as "art." The original image with added words becomes a package that assures clear communication. Wilson Hicks calls the photograph and its caption the "basic unit of photojournalism." On this basic unit, a wide range of photojournalistic approaches can be built (Fig. 1.8).

Fifth, photojournalism deals with people. To succeed, the photojournalist must have a great interest in people. People are the prime ingredient in both ends of the photojournalistic message—they are the subjects and the viewers (Fig. 1.9). Ginny Southworth, photographer on the Aiken, South Carolina *Standard,* is strong on people pictures, (Fig. 1.10). "First of all, learn how to deal with people . . . because work with people is what the whole profession is about."

Sixth, photojournalism communicates to a mass audience. This means that the message must be concise and immediately understood by many different people. Private images or meanings have no place in photojournalism. A photojournalist can produce lasting images, even art, but the immediate message must effectively communicate to a mass audience.

**Figure 1.8: Even photo essays that are heavily visual need words to complete the message. Robert Townsend, Manlius Publishing Co.**

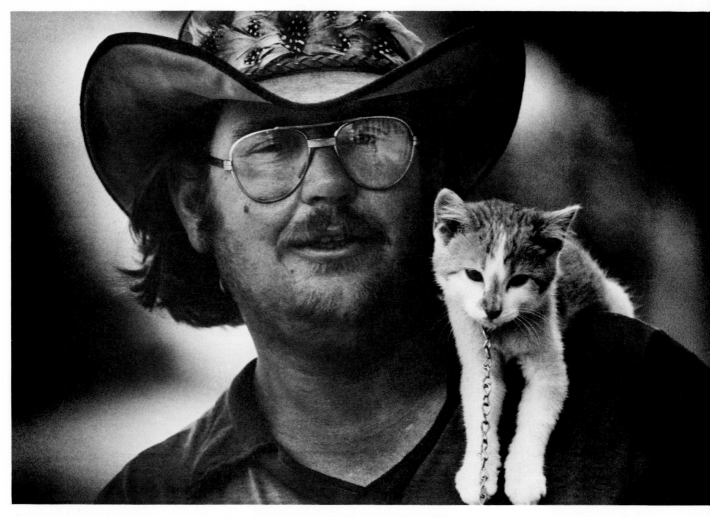

**Figure 1.9: People are the prime ingredient in a photojournalist's message. Photo by David Longstreath, courtesy** *The Daily Oklahoman.*

**Figure 1.10: The happy mood of a 100th birthday party as the celebrant shares a warm moment with her great granddaughter. Photo by Ginny Southworth,** *The Aiken Standard* **(S.C.).**

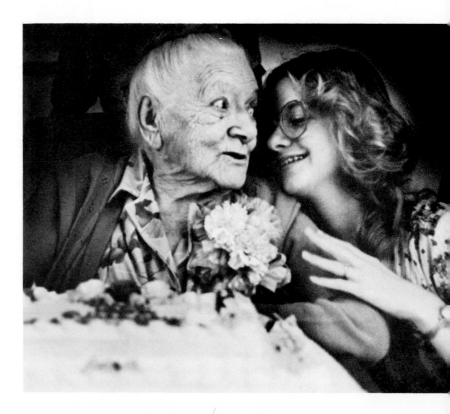

Seventh, photojournalism is presented by a skilled editor. The editor decides how, or even if the report reaches the public.

The good editor makes the photojournalist's message more effective. Cropping, selecting photographs, having them reprinted or even reshot, are usually within the editor's power. The good editor is visually literate as well as proficient in writing. He or she works with the photojournalist to constantly improve the quality of work.

Eighth, the primary belief of photojournalism is that informing the public is an absolute necessity in today's complex world. This belief is based on the First Amendment's protection of freedom of speech and press. As an integral part of a free press, photojournalists strongly believe that without their photo reports, people would not know what is happening in their community and the world. Joseph Costa, one of the premier American photojournalists sums it up:

Unless people understand the world we live in and are kept accurately informed of world developments, they cannot intelligently make the basic decisions that are necessary in today's complicated society. . . . We can communicate with the greatest precision when we combine words and pictures. . . .

This definition of photojournalism can be applied to a wide range of photography in our modern, visual world. Everything from a shot taken for a weekly newspaper to an extensive photo essay for a book fits into our definition.

Each of these areas has unique requirements, but many photojournalists work in several of them at the same time or in a succession during their careers. For example, a newspaper staffer might freelance for a local or national magazine. Also, many photojournalists begin on small newspapers and then move to magazines, television, or public relations. With the expanding use of photography in all media, there is a tremendous need for well-trained photojournalists.

The *Photographer's Market* lists more than 3,000 outlets for photographs. Projects that need photography include books, filmstrips, video discs, magazines, catalogs, posters, calendars, greeting cards, photodecor, audiovisual productions—the list goes on and on.

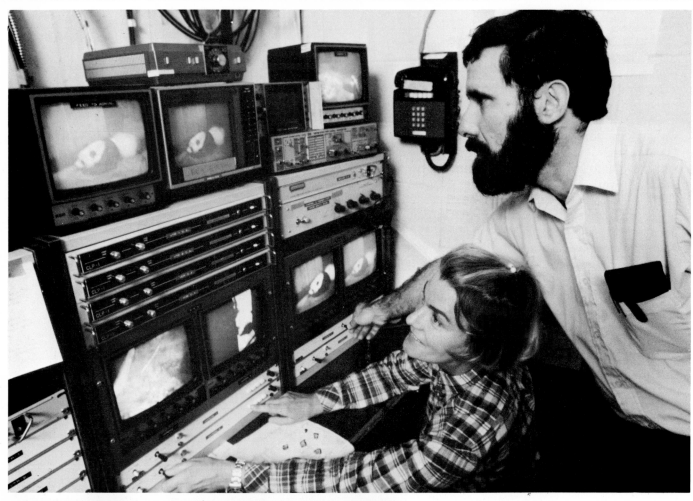

# HOME
## BIRTH

Guy and Nancy Lauderdale
feel the home
is the right place
to deliver their baby

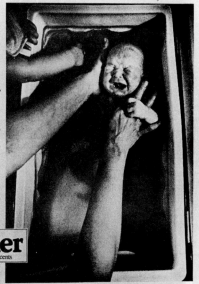

Fresh and Sweet: Eight-
pound **Ryan Alexander
Lauderdale** was born Mon-
day, January 28, 1985. His
parents are Claremonters
**Guy and Nancy Lauderdale.**

**6:40 a.m.:** "I'm in
labor, Pat."
A simple early morning
telephone message from Nancy
Lauderdale triggered a flurry of ex-
citement in a number of places.
As I placed a call to Peter
Weinberger and rushed out the
door with an illogical "I've gotta
go, we're having the baby" to my
showering husband, I recalled the
COURIER's first contact with the
family that was to become so close
to us before the day was over.
"We wanted it to be natural," ex-
plained the 31-year-old expectant
mother at our first meeting with
her and 31-year-old husband Guy.
They had decided over two years
ago to have their first child at
home and hoped to do the same
thing with a second baby. Jason, a
sturdy, healthy 20-month-old tod-
dler, seemed a good endorsement
for a home birth as he romped
about the living room of the simply
furnished home on a quiet street
in Claremont.
Nancy recounted that she and
Guy were not advocates of one
particular "natural" childbirth
method over another but had
drawn inspiration from family
members. One sister, Nancy
reported, had two children at her
home in Utah; another had plan-
ned for a home birth but had en-
countered difficulties; and a third
had delivered her baby at the
home of a mid-wife.
"With Jason, it just evolved,"
she stated.

continued next page

Claremont
**COURIER**
2-6-85    50 cents

*Ryan Alexander gets his first
bath in a cooler filled with warm
water about 15 minutes after
his birth.*

# 2 ▪ APPROACHES TO PHOTOJOURNALISM

*"Learn the fundamentals of photojournalism so you can cover news well on deadline. Then you can handle any type of photojournalism."*

Ann Bailie, *The Press-Telegram,*
Long Beach, California

Nearly any publication that communicates by combining words and pictures fits our definition of photojournalism. But an in-depth discussion of so many publications is beyond the scope of this book. Fortunately, for a study of visual news coverage, wire services, newspapers, and newsmagazines all follow the three principles of any form of communication:

- respect for accuracy
- respect for deadlines
- high degree of technical proficiency

Once learned, these principles apply, often with only slight adaptation, to any of a wide range of photographic markets, no matter how specialized.

For example, if you were to decide on a career in public relations, experience in wire service, newspaper, or magazine work would be a definite advantage. Industrial and corporate photojournalism is another field where these principles apply.

## WIRE SERVICES

Today, the two giant news services, Associated Press, (AP) and United Press International (UPI), are major news sources for all manner of communication media. Wire services have survived and grown by breaking news on the local, national, and international scene. They have continually adapted new technology for their coverage. Beginning in the mid-1930s with their coast-to-coast network of wire transmission over telephone lines, and continuing up to their present-day use of satellites and computers, the services have been in the forefront of dissemination of news on a round-the-clock basis. The AP is phasing the second generation of its "electronic darkroom" that revolutionized photojournalistic coverage of news (Fig. 2.1). UPI has computerized its transmission system and is introducing extensive color coverage on a local and national level. These modern systems will soon handle all phases of photojournalism via electronics—from shooting and printing to computerized editing and transmission.

Each wire service transmits hundreds of daily news photographs directly into the newspaper, magazine,

and television newsrooms of the world. They literally have "a deadline every minute" somewhere in the world.

According to Hal Buell, Assistant General Manager for Newsphotos at AP, that service has set up Laserphoto-II (Fig. 2.2), which transmits an average of 12 to 20 color pictures daily. Laserphoto-II also provides newspapers with the first satellite-transmitted picture network ever established.

Of the AP network today, Buell says "it is made up of hundreds of thousands of miles of circuits. This network can be altered on a picture-by-picture basis so that a single photo can go to the entire world or to just a single newspaper." This carries out the AP picture service mission today, he says:

> to cover all breaking news, to provide features, sports coverage and graphics, to shoot increasingly more in color. They provide, in short, the basic picture material any newspaper would use from outside its own area . . . AP serves literally thousands of newspapers, magazines and television stations in every corner of the globe.

11

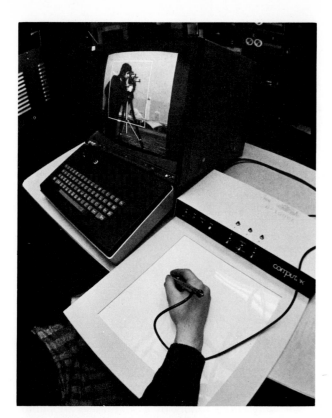

*Above*—Figure 2.1: AP's electronic darkroom is revolutionizing picture editing—the TV screen is where editing and cropping is done. AP/Wide World Photos.

*Right*—Figure 2.2: AP Laserphoto II transmits photographs all around the world. Courtesy Associated Press.

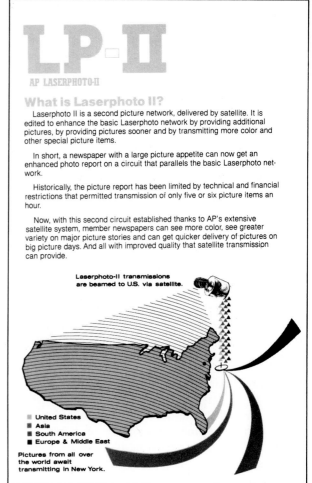

## LP-II
### AP LASERPHOTO-II

### What is Laserphoto II?

Laserphoto II is a second picture network, delivered by satellite. It is edited to enhance the basic Laserphoto network by providing additional pictures, by providing pictures sooner and by transmitting more color and other special picture items.

In short, a newspaper with a large picture appetite can now get an enhanced photo report on a circuit that parallels the basic Laserphoto network.

Historically, the picture report has been limited by technical and financial restrictions that permitted transmission of only five or six picture items an hour.

Now, with this second circuit established thanks to AP's extensive satellite system, member newspapers can see more color, see greater variety on major picture stories and can get quicker delivery of pictures on big picture days. And all with improved quality that satellite transmission can provide.

Laserphoto-II transmissions are beamed to U.S. via satellite.

- United States
- Asia
- South America
- Europe & Middle East

Pictures from all over the world await transmitting in New York.

Ted Majeski, UPI Vice President and Executive Editor of Newspictures, says:

United Press International is using more color [Fig. 2.3] on the wires and has many plans for the "electronic future." . . . But no matter how much things change, the need for accuracy, good news judgment and plain old technical know-how will always be the most important part of the wire-service approach.

Our staffers move more than 125 pictures daily on the UPI Telephoto network and each photo relates closely to the news, so we have to get the information right and to our clients as fast and as accurately as possible. Every part of the approach is keyed to the dual concerns—accuracy and speedy news transmission.

The predicted electronic cameras will speed transmission, but will still require the same traditional values of news judgment and accuracy from photojournalists scattered across the world's news scenes. Their work is the basis for UPI's credible news operation.

## WORKING FOR THE WIRES

Working for one of the wire services is highly pressurized, with constant deadlines. The pace of wire service work will introduce you to fast thinking in all manner of news situations, from light features to some rather volatile local or national situations. Whether you are on the staff of a large city bureau or run a one-person "bureau" all by yourself, you will learn how to handle pressure, people, and fast-changing news events.

Work on the wire services will include:

- a "hard news" emphasis
- a national approach to local news
- predominately black and white shooting (but with growing use of color)
- a single-picture orientation
- exclusively 35mm cameras
- tight deadlines
- an audience of editors across the country in newspapers, magazines, and television stations that subscribe to the wire
- Use of a wire transmitter rather than a printed page (Fig. 2.4).

As a service photographer you will work with constant deadlines, carry a transmitter and all manner of 35mm gear (including extra camera bodies and an assortment of lenses), and move from one assignment to

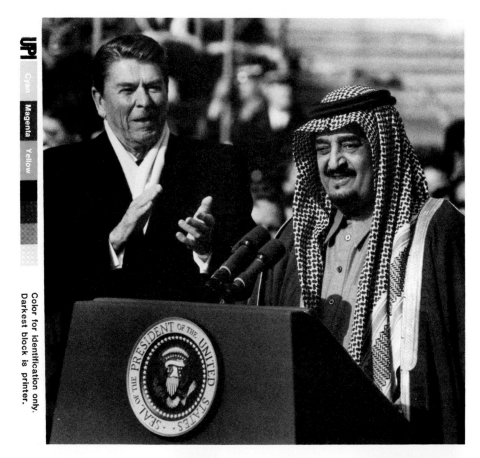

UPI

Cyan
Magenta
Yellow

Color for identification only.
Darkest block is printer.

**Figure 2.3: Wire service photos must be transmitted along with pertinent information. Here, a color key appears on one edge of a photo that was shot in color. Courtesy, United Press International.**

another. Assignments include features, riots and sports events, as well as every conceivable happening in between. You will be dealing primarily with the single picture and caption, so you will become adept at summing up any event in one dramatic photo. Your hours will be long and unpredictable. It is the rule that a wire photojournalist stays on an assignment until it is finished. This often means six to eight hours (or longer) on the scene without a break.

Chick Harrity describes his work on the wires (Fig. 2.5) as follows:

It's exciting and without what most people think of as normal hours. In my earlier days on smaller bureaus around the East, I shot, developed, captioned and transmitted; all on tight deadlines. And often on location with a portable transmitter and a bathroom sink for my lab.

There was a constant need to "get it all in one shot" because of this time factor in transmitting one photo, or at most a "combo" of two shots. We shot mainly black and white in the early 1960s but there for a while we shot *both:* a real challenge on fast-breaking stories. I always carried two or more camera bodies and an assortment of lenses. Naturally, when I moved to the D.C. bureau there was a team of editors and printers, but the deadlines and pressures remained.

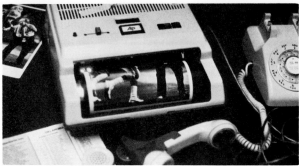

**Figure 2.4: The portable wirephoto transmitter gets the photo back to the office and onto the network from any point where a telephone line is available. This unit is on loan to an out-of-town newspaper photojournalist. Photo by Andrew Pleasant.**

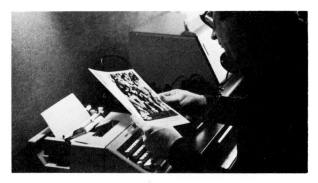

**Figure 2.5: Wire service photojournalists like AP's Red McClendon perform the jobs of photographer, editor, and telephone transmitter when they cover some assignments.**

# NEWSPAPERS

Of all outlets of photojournalism, newspapers offer the widest variety of assignments. With the insatiable need every day for news photos, newspaper picture editors are always open to good spot news and feature photos. Newspapers are more interested in local spot news than the wire services, but often you can make a sale to both if the photo is dramatic or important enough. Newspapers in general are looking for single photographs (with complete captions) but there is always the chance of a spread or layout of photos if your work is interesting or unusual.

## GENERAL ASSIGNMENT

In general, the newspaper staffer has a broader variety of work than the wire service counterpart. While both cover anything that happens during their working hours, newspaper general assignment extends beyond straight news.

The general assignment photojournalist covers spot news, features, fashions, studio work, illustrations, pictorials, and picture pages as well as some promotional or public relations shooting. Because any newspaper is basically a business, the general assignment photojournalist may be called upon to shoot all areas in which the business has an interest. In the course of a year, the newspaper general assignment photojournalist gets a chance to shoot a bit of everything.

General assignment is an important part of the newspaper business. In the past, newspapers have been heavily word oriented and in many cases remain so today. But with the impact of television and computer technology many newspapers are becoming what Dr. Mario Garcia, author of *Contemporary Newspaper Design,* calls "visually attractive packages of the day's news." This means the use of more, larger, and better photographs to report and even interpret the news. Some newspapers have changed to a magazine format featuring the visual design of the news.

But no matter what type or size of newspaper, its working conditions generally include:

- daily deadlines
- news orientation with features and picture pages a strong possibility
- single-picture emphasis
- wide variety of assignments
- locally oriented news with a growing awareness of local readers' interest in national news
- emphasis on black and white, but with growing awareness of color shooting and use
- almost exclusive use of 35mm cameras

You may have only a few minutes at an event before rushing back to print for an edition. On newspapers, meeting deadlines is paramount; getting the news published supercedes every other consideration, including, of course, any "artistic" approach.

Tim Koors describes his general assignment work for the *Phoenix Gazette.*

One of the most interesting things about working for a major metropolitan newspaper is that you usually have no idea what's going to happen when you get to work.

Working for an afternoon paper especially makes shooting a challenge. We have four deadlines daily: 7 A.M., 10 A.M., 12:30 P.M., and 1.30 P.M. In other words, we're running high gear most of the day. The paper changes from one edition to the other. If I have an 11:30 A.M. assignment, I'm expected to have a print on the photo editor's desk before the 12:30 deadline.

On an average day, I'll come to work and pick up two or three assignments for the day. All of these assignments are not for the same day's paper, however. One might be for a fashion page that will run the following week. One might be a news conference, which would be printed as soon as possible. Still another could be a sports assignment. I'm referring now to the assignments I know I'll be shooting that day. That doesn't include breaking news or features I find on the way to and from work. I might be sent out on a fire or a shooting or a car accident at any time.

It's difficult to develop a working routine because there are so many variables involved. Many times I will develop and print and caption three or four different times during the day. Other days I might be able to "soup" [develop] and print all of my assignments at the end of the working day. One thing, though, is constant. Each photographer is expected to caption his or her pictures as well. Most editors won't run [publish] a photo if there isn't proper identification with it. On the *Gazette,* the caption is almost as important as the photo itself.

In between these regular assignments, Tim is always on the lookout for what are called "enterprise" photographs. These are unassigned, unplanned, unexpected, and often taken on the way to or from an assignment, or even on a day off (Fig. 2.6). Koors explains how he knows he's got a good possibility:

Getting a good picture is a matter of instinct to anticipate and read a situation fast. You also have to be sensitive to every place where a *possible* picture might be. In the right places, you get this sense that the photograph is going to be good. That's where you get your extra kick that gives you that winning photo. I know when a photo is going to be good. I can feel it as I take it.

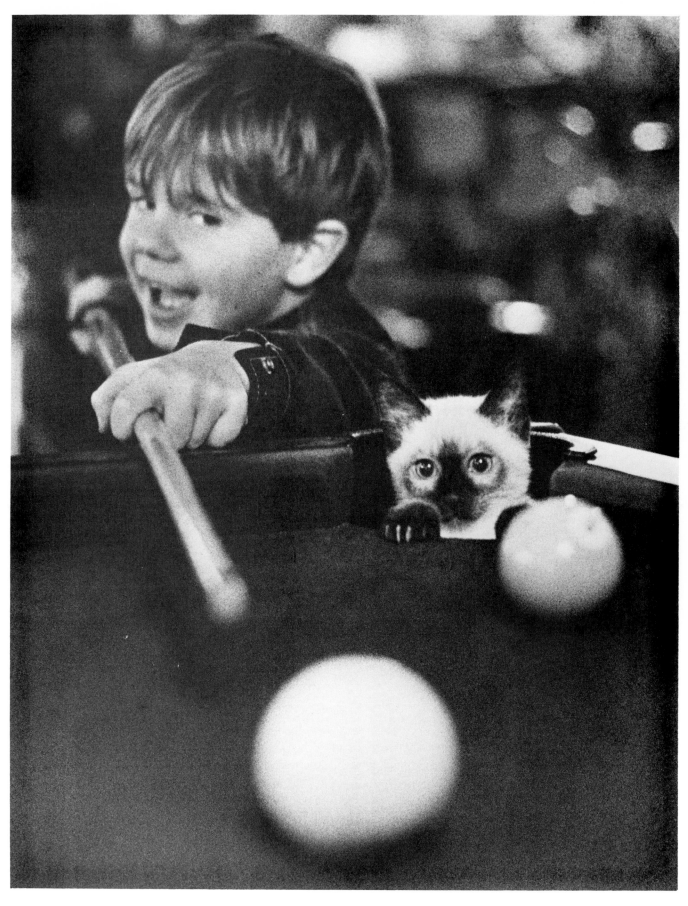

**Figure 2.6: Even on a day off, a feature shot may present itself. Tim Koors was visiting friends when he saw the kitten and took this striking photograph. Courtesy** *The Phoenix Gazette.*

## PICTURE PAGES

One specialty that goes beyond the single picture, but is part of general assignment, is the picture page. Some visual-minded newspapers use this to great advantage to produce pages of photo essays. Some pages take days or weeks to do and the photographer often shoots, prints, writes copy, and does the layout for the page. At its modern best, the newspaper picture page attempts to do in one page what some magazine essays do: offer an in-depth story that can't be told with only one photograph and a caption.

Brian Drake made in-depth picture pages a specialty when he worked for the Longview, Washington *Daily News.* He says: "A picture page is a form of photo essay, only limited to one page. A newspaper photojournalist can make some strong and effective statements through the picture page" (Fig. 2.7).

**Figure 2.7: Picture pages are possibilities on visual-minded newspapers. The photojournalist gets a chance to go more deeply into a subject. Photo by Brian Drake, *Longview Daily News* (Wash.).**

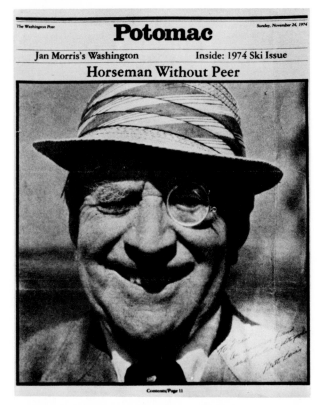

**Figure 2.8: Strong portraits were an ingredient in the work of Mathew Lewis when he won the Pulitzer Prize in 1975, working for the Sunday magazine, *Potomac.* Courtesy *The Washington Post.***

## SUNDAY NEWSPAPER MAGAZINES

Many newspaper photojournalists initiate stories for a paper's Sunday magazine and earn extra money, as well as practice, shooting the magazine style.

The Sunday magazine of a newspaper is feature-oriented rather than news-oriented. You shoot a high percentage of color and are expected to handle studio lights and to be able to illustrate articles with conceptual photographs. Your normal equipment is the 35mm camera, just as on the daily side, and working hours are generally more flexible. The deadlines are four to six weeks in advance of each issue, but because you may be working on several issues at once, you have overlapping deadlines. The result is often as pressured as work on the daily.

However, without being constantly "on call" for unplanned spot news work, you are freer to plan your coverage. Also, you will work closely with an editor or art director. This means much more exchange of ideas than for daily news. Assignments can be single pictures or photo essays, with emphasis on color, large spreads, and graphic display.

Mathew Lewis, Assistant Managing Editor of Photography at the *Washington Post,* won the 1975 Pulitzer Prize for his feature work for the paper's Sunday magazine, *Potomac* (Fig. 2.8). Lewis compares his work on *Potomac* with daily news work in this way:

On *Potomac,* we shot mainly color, approximately 85 percent. It is difficult to determine an "average" day's assignments because the variety is so great, but I probably averaged up to six assignments per week, not counting major assignments, which might take days, even weeks, to shoot. Also, we did quite a bit of studio work in fashions, home interiors, still life and illustrations.

April Saul is a staff photojournalist on the *Philadelphia Inquirer,* but she also does photo essays for the *Inquirer's* Sunday magazine.

April says, "the *Inquirer* is a great place to offer my extra photo essays. They take the time and have the space to make them look good." She wrote and photographed a photo essay depicting the first days in the United States of a Cambodian refugee (Fig. 2.9), for which she won a National Press Photographers Association prize. April spent months on the black-and-white feature, working around her regular schedule. She says, "I got to know Mao Soum, the Cambodian girl (Fig. 2.10) well in the time I shot her story, and I hated to say goodbye."

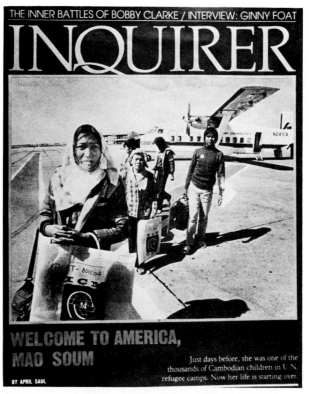

**Figure 2.9: April Saul wrote and photographed for this prize-winning Sunday magazine essay on a Cambodian girl's first days in the U.S. Reprinted by permission of *The Philadelphia Inquirer.***

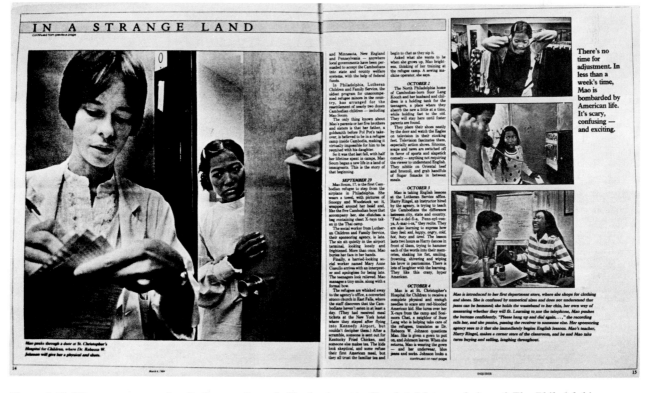

**Figure 2.10: The essay approach calls for creation of effective layouts. Reprinted by permission of *The Philadelphia Inquirer.***

## THE WEEKLY NEWSPAPER

A weekly newspaper is a great place to start, and many beginning photographers have gained valuable experience on such a publication. Peter Weinberger, Mananaging Editor of the Claremont, California *Courier* states the weekly's philosophy:

A weekly newspaper emphasizes *community* news and features that have no real deadline. We know that TV and daily newspapers will beat a weekly on any major news event, but to us that is an advantage. We do in-depth stories about Claremont people and give them personal attention. We feature the calendar of weekly events, police blotter [stories], and such community items as school-board review and film criticism.

The *Courier's* approach combines photos and story in some of the best graphic designs in today's weekly community newspapers. It has won the National Press Photographers Association award for best use of pictures in a newspaper twice in recent years.

## A NEW NATIONAL MARKET FOR PHOTOJOURNALISTS

One innovation in the newspaper field in the 1980s has been the introduction of the Gannett Corporation's national daily, *USA Today*. This newspaper has strong, all-color graphics (Fig. 2.11), reports national news in a brief bulletin style (few stories are longer than 500 words), has built a circulation of 1.3 million, and was available to 70 percent of the country by early 1985.

*USA Today*, with satellite printing plants in key cities across the country, uses small color photos, color weather maps, and color illustrations. The paper seems to have adopted the pictorial approach to news reporting used by television news programs. Gannett hopes this approach will appeal to the "TV generation."

The emphasis on color photography has reintroduced flash technique to photojournalism. Walter Calahan, photographer and picture editor at the newspaper's Washington, D.C. headquarters says,

Flash is a must on our assignments. Even on the many head shots we cover, we use multiple flash, so we try to arrive early to set up. Instead of shooting fast color film and "pushing" existing light, we use slow (50 ASA) film and flash. The result is well-exposed and lighted color that reproduces on our new presses excellently.

*USA Today* hires many freelancers across the country to cover local events. "We can't possibly have a staffer in each city, so the local newspaper staffer or freelancer gets a lot of work from us . . . and at good pay," says Calahan.

# WEEKLY NEWS MAGAZINES

The weekly newsmagazines such as *Time, Newsweek,* and *U.S. News & World Report* build on the basic wire service and newspaper approach, but add some unique working conditions that include:

- national and international news orientation
- exclusive use of color
- extensive travel
- weekly deadlines and more time on certain stories
- more possibility for interpretation

Work for one of these newsmagazines is a glamorous job and takes years of experience to attain. The staffs of newsmagazines have spent years on wire services or newspapers.

Photojournalists on a weekly newsmagazine use 35mm cameras and lenses, and cover the same mix of hard news and feature as wire services and newspapers. Many assignments require one photo, so the ability to "tell it all in one shot" is an advantage.

But weekly deadlines offer a chance to shoot an occasional photo essay. Certain stories receive a special treatment that calls for photographs. *Newsweek's* 50th anniversary issue in 1983 on "the American dream,"

for instance, was devoted to a photo essay on the growth of an Ohio town; the story filled the whole magazine.

Competition at the newsmagazine is fierce because each story is of national importance. It is covered by the wire services and newspapers. The newsmagazine photojournalist has to produce work that is different from theirs. Also, editors often hire freelancers for extra coverage of the same assignment, so magazine staffers are faced with extra competition.

The most important differences between working for newsmagazines and for wires and newspapers, at present, is the almost exclusive shooting of color and the amount of travel in assignments (Fig. 2.12). Newsmagazine photojournalists often find themselves mailing film from exotic (even dangerous) locations.

These working conditions make the work of a newsmagazine photojournalist a pressured one of hard work along with the glamour. Max Desfor, a Pulitzer Prize-winning AP photographer with nearly 50 years of photojournalism experience, tells about a typical week at *U.S. News & World Report*. He describes the deadline pressure of a weekly newsmagazine as "dif-

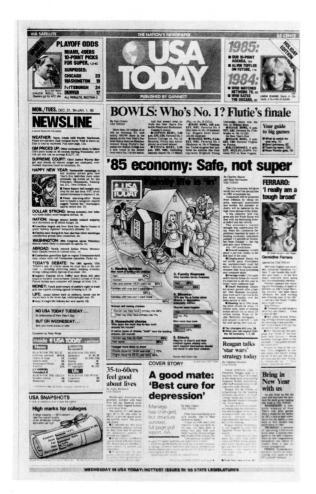

Figure 2.11: *USA Today* presents information briefly and in many color photos and graphic illustrations. Copyright, *USA Today.* Reprinted with permission.

Figure 2.12: News magazines cover national and international news on a weekly basis. Much of a news magazine's coverage today is in color. Copyright 1985, *U.S. News & World Report.*

ferent from the wire service 'deadline every minute,' but it's still intense. The pressure builds day-by-day to reach a peak intensity at the weekly deadline schedule.''

The basic work week at the magazine for each issue stretches from Monday to Friday. The presses run all weekend so the magazine can be home delivered to its more than 10 million subscribers on Monday.

They need the full week, Desfor says, because the magazine is

competitive with business and economic weeklies and monthly publications as well as the other two weekly

newsmagazines. Our approach is to take a news event as an immediate peg and then go on from there for a broad view. We dissect news events and analyze the consequences of them. Stories and photos on a breaking story in the early part of the week must hold up—and project—a week or more after the event itself is over.

Photographers must be ready to cover spot news events as well as studio or table top set-up for the cover or out on location with models. They must be able to deal with ideas to illustrate the weekly stories. A spot news photo could be a lead story, but only if it is part of and leads into the other graphics that illustrate the general thrust of the in-depth approach.

## OTHER MAGAZINES

No survey of photojournalism would be complete without mention of *National Geographic* magazine (Fig. 2.13). This publication is an outstanding example of the major magazine market—that of the nonweekly special-interest publications. Presenting a level of

professionalism that has remained a standard for over fifty years, *National Geographic* has a staff of photojournalists but also uses work from freelancers and from experts who also use the camera to report.

Robert Gilka, Senior Assistant photography editor

19

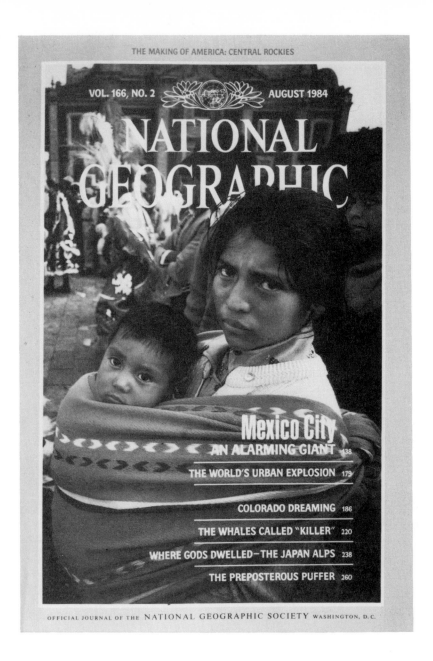

VOL. 166, NO. 2    AUGUST 1984

# NATIONAL GEOGRAPHIC

OFFICIAL JOURNAL OF THE NATIONAL GEOGRAPHIC SOCIETY WASHINGTON, D.C.

**Figure 2.13:** *National Geographic* represents a style of photojournalism that demands travel, technical skill, and the ability to handle a range of assignments in color. Copyright, National Geographic Society.

for the magazine and a strong force in its photographic excellence for over 30 years, wrote on the eve of his retirement:

> In the minds of many photographers a special aura seems to surround a shooter for *National Geographic*. And why not? Its photographers are forever off to exotic places on exciting assignments, places where the images come naturally. Or so it seems.
>
> At a given moment, the news in the *Geographic* photographic division is that Dean Conger is on his way back from Outer Mongolia with word of a good take. Steve Raymer reports on a coverage of poppies and opium which has taken him around the world. He tells of photographing Mexican fields from a police helicopter while its guns are spraying bullets on the illegal poppy farmers. Steve McCurry leaves mainland China after a visit to record the monsoon there. He's on his way to Kabul—if the Russians will let him in. A telex from Tom Abercrombie informs

the office on his progress through a difficult part of the Middle East. Closer to home, Annie Griffins finishes a story on Tulsa.

> What does it take to be a photographer for *National Geographic*? It takes technical skill, of course. Most *Geographic* photographers polished these kinds of skills in newspaper jobs, putting in five years or so on the street.
>
> A photographer for the *Geographic* must be a well-rounded journalist who realizes successful communication with the readers means a combination of good text and good photographs. . . . *Geographic* photographers must be generalists, ready to take on almost any kind of assignment anywhere.

Gilka feels strongly about well-rounded education for photojournalists.

> For the photographer now in a college or university and with the long-term goal of doing assignments for the *Na-*

*tional Geographic,* there are a few recommended courses of study: history, English literature, political science and, especially, if the interest is there, a science such as anthropology, archaeology, or biology. A solid conversational knowledge of one foreign language or more can be a most valuable asset. An ability to touch-type—once simply desirable—is essential with the advent of portable word processors.''

There are an estimated 10,000 magazines published in the United States each month. The majority of these are either trade publications (connected with a company or corporation) or special-interest magazines (aimed at an audience interested in *one* particular subject—health, computers, women's issues, the arts, and so on). All need good photographs on a regular basis. Few have staff photojournalists, so they provide a good market for freelancers.

One such special-interest magazine is *News Photographer,* published monthly for the 8,000 members of the National Press Photographers Association (there is a student membership category). Reporting on still, motion picture, and television news photography, each issue of the magazine contains interviews with working photojournalists, historical information, and usually an in-depth article of topical interest to photojournalists. It is a good source from which to learn.

Ann Bailie, Graphics Editor of the Long Beach, California *Press-Telegram,* feels a small paper is the best place to start in photojournalism:

Small dailies and weeklies are generally more receptive to photojournalists than large city papers, so they are a good place to start. Land a job, take good pictures, and . . . maintain your idealism. . . . Get a few year's experience, move up and start all over again.

Bailie adds that you can try to get a job freelancing, or "stringing," for the wire services to perfect your technique. Daily deadline work will help you develop your skill quickly.

Merle Agnello, after more than 40 years on the Johnstown, Pennsylvania *Tribune-Democrat,* advises, "shoot, shoot, and shoot for any publication that will publish your photos. Don't worry about big pay. Just carry your camera and look for photos. . . . Just let them know you're around and you'll get a break.''

Naturally, the need for photojournalism extends beyond the types of publications discussed here. It seems photographs are needed in every field.

The key to working for any of these publications is experience. They hire freelancers with proven reputations to shoot assignments. The pay is very good.

Anything beyond this brief mention of these important photojournalism fields is beyond the scope of this book. We will concentrate on fundamentals and stress news basics, so that, with a thorough command of making a single picture "tell all," you can develop as far as your talent will take you.

# 3 · HANDLING THE CAMERA

*"Take hold of your camera—get to know it—shoot roll after roll after roll—let your camera become an extension of you so that your actions are instinctive."*

Harry Benson, freelance magazine and book photojournalist

Harry Benson's advice is a modern update to the old saying, "The camera is only as good as the person behind it." Thorough understanding of your camera as a communication tool is more important than its make, model, or format. Once your camera becomes "an extension of you," you forget about camera operation and concentrate on shooting the visual story. If the camera is a 35mm, you already have the same format used by most newspaper and magazine photojournalists.

In this chapter, you will get to know your camera with a "hands on" approach. You will examine your camera, learn to load a roll (the right way), be shown how to hold it for sharp photographs, and so on. Don't worry about the details of camera operation for now. Those details will be discussed in a later chapter.

But for this get-acquainted chapter, just follow the directions in the basic operation of shooting your first roll of film. Just enjoy shooting.

## 35MM: THE CAMERA FOR TODAY'S PHOTOJOURNALIST

As long as you are comfortable with it, almost any 35mm camera is good for photojournalism. But, remember, the camera is only as good as the person behind it. Examine your own camera for its "feel" and features. Get out your camera manual and read it carefully. These manuals themselves are minicourses on the the use of your camera.

### AUTOMATIC VERSUS MANUAL CAMERAS

If you have an automatic camera, there seems to be little to learn—just point and shoot. But when you *must* get pictures on deadline, automatic, or programmed cameras (Fig. 3.1) can cause problems. If you do have an automatic camera, or might buy one in the future, consider these questions:

- If the camera has automatic exposure, does it have a manual override for special lighting conditions when you want to second-guess the meter?
- If the camera has automatic exposure, does the mechanism adjust the shutter or the aperture?
- If the camera has automatic focus, do you know that the focus will be whatever is in the *center* of your frame?
- If the camera has an electronic shutter, does it have a backup system for the manual operation if the battery dies?

But perfect exposure does not assure good photographs. Whether it is automatic or manual, you need to know your camera so intimately that it becomes what Harry Benson calls "your second skin." This amounts to an acquired skill based on a systematic, logical method that begins with Benson's basic premise: "photograph everyday—take your camera with you everywhere."

Handle your camera like the communication tool it is. The 35mm camera is only an instrument for telling a story. Don't baby it, but always have it securely around your neck, or have the strap wrapped around your wrist.

### LOADING THE CAMERA

Every beginner knows how to load film in a camera—or assumes it's such a snap that no care is needed.

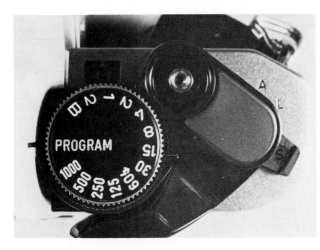

**Figure 3.1: Programmed or "A" cameras do much of the exposure work for you, but be certain you know the manual features; in some instances you will need them.**

**Figure 3.2: When loading your camera, check that the leader is firmly caught by the take-up reel.**

**Figure 3.3: In loading, another safety check is to make certain that gear teeth show through film sprockets on both edges of the film. Advance the film a bit for insurance.**

Unfortunately, even this simple step can cause problems if you trust the camera (or the ads) too much. Although today's cameras are built for easy loading, things can go wrong because the film is pulled out of its cassette during shooting and then is rewound back when you reach the last frame. Nothing is "fail-safe." Even with automatic loading cameras, you must double-check to assure proper loading.

First, visually check that the film leader is firmly caught in the take-up spool (Fig. 3.2). Second, make certain that the sprockets on the advancing gears show through the holes on the film. Advance the film a bit to check. These teeth are what grab the film and advance it, so they must be engaged (Fig. 3.3). Third, turn the rewind handle to take up the slack in the film canister. Watch the rewind handle as you advance the film into place for the first frame. It should revolve each time the film advances (Fig. 3.4). If the handle does not turn, chances are that the film is not advancing, and you must open the camera to double-check.

## KEEPING STEADY

During the excitement of shooting, you may move the camera during exposure so that the image is blurred. If you look closely at the film after developing you may even see a "ghost" image. Nothing on the negative will be sharp when you try to print.

In situations needing a shutter speed of 1/60 second or slower, the camera should be rock-steady. You should avoid shooting at shutter speeds slower than 1/60 second without a tripod. However, in photojournalism you will come across photo possibilities that will not allow you to set up a tripod. Therefore, you need a method of eliminating hand-held camera movement so you can produce sharp images.

Be conscious of yourself as a solid support for your camera. Then, to ensure consistently sharp images, follow this technique:

- Hold your camera comfortably in the upturned palm of your left hand.
- Rest your left elbow snuggly on your left rib cage and turn your elbow inward. The closer to your side you hold your elbow, the better.
- Hold your camera firmly to your eye, secure against your cheek. Even if you wear glasses, have the camera snuggly against your face (Fig. 3.5).
- Bring your right hand lightly up to the camera and rest your right index finger on the shutter release button.

Once you are solidly placed, use these steps for photographing:

- Focus with your left hand firmly around the lens barrel but with a light touch.

- Take a deep breath, let it out, and then stop breathing while you frame the subject.
- Suspend all movement while you shoot.
- When you shoot, squeeze the entire hand, not just the index finger on the button.
- After shooting, immediately advance the next frame to be ready for the next shot.
- Start breathing again.
- Get "set" for the next shot by repeating the preceding steps.

With practice, you can be solid enough to shoot sharp photographs at shutter speeds that normally need a tripod. That extra-good shot may be available only if you use a shutter speed that is very slow, so you will be forced to be as solid as a tripod.

You can also use other supports to reduce camera movement—for example, a tree, a tabletop, a wall, a door frame, or any similar support (Fig. 3.6). But even with these supports, follow the procedure above, because a sloppy shutter finger or breathing while shooting can ruin a shot even with firm support.

When this system becomes instinctive, unwanted camera movement will all but disappear. You will also develop a more conscious method for focusing, framing for composition, and shooting while on assignment.

Figure 3.4: When film is loaded, double check by watching the rewind knob turn as you advance the film. If it is not turning, the film may not be caught properly.

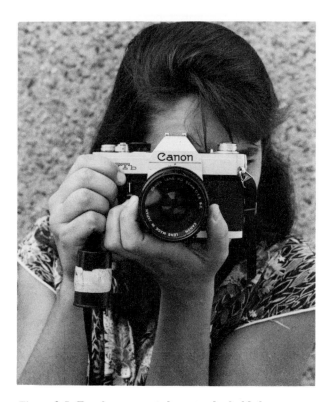

Figure 3.5: For sharpness at slow speeds, hold the camera firmly in your upturned palm, with your elbow in your side and the camera firmly at your eye. Photo by Bill Peck.

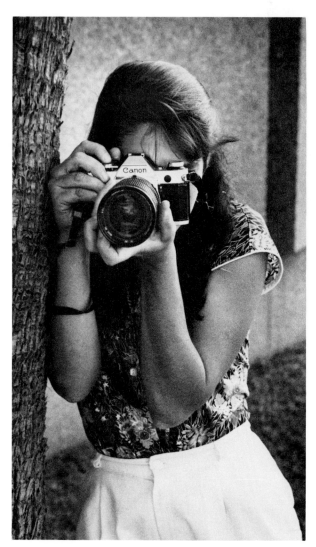

Figure 3.6: Rest on a fixed prop to be sure that you are steady while shooting. Photo by Bill Peck.

## DON'T BE SELF-CONSCIOUS

When you are on assignment in front of people, you might become self-conscious and forget your technique. But nothing is more important in photojournalism than consistent and confident camera work. It demands that you forget about your ego and concentrate on getting the best, sharpest photograph under a variety of conditions.

The test of your understanding of the camera and its use will come when you can thoroughly enjoy its operation from loading to shooting the final frame without worry or conscious effort. You will have the "touch" of the experienced photojournalist telling stories with the camera as a communications tool.

# THE BASICS OF EXPOSURE

Now that you are familiar with your camera, it's time to shoot a few rolls of film. In the next chapter you can actually follow a step-by-step method of seeing and shooting for best results. But first you need a "feel" for exposure or the amount of light on the scenes you will be shooting.

Your light meter is a marvelous instrument and is very accurate within certain limits. It can be fooled by unusual light, or it can malfunction. In either case, you need a backup to second-guess the meter.

Before you go on to Chapter 4, memorize this exposure sheet for 400 ASA black-and-white or color film (Fig. 3.7). This sheet gives you usable exposures for different lighting, so you can get a photograph even if your meter fails.

The information in the figure will allow you to make an educated guess of the exposure in almost any lighting situation. A closer look at the figure will show that these exposure ranges are even simpler than you think. Just a few shutter–f-stop combinations fit a variety of lighting scenes.

## EMERGENCY EXPOSURES OUTDOORS

For instance, with Tri-X film, all of the sunlight scenes call for 1/500-second shutter speed and only the f-stop is changed to adjust to lighting changes. We can sim-plify this even further by following the old adage, "expose for the shadows and let the highlights take care of themselves."

This means that even on a sunny day that calls for f/16, you still might shoot f/8 to get shadow detail. So, a good emergency exposure outdoors, regardless of the lighting, would be: 1/500 second at f/8.

In the case of emergency shooting indoors, a good "average" exposure would be: 1/60 second at f/2. This exposure would assure you of a printable negative for almost any indoor scene.

Another guide to outdoor exposures is the "sunny/16 rule." This rule matches your shutter speed with your film's ASA and f/16. For example, the shutter speed for Tri-X at f/16 would be 1/500 second.

But whether you follow the exposure sheet or use emergency exposures, you should always *bracket* your exposures to be safe. To do this, start out with one exposure and then shoot the same scene at one stop under and one stop over the original exposure. For example, shooting an open-shade exposure, you would shoot (1) 1/250 second at f/8, (2) 1/250 second at f/5.6, and (3) 1/250 second at f/11. This is a common practice in photojournalism, and gives you three chances of coming up with a printable exposure.

Now it's time to shoot a roll—maybe two or more.

**Figure 3.7: Use this exposure sheet for "educated guesses."**

| PICTURE SUBJECT AND LIGHTING | SHUTTER SPEED | LENS OPENING |
|---|---|---|
| Home interiors at Night | | |
|     Areas with bright light | 1/30 | f/2.8 |
|     Areas with average light | 1/30 | f/2 |
| Interiors with bright fluorescent light | 1/60 | f/4 |
| Indoor, outdoor Christmas lighting at night | 1/15* | f/2 |
| Brightly lighted street scenes at night | 1/60 | f/2.8 |
| Neon signs, other lighted signs at night | 1/125 | f/4 |
| Store windows at night | 1/60 | f/4 |
| Floodlighted buildings, fountains, monuments | 1/15* | f/2 |
| Fairs, amusement parks at night | 1/30 | f/2.8 |
| Night football, baseball, racetracks | 1/125 | f/2.8 |
| Basketball, hockey, bowling | 1/125 | f/2 |
| Stage shows—average lighting | 1/60 | f/2.8 |
|     (bright light, 2 stops less) | | |
| Circuses—floodlighted acts | 1/60 | f/2.8 |
| Ice shows—floodlighted acts | 1/125 | f/2.8 |
| Ice shows, circuses—spotlighted acts | 1/125 | f/2.8 |
| School—stage and auditorium | 1/30 | f/2 |

*Use a camera support for exposure times longer than 1/30 second.

## DAYLIGHT EXPOSURE TABLE FOR KODAK TRI-X PAN FILM

| SHUTTER SPEED 1/500 SECOND | SHUTTER SPEED 1/250 SECOND | | | |
|---|---|---|---|---|
| Bright or Hazy Sun on Light Sand or Snow | Bright or Hazy Sun (Distinct Shadows) | Cloudy Bright (No Shadows) | Heavy Overcast | Open Shade* |
| f/22 | f/22† | f/11 | f/11 | f/8 |

*Subject shaded from the sun but lighted by a large area of sky.
†For backlighted close-up subjects, f/11 at 1/250 second.

# 4 ▪ VISUAL AWARENESS

*"Above all, I want to make you see."*

Joseph Conrad, novelist;
D. W. Griffith, movie director

"He never stops looking." "He's a great photographer."

*Newsweek* photojournalist Wally NcNamee made this comment years ago as he watched George Tames of the *New York Times* working during a Senate hearing in Washington, D.C.

As Tames moved through the room, he never stopped looking steadily for photographs. Slowly, with two 35mm cameras at the ready, he circled the room, looking for picture possibilities. He moved constantly, but slowly and deliberately.

But the casual demeanor was deceptive. For, like all successful photojournalists, George Tames was on the alert for storytelling photographs. As a visual person, he knew that the subject must be observed and explored in great detail in order to produce the right photograph that reports a specific news event. Tames was on the lookout for that one excellent photograph that could be waiting on even the most routine assignment (Fig. 4.1). Tames was using the old news-photography saying: "Think, see, move, shoot."

**Figure 4.1:**
**A child's curiosity can be illustrated by showing only her tiny fingers and the fly that captured her interest.**

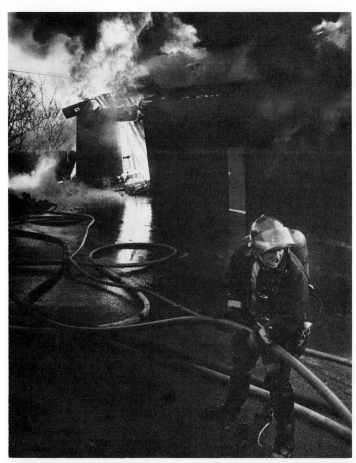

*Left*—**Figure 4.2: This shot captures the scene overall: the flames and smoke and fire hoses, but also the firefighter's face. Photo by David Longstreath, courtesy** *The Daily Oklahoman.*

*Below*—**Figure 4.3: Of this detail of the same fire, the photojournalist remarked: ''The heat from this fire was intense and the firefighter's expression shows it.'' Photo by David Longstreath, courtesy** *The Daily Oklahoman.*

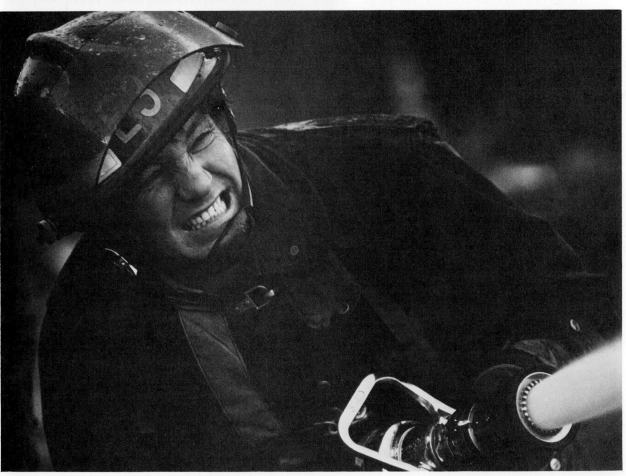

Over the years, each working photojournalist has refined this terse advice into a personal method of shooting. Each states his or her approach slightly differently, but all agree that the basis of such a visual approach is the trained ability to see everything in great detail. They also agree that such an approach allows them to capture many visual possibilities in a scene.

The result is variety in shooting. There will be different angles, a variety of lenses used, vertical and horizontal compositions, and a selection of general views, medium shots, and close-ups. In short, the range of selections will give the editor a variety of choices for the best storytelling photograph.

To find that best photograph takes acute visual awareness, constant thinking, and training in a method that assures full coverage. Photojournalists like Tames and McNamee do this by intuition after years of experience. They know just what to look for, and automatically seek out the angle, composition, or detail that captures the heart of the assignment.

As visual communicators, they know that the only way to improve is to approach each assignment with a combination of experience and enthusiasm. As McNamee says:

> Each assignment is different from the last, sometimes only slightly so, and with competition so fierce, we have to see that extra detail that is often the only difference between assignments. The photographer who sees the sharpest consistently comes back with that special shot that beats the rest.

# DETAILED SEEING

In a later chapter, composition in photojournalism will be discussed. But even the most sophisticated approach to composition begins with observation—a hyper-awareness of the subject's details. Edward Weston, the great art photographer, called composition "the strongest way of seeing." So, when practicing your photojournalistic composition, you won't even need a camera—you will simply be practicing seeing. Seeing for detail does take practice.

For this detailed seeing, you don't need any rules of composition, no special formula for the "right" combination of elements or design. All you need is an open mind to go with your open eyes and a willingness to accept everything you see as being a picture possibility. Organizing this awareness into a photojournalistic approach with camera comes later.

## GENERAL, MEDIUM, AND CLOSE-UP VIEWS

For a start, organize your seeing in the broadest terms by using these three categories: the establishing shot (Fig. 4.2), the medium shot, and the close-up (Fig. 4.3). Apply this approach to everything you see. This basic visual approach has provided a shooting structure from the earliest days of photography, and is logical for visual language.

This classic organization of seeing in photographic terms is useful for a basic introduction to detailed seeing, but for the visual world of the 1980s, it is still too broad. You need a more sophisticated awareness to assure that you miss no storytelling detail.

# EDFAT

One method that allows you to fine-tune your photographic seeing is EDFAT—Entire, Details, Frame, Angles, Time. EDFAT trains you to:

| | |
|---|---|
| *Think/See* | observe the *entire* subject (Fig. 4.4) |
| *See* | dissect the subject into specific *details* (Fig. 4.5) |
| *See/Think* | *frame* those details into strong, original compositions (Fig. 4.6) |
| *Move/Shoot* | shoot from a variety of *angles* (Fig. 4.7) |
| *Shoot* | build visuals by using slices of *time* |

This approach works well with things as well as people. EDFAT will help you explore the familiar as if it were brand new.

The old saying "what you see you can photograph" only applies to someone who sees in rich detail. So take the time to make a short field trip as a practical test of the method.

Sling your camera on your shoulder and carry it with you while you learn to see deeply, enthusiastically, and in detail during a short walking tour. Take yourself and this book. The tour will work best in an area where there are a lot of people. It might be best to apply EDFAT as you observe the activity of your campus or busy street.

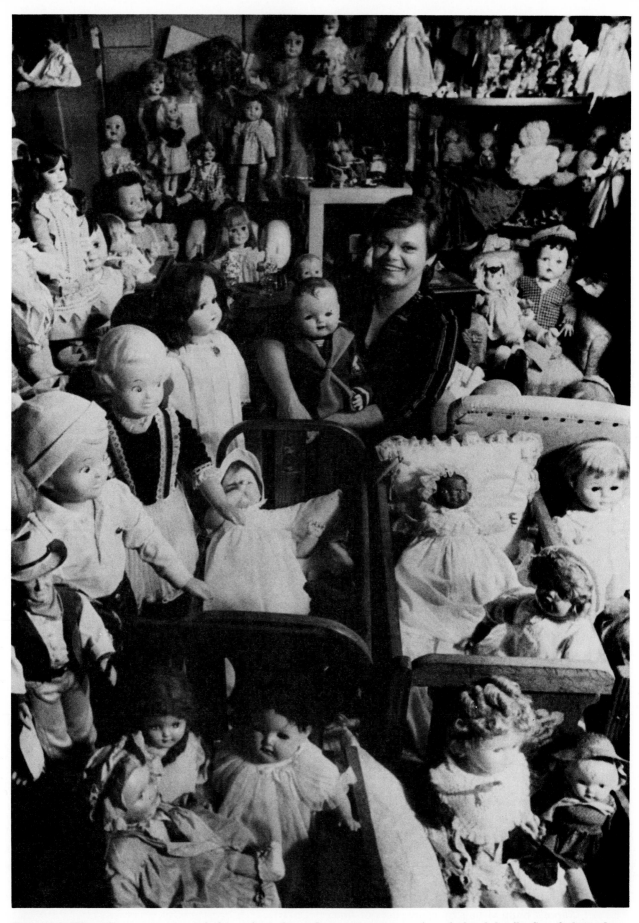

**Figure 4.4: The entire scene, or general view, orients the reader so you can move in to isolated details. Set of photos by Robert Townsend,** *Pittsburgh Post Gazette.*

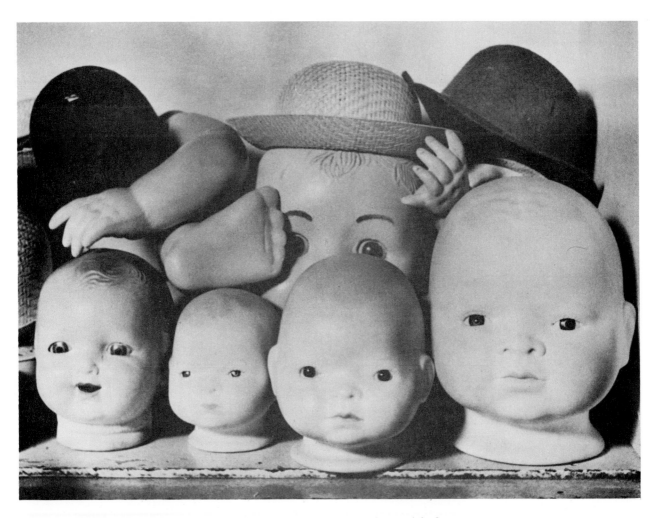

**Figure 4.5: Medium shot moves in closer, usually by isolating a part of the original scene.**

**Figure 4.6: Details have impact because they concentrate the reader's attention on only one small part of the story or scene.**

**Figure 4.7: The photographer's choice of angle in this case emphasizes the players' expressions. Photo by Mike Rynearson.**

First, look around slowly. See that tree off to your right? See that boy or girl passing on a bike? That sign? That group of people wandering by? The building silhouetted by the sun? The grass? The cars or buses passing? The sunlight on the road, reflecting into your eyes? If it's cloudy, how about the dull, gray light that floods everything?

Each of these and hundreds of other elements are worthy of recording. You could shoot an entire roll during this walk, if you were shooting now. You could shoot at least one full roll on each of the subjects named so far. And don't forget that flock of pigeons flying past. Or the student reading a book under that tree. But, for now, you are not shooting, so explore the environment by making yourself see.

If you have followed this chapter so far, you have collected a mindful of assorted images, and you probably missed many others. Of the subjects of which you have images, did you really *see* them? For example, how tall were the girls or boys? What color clothes did they have on? What type of tree was that? What was the make of the bike? How many people were in the group, and were they young or old? Did you pass each subject before you exhausted all its possibilities?

If you have only a vague image of each subject you saw, begin to apply EDFAT as a definite checklist for exploring any subject before you shoot. Chances are you saw each subject only as an element in the visual landscape. If you had taken photographs with this viewpoint, you would have a collection of snapshots—long shots—that are acceptable for general information, but that do not explore the visual storytelling possibilities inherent in any single subject.

## EDFAT WITH CAMERA

The first half of this field trip is over. It's time to take photographs. You will apply EDFAT now as a shooting method:

- Entire
- Details
- Frame
- Angle
- Time

Use a camera with a standard lens (50mm is good), and loaded with a 36-exposure roll. Use a person as

34

your subject. As a photojournalist you will constantly deal with strangers, so your subject should be a stranger. So, start from where you are now and walk. The first person you encounter will be your subject.

Approach the subject and introduce yourself. Explain what you want: a complete portrait of him or her based on shooting many photographs. Don't hesitate, because you are on an assignment. (This is your assignment for this chapter.) If necessary, show the person this book and explain that you are following instructions. You will be surprised how cooperative most people are when you explain your needs. When the subject agrees to be photographed, move back to about 15 feet away to start shooting.

## ENTIRE

From 15 feet away, focus on the *entire* person as part of the environment, and shoot three horizontal shots. Turn the camera and shoot three vertical shots. Move around and compose each shot differently in some strong composition. Don't place the person in the center of your frame. While shooting, explore the person through your lens, dissect him or her from head to foot. Relate the person to the background.

Move in and from approximately 10 feet away, repeat the procedure. Then, move in to about 7 feet and repeat your shooting procedure.

## DETAILS AND FRAMING

Now move in to about 5 feet and search for details of the person. At this distance, you are no longer photographing a person in relation to a large background, but are making a portrait. So concentrate on details. Shoot the three horizontal frames from the waist up. Repeat from the waist down. In doing this, you are framing the person in relation to the edges of your photograph and are exploring the composition possibilities in a sort of framing free association. Try any composition that comes to mind. Use feet, books, boots, a hat, gloves, hair, eyes, even the background as elements to compose a variety of shots: no two frames should be the same. Make strong visual shots, and compose as you shoot.

Talk with the person as you shoot. Get to know the person's background and personality. Soon he or she won't be a subject anymore, but an interesting individual.

## ANGLES

What would this individual look like from a different *angle*? If you have taken all shots so far from eye level and straight ahead, now take shots from the left, then right, from a low angle and then from a high angle. Look for something to stand on, or even squat down to get an especially low angle. Perhaps you might ask

the subject to sit down, or stand a special way. By this time, you should be working with a very cooperative subject.

Your film counter should be at about 26 by now, or maybe you have run out of film. This is good, for it means you are really seeing and have a good rapport with your subject. Put in another roll. One roll is a bare beginning for detailed photographic seeing.

Now move in very close, to the shortest distance your lens will focus. Study the details on the subject's face. Concentrate on photographing the eyes, lips, nose, hair, and features of the face. At this close distance they are your material for a close-up. Remember to vary your composition with horizontals and verticals, and experiment with different framing and angles. Try to get your subject's hands in the photo, perhaps close to the face, to frame it. By now you are working with your subject to get a character study, or what is called a personality portrait. Both you and the subject should be too involved with creating, composing, and interacting to merely be taking a few snapshots.

## TIME

By now you should be coming to the end of your second roll of film. You might be out of film, but not out of enthusiasm. During the shooting session, you have been using the fifth element of EDFAT—*time*—in two ways: first, as a series of shutter speeds to capture the action, and second, as a span of time that allows you to explore in full detail many visual possibilities of a single subject.

More importantly, you have introduced yourself to a way to be photographically perceptive. Concentrated, in-depth seeing is an absolute necessity for making meaningful journalistic photographs. And you will begin to understand that there is no one way to shoot an assignment. Your own imagination is the only limitation to the number and type of compositions you can produce in any shooting session.

Howard Chapnick, in his column "Markets and Careers" in *Popular Photography*, summed up this imaginative approach to photographic seeing by quoting the poet, Ezra Pound: "Genius is the capacity to see ten things where the ordinary man sees one, and where the man of talent sees two or three, plus the ability to register that multiple perception in the material of his art." The EDFAT method helps you find multiple ways to see. Many ordinary photographers will try to record a first impression over and over without thinking of changing angle or framing. You now have the beginning of a method that will make you unique and personal in your perception.

By following this method (and shooting lots of film to record those visual details) you can develop your own perception to overcome this problem that Chapnick sees: "If we had more perceptive photographers,

**Figure 4.8: This contact sheet follows EDFAT steps to give the editor a choice beyond what he or she asked for. The choice gives flexibility in creating a layout on deadline. Photo by Kevin Elliot.**

Figure 4.9: A man's hands become details that break the rigid pattern of electronically locked doors in a state institution. Photo by David Longstreath.

we would not be overwhelmed by pallid, minimal, empty photographs as we too often are now.''

Of course, there is no need to stop at only one roll. You could begin with smaller details and slowly back up to your original 15 feet, say "thank you," and leave. But even if you leave now, you still have 36 exposures on a single subject, and could not have exhausted the visual possibilities in that one person. As a matter of fact, as you leave this subject after applying EDFAT for the first time, you might agree with Douglas Chevalier, staff photographer for *The Washington Post*:

one of the most interesting aspects of this business is that you always leave any assignment dissatisfied with the feeling you could have done better—given more time, more film or, sometimes, another chance. But for me, that leads the way to say, "Well, next time do it better"—it all makes you push next time for that 'one more' we always want.

## CAPTION INFORMATION

As explained in Chapter 2, no photograph is complete without a caption. However, gathering the necessary caption information while you are shooting the subject can be a problem.

There are two times during shooting when you can get the caption information; both are natural and effective. You could ask the questions of name, occupation, and so on, as you establish rapport with your subject and have it all done at the end of your shooting session. Or, you could wait until after you've shot and then ask the questions that will result in a complete caption. Either way is acceptable; but waiting to the end has its advantages when you are new at shooting.

You can keep this caption information with the film so it will be available when you hand your work to the editor. One advantage of shooting the same subject in so many shots is that one set of information will suffice for any shot, even if you shot several rolls.

You now have a definite system of visual organization. You can approach any subject and come away after shooting with a selection of photographs. There are many subtle expressions of your subject you probably missed, and if you are like many of us, you will later think of compositions you should have taken. Even so, the many photographs you took in this one session are an excellent beginning.

## SEEING THE RESULTS

The next step in photographic seeing is to develop and make a contact sheet of each roll. On examining these contacts, you should be able to trace your shooting steps in your contacts beginning at frame 1. Frame by frame, you should see the subject relax as the shooting session progresses. If you are like many of us in photojournalism, that last frame may be the right one.

However, you should have many more than one possibility on your contact sheets (Fig. 4.8). The final question will be, "How can I possibly print all of these good photos?"

Your editor will have the same dilemma. He or she will have to choose one photo from among the many striking images you have produced. You will have expanded your range of visual possibilities greatly, and the editor will be happy with your work. The editor might even decide to use several photographs to tell the story.

Finally, EDFAT should free you from the snapshot approach. By perfecting the method you will make yourself a visual communicator who sees well beyond average "looking." As Robert Rauschenberg, one of the founders of Pop Art in the 1950s states, "As far as taking the picture, the most important exercise is looking—first totally observing and then selecting what you think might be a special aspect."

The exploratory method of EDFAT (Fig. 4.9) guarantees that you will produce a variety of vital images having that "special aspect" of a story and will make you a strong photojournalist.

# 5. DEVELOPING FILM

*"Don't tell me about your photos—go out and shoot them—then* show *me."*

Paul Harrington, AP Picture Editor

## A ROLL OF LATENT IMAGES

Unlike the majority of the chapters in this book, this chapter will be a straight how-to one that will guide you step-by-step in developing a roll of film. If you have developed film before, it will give you a systematic approach to this vital process. If you are brand new to film developing, it will introduce you to one of the most exciting gifts photography can offer: the chance to create an image yourself from start to finish.

You should have one (or more) rolls of film ready to develop. (If not, then go ahead and shoot the ED-FAT assignment as prescribed.) As you shot your film, you were recording invisible images. Now on your film is a whole series of latent images that will become vis-

ible through the near-magical process called developing, or processing.

During this process, you put the film through a series of different chemicals that *develop* the latent image to a visible one, *fix* the image so it will be permanent, and finally *wash and dry* the film to prepare it for *printing*. At the end of the process, the film will be in a negative form, or a reverse of the way you saw the subject when you were shooting. Such negative images are the basis for photographic recording on film and will lead to the next step: printing an enlarged positive image on photographic paper. But for now let's cover the film processing basics.

## IN THE DARKROOM

The fast 35mm film you used is extremely sensitive to light. Therefore, the film must be loaded in the developing tank in *total* darkness. Even if you turn off the light when you enter the film developing room, or darkroom, make certain there are no light leaks. After waiting 30 seconds to adjust to the dark, examine the room for light leaks. Also make certain the door is firmly closed and that no one can enter accidentally while you are loading the film. One way to assure complete safety while loading your film is to follow the traditional courtesy observed in every darkroom. If you ever see a darkroom door closed and you want to enter, always knock first and wait for a reply.

The answer to that traditional courtesy knock on the darkroom door is a loud *Dark!*

The room *should* be locked, but if not, this answer can save many rolls of film from ruin. You will need no more words. So, as you close the door to develop your first roll of film, make certain it is secure and be prepared to warn someone else with the yell *Dark!*

### BEING PREPARED BEFORE IT'S DARK

Before you turn out the light to load film, make certain you have all the necessary tools for successful developing. These include (Fig. 5.1):

- processing reels
- a bottle opener of some type
- scissors
- developing tank
- all chemistry at the correct temperature and in order they are to be used
- a clean, dry area (spotless)
- a chart that gives you complete developing times and steps
- running water
- a thermometer

These tools should be in place even before you load film so you can reach out in the dark and easily find them. Handling precious film that took such imagination and work to shoot demands an unchangeable system where everything is in place.

## PROCESSING TANK AND REEL

There are many types of processing tanks and reels and they usually come as a set. But stainless steel tanks and reels are the most widely used by professionals in newspapers and magazines for hand processing. The reels are millimeters narrower than the film. This assures that the film does not wind tightly or compactly on the reel; instead it is slightly bowed so it will not touch during development.

You should practice with these reels before attempting to use them for developing. It takes some dexterity to get the film started without crinkling it and you have to apply just the right pressure on the film so it will bow, but not too much. Practice with old, exposed film. If you are developing your first rolls of film, see if your darkroom has other types of reels, besides steel, that are easier to use. You could switch to steel reels later.

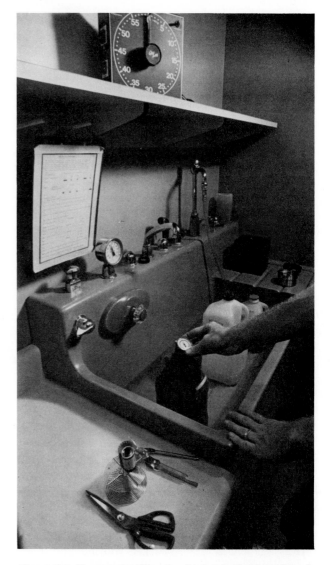

Figure 5.1: Prepare for film developing by having all tools in order and the water and chemicals all at the same temperature.

# PROCESSING

Processing tanks have a light trap in the top that allows processing chemicals to be poured in and out without light ruining the film. This means that after you have loaded the film into the tanks you can turn on the lights. With the lights on you can check each chemical step in the process.

Briefly, film processing is a chemical process that first changes (develops) the latent image into metallic silver, then dissolves all unexposed silver halides (fixes), and then washes out excess chemicals to produce a permanent visible negative image.

The steps and results of each of these steps include the following (Fig. 5.2):

| STEP | RESULT |
|------|--------|
| Development | Changes exposed silver halides into metallic silver in a process called reduction |
| Stop bath (rinse) | Stops developing action by rinsing off chemicals with water or an acid "bath" |
| Fixer (hypo)* | Dissolves away unexposed silver halides to make image permanent |

*Nickname for fixer that has been used for many years.

Rinse — Rinses away excess fixer

Fixer clearing agent (in most labs) — Chemically neutralizes fixer so washing is faster, more complete

Wash — Running water cleans film of excess chemicals

Drying aid — Treats water so film dries without spots

Dry — Dries film

## PREPARING CHEMICALS

Prepare the chemical solutions by following the manufacturer's instructions for mixing. The recommended temperature is usually 20°C (68°F), but in photojournalism, film is often run at other temperatures. The crucial consideration is to have all the chemicals at the same temperature. You can do this in one of two ways. You can place all the chemicals in temperature-controlled water and bring them all to the required temperature reading. If you are the first to use the chemistry, this might take some time, depending on the room temperature. Or, you can develop at room temperature (as long as the temperature is not above 75°F) and then adjust the wash water later to whatever the room temperature is. This second method is an easy one for your own darkroom, or in a lab where the water is not running all the time. Manufacturers supply charts to show a range of temperatures and times for development from 65° to 75° F. The wash water is only turned on during rinse and wash. With temperature-controlled water, this is easily done. It also assures regulated temperature (a must) and saves a great deal of water.

With either method, make certain to take the temperature of all chemicals. One rule of the darkroom is never to assume anything—always double-check everything from chemical levels to temperature. If you even have a doubt about a chemical (unfamiliar odor, color, unmarked bottle) dump it or call the lab person.

## SURFACES AND TOOLS

After the chemicals are set up in the order to be used, check all surfaces to make certain they are dry and totally clean. Your hands should be dry and free from any trace of chemicals; even a slight residue on your hands will mark the film permanently. Lay out all necessary tools—it is a good idea to have your own checklist of these items as you set them out in front of you, but before turning out the lights, close your eyes and then find them by touch. Set the darkroom clock at the recommended time for the temperature of the chemicals and film used. After a double-check, turn out the lights.

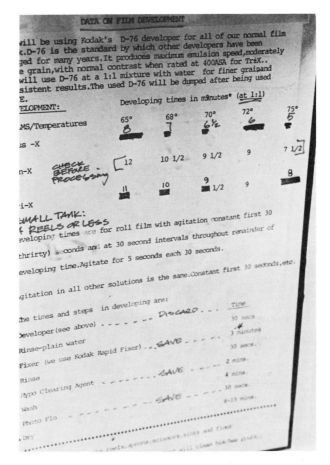

Figure 5.2: A chart on the darkroom wall helps remind you of the steps until you are completely familiar with them.

For your 35mm film, you will need the bottle opener in order to pry off the flat end of the cassette. The preloaded film cassettes you buy are made to be opened in this way and can only be used once (Fig. 5.3). It is possible to buy empty cassettes and load your own film into them. With these, you can gently twist off the cassette's end and then reuse it.

Once the cassette is open, gently push the film from its cassette. Once the raw film is in your hand, handle it only by the edges. Do not touch the film surface.

## LOADING THE TANKS

At this stage, you need a straight edge of the film to make reel loading easy. You can make this edge by cutting off the leader (Fig. 5.4) or by carefully rerolling the film until the taped end (attached to the plastic spool) is accessible. Then gently remove the tape and use that straight end for your lead. The tape has to be removed anyway, and this is usually easier and safer than cutting in the dark.

When you have a straight edge, load the reel according to the lab or manufacturer's instructions (Fig. 5.5). As you do, remember to use a fine touch. Don't force the plastic film. Let it ride by itself with you gently guiding it onto the reel (Fig. 5.6).

Load your reel or reels into the tank and place the lid on tightly. With the lid on securely, you can turn on the light. The rest of the process can be done in the light. *But don't remove the lid until after the fixing step.*

## DEVELOPING

The developing step is the most important one in film processing. Take care, beginning with the pouring of developer into the tank. First, make absolutely certain you have enough developer to cover the film (Fig. 5.7). To ensure this, the developer should bubble out and overflow from the light trap. Occasionally, a beginner will measure out an amount adequate for an 8-oz. tank, but inadvertently pour it into a 16-oz. tank with two rolls in it. Here, a visual check (the overflowing developer) is your best safeguard against a half-developed roll. You should also tip the tank during pouring to avoid an air lock.

As soon as the developer is poured in, start the developing procedure using these steps:

- Turn on timer clock (Fig. 5.8).
- Rap the tanks sharply against your hand to dislodge air bubbles (one of the problems of pouring rather than deep immersion).
- Begin the systematic agitation of the film. This agitation assures even development of the film. Agitation also activates the chemicals, so must be controlled and consistent.

## AGITATION

Three common methods of agitation are as follows. (1) Turning the tank upside down (using a spill-proof top) and back to allow the film and developer to move during agitation. (2) Using a gentle circular movement of the tank to allow the developer to flow around the film. (3) Combining the first two methods. These styles are equally effective as long as they are done consistently and smoothly.

A beginning approach to agitation is constant agitation for the first 30 seconds of development and then 10 seconds of agitation every minute thereafter.

The method and pace of agitation should be uniform each time you develop. It should be gentle and the same duration and frequency should be used. Any deviation from that norm will change the contrast and density of the film. Even though each person agitates slightly differently, to get consistent quality your method must be standard.

**Figure 5.3: Open film cassette in darkness by twisting if it's reloadable and by using a bottle opener if it's packaged by the manufacturer.**

**Figure 5.4: Cut film across evenly for ease of loading the steel reels.**

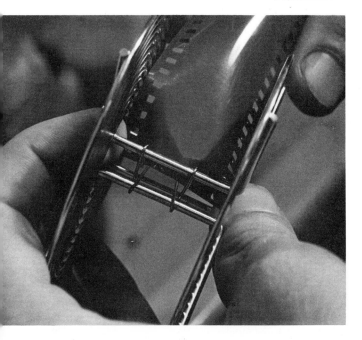

Figure 5.5: Proper loading of steel reels in darkness requires careful loading onto the inner clip; slightly pinch the film with one hand while gently turning the reel to load without crinkles. If you are pinching too hard or forcing the film, you will be able to feel it. Just back up and start again. The first few turns are crucial to perfect film loading.

Figure 5.7: Pour the mixture of developer into the light-tight lid of the processing tank. Then rap the tank against the side of the sink twice to dislodge air bubbles.

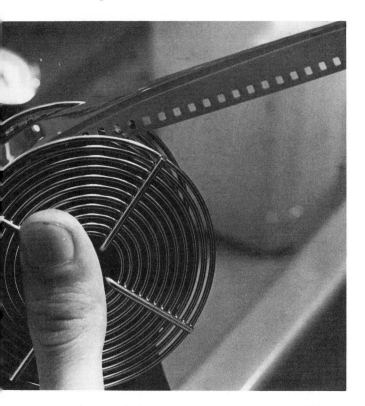

Figure 5.6: When film is completely loaded, it should be loosely wound into the reel so you can slide it gently back and forth. Properly loaded film will also shift if you shake it gently. Now place the film in the light-tight tank and proceed with the lights on.

Figure 5.8: Set the timer at the developing time that corresponds to the temperature.

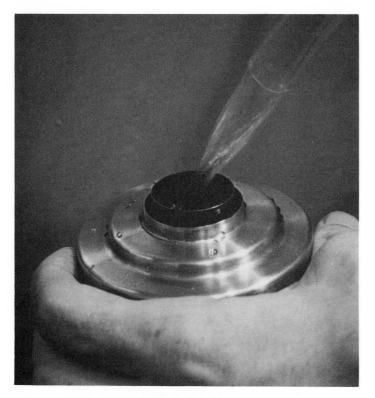

Figure 5.9: After developing for the proper time, pour out the developer (for 1:1 mixture) and then rinse. Pour running water that is the same temperature as the developer into the tank. Dump this water and refill several times during a 30-second rinse.

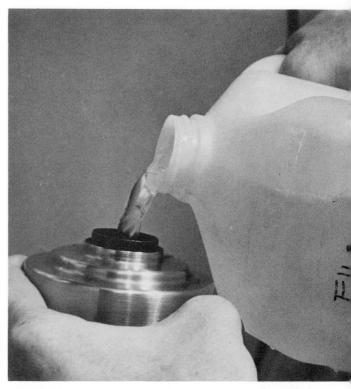

Figure 5.10: Pour film fixer directly from the jug (or the amount you need from a graduate, making certain to rinse the graduate thoroughly afterwards to avoid contamination). Agitate for about 30 seconds every minute.

When development is complete, pour off the developer immediately. Whether you pour the used developer down the drain or pour it back into a bottle for reuse depends on the type and dilution of the developer. The so-called one-shot developers are made for one-time use and are then discarded. Other developers are reusable, but they require a small amount of special replenishment to replace chemicals lost in development.

### STOP BATH

After the developer has been poured off, you need to stop further action of the developer and to dilute the developer so the fixer can work easily. A common method is to use plain water at the same temperature as the developer to rinse the film for 30 seconds (Fig. 5.9). Do not open the tank during this rinse.

### FIXING

After the rinse/stop bath, pour fixer into the tank until it overflows. Set the timer for the recommended time. Agitate constantly for the first minute and then for 10 seconds of each 30 seconds thereafter (Fig. 5.10). In fixing, it is better to over-agitate than to under-agitate. The time in fixer (and other chemicals) is not as critical

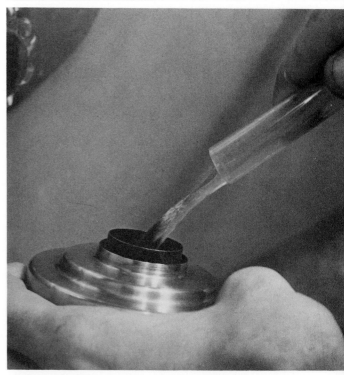

Figure 5.11: Rinse after fixing as you did before: fill and dump several times during a 30-second rinse.

as in the developing process, so if you go over the recommended fixing time by a minute or so, don't worry. After the clock stops, pour the fixer back into its bottle for reuse. Fixers can be used for many rolls of film.

### RINSING AND INSPECTING

As soon as fixing is complete, you can open the tank to inspect your film. Many people go through this stage without inspecting the negatives, but you probably want to see what you've created on film.

There is a more practical reason for inspecting the film immediately after fixing. Often, the film does not clear completely in the time recommended. The fixer might have been too old, or agitation was uneven, or perhaps you set the clock wrong and gave it too little time. Whatever the reason, if it is not caught at this stage, you will have cloudy negatives after they are dried.

To inspect, simply remove the film reel from the tank, rinse quickly, and hold up to the light. If the film looks cloudy, faintly yellow, or even a milky white in the center, it has not fixed properly. Place it back in the fixer for an additional minute or two and then reinspect. After the final inspection, rinse for 30 seconds with constant agitation to dilute the fixer for the next step (Fig. 5.11).

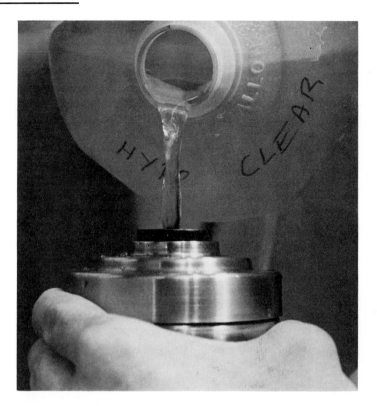

**Figure 5.12: Pour "hypo clear" into the tank and agitate for the full 2 minutes.**

### CLEARING AGENT AND WASH

Film processing chemicals are strong and must permeate the emulsion in order to work. They become embedded in the emulsion, and it takes a long washing time to completely flush the film clean. If not removed, this chemical residue will eventually cause the film to deteriorate. This washing step takes a long time in plain water. One of the most efficient ways to aid the important washing process is to use a washing aid called a clearing agent (Fig. 5.12). This chemical clearing agent clears the excess fixer from the emulsion by neutralizing it. After only a minute or two in this clearing agent, the film is ready to wash.

With the use of a clearing agent, the wash time is cut considerably. The recommended washing time after using a clearing agent is 5 minutes. It is about half an hour without the clearing agent (Fig. 5.13).

### DRYING FILM

Drying your film can be a problem unless you take care to avoid water spots on the film. Even filtered water contains a residue of minerals that will cause spots on the film. To eliminate these harmful water spots, you should use either a wetting agent or some fast-drying aid.

A wetting agent combines with the water to form an emulsified liquid. This assures the minerals will stay in

**Figure 5.13: Washing film in steel reels is easy. Running water into the tank (or with the reel in the sink) sufficiently washes the film within 5 minutes. You may wish to dump the tank every minute or so to rid it of chemical residues.**

the water and literally slide off the surface of the film (Fig. 5.14).

Other rapid-drying aids contain alcohol, so are used only when there is deadline pressure. With them, the drying time is reduced from 10 or 15 minutes to about 1 minute.

In reality, the drying process in photojournalism is usually done as speedily as possible. Photojournalists do everything possible to get the film done on deadline. But, for our purposes, the following methods will work well under less-stringent deadlines.

One of the best methods of drying film is to hang it full length in a drying cabinet or in a dry, dustfree area. Hanging the film full length allows the wetting agent to run off without forming water spots. The film is clipped to a rod, and allowed to dangle full length. A film clip or clothes pin attached to the bottom assures the film won't curl during drying. Air-blowing dryers are used widely (Fig. 5.15).

Some photojournalists wipe off excess wetting agent or drying aid with a chamois cloth or squeegee before drying. Others drip dry or place the film under a strong blower dryer, sometimes with heat.

A disadvantage to wiping the film is the possibility of scratching it. The wipe method is used on deadline when time is of the essence. Otherwise, the drip dry method is the safest. You can experiment to find the best method for you and your style of working.

### CLEAN-UP

The strong and varied chemistry used in film processing demands a consistent and thorough clean-up. If left uncleaned, the chemicals will form a white salt wherever they have spilled. To prevent this, the developing area must be wiped down and mopped immediately after each lab session. There is nothing more detrimental to quality than a messy lab. Wipe down all wet surfaces with hot water and then wipe dry. Mop the floor thoroughly. Replace all tools in their correct places if it is a community lab; if the tools are yours, store them in a locker for use next time.

### FILING SYSTEM

After the negatives are dry, cut and file them according to a system that will assure your access to them in the future. You never know when you will need a negative.

One of the best ways to file your negatives is by using see-through plastic sheets that hold one roll apiece. These sheets (one example is Nega-file) also contain a space to write exposure and story information. They are punched for a looseleaf notebook and you can make a contact sheet through them without removing the film (Fig. 5.16).

One of the best filing methods is to make a contact sheet and then staple it to the plastic sleeve. By filing

Figure 5.14: Soaking film in a drying aid such as Kodak's Photo-Flo can guard against water spots when the film is dry.

Figure 5.15: Drying film can be done by hanging it in a dust-free area. Hanging film on a clothesline with clothespins attached to the bottom of the film—straight— is one popular method. Or use a film dryer with an air blower for speedier drying.

Figure 5.16: When film is dry, cut it into sections of five frames and insert each into a film file. Assign a number to each roll right from the start and you will have the makings of an orderly system.

this set in a looseleaf notebook as you develop and print, you have a handy reference method for your work. Always date and describe each contact sheet with some numbering system for future reference. You will be surprised how fast your negatives accumulate. Without a system, they can soon get out of hand.

## PROCESSING CHECKLIST

Even though this discussion has given you a detailed introduction to the steps involved in film processing, the following checklist might help you on your first roll of film:

1. Secure the darkroom.
2. Prepare all necessary tools.
3. Bring chemicals to temperature and place in order.
4. Check darkroom for cleanliness, dryness.

### LIGHTS OUT

5. Open film cassette.
6. Load onto reel and into tank.

### LIGHTS ON AGAIN

7. Pour developer into tank.
8. Turn on darkroom clock.
9. Rap tank sharply against hand three times.
10. Agitate constantly for first 30 seconds using consistent method.
11. Place tank in sink and allow to "work" for 50 seconds.
12. At end of 50 seconds, agitate tank gently for 10 seconds.
13. Repeat agitation every 10 seconds each minute until done.

14. Pour out developer (save or dump as required).
15. Pour in water, agitate for 30 seconds, dump.
16. Pour in fixer.
17. Tap tank three times. Agitate first 30 seconds, then 20 seconds per minute.
18. Pour out fixer; save.
19. Rinse 30 seconds in water with agitation.
20. Pour in clearing agent. Tap, then agitate for first minute, then 10 seconds each 30 seconds.
21. Pour out clearing agent; save.
22. Wash in running water for 5 minutes.
23. Immerse the film in a wetting agent and dry.
24. Cut and file negatives in a system.
25. Clean darkroom thoroughly.

This introduction is only the beginning of many such sessions in the darkroom. You will soon have your own system.

## TESTS FOR SUCCESS

There are two visual tests for success in the film processing. The first is when you inspect your finished negatives on the light table. With a loupe—a small, plastic viewer for inspecting film closely—you will check the film for proper exposure and development. You can also check focus, composition, and subject expression, but at this point we are interested only in the basics.

The second test is when you print your negatives, for the quality of both the contact sheet and the final print depend completely on how well you exposed and processed your film.

AMERICAN BRIDGE

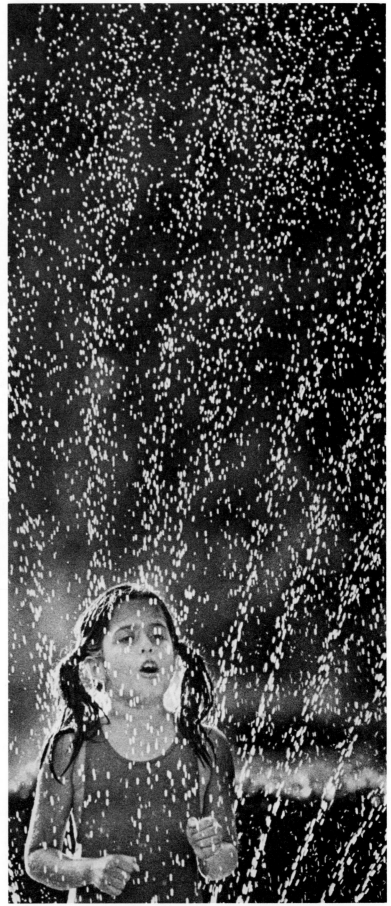

# 6 • BLACK-AND-WHITE PRINTS

*"The first print always looks good until you make the second and the third print always looks good until you make the fourth, etc. . . . "*     Old darkroom saying

This chapter is an introduction to the practical, step-by-step process of printing. The procedure is placed here so you can gain the experience of printing before continuing to a more in-depth discussion of the tools of photojournalism. Once you have mastered the basics of black-and-white printing, you can carry out assignments in the lab while you continue your reading.

Despite the current trend toward more color in newspapers and predictions of electronic cameras in the future, you will need to know how to make black-and-white prints for newspapers for at least the near future. Although many newspapers use such machine processing as Kodak's Royal Printer and the Versamat, hand or "wet" printing is still a necessary darkroom skill. Photojournalism management at fifteen major newspapers surveyed recently indicated that nine newspapers had definite plans for using electronic/automated lab technology when it becomes available. But all the newspapers answered "yes" to the question, "If you were teaching, would you go into detail on the wet process?" They added the following comments:

No question! The wet process has been the basis for this profession since the beginning and despite the electronic future most photographers will be using the wet process for at least the next ten years. . . . (Don Stevenson, Director of Photography, *Mesa Tribune*)

Would never hire a photographer who was not completely qualified in the "wet" printing techniques. How could they be used in remote locations when it is necessary to shoot, print, and transmit. . . . (Ken Feil, Picture Editor, *The Washington Post*)

For major newspapers electronic "chips" may soon become a reality, but I suspect that many, many papers will be using D-76, etc., for quite some time. . . . Keep teaching wet printing! (Al McLaughlin, Chief Photographer, *Daily Oklahoman*)

So, black-and-white printing will be a part of the news business for some time. Good black-and-white printing is demanding and teaches respect for craft and concentration, two attributes that never go out of style no matter what the technology. In this chapter you will learn the craft of making a first straight print. Then you will start perfecting your skill into a craft and art.

## THE PHOTOGRAPHER'S DUAL PERSONALITY

If you shoot and print your own work, you need a dual personality. When shooting you must be hyperactive to cover fast-moving events and capture the "decisive moment." But for successful printing, you need the opposite personality. Your other self should be calm and analytical. This takes considerable self-discipline and a system, especially on deadline. A good printer is mainly a good technician who makes the best quality print from the negatives of that fast-moving photojournalist. Your personality switch begins when you enter the lab for your first printing session.

The atmosphere of the lab should encourage this quiet personality by providing a darkroom that duplicates your developing area, with everything in its place. This leads to a printing system that is almost automatic. Once you are thoroughly familiar with darkroom equipment and material, you will be able to make excellent prints under severe deadline pressure with little wasted motion.

# BASIC PRINTING

A printing system is simple and easy to establish. You use the same steps, in the same order, as in film processing. But even better, unlike film, printing paper is made insensitive to amber light. Special amber "safelights" illuminate the darkroom without affecting the paper. This allows you to view all of the steps in the process from enlarging to developing and washing. This helps because you have visual control from the start.

Basically, the printing process is transferring an image to the paper base by light projected through the negative. When the light shines through the negative, the film emulsion either transmits or blocks the light rays in proportion to differing amounts of silver in the film. Strong highlights that have been recorded as heavy silver deposits block the light. This results in little or no light striking the paper during exposure and a corresponding whiteness to that area. Conversely, shadow areas on film have little or no silver to block the light. This results in a corresponding blackness to that portion of the paper. In between are a variety of silver layers that produce the middle or grey tones on your printing paper. When you make the print exposure, these variable silver amounts project a black-and-white image onto the paper surface.

## TYPES OF PRINTING

There are two types of printing used in photojournalism—*contact printing* and *projection printing*.

Contact printing is also called proofing. Contact sheets are produced by exposing the negatives in contact with printing paper. The result is a set of positives the same size as the negatives. Contact sheets are convenient for choosing and editing, and can also be filed for later reference. Although contacts are seldom made for daily newspaper editing, they are of great use for picture pages, magazines, and freelancing.

Projection printing uses the enlarger to project the image to a size suitable for reproduction. This is usually 8 × 10 inches, but can often be enlarged to 11 × 14 inches or larger.

## ENLARGERS

The enlarger is your main tool in the print darkroom so it should be as familiar to you as your camera. Actually, the enlarger is a camera in reverse. An enlarger has a light source at one end, a fixture to hold the negative so the light can shine through it, a lens to focus the image on the paper, and a board to hold the paper that records the projected image (Fig. 6.1).

There are two types of enlargers—diffusion enlargers and condenser enlargers. Diffusion enlargers are not used widely in photojournalism. They have a light housing that diffuses the light making it softer and more even. This also diffuses the image and is used effectively in commercial portraiture.

Condenser enlargers are so prevalent that they are *the* photojournalism enlarger. They give undiffused light that is actually sharpened by a set of condensers placed between the light and the negative. The crisp, highly defined light emphasizes detail in the print, a necessity for photojournalism.

Prior to your first printing session, become familiar with your enlarger by closely examining and handling its moving parts in the light. Although there are various enlargers on the market, they are all similarly made. Find and familiarize yourself with the following (Fig. 6.2):

Figure 6.1: The enlarger is a projection camera with a light source at the top. The negative image is projected onto printing paper. Before you start, set up all the tools you'll need so that you will be able to find what you need in the dark.

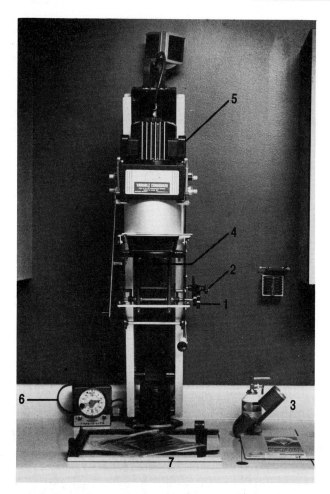

**Figure 6.2: The parts of an enlarger are: 1) focusing knob, 2) projection control, 3) paper, focuser, 4) lens and *f*-stop adjustment, 5) light source, 6) timer, 7) easel.**

1. focusing knob
2. projection control (lowers/raises negative for blow-ups)
3. paper, focuser
4. lens and *f*-stop adjustments
5. light source location
6. timer controls and its adjustments
7. print easel and its adjustments

## BASIC OPERATION

The enlarger is similar to a camera, so its controls correspond to those on your 35mm camera. The basic camera relationship between shutter speed and *f*-stop corresponds to the enlarger relationship between the timer and the *f*-stops. The timer counts the print exposure in seconds, but the *f*-stops are the same as those on your 35mm camera.

Printing timers are calibrated in seconds from 1 to 60 to time your exposures accurately. To operate, the timer needle is set for the number of seconds required.

The timer has two switches. An off/on switch is for manual control and for focusing. In some timers, the "on" setting is marked "F" (for focusing) and the "off" setting is marked "T" for timer. The timer switch for the mechanism times the light.

Although the enlarger lens has the same *f*-stops as your 35mm camera (although not as many), you can standardize printing technique by using the same "click" stop for the majority of your printing. (Try three click stops down from wide open.) Many good printers recommend this practice for a simplified printing routine.

## BLACK-AND-WHITE PAPER

Photographic papers are available in a wide assortment of types, but like films, they all fit a general definition: a light-sensitive material made of paper (or plastic-coated "RC"—resin-coated—paper) coated with an emulsion of light-sensitive silver halides that records a positive image when light is projected on it through negatives.

You can use either Kodak's Polycontract RC-Rapid, F (glossy) Surface, or Ilford's Ilfospeed Multigrade II (RC-Glossy), two popular papers for photojournalism printing. Almost any photographic paper can be used, so if you have paper already or your instructor recommends another brand, feel free to use that. Remember that paper-based papers may need a special dryer.

## LAB LANGUAGE

These are a few basic terms used in the lab.

- *Straight print*: a print made with one basic exposure and processed "as is" without special manipulation.
- *Full development*: the time it takes for the print to reach full, rich detail in shadow, highlights, and grey areas, usually 90 seconds for RC paper. Full development time should be *standard* time for every print.
- *Basic exposure*: The correct exposure for the majority of the print.
- *Test print*: a print that serves as a basic exposure guide. The print is made with a series of exposures in increments of several seconds on the same sheet. This produces a series of strips of exposure times that range from light to dark to help in selecting the "right" exposure.
- *Contact sheet*: a print made by contacting the negatives against the paper to produce rows of prints the same size as the negative frames. Used in editing.

- *Dodging*: to place an object between the light and print during basic exposure to "dodge out" or lighten an otherwise too-dark area.
- *Burning in* (also called *printing-in*): to add exposure to an area of the print by blocking all but that area to be burned in after the basic exposure has been made.
- *Standard f-stop*: a standard setting for the majority of printing. This is usually *f*/8, but in prac-

tice the printer counts click stops from wide open to *f*/8 and uses this as a standard lens setting automatically.

Few as they are, these definitions provide a basic lexicon of black-and-white printing. You'll soon become familiar with them as you get the feel of the print process.

# THE VISUAL APPROACH

Now you are ready for a visual approach to printing. Although you can see under safelights, you should set out your tools before you turn off the white lights. These tools include: printing paper (do not open in white light), negatives in clear plastic sleeves, negative brush (or Dust-Off), an 8 × 10 inch mount board (one side black), scissors, set of dodging tools (to be explained later), and a sheet of black construction paper (Fig. 6.3). Although you may not need all of these tools for your first session, it is a good idea to have them in one place; perhaps in a small box or case for easy storage. For now, set these tools out within easy reach.

As with film processing, carefully set out your chemicals. They should be in a series of shallow trays a little larger than the size of the paper and deep enough for the chemicals to cover each sheet of paper adequately. The trays are usually in order from left to right. The steps in printing chemistry are the same as those of film and include the following:

| STEP | RESULT |
| --- | --- |
| Developer | Changes (reduces) exposed silver halides to metallic silver |
| Stop bath | Chemically stops development (if water bath, dilutes developer) |
| Fixer | Dissolves away unexposed silver halide crystals to "fix" image as permanent |
| Rinse (RC paper) | Dilutes fixer |
| Clearing bath (paper base paper) | Chemically neutralizes fixer for easy washing |
| Wash | Circulating water wash to remove excess chemicals |
| Dry (RC paper) | Air |
| (Paper base paper) | Heat or air dry |

## FOCUSING AND EXPOSURE

Now turn off the white lights. With only the safelights on, switch your enlarger timer to "on" (focus) and turn your lens ring until the light is the brightest. Next, turn the lens ring slowly down until the light is darkest. As you turn the lens, listen for the soft sound of clicks that mark each stop. Now, return the lens setting to its brightest.

Because this wide opening gives you the brightest light, always focus at wide open. After careful focusing, close down (stop down) to a standard opening. Usually this is down two or three clicks from wide open

Figure 6.3: For organization nothing is better than a plastic utility box, which costs under $3.00, kept within easy reach.

to about $f/8$. Deciding on a standard opening relieves you from thinking about $f$-stops so you can concentrate on printing technique. This makes your enlarger almost automatic, because you will always print at your standard $f$-stop.

Using a standard $f$-stop allows you to use the timer alone to adjust exposure and further standardizes printing. This practice also eliminates confusion caused when you change $f$-stop and timer at the same time.

## CONTACT SHEETS

Making a contact sheet is a good place to start printing. Contact sheets (or proof sheets) are the photographic equivalent of writing notes. They give you a set of positive prints the same size as your negatives and are more convenient to read than the negatives. Although not used very extensively on daily newspapers, contact sheets are invaluable for editing picture pages, long-term projects, or magazines.

To make a contact sheet, place the negative in contact with a sheet of printing paper and expose through them. The result is a set of positive "proofs" of everything you shot. Because contact sheets reveal your shooting style, many editors ask to see contacts as part of your portfolio.

You can either use a contact printer especially made for the purpose, or simply buy a sheet of thick safety glass. As long as the glass presses the negatives firmly against the sheet, the contact sheet will produce a sharp image. The thin plastic negative sleeves such as Nega-File that hold negatives in neat rows can be used for contact printing if sleeves are held firmly against paper. To make a contact sheet, follow these instructions:

1. Place the negative carrier in the enlarger (Fig. 6.4).
2. Turn on the enlarger light at wide open.
3. Put the printing easel away.
4. Raise the enlarger until the light illuminates a rectangle at least $10 \times 12$ inches on the enlarger baseboard.
5. Close down to your standard $f$-stop setting (Fig. 6.5).
6. Place the contact printer inside the $10 \times 12$ rectangle of light (Fig. 6.6).
7. If using a sheet of safety glass, mark the light area for some guidance when light is off. Remember: white light cannot strike the paper before exposure or the paper will be ruined.
8. Turn off enlarger light and place a sheet of printing paper in contact area with shiny side upward (facing lens).
9. Place the negatives in contact with the paper, shiny side up. This places "emulsion to emulsion" to assure proper positive printing.

Figure 6.4: Set the negative carrier in place and raise the enlarger until it projects a rectangle large enough to cover the contact sheet.

Figure 6.5: Set the enlarger $f$-stop to your standard "clicks down." This should always remain the same for ease in printing.

Figure 6.6: Under darkroom safelights, place the contact printer under the enlarger light and place a sheet of printing paper, shiny side up, straight in the frame.

**Figure 6.7: Place negatives on top of the paper shiny side up (dull side in contact with the paper).**

**Figure 6.8: Press the timer button to expose the contacts. Try 10 seconds to start.**

**Figure 6.9: Develop the paper at full time (90 seconds for RC paper). Slide paper smoothly into the developer and agitate it gently during the full development.**

10. Close contact printer and lock or place glass atop negatives (Fig. 6.7).
11. Punch button for exposure. For starters, try 10 seconds at your standard stop (Fig. 6.8).

## STEPS FOR DEVELOPING

STEP ONE—DEVELOPER: Slip the print into the developer rapidly and smoothly. Agitate the print by moving it gently with tongs or rocking the tray to assure even development (Fig. 6.9). Set the clock to 90 seconds. This is full development for RC papers and should be a rule. Start with the rule of full development for quality control and you will develop into a good printer who can also print fast on deadlines. At the end of 90 seconds, remove the print from the developer, drain for 5 seconds, and deposit in the stop bath.

STEP TWO—STOP BATH: Time in stop bath is 10 to 30 seconds, whether you use an acid stop bath or just water (Fig. 6.10). Agitate the full time. This step dilutes the developer so the next step can do its work. After 30 seconds, drain the print and slip it into the fixer.

STEP THREE—FIXER: This is where the unexposed silver halides will be dissolved. This leaves only the developed metallic silver "fixed" as a permanent image in the emulsion. For RC paper the fixing time is 2 minutes in fresh fixer. Agitate by gently turning the print in the solution (Fig. 6.11). At the end of 2 minutes, view the fixed print.

STEP FOUR—VIEWING THE FIXED PRINT: Because white light will not affect the image after fixing, you can now examine the print for proper exposure and so on. Since it is difficult to set a true "reading" of the print under safety lights, take the print into white light after a 10-second water rinse. Carry it in a tray so no chemicals will drip. The white light will give a reading of the white, black, and gray print values. In the white light, examine the contact sheet to evaluate focus and overall exposure. If you bracketed your exposures when shooting, you will have a range of exposures, and you'll have to choose the best overall exposure. If the contact sheet is too dark, expose for less time. If too light, expose longer. To adjust the time follow the basic calculation:

If too light, DOUBLE THE TIME. If too dark, CUT THE TIME IN HALF. At this stage in your printing it may make sense to you to adjust the time by adding or subtracting a "few seconds." But without experience, this could waste paper. The 2X or 1/2 system corresponds to the *f*-stop adjustments. A typical example is your original 10-second exposure. If it is too dark, you cut the time to 5 seconds for your next print. Then, if that is too light, you know the correct exposure is somewhere in between. Following this system, your next exposure would be in be-

tween 10 and 5, or 7 seconds. (For your second printing session, you will be introduced to the "test print" approach that is much more accurate.)

When you have a good contact print, proceed to the rinse or clearing bath.

STEP FIVE (FOR RC PAPER)—RINSE: Place the print in a tray of plain water to rinse for about 30 seconds. If you are in a lab with many other people or you are making other prints, this rinse step can be a holding bath until you have enough prints to wash in a batch.

STEP FIVE—(FOR PAPER BASE PAPER)—CLEARING BATH: Two minutes in hypo clearing agent, a chemical bath that neutralizes the fixer and reduces washing time for paper prints. This is not required for RC papers. At the end of this step, the print is placed in the rinse. After the rinse, prints are ready for washing.

STEP SIX—WASH: For RC paper, about 5 minutes is adequate. The plastic or resin coating of this paper keeps the chemicals from soaking into the paper itself, so water takes little time to wash away the surface chemicals. With paper base prints, however, chemicals have lodged in the fibers and need both the hypo clearing agent and longer time for proper wash. Wash paper prints about 15 minutes after using hypo clearing agent, and a full half hour without this chemical aid. After sufficient washing, prints are ready for drying (Fig. 6.12).

STEP SEVEN—DRYING: RC prints will air dry easily without curling, but can be dried in a special warm air dryer (or with a hair dryer). Paper prints are not normally air dried, but require a heat dryer. Double-weight paper prints can be air dried; but they do curl so they must be flattened with a weight after drying.

When your contact sheet is dry, choose the negative you think is the best for printing and make an 8 × 10 inch print (Fig. 6.13).

## TEST-STRIP AND STRAIGHT PRINTING

The first step in making a good print is to give yourself a variety of exposures for a choice of just the right time for a particular negative. An "educated guess" wastes paper. You need the right visual information to make a good print in as few tries as possible. A test-strip print the size of your final print is the place to start for such information. For test-strip printing you need an 8 × 10 inch black mount board and several sheets of 8 × 10 inch paper. The process includes the following steps:

1. Place the negative in the carrier—dull (emulsion) side down—and project the image onto the 8 × 10 inch easel (Fig. 6.14). Set the lens wide open, focus carefully, and close down to your standard stop.

Figure 6.10: Rinse in stop bath for 30 seconds, then drain.

Figure 6.11: Place the print in fixer and agitate it gently (for 2 minutes for RC paper).

Figure 6.12: Wash the print for 5 minutes in running water, then dry. RC paper dries rapidly in the open air without curling. (Clothespins are good holders.) There are also dryers specially made for RC paper.

**Figure 6.13: A close inspection of your developed film with a lupe is the best way to choose the right one to print.**

**Figure 6.14: Place the film carrier, with film in place, between the light and the print for projection printing.**

**Figure 6.15: Test strip printing is done by setting the timer (for example at 2 seconds), then exposing the print in a series of 2-second exposures, blocking all but a strip at a time. The result is a series of differently exposed strips. Here, the print is halfway through a test-strip printing.**

2. With the enlarger light off, place a sheet of 8 × 10 inch paper sheet on the easel, shiny (emulsion) side up. Use the board to cover all but a half-inch strip at the edge of the sheet (Fig. 6.15). To get a reading of the most values, place the board so it crosses the widest range of negative densities. Example: If the negative includes dark trees, a person, and the light sky, place the board so that it bisects each range during testing. This makes certain you can read a wide range of exposures. Even though you will use only one straight reading for this printing session, the test-strip approach above will later give you information for extensive dodging and burning exposures on your second printing session.

3. Set the timer for 2 seconds.

4. With the board in place and a half-inch of paper uncovered, press the button to expose the first strip.

5. When the timer goes off, move the board carefully another half-inch and press the timer again.

6. Repeat this procedure for a series of strips, moving the board each time.

When you have reached the other end of the paper, you will have a series of exposures in "strips" of 2-second increments. Even without changing the timer, each succeeding exposure will build an additional 2-second exposure. The result is an 8 × 10 test-strip print that gives you exposures ranging from 2 seconds to 16 or so seconds, depending on how accurately you measured.

After processing the test-strip print as you did the contact sheet, examine the print in the white light. A good test-strip print will have a full range of strips across the print, from too dark to too light. Somewhere should be the right exposure for a straight print. If your first test strip print is too dark or too light, however, re-expose at either 1-second or 4-second increments (half as long or twice as long), whichever is needed.

When you have a good test-strip print, examine it for the one strip that looks best (Fig. 6.16). For this first printing session, you are looking for a good straight print at one basic exposure. The strip that most closely matches the values of the subject will produce an adequate first print.

Now, with the enlarger set up as before, make a full print at that one exposure. Develop and fix according to the above instructions.

When this first straight print is fixed, take it out to the white light in a tray to examine. If you have read the test strip properly, this straight print will be acceptable. If it is too light or too dark, you may have to return to the test-strip print for another try.

Figure 6.16: By making a series of exposures across the print, you will have a series of exposure choices.

This first straight print is probably enough for your first printing lab. If you chose an evenly lighted negative, you probably have a pretty good print. But once you inspect this first print closely, you may see areas that are too light or too dark. You should work for a better print. That requires another examination of the test-strip print and more advanced printing techniques. In the meantime, wash and dry your test-strip print and straight print, write the exposure times on the back and keep them for reference at the next printing session.

## BEYOND THE STRAIGHT PRINT

Your straight print is only the beginning. It is the proverbial "first print" and probably needs some work to improve it. What looked like a simple printing job calls for adjustment of exposures so you can produce a balanced print.

This calls for two indispensable darkroom skills: dodging and burning-in. It is rare that a 35mm negative can be printed properly without using them both, so most photojournalists have developed these skills into an art.

Dodging is simply the act of placing something between the enlarger light and paper during basic exposure. This lightens an area that would otherwise be too dark. In printing this is called "opening up the shadows." You must be careful, however, not to move the enlarger or the easel.

Burning-in is the opposite of dodging. You *add* exposure to a certain area after the basic exposure to literally burn more light into that area. This naturally makes it darker than the basic exposure. Burning-in is also called printing-in.

To find the right exposure time for both dodging and burning you must return to your test-strip print and use it to "read" the exposures again. Only this time, save time and paper by reading for three exposures at once.

You already have the basic exposure from your straight print. Let's assume it was 10 seconds. Next, read the test strip for dodging and burning exposures, by reading extremes rather than basic exposure.

For example, let's say your 10-second basic exposure is not enough time to expose a white shirt in the background. You read the overexposed strips of the test print to find an area where a white of the same density is well exposed. Chances are that a darker strip will give you the right exposure for the white shirt. For example, if that area is in the 16-second strip, set the timer for 6 seconds. Then expose, covering all but that white shirt; this will add the needed time to expose it correctly.

On the other hand, if an area in shadow is too dark at the basic 10-second exposure, search back into the

**Figure 6.17: For dodging, place the back of one hand flat atop the palm of the other.**

**Figure 6.18: To form a burning-in shape, place one hand flat and with your other hand cupped form a half-moon shape.**

lighter test strips to find a time that will "open up" the area. For example, if the lighter strip is a 6-second one, you will merely cover the dark area for a count of five during basic exposure to dodge out the shadow.

## TOOLS FOR DODGING AND BURNING-IN

The tools for expert dodging and burning are your own two hands. They can form any shape, and with a little practice, you will be dexterous enough to handle most needs. Of course, some prints might need special tools, but we'll cover that later. For now learn to use your hands.

For dodging, place one hand flat atop the other (Fig. 6.17). Tuck your thumbs in and you have a long flat surface to cover any area of the printing paper. By raising and lowering your hands in the light or moving one hand in relation to the other, you can form any number of shapes. This "dodger" is excellent for

Figure 6.19: With needlenose pliers, grasp the end of a length of thin wire and twist it into a few circles to make the stem of a dodger.

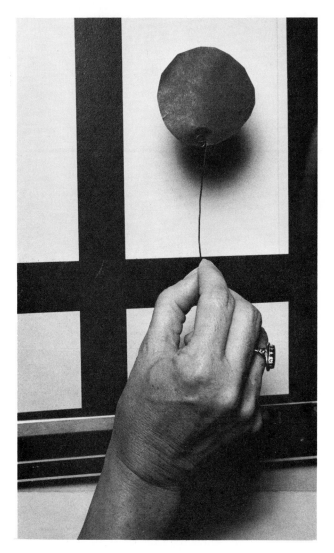

Figure 6.20: Areas that need dodging require this easily made disc made from black construction paper and thin wire.

dodging horizons or building lines. For large round surfaces, use one fist as a round dodger.

For burning, begin with the left hand out flat, palm upward. Then add the right hand perpendicular to it, but with fingers curved to form a cup (Fig. 6.18). (If you are left-handed, reverse this order.) When held in the enlarger light this forms a half-moon shape. By moving either hand slightly you can form virtually any shape or size needed for burning-in. Practice with the enlarger light on and you will become adept at making any number of shapes.

Two things to remember are:

1. Move your hands continually when either dodging or burning. Don't pause.
2. Cover the lens with one hand, push the timer button, then speedily form hands to the shape you want in the light.

Used with skill and practice, your hands can handle most problems of dodging and burning-in. But there are times when you will need special tools. Usually this is when your hands are too large to get into certain areas or the shape is too small to make with your hands. Dodging under hats or eyes or burning-in some very small areas need special shapes. Although you can buy ready-made dodging/burning kits, you can make two basic tools that will suffice with some stiff wire, a pair of pliers, and some black construction paper.

For dodging beneath hats and eyes, you need a slender holder for the dodger. Cut a length of wire, twist it at the end (Fig. 6.19), fit it with a small piece of black construction paper the desired shape, and you have a perfect tool (Fig. 6.20).

For burning when the shape is too small or awkward for your hands, simply cut a hole the desired shape in the center of the sheet of black construction paper (Fig. 6.21) (or black mount board). Use this instead of your hands.

Figure 6.21: Hard-to-burn areas can be handled with a hole cut in black construction paper.

Don't get carried away making shapes and tools. Your hands can handle most dodging and burning needs. The tools will be only for special needs.

Every negative (Fig. 6.22) needs some burning-in or dodging to improve it from the straight print, so here is a brief anatomy of a print.

Start with a test strip (Fig. 6.23) across the whole surface. Here, 2-second increments were made on Number 2 Ilfobrom paper. A 6-second basic exposure was used.

The final print (Fig. 6.24) gives a balanced exposure. Overall exposure was 6 seconds, based on the third test strip, but the face was dodged to 4 seconds and the wall at the right was burned an extra 2 seconds. Full development assured deep black, detailed white, and uniform gray, producing a print on Number 2 Ilfobrom paper. These manipulations would produce similar effects with any paper.

Practice your new skills by returning to your original print and improving on it. Dodging and burning skills are needed constantly in photojournalism and soon will become second nature to you in printing assignments on deadline.

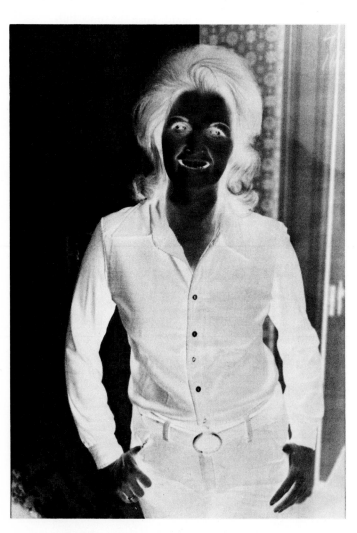

Figure 6.22: Every negative needs some burning in or dodging to improve it over the "straight" print.

Figure 6.23: Start with a test strip across the whole surface. Here, 2-second-increment exposures were made on number 2 Ilfobrom paper. The printer chose a 6-second basic exposure.

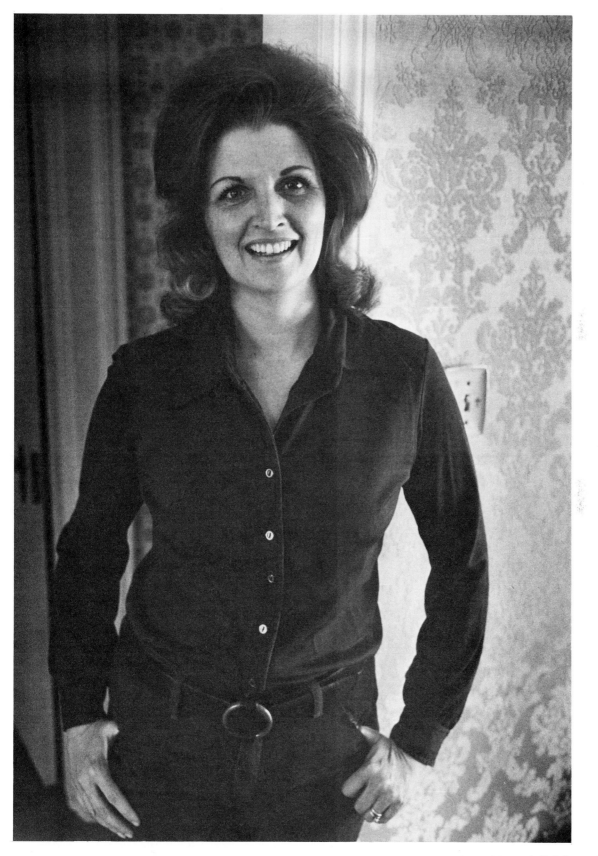

Figure 6.24: The final print gives a balanced exposure. It was dodged on the face and shirt and burned slightly on the right wall. The overall exposure was 6 seconds, based on the third test strip. Full development assured deep blacks, detailed whites, and uniform grays.

## PAPER CONTRAST

So far we have assumed that you have a negative with "normal" contrast that will print well on "normal" paper. But sometimes your print either lacks contrast (looks gray overall) or has harsh contrast (too much black or white). Either extreme will be a problem in reproduction, so you need a way to adjust contrast in the darkroom for problem negatives. Fortunately printing papers have a built-in way to adjust contrast.

First, what is paper contrast?

The three prints here show contrast. The first (Fig. 6.25) lacks contrast. It was printed on Number 1 Ilford paper, and looks muddy, grayish. There is little difference between the highlights and the shadows. The second (Fig. 6.26) is a normal print with detail in the white, a rich black, and shades of gray; it was printed on Number 2 Ilford and has a good range of contrast. The third (Fig. 6.27) is too contrasty; the white has no detail and the shadow is deep black without detail. It was printed on Number 4 Ilford, and has harsh contrast, with little or no gray tones.

Of course, some lighting conditions produce more

or less than "normal" contrast and can enhance the mood of your photos, so you might want them as they are. Often, however, you will want to change contrast because of an under- or overexposed negative, or to improve the print (Fig. 6.28). This is done with printing paper contrast.

There are two types of papers that can change contrast. The first are called graded papers. They are made in a series of contrast grades that range from Number 1 to Number 6. Number 1 paper lowers the contrast; Number 6 heightens it drastically. The numbers in between give a variety of contrast. The normal contrast for these papers is Number 2, which matches the "normal" negative. Unfortunately, each grade is packaged in a separate box, so you must buy several boxes to get different grades.

The second type of paper is selective contrast, also called polycontrast. These papers work with filters that are numbered from Number 1 through Number 4, with half-step filters. The normal for this type of paper is a "no filter."

Selective contrast papers have two special emulsions in layers. Each reacts to filtered light to produce a va-

**Figure 6.25: Number 1 Ilford paper gives a flat, overall gray to the print.**

**Figure 6.26: Number 3 Ilford paper produces a harsh effect. Notice that the areas around the eyes have darkened to an unattractive appearance.**

riety of contrasts. One emulsion reacts to a yellow-light filter and produces a lesser contrast. These are the 1 and 1½ filters.

The other emulsion reacts to a magenta-light filter and increases contrast. These are the 2, 2½, 3, 3½, and 4 filters. The higher the number, the higher the contrast. The higher the filter number, the heavier its color, so exposure has to be increased accordingly. The manufacturers supply a small paper dial to compute these changes, but for our purposes here, and using the "no filter" as a guide, try this: If "no filter" is 10 seconds, Number 3 filter will be twice that, or 20 seconds, and Number 4 filter will be 4½ times that, or 45 seconds. Here you might open up the lens to cut the exposure time.

When printing, you place the appropriate filter between the light source and the paper in a filter holder to change the color of the light. When "no filter" is used, both emulsions react to white light to produce a normal contrast.

## VISUAL CONTRAST TESTING

Experienced printers can match the right contrast paper or filter to a negative just by looking at it. But in the beginning you need a system for this. The following visual comparison test for contrast is simple to do. Try it during your next printing session.

1. Cut a sheet of Number 3 or 4 paper or a sheet of polycontrast paper into 3-inch strips.
2. Make a straight print of your negative (on either "no filter" or Number 2 paper) and label it with pen.
3. In order, expose either Number 3 or 4 paper or polycontrast paper through Number 3 or 4 filters (at twice or 4½ times the time, respectively) and label them.
4. Develop papers together, and fix and lay them side by side in a tray.
5. Inspect them each for differences in contrast.
6. Choose the one for which the contrast is best and make a final print.

If you want to perfect this test, try the whole range of papers and filters in the same way and compare all of them.

Figure 6.28: Polycontrast paper uses filters numbered 1 to 4 to change the contrast of one paper.

Figure 6.27: Number 4 Ilford paper is similar to number 3, but the areas around the eyes, the hair, and shirt are now extremely dark, and no detail is visible in the shadows.

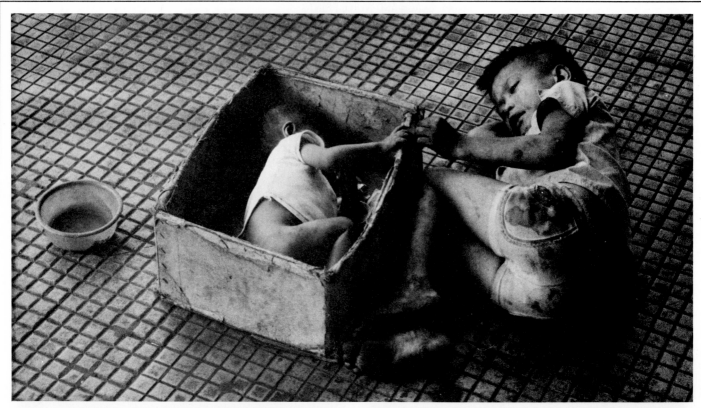

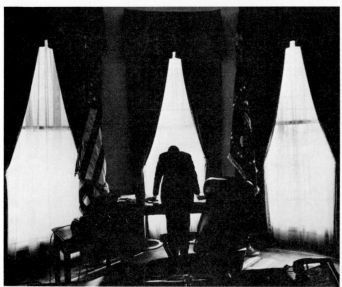

# 7 . SINGLE PICTURE AND CAPTION

*"The basic unit of photojournalism is one picture with words."* Wilson Hicks, *Words and Pictures*

*"Get that one grabber shot . . . the one that tells the story"* Francis Routt, *The Washington Evening Star*

Whether you take only one course in photojournalism or plan a career, you must begin with a thorough understanding of the single picture and its caption. This basic unit that Wilson Hicks described 30 years ago is still the most important facet of photojournalism practice. It is the building block for more extensive work. Even the photo essay depends on your ability to make strong storytelling single pictures.

In this chapter we will concentrate on the basic categories of the single picture with caption that are found in all areas of photojournalism. This basic package of words and a picture is like the lead paragraph of a story. Both carry a great deal of weight because they must capture the reader's attention and establish the tone of the story. The difference, though, is that the photograph is very often alone in illustrating the article. It has no other pictures to clarify it or build on. As such it must be both a "grabber" and an accurate report of the news event. On assignment, this puts pressure on the photojournalist to get the one photo that tells the story.

At most events, it is easy to shoot many photos that somehow combine to tell the story. But it takes skill and concentration to get the single photograph that sums up an entire story. Single photo "stoppers" can tell the reader more than a page of pictures (Fig. 7.1).

This belief in the single telling photograph is echoed by Henri Cartier-Bresson, master of the straightforward shooting technique he calls "the decisive moment." Bresson says, "There is one moment when all the elements are in balance. Photography must seize upon this moment." By superb timing and concentration, Bresson produced single photographs shot during a split second when lighting, composition, and expression combined to frame a storytelling photograph.

Naturally, a great deal depends on the type of event itself, your degree of access to the subject, the lighting, the focal length of your lens, and of course, the essence of the story itself. There is no one "right" photograph for any event, as long as the photograph reports the story honestly.

## PICTURE CATEGORIES

How well any single photograph succeeds depends on the type of news event, so there are different categories of the single picture. Here are the established newspaper categories used to judge the annual Pictures of the Year competition cosponsored by the National Press Photographers, Canon Inc., and the University of Missouri.

**Spot news photographs** are pictures of unscheduled events for which no advance planning was possible. They can range from tragedy to good fortune, from crime to war. Locally, spot news generally means a spontaneous photograph of a fire, an accident, or a rescue. The photo is straight news and puts pressure on the photojournalist to produce under trying conditions.

In covering spot news, stay out of the way of police, fire, or medical personnel. A long lens helps in this, but don't forget to take an establishing shot that sets the scene. Spot news photos show emotions and affect the reader, so when the scene is gruesome, shoot in a way that reports without emphasizing gory details.

It is often difficult to gather caption information at the spot news scene, but if you get the name of a police officer, or the station of the fire-fighters or para-

*Above*—Figure 7.1: Morris Berman captured football star Y.A. Tittle after a bloody injury that ended his career in 1964—and also produced one of the most famous sports feature photographs ever made. Courtesy *The Pittsburgh Post-Gazette.*

*Right*—Figure 7.2: Spot news also captures confrontation. Here, anti-nuclear demonstrators are arrested for protests on an army depot in New York. Photo by Richard Marshall, *Ithaca Journal.*

medics, you can later phone for more details. Of course, the report on the scene can help on the more hectic assignments, but get as much as you can for your caption (Fig. 7.2).

**General news photographs** are less hectic to shoot than spot news because the event is planned or scheduled. You can arrive early and reconnoiter the scene for best camera position, and get some idea of the scheduled activities. Parades, concerts, holiday celebrations, and a host of other planned events are general news. But you are still aiming to get a spontaneous photo, so look for candids as the event unfolds. After you have covered a number of similar events, you can anticipate the action (Fig. 7.3).

**Feature photographs** are a favorite of photojournalists because they are human interest in a "creative" way to show readers a "slice of life." Although they

can be taken at planned events, most feature photographs are "found" situations. They can be used days or weeks after they were taken. Subject matter is broad, but children (and/or) animals and all kinds of people in happy situations are favored.

Many successful feature photographs are taken while the photojournalist is "enterprising," cruising around looking for something. Often you run into the best features as you drive to or from an assignment. Having a ready camera and eyes open to everything is the best way to find features (Fig. 7.4).

**Zoo feature photos** are a special category, added here because they can be delightful. On a slow news day, just drop by the zoo and ask about new births, new arrivals, or even a favorite of one of the zoo workers. Zoo features are high on the list of favorites for readers and photojournalists alike (Fig. 7.5).

*Below*—Figure 7.3: General news coverage gives a photojournalist a chance to add a light touch to the news. Photo by Richard Marshall, *Ithaca Journal*.

*Right*—Figure 7.4: Feature photographs are "found" scenes that usually give a fresh view of daily life. Photo by Matt Lewis, *The Washington Post*.

Shooting zoo features are fairly easy because the animals are confined, but be careful of their reach and stay safely away from the bars. When the pens or cages have heavy wire, use a wide aperture to throw the wire out of focus. Don't forget the people at the zoo—their antics are often as photogenic as those of the animals. If you live in a rural area, local farms provide good animal features.

**Sports action (stop action)** is the typical sports photograph you see in newspapers and magazines. In it the photojournalist tries to stop the action at its peak, using a fast shutter speed of no less than 1/500 second and preferably 1/1000 second. The object is to stop the action for maximum detail in reporting a sport event.

Getting the shot at the peak of action takes timing, practice, and often motorized advance. The best stop action shots have: sharp focus with no shutter blur, a peak of action to show drama, the ball in the photo if the sport uses a ball (Fig. 7.6), a strong show of competition between teams or individuals.

Shooting sports requires a long lens, even indoors, and physical stamina. You must be willing to shoot in all types of weather and to squat on the sidelines for hours. You also need to know the sport so you can anticipate the action.

**Sports action (blur of action)** is used when the special feel of motion is more effective than the stopped action. You don't see blur of action shots as often as stop action shots, but they can be very effective (Fig. 7.7).

Shooting blur of action shots breaks all of the rules for sports shooting. You shoot at a slow shutter speed (1/60 second or slower), generally use a shorter lens, "pan" or move the camera while shooting and even move your zoom lens while exposing. All of these actions are aimed at making a decided blur that tells the story. For panning, you keep your camera on the subject and swing with the action until it is directly in front of you. Then you press the button as you continue panning. The result is a blurred background with a sharp subject (compared to the background).

**Sports feature** combines the feature approach with the sports event. The photo is usually of a sidelight: the cheerleaders on the sideline, coaches yelling at players, or even fans in the stands. Often action after the play or game makes an excellent sports feature.

**Figure 7.5: Zoo features are a favorite of readers and photojournalists. Photo by Don Stevenson, *The Mesa Tribune*.**

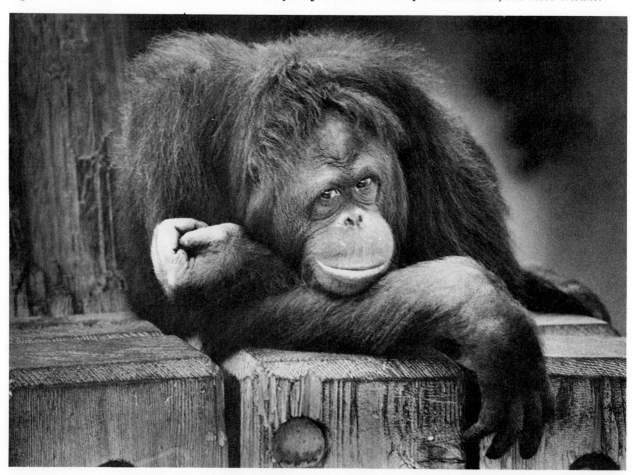

*Left*—Figure 7.6: Sports action captures the drama of a game. This women's rugby shot has all the elements for outstanding sports action. Photo by April Saul.

*Below*—Figure 7.7: This blur-of-action shot was made at a high school track meet. Courtesy *The Washington Post*.

**Figure 7.8: Sports feature photos capture the human side of competition. Here, the celebration of a boxer's victory tells as much as a dramatic punching photo. Photo by Walter Calahan,** *Billings Gazette,* **Montana.**

One good sports feature shot can say more about the outcome of a game than a stop action shot (Fig. 7.8).

**Portrait/personality (close-up)** goes beyond merely recording a face to show some aspect of the subject's personality or character. To consistently produce outstanding portrait/personalities the photojournalist must be part psychologist, part photojournalist, and part interviewer. Often, "personality" is defined as a well-known person, but it also means the visual personality of the subject.

Moving in for a close-up (or using a long lens) assures a strong center of interest as well as a simple composition. Beyond these, try to capture some aspect of the subject's character, emotional appeal, or some other unusual angle. The close-up needn't be the whole face—eyes only or part of the face can often reveal more than the full face (Fig. 7.9).

**Portrait/personality (environmental)** is usually the opposite of the close-up because you add storytelling details in the environment to the portrait. A medium range or long shot that includes revealing visual information about the subject adds impact to the straight portrait. In general, environmental portraits are not as spontaneous as close-up portraits.

Posing can be of great help, because you are enlisting the help of your subject to make the photograph work. Tools of the trade, elements in the background or being held, or even another person may all add to the environmental portrait.

The environmental details should be obvious, so simplify the elements. The viewer should know immediately what the person does by the elements, so eliminate any elements that may clutter the photograph (Fig. 7.10).

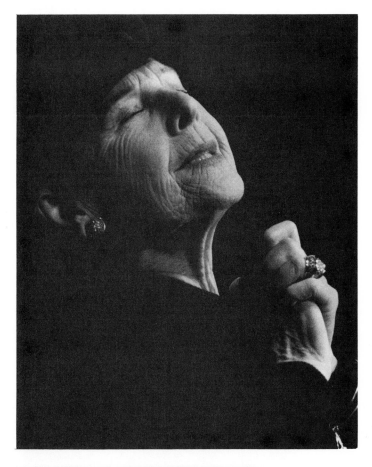

*Above*—Figure 7.9: Portrait photos try to depict personality. Here, April Saul concentrated on lighting effects to capture actress Ruth Gordon.

*Below*—Figure 7.10: Wally McNamee captured the freewheeling spirit of this woman by photographing her in flight. Courtesy *Newsweek*.

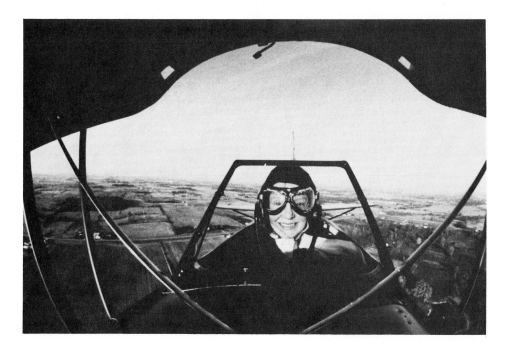

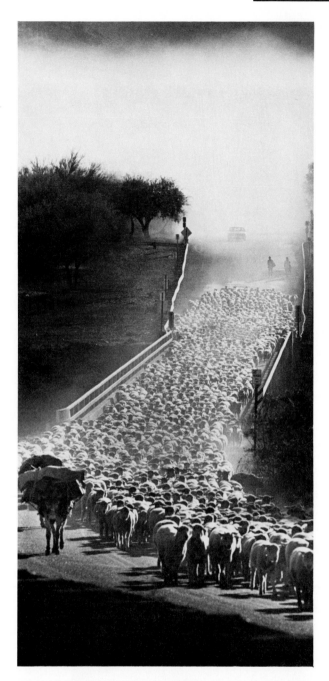

**Figure 7.11: Pictorial photographs combine reporting with artistic composition, as in this Arizona sheep roundup. Photo by Peter Ensenberger, *The Mesa Tribune*.**

**Pictorial** is even more enterprising than the feature approach. Often the feature and the pictorial say the same thing, but the pictorial makes the subject a small part of the scene. Pictorial photographs combine composition with people and are often artistic rather than photojournalistic. The sweeping lines of road, clouds out in the country, or similar artistic subjects are valid for photojournalism as long as there is some tie with the news. Most photojournalism pictorials have people

in them as a news tie and to give the scene depth or comparative scale.

Often that news tie is tenuous, but the combined beauty of the photo and the news peg in a caption may persuade the editor to use the photo (Fig. 7.11). Examples of pictorial art for photojournalism would be the reflections in a puddle to show yesterday's rainstorm, or the bucolic scene with fleecy clouds framing a farmer at work to show the end to a long drought.

**Food illustration** is usually a single picture in color, and tends to be a studio set up, so it gives you a chance to use studio lighting and storytelling details without people. Naturally, the main purpose of food illustration is to show the food to best advantage by excellent lighting, composition, and technical quality.

Food illustration usually takes time and is preceded by preparation of the food and even the making of a set. Often you will be working with a food editor so you can brainstorm ideas. The most effective food illustrations go beyond just showing the food; they capture the reader's imagination with a mood or theme (Fig. 7.12).

**Fashion illustration** works best when it is in the "high fashion" style of magazines and ads. The products are important, but so are mood lighting, composition, environment, and often color. Fashion assignments give you a chance to go beyond straight reporting to create an unusually eye-catching photograph (Fig. 7.13).

Control of lighting is a hallmark of fashion photographs and takes considerable skill. When shooting outside, fill flash (or a reflector) is often needed to soften the shadows. Inside, multiple flash can create the exact environment you want.

**Editorial illustration** illustrates a concept that is difficult to envision through a straight news photo. This category gives the photojournalist a chance to use his or her imagination freely.

In shooting an editorial illustration, the photojournalist usually has the story to use as a guide and can take the time to gather props or set up special lighting, if needed (Fig. 7.14).

**Documentary photographs** are not part of the Pictures of the Year categories; however, it is valuable to mention them. Documentary traditionally is a straight record of a scene or person without a lot of visual tricks. The term *documentary* is generally associated with the FSA documentary approach in the 1930s and is usually connected with strong social comment.

Strictly speaking, all photojournalism photographs are a form of documentary. But when a photograph is more formally composed with obvious elements, and is aimed at persuasion or some future audience, it falls into the documentary category. Also, documentary photographs are usually a part of a larger statement about a social condition (Fig. 7.15).

*Above*—Figure 7.12: Food illustrations are enhanced by simplicity. Bare essentials in a square format make this shot by Bill Tiernan especially effective. Courtesy *The Virginian Pilot* and *The Ledger Star*.
*Right*—Figure 7.13: Fashion illustration almost always depends on a pose that is dynamic and eye-catching. Courtesy *Claremont Courier*, California.
*Below*—Figure 7.14: Editorial photography comments on a social problem or illustrates a concept. Here, Tim Koors used a simple design to illustrate the plight of adults struggling to learn how to read. Courtesy *The Phoenix Gazette*.

**Figure 7.15: Documentary work is straightforward, yet it implies a commentary. In this shot by Arthur Rothstein (a master of the style), we notice the newspaper ad from a prosperous world this girl does not know, but also her dignity at the window.**

**Sequence photography** combines three or more photographs into a flow to show movement; thus it is beyond our single-picture orientation. However, you should start thinking in sequence because that is how you shoot 35mm pictures—in sequence. Even your early contact sheets may contain material for sequences.

When printed, the sequence is a set of three or four photographs that tell a story and appear to be chronological. The most effective sequences carry the viewer's eyes in a step-by-step movement. The simplest form is one that reads left to right, with all photographs the same size and in a straight row.

You almost naturally shoot sequence when you need more than one photo to capture personality, sports action, or some educational feature. Sequence shooting and thinking is the first step toward the layout of more than one photograph (Fig. 7.16 A, B, C, D).

Every photojournalist has a portfolio that includes most of the categories listed above. If you produce at least one photograph in each category (and then add a photo essay or story) you will have a strong, balanced portfolio that shows your ability to handle varied assignments. In effect, you have the basic vocabulary of single picture use and the framework for further development. Editors expect to see the portfolio of the prospective photojournalist for evidence that he or she can handle these basic categories well.

**Figure 7.16: The sequence is most effective when it shows movement and tells a story, as in this humorous case entitled, "Oh, Say, Can You See?" Photos by Clem Murray.**

# JUDGING THE SINGLE PHOTOGRAPH

Each of the preceding photographs were judged "good" examples of the single picture. Like most editors and photojournalists, I judged these photographs by criteria based on experience and intuition. Now I will explain one method for judging the single photograph. This method is borrowed from many sources and from characteristics of photography.

To begin, the three characteristics of photography that affect photo judgment are:

- as a visual language, a photograph communicates immediately.
- a photograph appeals to the emotions.
- any single photograph is only one view and can rarely tell the "whole" story.

## IMMEDIACY

The great French photojournalist Henri Cartier-Bresson applies "one act of vision" to the taking of photographs as "immediate sketches" and carries it over to the judging or appreciation of the photo. "To look at a photograph for more than two minutes . . . it's extremely long," he says. In judging any photograph, then, the first circumstance is immediacy of message and effect.

## APPEAL TO THE EMOTIONS

Because of its immediacy, a photograph affects the emotions. John Whiting, in his book *Photography Is a Language*, writes, "As a means of expressing ideas and emotions as well as direct facts, photography has achieved a unique distinction." He continues:

> everyone had heard and read about the Nazi concentration camps for . . . years, but the thud in the pit of the world's stomach, the raising of the world's anger did not fully come until the photographs of the shrunken bodies and horror-filled faces were published and released in newsreels in the spring of 1945.

Photographer Edward Steichen stated this emotional association differently when he addressed the Wilson Hicks International Conference on Photojournalism in 1961. Steichen said:

> Anytime you point the camera at something and press the button, you can create an image. . . . But I don't call it a *photograph, unless* it is something more than that. I used to use the term *alive*. That's correct, because unless the image becomes *alive*, it's not a photograph. It's just a record, a mechanical record. The machine has produced the object.

What is produced, said Steichen, is a photograph that is taken with the "heart and . . . mind" of the photographer that affects the viewer emotionally.

## PRESENTATION OF A VIEWPOINT

A single photograph can be only one isolated view of an event. A strongly emotional or eye-catching photo may in fact be an uncharacteristic side of an event. In many instances, the photograph is *interpretative*, in that it can also present a *point of view*—the photographer's personal intellectual stance, opinion, or unique attitude toward the subject.

At its best, however, the single photograph overcomes its "one-view" disadvantage by communicating the significance of a scene or event. To do this, the photojournalist must know the story and how much to include in the frame. He or she must also question the resulting photograph, asking whether it is true to the nature of the particular news.

### JUDGING SINGLE PHOTOGRAPHS

Often we get so involved in our own work that we add meaning to images that others can't see. Therefore, a questioning method helps guide self-criticism.

**Stopping power (visual impact)**
- Is the photograph powerful enough to be noticed?
- Is there a strong center of interest?
- Is the photograph an original point of view?
- As a reader, would I stop and look at this photograph? Why or why not?

**Purpose of meaning**
- Is the meaning or story clear immediately?
- Is the meaning what I think it is?
- Am I reading too much into my own knowledge of the situation?
- In a short statement, what is the meaning?

**Focus**
- Is it in focus?
- If not, is the lack of focus compensated for by more dramatic elements?
- If out of focus, what is the cause?

**Emotional Impact**
- Does the photo depict a single, strong emotion?
- Is the emotional impact what I intended? Or is the photograph just a lucky shot that is out of context?
- If it is out of context, is it still worth using as a report, or is it untrue?

- Will the reader react strongly, or simply glance at the photo?

**Print Quality**
- Is the graphic quality a result of skill and craftsmanship, or is it accidental? Example: Is the graininess a planned graphic effect or just bad developing technique?
- Is the print a simple, uncluttered statement?
- Does it have clean, detailed whites, rich blacks, and acceptable gray tones?
- Is burning or dodging noticeable and if so, does it detract or add to the message?
- Is there any element that could be cropped out for better communication?

In practice, each of these separate judgments are made simultaneously. An effective photograph works without a lot of analysis. It's the ones that don't work that need careful scrutiny to determine what went wrong.

This checklist gives you the guidance for judging technique and communication. With self-criticism and practice you will soon be producing photographs that appear to be done with intuition, but will be effective examples of "good" photojournalism based on strong judgment. Now let's consider captions, which serves to complete the overall communication of the photograph by enhancing or clarifying its message.

# THE CAPTION

No matter how thoroughly you shoot a photojournalism assignment, words are a necessity to complete the message. Written material that accompanies a photograph is called a *caption* on a magazine and a *cutline* on a newspaper. (For simplicity, we will use the term caption for both.) Both serve the same purpose: to clarify the photograph's message. The more written material you collect on the scene while shooting, the more complete will be your report. Questions not answered by the photograph itself should be answered by the caption. An unchanging rule is "All photographs will be submitted with a complete caption attached." If you apply this "complete caption" rule consistently, you will do well in photojournalism. Whether you are a freelancer or a staffer on a publication, your "picture plus caption" habit provides the editor with a professional package, with a publishable photo (Fig. 7.17).

## TWO TYPES OF CAPTIONS

There are two types of captions and each is aimed at a different audience. The first is the caption you tape to every photograph. It is aimed at the editor and is informational. This caption is complete, preferably with too much information rather than too little. The second is the actual published caption. This is aimed at the reader and can either be as complete as your original caption or as sparse as one line. Its length depends on whether a story accompanies the photo or not.

## THE COMPLETE CAPTION

The caption you attach to your photograph should supply the editor with all information needed to publish the photo. A lack of a name or pertinent information is a headache for an editor on deadline. How complete should your caption be? A complete caption answers the five W's of journalism and is typed in a format that includes complete sentences in the news writing style. It answers any question regarding the photograph. The complete caption is a full information guide to the editor who has to write the published caption.

This complete caption is attached to the print in such a way that it can be read while the editor is viewing the photograph. It includes all information necessary for understanding the photo, including the full names of people, their addresses, ages, and occupations; the location and time of the event (if relevant); and a direct quote from the subject. It should also follow the AP Stylebook for abbreviations, spelling, and punctuation; contain the photojournalist's name and the date five spaces below the caption in the lower right-hand corner; and contain an *overline* (also called a tag line or teaser) placed five spaces above the caption, centered, and typed in capital letters. It functions as a headline to connect the photo with the caption text (Fig. 7.18).

The following guidelines will ensure a complete caption.

**Overline** (or tag line) sums up the caption/photo message.

**Full name of the subject** accurately identifies him or her. Be careful; often a different middle initial or a "Jr." is the only thing that distinguishes the names of two people.

**Address of the subject** locates him or her in the circulation area of the publication. Equally important, it allows the editor to contact the subject later for additional information.

**Getting a subject's age** is probably questioned more

78

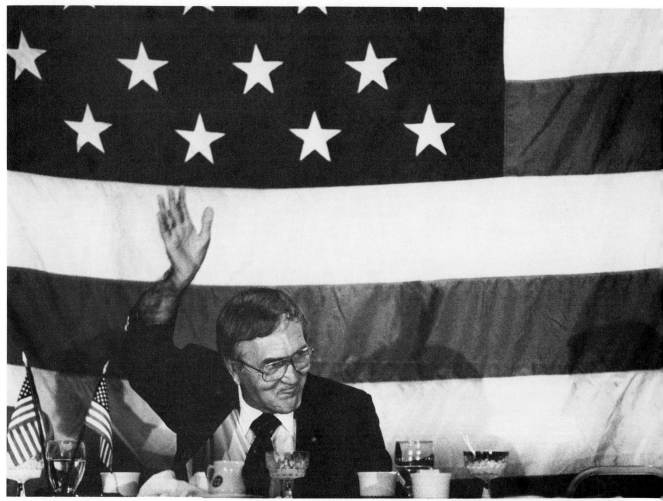

*Above*—Figure 7.17: In this photo, who or what is the subject? Is he a speaker at a Memorial Day celebration? A caption saves us from guessing: ''Retired Air Force Col. Bud Day, who was shot down over North Vietnam in 1968 and spent six years in a POW camp, was the speaker at the July 4, 1983 heroes banquet at the Phoenix Hyatt Regency. Photo by Mike Rynearson, *The Phoenix Gazette*.

*Right*—Figure 7.18: The complete caption, gathered by the photojournalist, is the basic information that the editor can use when ''going into print.'' Photographer Sam Phlug sent this photo with the following: ''NOSEY FRIEND: Six-year-old John Phrog of North Ave., Talbot, N.Y. poses with a toad he found in his backyard. Later, John let it go 'so he can be free.' He told me he likes animals, 'especially snakes,' and hopes to study them in school.''

than any other part of the caption material. Often a beginning photojournalist is shy and too embarrassed to ask a personal question of a stranger. However, many stories find human interest in the subject's age. For example, suppose you photographed a first-year college student and found out she was 48 years old? There might be an interesting story on this subject's experiences before going to college.

The **occupation or major** of the subject can also add to a story. There are many unusual occupations and each person has a story to tell about his or her work. Merely asking identifies the person further, and can lead to follow up stories and possibly a photo essay.

A **quotation** is a natural part of a reporter's work. The strongest stories are often the ones told by quotations from the subject. It should be natural to get a pertinent quote from the subject. Just make sure to get the wording exactly right so you can set the color of the subject's language or attitude.

**Location or time** are both optional, but on news stories such information is often a great help to the editor. For example, if you take a photograph of a participant in a parade, you might want to include the location.

Gathering caption material is an integral part of being a photojournalist. Never allow the pressure of time to force you into careless mistakes. Slow down and don't be afraid (or too shy) to ask the subject to repeat the spelling of a name, fact, or even a quote. Apply these basic rules:

- Get all the information yourself. Don't depend on another person or reporter.
- Be particularly careful with proper names. Even common names may have different spellings, so ask the person to repeat and spell out the name, no matter how common it sounds. Show the person what you wrote for verification, or have the person print the name for you.
- Place *cx* over words to signal unusual but correct spelling.
- If the event is a planned one, get any and all handouts such as programs, lists of names, and texts of speeches. Even if there is a reporter on the same story, gather all of this for the editor.
- Get the name and phone number of the person in charge of publicity. They can help later if the editor needs additional information about the event or a person in the photograph.
- Never ask one person for the name of another person in the photograph, unless the person is the spouse of the subject or a trained information officer or public relations representative.
- Never make an excuse to skip information. Even if the person is preoccupied or in the midst of a crowd, pass in a note and get this information.
- For a spot news story, gathering caption infor-

mation may be difficult because no one may yet know the information. Always get the name and phone number of an officer on the scene. At a fire, get the engine number of the station so you or an editor can call later to get information.
- On each information sheet, describe anything unusual about the subject for your later reference. This can become a problem when taking photographs *and* information on a deadline. But wrong identification can lead to a lawsuit.

UPI offers these strict rules for captions:
*A caption should never underestimate the intelligence of the client editor nor overestimate his [or her] information.*

The first sentence in a caption should describe *exactly* what is occurring in the photo. Use the present tense (Joe Doakes *testifies*, Joe Doakes *runs*, etc.). Past tense can be confusing and should only be used when writing a caption for a file picture.

Do not generalize. Be specific. The second sentence of your caption can add general information about the particular story if needed. Always avoid casualty figures in captions—they often change up or down drastically.

Take nothing for granted in writing a caption. For instance, in a sports picture if you are not sure of the umpire's or referee's name, don't guess. *When in doubt, leave it out!*

Be sure of your sources when quoting someone in a caption.

## THE PUBLISHED CAPTION

By following the "complete caption" rule, you will hand in photographs with too much information to be published. But you will have prepared an excellent package for the editor or caption writer who decides how much of your complete caption gets into the publication.

As deadline approaches, the editor tries to produce just the right length caption to complement the photographs. This length is determined by whether there is a story written to accompany the photo or not.

**No-Story Caption.** The no-story caption stands alone. Without an accompanying story the caption below the photograph is the story part of the message. In many instances, no-story caption is your edited, complete caption with a catchy overline.

The overline or tag line of a no-story caption serves the same purpose as a headline on a story. It attracts attention, sums up the effect of the caption and generally ties the text of the caption to the photograph. Years ago this line was actually run atop the photograph, with the caption text below the photograph. Now, however, the overline may be situated atop the caption text and below the photo. Or, it may be set as a run-on line, or as the first two or three words of the caption.

**With-Story Caption.** The with-story caption is more flexible than the no-story. It gives the editor or caption writer a chance to be a bit more creative. Because there is an accompanying story, the photograph needs less of a caption—often, only a name line or a quote (Fig. 7.19).

## THE ART OF CAPTION WRITING

Writing captions for photographs takes a special skill. Where the editor approaches the work with respect for both words and pictures, caption writing becomes a real art. The good caption writer shows this respect for the medium by attention to detail to get just the proper balance between the photograph and its caption.

Good caption writers always write the caption with the photograph, or at least a photocopy of it, in front of them. They start the caption with one of the five W's, which one depending on the content of the photograph. They use specific adjectives, not words such as *pretty* or *old*. And they make cutlines that interpret what the picture says rather than simply repeating what the picture shows.

The good caption writer also follows these rules of caption writing:

1. Study the photograph. Is there some detail that a hurried reader might not see at a glance, such as the batter closing his eyes as the ball approaches?
2. Don't describe features that are obvious. The reader can see the woman smiling.
3. Explain everything that the reader, at first glance, might misinterpret. Are the men hugging or wrestling?
4. Use present tense when describing action taking place in the photo. For example: "A mounted policeman uses a broomstick to fend off a rioter."
5. Use past tense when giving additional details that do not describe action in the photo. For example: "That was just part of the wild action in Miami today."
6. Don't mix past and present tenses (or time elements) in a single sentence. For example: "Stunt man John Smith jumps 30 cars on his motorcycle at Las Vegas yesterday." Make two sentences instead. Place a period after *motorcycle* and incorporate *yesterday* with the other information in the next sentence with a past-tense verb.
7. Don't use phrases such as "shown here" or "pictured here."
8. Tell the reader what the photo is. Don't try to tell the reader what the photo seems to be or what the picture isn't.

Figure 7.19: Some magazines combine overline, identification line and a quote as part of the layout design. Courtesy of *Arizona Highways*. Photo © Jerry Jacka.

Figure 7.20: Full newspaper cutline in a photo layout becomes a short story. Courtesy *The Charleston Gazette*.

9. Make the cutlines fit the photo. If it is a disaster photo, stick with the facts. For a feature photo, more creative writing might be appropriate.

10. When writing cutlines for a "wild" photo (one that stands alone) answer all the basic questions just as you would in a news story. Include the action in the photo in the first sentence.

11. If a picture accompanies a story, write a flash line (one line) that identifies the people and the action. Do not repeat any information in the flash line that is contained in the accompanying story.

12. In photos whose only action is obvious (shaking hands, receiving an award) use only namelines.

13. In identifying subjects in the picture, write "from left," not "from left to right."

14. In pictures where the identification of one subject makes the identity of the other(s) unmistakable the "from left" is usually unnecessary.

Supplying caption material can be a problem on fast-breaking news stories. But words are always a "necessity," in photojournalism. A published report is best when it balances words and picture that communicate clearly to the reader (Fig. 7.20).

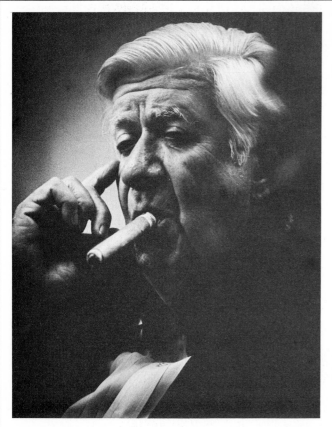

SLATERVILLE SPRINGS VOL. FIRE CO.

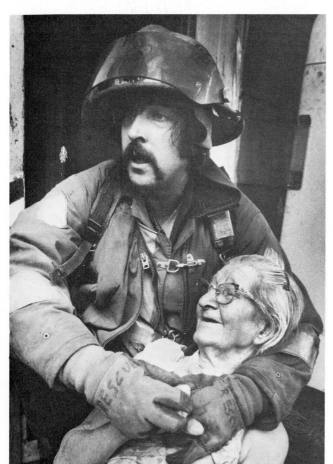

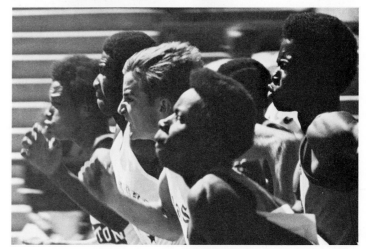

# 8 . PEOPLE PICTURES

*"We are in the people business. We must communicate with people on assignment and then we must communicate with our readership."*

Robert Brush, *The Bergen Record*

People from all walks of life are the prime ingredient for photojournalism. In fact, ability to relate to people is as important as ability with the camera. If you are sensitive to people you have the basis for becoming a successful photojournalist.

However, you need just the right approach. The key to successful people pictures is a balance between sensitivity to their feelings and a forceful personality to push yourself into new situations.

## INSTANT RAPPORT

Successful photojournalists establish instant rapport with their subjects. People must feel as natural as possible, and not just the object of a camera. Whether you shoot candids or enlist the cooperation of your subjects in posing, these steps will organize your approach to people pictures:

Know the story.
Have an idea for the photo.
Be sensitive, approach your subject with respect, and establish rapport.
Be ready to pose your subject if you need to.
If you pose your subject, take charge and explain: who you are, why you want the photo, what you want the subject to do (if anything).
Listen to and converse with your subject.

### KNOW THE STORY

Exactly how you apply these general guidelines depends on the story, so you should know the story before going out. You don't have to read every word of the story, but check with the reporter or editor before leaving to prepare yourself. Conditions on the scene will vary, so be flexible. Some stories unfold spontaneously and directing the subject would be unethical. Others need your direction from the start.

### BE SENSITIVE

Here we will emphasize rapport gained by approaching your subject, but it is sometimes best to try candids first. On many assignments, the subject knows you are there but is not disturbed if you shoot first before getting information. This is especially effective if your subject is engrossed in some activity when you arrive.

Whether you shoot candidly or pose your subject, do so openly as a member of the press. You may feel like an outsider at first—and you are—but photographing strangers is part of your job. Even when you shoot without the subject's permission, show by your demeanor that you are sensitive.

Your subject has rights to privacy under certain circumstances, so approach with sensitivity and respect. Because you are meeting a person for the first time, approach slowly and openly, with full eye contact and a smile (Fig. 8.1).

AP's David Longstreath regularly produces "enterprise" people pictures—those found spontaneously on the street all over the Oklahoma City area. Like so many photojournalists he combines sensitivity to people with his forceful personality to get many natural and lively feature photos of strangers.

Dave says, "For me, the key to people photos is to be willing to get involved, but not to the point of di-

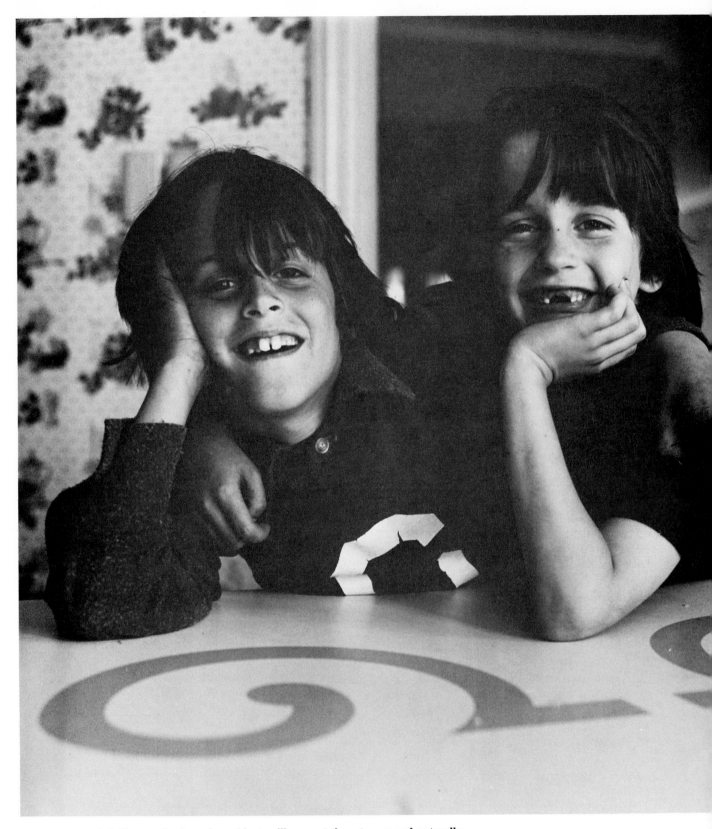

**Figure 8.1: Your enthusiasm for subjects will prompt them to respond naturally.**

**Figure 8.2: "Booger" Red Lee, an Oklahoma City street musician, responds to a friendly photographer's presence and becomes an ideal subject. Photo by David Longstreath, Courtesy *The Daily Oklahoman*.**

recting the action. I usually talk with my subjects for a while before I even take out my camera. Even then, I keep the equipment simple. On a series of 'street people,' I found that just approaching and getting them to talk opened the situation. You can tell within minutes whether the person is worth pursuing for a photo. Many so-called 'street people' are lonely and just looking for someone who listens to them. The photograph of Booger Red (Fig 8.2) is a good example of this. I saw him walking along the downtown street with his fiddle and asked him if he would play. . . . In no way was he looking for a handout. He just wanted to play his tunes for people."

David encounters all sorts of people in his feature shooting and finds that he rarely poses them, per se. In fact, many people will "act" for the camera; they react to your desire to have a subject worth photographing.

## ESTABLISHING RAPPORT

People will usually cooperate when you explain what you want. Ann Bailie says: "People were willing to co-

operate with me when I explained why I needed the photograph. Other people, like police on spot news stories, firefighters at fires or parents of young children I wanted to photograph also work with me when I take the time to explain what I want."

Once you get cooperation, be willing to listen. One of the secrets of establishing rapport is not to appear rushed. Listening takes discipline when on a tight deadline, but it is worth the effort. The late Barry Edmonds, a prize-winning photojournalist and former NPPA president, once wrote that "dealing easily with people of all kinds means conversing with them. I don't just take the photo and run, but take time to listen to the person's conversation. After all, communication goes both ways. Half the fun of this job is constantly learning from the great people we meet."

## HAVE A PHOTO IDEA

Conversing with your subjects gains their acceptance for your photo idea, so have a definite idea ready. Subjects contribute a great deal to your photograph by their expression and reactions to you, but they still need

85

some ideas. If you have established real rapport the subject will actually help interpret the photo idea. He or she will then relax and react naturally. Often you will not even have to suggest a pose or direct your subject. On many assignments, of course, your photo idea will call for posing or directing a subject. Naturally, you want to shoot as candidly as possible, but be ready to pose the subject if necessary.

## POSED/UNPOSED APPROACH

When you do pose, use the posed/unposed approach to get more than a snapshot. In practice, you *start* with a pose (Fig. 8.3) and then progress toward a natural, or even a candid, photograph.

The word *pose* needn't conjure up a formal approach. Bernie Boston, Washington photojournalist for the Los Angeles *Times* says that often you only "subtly direct. You introduce the players to the scene but you don't have to tell them how to act. They will do the acting for you. You are then really cooperating to make a photograph." In other words, a posed subject can look just as natural as an unposed subject (Fig. 8.4).

Some assignments in which the posed/unposed approach works best include: color, food illustration with people; environmental portraits; awards photos and ceremonies of all types; rush assignments on deadline with only moments to shoot; fashions, documentaries,

or illustration work; and studio portraits or a shot for an already-written story.

Pose first in a strong, simple composition (Fig. 8.5). If you are shooting a group, have them pose close together and add some sign or environmental touch to the scene.

## UNPOSED SHOTS AND CANDIDS

By posing subjects you establish some control by directing your subject(s) onto the stage of your choosing. On tight deadline, try unposed shots after you have a good pose (Fig. 8.6). (Or simply shoot candids *first,* if possible.)

The unposed phase can be totally candid depending on the time you have (Fig. 8.7) and the behavior of the subject. In extended shooting situations where subjects are cooperating fully, drop back after the pose and shoot candids. Then, use available light instead of flash, so that the people forget you are there (Fig. 8.8). You can then try to catch the elusive expression, the interaction of people, the lighting effect, or a touch of the atmosphere.

Whether you pose or take candids, your enthusiasm for the subject can't be faked. To make great people pictures, you must enjoy each assignment. John Metzger, Director of Photography for the Ithaca, New York *Journal* says this: "People are what make this job what it is—fantastic!"

**Figure 8.3: A posed shot establishes rapport and gains the confidence of your subject. Photo by David Longstreath, courtesy *The Daily Oklahoman*.**

*Above*—Figure 8.4: This responsive man posed in a natural composition, and the photojournalist's use of light enhanced the shot. Photo by Clem Murray.

*Right*—Figure 8.5: Rush assignments can still lead to natural photos. This man and his children show their warmth for each other in an obvious pose. Photo by Bob Miles, *The Phoenix Gazette.*

**Figure 8.6: Chances for unposed pictures may arise after posing subjects. After posing these girls for several shots, David Longstreath stayed back with a long lens and let them be more natural. Courtesy** *The Daily Oklahoman.*

**Figure 8.7: An unposed sequence may result when you have time to let the subjects forget you are there. Courtesy** *The Daily Oklahoman.*

**Figure 8.8:**
**George Tames of**
*The New York Times*
**caught two expressive**
**Senators when they forgot that**
**he was standing by.**

# REPORTERS AS ALLIES

Although you will work alone on many of your assignments, teaming up with a reporter adds an extra dimension to people coverage. Introductions, conversation, even photo ideas and background on the story can come easier when you work with a writing counterpart.

But remember, you work with a reporter and not for him or her. You and the reporter make up a team. One of the real pleasures of photojournalism is to work with a good reporter who offers ideas, support, and mutual respect. The reporter helps with the photo and the photojournalist contributes information to the story.

But teaming with a reporter requires flexibility and sensitivity. The photojournalist can play either a leading role in approaching people or can stay back and capture the photo while the reporter leads the way. A lot depends on the experience of each. Many a new reporter has been helped by the seasoned photojournalist who helped with the story subject.

## THE PERFECT WORD–PHOTO ACT

This was the title of a talk given by Bob Lynn, Graphics Director of the *Virginian-Pilot* and *Ledger-Star* (Norfolk, Virginia), in describing the reporter–photojournalist team. He said, "Reporters and photographers have been working together for more than 100

years, but even today a perfect teamwork is more dream than reality. 'Working apart' might be more accurate. 'Teamwork' should be a goal."

Lynn went on to present a three-act view of the teamwork from a photographer's point of view. In Act One, he suggests that the reporter contact the picture editor as soon as the story takes shape. Then the photographer assigned to the story contacts the reporter. The reporter gives the photographer a general outline and tone of the story, and information on some of the main characters to be photographed. The photographer then responds with some photo ideas.

Lynn's Act Two places the reporter and photojournalist in the field together. There, "after sizing up the scene together as two professional equals, each does his or her thing. If the story has already been written, the reporter can stay out of the photojournalist's way while being ready to suggest photo ideas."

In Act Three, the two return to the office to complete the story and photographs. Their efforts are then artfully blended onto the page to form strong communication.

Lynn ends Act Three with the observation, "it is important that reporters and photojournalists get together on stories; it produces strong professional communication. Often no picture accompanies a good story because the reporter or editor could not envision visual possibilities. But someone in the photo depart-

*Above*—Figure 8.9: Photojournalists often encounter crowds of other photojournalists. Photo by Tim Koors.

*Right*—Figure 8.10: Posing in a straight, honest manner can be forceful. Here, as the subjects looked directly into the camera, the man naturally placed his hand on the woman's shoulder and added to the poignancy of the message. Photo by Don Stevenson, *The Mesa Tribune.*

ment could have. The reporter and editors should talk to the photo department about *all* stories.

"Often publications must use inferior photographs because the assignment came in late and the photographs had to be shot on deadline. But when the reporter–photojournalist team cooperates early, readers receive the most complete word-and-picture report possible."

Many newspapers and magazines have reporters who have a specific "beat" and have become experts in that area. They know all of the people, initiate many stories themselves, and are more knowledgeable on their beat than a general assignment photojournalist can be. When working with these specialists, it is a good idea to follow their lead. With a few words from the "beat" reporter, you know the story and are free to cover it. Police, sports, business, and art news are a pleasure to cover with the help of a specialist.

## CROWDS OF PHOTOJOURNALISTS

On some major assignments, fellow photojournalists may number into the hundreds. Often you and they are assigned to photo stands where everyone has a reserved place (Fig. 8.9). On assignments like inaugurations, the Olympics, national conventions, and so on, this can mean very crowded conditions.

Chick Harrity suggests these rules for survival on such packed stands:

Get in place early.
Don't get in the way of those behind you.
Stay in place.
Fight for your own space. Don't let anyone come in at the last minute and crowd you out.

Use a long and a short lens.
Have plenty of film.
Pack some light snacks (you may be on the stand for hours).

If coverage requires following the action on foot among a great crowd of photojournalists and subjects, Chick says, "stay as close to the main subject as possible and use the widest lens you have. In these free-for-alls, you have to be a little bit of a football tackle. You can't let anyone get in front of you to block your view."

In general, photojournalists work well together and help each other. An experienced photojournalist can help a beginning photojournalist (and everyone) by posing the subject.

# ETHICS OF POSING

Perhaps one of the most confusing myths of photojournalism is that posing or directing a subject is unethical. The second most confusing myth is that the vast majority of good photographs you see in magazines and newspapers are totally candid. The old photojournalism saying, "make a picture, don't just take one," applies to imaginative thinking. It also applies to the many situations where some posing of the subject is needed to get more than a snapshot.

Posing is the directing, managing, or request for overt cooperation by the subject in making a photograph. Therefore, posing itself is not unethical, and many photographs that fit this definition are published every day (Fig. 8.10). Many are obviously managed photographs and are so identified in their captions.

However, when a photo purports to be candid, or has been shot to give the appearance of something it is not, or to give a false impression to the reader, then it is unethical.

A working photojournalist cannot consistently cover assignments without being willing and able to pose, direct, or otherwise enlist the cooperation of subjects. It is ethical to do all of this to get a better, more story-telling, photograph.

Where ethics are concerned, the caption can help greatly. In the complete caption, the photojournalist must tell the editor whether the photo was posed or directed. Then, in the published caption or cutline, the editor can make it clear to the reader if the photograph was posed.

# 9 · LIGHT FOR PHOTOJOURNALISM

*"When I'm on location, I feel the light,"*
Alfred Eisenstaedt, *Eye of Eisenstaedt*

Light is more than another tool to a photojournalist. It is the basic medium that physically and aesthetically makes the photograph. No wonder photojournalists are so aware of light "on location." They know light on the scene is one of their strongest storytelling elements. The way light on a scene affects the story is almost as important as correct exposure. Light coming from the top will say something entirely different from sidelight, and so on. A feel for what the light says is more important in photojournalism than lighting rules.

Experienced photojournalists gain practical knowledge of light by years of daily assignments, but to gain your own feel for light's effects, you can carry out the simple procedure shown in the student assignment. You can do the exercise now, before proceeding further, or wait until you reach the section on lighting.

## VISIBLE ENERGY

Light is the visible energy portion of the electromagnetic spectrum. It travels in waves of particles from its source to make light and color possible (Fig. 9.1). This fundamental definition shows the dual nature of light. It is waves of energy *and* particles of matter.

### LIGHT'S EFFECT

Your imagination can help you gain a more practical feel for the dual nature of light. Imagine a bucket of water being thrown onto a person and you have a visual idea of the dual nature of light. As the water is thrown through the air it travels in a wave, solid to the sight. But when it strikes the person, it immediately scatters and you see myriad droplets of water all going in different directions. Imagine further that the water comes in a constant, never-ending stream and that it is so finely constructed that you cannot see the particles, and you have a mind's-eye view of light (Fig 9.2). Because you can't see the particles of light, concentrate on its wave nature for practical study.

When an object blocks the light, shadows are formed. But where the full force of light strikes, bright highlights appear.

The interaction between light's energy force and the objects it strikes creates all the lighting effects for photojournalism. To understand the relationship between these two elements, we need to examine the characteristics of light itself and the characteristics of objects that light strikes.

Light travels in straight lines in all directions from its source at the speed of about 186,000 miles per second. When light strikes any interference or obstruction, it changes direction. This means that light is really bouncing in all directions at once. But when discussing practical lighting, we treat it as though it were a solid ray, a single beam of energy striking our subject. When it strikes the subject, light can be reflected, refracted, transmitted, or absorbed.

Further, how light reacts and how drastically it changes direction after striking an object depends on the object's characteristics.

*Left*—Figure 9.1: Shadow is the absence of light, which washes over the subject in waves of energy. Photo by Brian Drake, *The Longview Daily News.*

*Below*—Figure 9.2: Particles called *photons* make up the broad waves we see as light, much as tiny drops of water make up the spray from this hose. Photo by David Longstreath, courtesy *The Daily Oklahoman.*

# REFLECTION

When incident light (what we call light before it strikes the object) encounters any solid object, it reflects off, changes direction, and then travels in a straight line in the new direction. This new direction is always at the same angle to the object as the old direction and is expressed by this equation:

$$\text{angle of incidence} = \text{angle of reflectance}$$

Thus, if light strikes a reflecting surface at a 45-degree angle, it will reflect off at the same 45-degree angle. We can control light's effect if we control the angle of incidence.

## DEGREE OF REFLECTANCE

The actual angle at which the light reflects depends on the degree of reflectance of the object which it strikes. If the object is made of a highly reflectant material, like metal, glass, or some other shiny substance, and is lighted with direct light, a high percentage of light will reflect directly back into the lens because the angle is straight. This produces specular reflection, or glare. Such objects are best lighted with indirect light to diminish direct reflectance (Fig. 9.3).

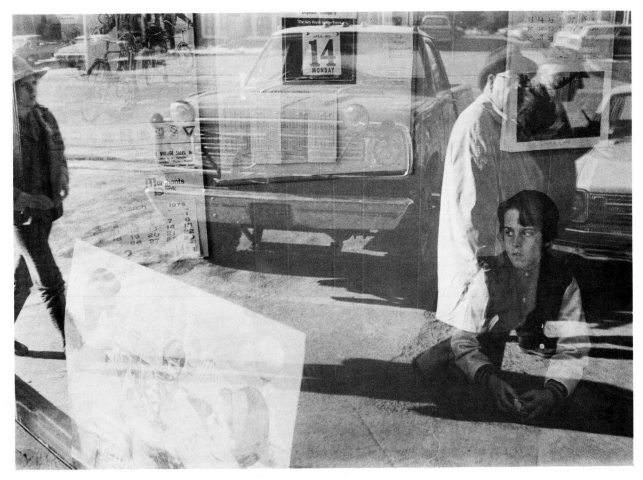

**Figure 9.3: This is a photograph of almost entirely reflected light.**

# REFRACTION

When light strikes some transparent object at an oblique angle, the rays are bent, or refracted. They continue in the same general direction, but change course slightly.

This refraction occurs because the parts of the ray are traveling at different speeds. Thus, one side of the ray strikes the glass first and is slowed down. The other side strikes slightly behind the first and so continues at the same rate of travel for an instant longer before it is bent. The result is that the two sides of the same ray bend, changing the original direction of the ray.

## DEGREE OF REFRACTION

Any object that is heavier than air refracts the light in some way. In addition to glass, heavy fog, rain or similar atmospheric conditions refract light through interference to create a soft, even hazy effect (Fig. 9.4). But perhaps the best example of refraction is the ability of photographic lenses to form and focus the image. This will be discussed in the chapter on lenses.

# TRANSMISSION AND ABSORPTION

Light is transmitted, with no appreciable change in its direction, when it strikes a transparent surface perpendicularly.

Clear, unblemished, flat surfaces like air, glass, or plastic transmit light when it strikes the surface at an acute enough angle to pass directly through (Fig. 9.5).

Light is absorbed when it is captured within the texture or contours of an object, producing little or no reflected light. It also produces the color of an object. Fig. 9.6 illustrates light absorption as well as transparency. Pigment of paints, dyes of fabrics, and numerous surfaces absorb varying degrees of the light.

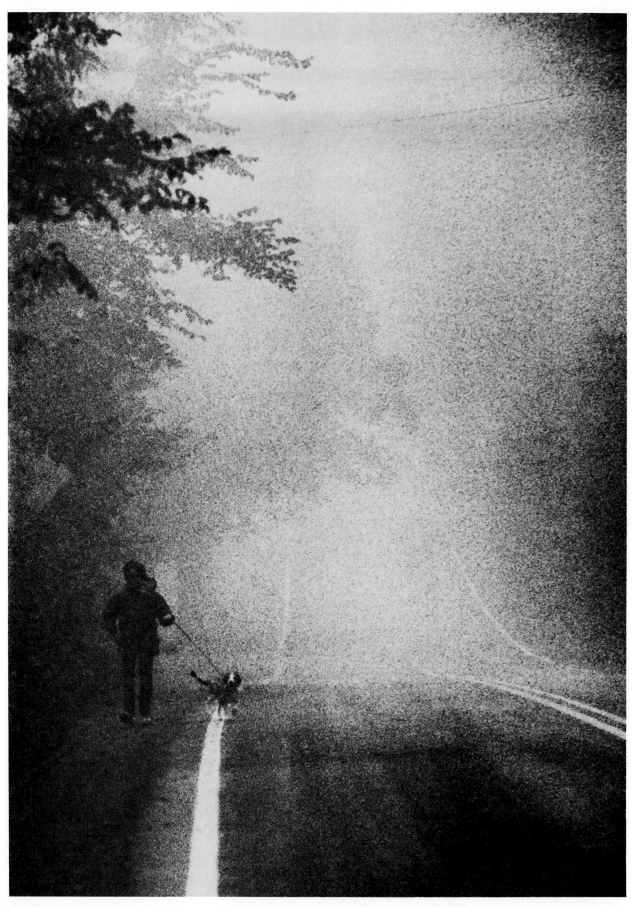

**Figure 9.4: The morning fog has refracted the light to give an eerie appearance to this scene.**

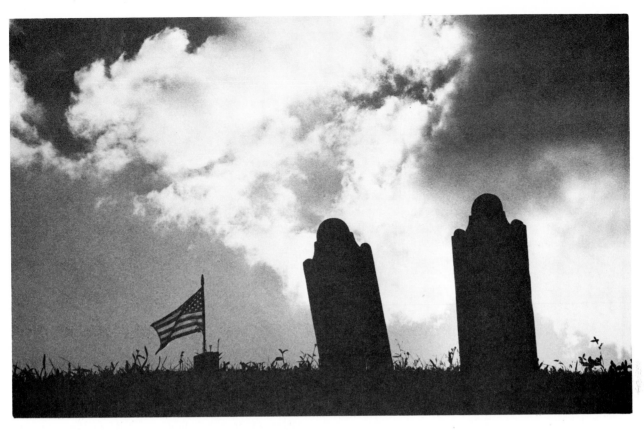

Figure 9.5: The semitransparent flag allows strong sunlight through, while gravestones block and clouds refract the light.

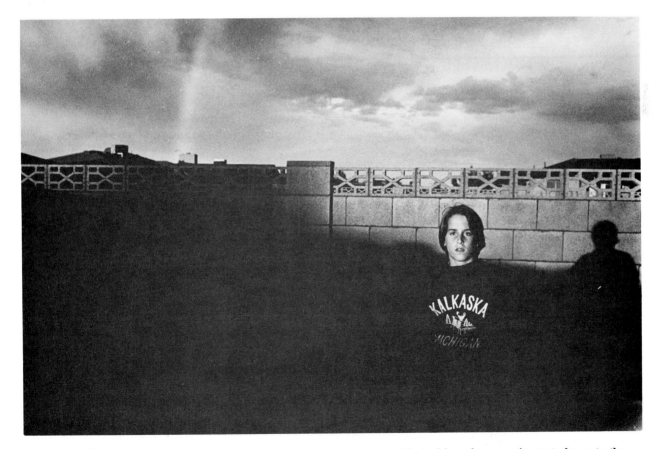

Figure 9.6: The late afternoon light, absorbed by the dark sweater, is also blocked by a fence to give a starkness to the photo. The refracted light creates the rainbow.

## COLOR

But the absorption of light is more complex than this. Light is the source of all color and is therefore tied to *selective absorption.* For simplicity in black and white we discuss light as a mass of white light, but if it is absorbed to any degree, it produces color. What we see in white light is an equilibrium of the primary colors red, blue, and green.

Each of these colors is light with a different wavelength, and if there is no interference, they combine to create white or "pure" light (Fig. 9.7). However, if this fragile balance of the three colors is upset by any interference, the light ceases to be pure because one of the colors has been deleted to some degree. Light then takes on a coloration that results from a recombination of the remaining colors (Fig. 9.8).

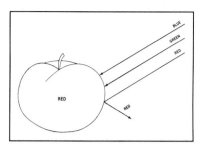

**Figure 9.8**

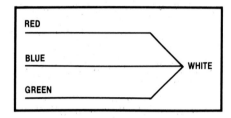

**Figure 9.7**

An object thus has color because of either the color of the incident light falling on it, or the color the object absorbs. What we see as color is the effect of selective absorption. The pigment, fabric, and surface contours of any object absorbs light to varying degrees to form color. The red apple, with skin that absorbs blue and green and thus allows only red to reach our eyes, is a classic example. Any known color can be produced by a mixture of proportions of the three primary colors.

This is only a brief introduction to light as energy. For the rest of this chapter, we will simplify our discussion of practical lighting for photojournalism by referring to light as though it were always white light, and you are shooting with black-and-white film.

# LIGHTING PRACTICES AND SOURCES

Dealing with light as energy leads into a discussion of lighting for photojournalism: a practical use of light to tell stories. Now we will go beyond the feel for light itself and introduce a practical language of lighting.

We divide lighting language into three parts: intensity of light, its direction, and its source.

## INTENSITY

The intensity, or strength, of the light falling on a subject determines the contrast between the highlights and shadows. Highly intense light comes from a point source and gives a scene high contrast. Deep shadow and bright highlights convey a certain crisp, even harsh, mood. Low intensity light comes from a weak or diffuse source and produces low contrast. Soft shadows and detailed highlights convey a certain soft, subtle, mood.

In photography, lighting intensity is measured in ratios between highlight and shadow. Ratios correspond to *f*-stop differences. Some examples of ratios follow:

- **2:1** means highlights are 1 *f*-stop more light (twice the light) than shadows.
- **4:1** means highlights are 2 *f*-stops more light (four times the light) than shadows.

- **8:1** means highlights are 3 *f*-stops more light (eight times the light) than shadows.
- **16:1** means highlights are 4 *f*-stops more light (sixteen times the light) than shadows.

For exposure control, take a meter reading from the highlights and then from the shadows and compare. A high ratio can be dramatic, but you would need full light if you want shadow detail.

For artificial light, intensity is greatly affected by distance from the light source to the subject. The closer the light source, the more intense the light that creates the highlights.

This fact is expressed through the *inverse square law* which says that light's intensity decreases as the distance of the light source increases. More specifically, if the distance from the light source to the subject *doubles,* the intensity of the light is *reduced by one-fourth.* To compensate for this loss of intensity, you would open up two *f*-stops. For example, if your meter reads *f*11 at five feet and you then move the light back to ten feet, you would use a setting of *f*5.6. Naturally, you don't compensate outdoors, because sunlight can be considered to remain a constant distance from your subject.

## DIRECTION

No matter how diffuse the light or what its color or source, there is always one dominant direction to it. This direction is shown by the shadow that is cast. Light naturally divides a scene into shadows and highlights. Because of the directional nature of light, it strikes the most prominent areas of a scene first. These areas, whether of a person's face or the side of a mountain, are washed by the strong force of light. But they also block part of the scene to form shadows located on the "far side" of the light. These shadows are really the absence of light's energy; thus they photograph as dark areas. The contrast ratio between these areas is in direct proportion to the direction from which the light strikes the subject, since the dark areas increase or decrease as the direction changes (Fig. 9.9).

We say that light is directional (strong, one-directional) or diffused (soft, multi-directional).

## DIRECTIONAL LIGHTING

There are eight convenient types of directional lighting. Remember that each type refers to the direction as viewed from the camera in front of the subject:

- front light
- 45-degree front light
- 90-degree side light
- backlight and silhouette
- rim or edge light
- top light (high noon light)
- bottom or "monster" light
- fill-in light

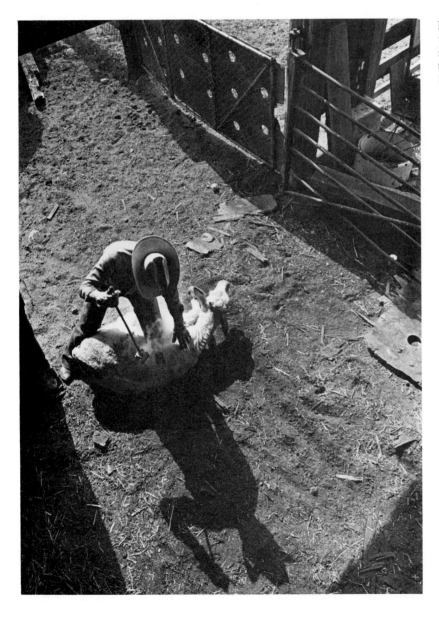

Figure 9.9: One-directional light divides the photograph into highlight and shadow. Here, the backlighted subject throws dark shadows. Photo by Don Stevenson, *The Mesa Tribune.*

**Front Light.** Front light is light that faces directly toward the subject from the direction of your camera. Front lighting flattens perspective because it fills in highlight and shadow. The shadow is cast behind your subject (Fig. 9.10). Consequently, there is little or no illusion of depth with front lighting. Generally it is used functionally rather than creatively.

**45-Degree Front Light.** A classic for portraiture, 45-degree front lighting creates modeling on the subject by striking the subject at a high, 45-degree front angle. This creates a 45-degree shadow across the nose and face to give depth and contrast to the subject. This type of lighting is called "glamour lighting" because it is the lighting often seen in movies. It is also the favorite for formal studio work. It is usually flattering (Fig. 9.11).

**90-Degree Side Light.** When you place the lighting 90 degrees from the front, you create extremely dramatic lighting that cuts the face right down the center.

This is referred to as "hatchet" lighting (Fig. 9.12). It is extremely dramatic, so you should use it only when you want to communicate strong drama. The strong contrast produced by 90-degree lighting also gives a depth to the face or scene.

**Backlight and Silhouette.** Backlight dramatizes the subject nearly as much as 90-degree lighting, but its ability to separate the foreground from background creates a more pleasing effect. A high percentage of creative photographs are shot with backlighting. Typically, the scene or person is given a slight glow around the edges where the light strikes (Fig. 9.13). Carefully overexpose the shadows to get a rich black and white negative. Exposing for these shadows gives them more detail and softens the shot.

When a backlighted scene is exposed for highlights and shadows are underexposed, a dramatic silhouette is produced (Fig. 9.14). This is one of the easiest lightings to expose for, but can be difficult to print. Unlike

**Figure 9.10: With front lighting, the shadow is cast behind the subject, so the illusion of depth is diminished. Courtesy** *The Washington Post.*

Figure 9.11: The flattering, contrasting shadow created by 45-degree lighting "models" the subject's face. This type of lighting is the Hollywood glamour lighting familiar in movies. It is the favorite for formal studio portraits.

Figure 9.12: Also called "hatchet" lighting, 90-degree lighting is very dramatic. Use it sparingly.

Figure 9.13: A high percentage of creative photographs are shot with backlighting, which often gives the subject a slight glowing-edge effect. Exposing for the shadows brings out more detail and softens the depth. Photo by Jim Bryant, *The Jacksonville Journal.*

Figure 9.14: With backlighting, underexposure creates a silhouette. In effect, the subject becomes a shadow, especially against a light background. Photo by Peter Ensenberger, *The Mesa Tribune*.

Figure 9.15: Edge lighting also comes from the back and rims the subject, isolating and profiling it. Photo by Peter Ensenberger.

backlighting, silhouetting makes the subject a complete shadow, especially when the background is a light color.

**Rim or Edge Lighting.** Edge lighting also comes from the back, but illuminates only an edge or rim of the subject. By "rimming" your subjects outline, you isolate a profile or dramatically emphasize part of the subject (Fig. 9.15).

**Top or High Noon Light.** From its location above the subject, top lighting throws the eyes into shadow and creates a hard, even sinister, effect. But this lighting is extremely dramatic. The main consideration with such strong lighting is to make certain that it says what you want it to. It matches a tough, sad, or virile subject (Fig. 9.16).

**Bottom or "Monster" Light.** Bottom or "monster" lighting is used very sparingly in news work (usually only at Halloween). But it could be used to capture a mood of horror, as in a portrait of film actors known for monster roles, or when you want to create the direction and feeling of a low light source, such as camp-

fire light. This lighting is seldom seen as available light on a news scene.

**Fill-In Light.** Because it is so directional, this type of lighting can produce strong contrast between deep shadows and bright highlights. You may eventually want to soften this ratio by adding either a reflector or fill-in flash.

But adding other lighting sources gets ahead of this part of the chapter. Even the most elaborate lighting setup gives the effect of a single dominant light, so any additional reflection or lighting is auxiliary.

## DIFFUSED LIGHTING

The lighting examples shown so far capture or create dramatic effects because they are strongly directional, but much lighting is diffused in one way or another and has a softness that tells its own story. Non-directional lighting softens the shadows and gives a closer ratio between highlight and shadow because it reaches the subject after reflecting off another surface and diffusing in the process.

**Figure 9.16: Top lighting throws the eyes into shadow and creates a hard, even sinister, effect. With such strongly emotional lighting, always be sure it is appropriate to the story.**

As a result of diffusion, light strikes the subject from various angles. The two main types of diffused light are: multi-angle and single dominant angle reflection.

**Multi-Angle Diffusion.** When the light has been refracted by the atmosphere or some studio device, it surrounds the subject. It wraps around the subject and produces a low lighting ratio. The light created is so soft that it is practically shadowless. The light on a foggy or cloudy day or the light produced by a studio tent creates this type of diffuse light. This is similar to northern light (Fig. 9.17).

**Dominant Angle Reflection.** When the light reflects off a single surface before striking the subject, you have a softened version of the lighting directions listed above. By diffusing off the wall, ceiling, building, or natural object, light is softened (Fig. 9.18), but still comes from one dominant direction. The effect is a softened version of directional lighting. Depending on how close other reflectors are, lighting produced by single dominant reflection can be from high to low in contrast ratio. Sunlight reflecting off a nearby wall or flash bounced from a wall or a studio umbrella is one of the most popular and effective diffuse lighting effects using a single source.

## LIGHTING SOURCES

There are two basic lighting sources: sunlight and artificial light.

**Figure 9.17: Sunlight diffused by an overcast sky almost always favors your subject's features. Photo by Robert Hoy.**

### SUNLIGHT

Sunlight is strong, available, and changeable enough to fill any creative need. Sunlight is also the standard used for artificial lighting effects. Studio lighting is an attempt to copy or recreate some lighting effect that the sun has produced in nature. When you work with sunlight as the only lighting source, you recognize and utilize what is on the scene. In the course of a normal sunny day you see the following lighting directions:

- Bottom light—the low angle sun at dawn
- Front light—early morning, subject facing sun
- Ninety-degree light—early morning, subject at angle to sun
- Forty-five-degree light—late afternoon or early evening, with sun high
- Backlight—subject's back to the light
- Silhouette—sunlight on a white wall, subject in shadow
- High-noon—noon sun high above
- Diffused—light in a shady area, light on a cloudy or rainy day

Shooting for any of these effects in sunlight means adapting to the time or even the type of day.

### SHOOTING GUIDES FOR SUNLIGHT

You can shoot any time of day, but the following are a few basic steps for shooting in sunlight:

- Expose for the shadows.
- Try backlight when possible . . . it gives a pleasing depth to the photo.
- Stay away from high noon sunlight unless you want its harsh effect.
- Try to shoot early or late in the day, when sunlight is softened or the sun is lower in the sky.
- If you have a choice, try a day that is "cloudy bright" rather than the clear, sunny, high-contrast day. The softer light gives detail in shadows and a feeling of depth.
- Be aware of differences in the light as it changes hourly, and use them creatively.
- Even indoors, take advantage of window light when possible.

### ARTIFICIAL SOURCES

Artificial lighting is everything other than sunlight. For photojournalists, this includes indoor existing light and flash (to be discussed in a separate chapter).

---



## INDOOR "EXISTING LIGHT"

Existing light is any light you find indoors: from TV lights to a single bare bulb to sunlight through a window. It is sometimes called *natural* or *available* light (Fig. 9.18). Existing light has all the characteristics of other lighting.

Existing light is preferred by many photojournalists. When it is used with knowledge of its storytelling effect, it is the most truthful light on a scene. Under existing light, photographs come close to recording the scene exactly as a witness would see it. Photojournalists have been using this lighting since the early days, but today, with sophisticated cameras, fast lenses and fast film, we are in an existing light era.

For photojournalists, existing light is always part of a positive, truthful method of reporting things as they are. This search for reality eschews any form of lighting except what exists on the scene. As an aesthetic, it grows from the characteristics of existing-light photography:

- It's practicable nearly everywhere.
- It's a natural approach to shooting.
- It's true to the way the eye sees the light on a scene.
- It's easy on both the subject and photojournalist.

This aesthetic was stated by Henri Cartier-Bresson in *The Decisive Moment* (1952): "We must neither try to manipulate reality while we are shooting, nor must we manipulate the results in the darkroom . . . we must approach the subject on tiptoe . . . a velvet hand, a hawk's eye—these we must all have."

Even though this tenet was written over 30 years ago, the basic approach has not changed significantly.

But with all of its advantages, existing indoor lighting remains "found" light. The storytelling light on the scene has been set for you. This lighting is often right for the story, but often it is not. This places the responsibility on you as a photojournalist to know exactly what existing light communicates to readers.

For example, top lighting might be the right existing light for covering a murder scene: a body found in a rooming house, lighted by a single bare bulb. The lighting found on the scene fits the somber mood of the story and could be used as such.

However, in an interview with a visiting politician, top lighting (say, the light of a meeting room), might give a harsh, even sinister look. This lighting could make a statement about the subject that is false. A photojournalist who is aware of the effects of lighting only needs to introduce flash or have the subject move nearer to neutral lighting. In your search for truthful photographs, you must know what the existing light is telling the reader. Our search for naturalness can lead to editorializing with lighting unless we know precisely what we are saying.

## SHOOTING TIPS FOR EXISTING LIGHT

Shooting existing light naturally means shooting with slower shutter speeds and wider apertures, so for success here are a few basic steps:

- Make certain the camera is steady.
- Expose for the shadows.
- Make certain lighting says what you think it does.
- Shoot when subject is at rest (to curtail blur). Try to shoot at 1/60 second or faster.
- "Push" (overdevelop) film if needed.

Figure 9.18: Available light is "found" light and often creates its own mood. Photo by David Longstreath, courtesy *The Daily Oklahoman.*

# 10 · CAMERA DETAILS

*"The camera is only as good as the person behind it."*
Old saying

In Chapter 3 you became acquainted with your camera and shot a few rolls, so by now you know the workings of your 35mm camera fairly well. In this chapter we will go into more detail on cameras for more background and understanding.

No matter how sophisticated your own 35mm camera is, it is only the latest in an evolution of camera types that began with the wooden box used by the Frenchman Louis Daguerre, when he announced his invention of photography in 1839. Since then, photographers have used every kind of camera, from view cameras to 35mm cameras, to produce great news photographs.

All cameras operate on the same principles, and all cameras can be described in the same terms: a light-tight box with a lens at one end to let in the light and light sensitive material at the other end to record the image formed by the light when the lens is opened.

All cameras have the same basic parts, although at different levels of sophistication. These parts include:

- a camera body that is light-tight and houses all other parts
- a viewing system that allows you to frame the image
- a focusing system that allows you to make the image clear
- a shutter that opens and closes to make an exposure by controlling the amount of time that light strikes the film
- a mechanical diaphragm that controls how much light strikes the film by means of an opening (called an aperture)
- a lens that directs and focuses light rays onto the film
- a film holder to hold film flat and in place
- a film container to store and protect film before and after exposure
- a film advance to supply film for subsequent exposures

## MAJOR CAMERA TYPES

There are four areas of mechanical differences that help to classify cameras and determine to a great extent the photographer's style and even subject matter. They are: the viewing system, the focusing system, the shutter type and operation, and the film size.

### VIEWING SYSTEMS

Four major types of viewing systems include: (1) direct through-the-lens, (2) twin lens reflex (TLR), (3) single lens reflex (SLR), and rangefinder.

### DIRECT THROUGH-THE-LENS

Direct through-the-lens viewing is the simplest viewing system and was one of the first used in cameras (Fig 10.1). All you do is open the lens and the camera back to view the subject. The view camera is a basic camera, with a lens at one end and a glass viewing screen at the other. In between is an accordion-like bellows that allows you to focus by moving the lens forward or backward on a rail or track. Through the view camera, you see the subject upside down and backwards, exactly as the image will be on film. The view camera uses large film—8 × 10, 5 × 7, or 4 × 5 inches—and must be used on a tripod.

**The Speed Graphic Camera.** Although the 4 × 5-inch "press camera" is no longer used in photojournalism, this outstanding communication tool was the reigning camera for newspapers and wire services from the 1930s to the early 1960s (Fig. 10.2).

*Above*—Figure 10.1: Boris Yaro of *The Los Angeles Times* demonstrates a view camera, a basic camera with a lens on the front and a film holder on the back. Courtesy Dover Publications, Inc., John Faber.

*Right*—Figure 10.2: The Speed Graphic camera served many news photographers well for decades, as Ernie Sisto of *The New York Times* would testify. Courtesy Dover Publications, Inc., John Faber.

The Speed Graphic, introduced in the 1930s, is a view camera ingeniously adapted for on-location or news work. It is made with such balance and compactness that it can easily be hand-held or used on a tripod. It has ground glass for focusing, but it is also equipped with a rangefinder. It has a wire finder for framing fast action. Early models had both a between-the-lens and a focal plane shutter.

Like the view camera, the Speed Graphic is basically a one-shot camera. But despite its resemblance to the view camera, it is much more versatile. News photographers took the Speed Graphic everywhere that news was being made. They learned to change film holders very rapidly and approached each assignment with the now-classic general view, medium shot, and close-up. Today the Speed Graphic is used both in the studio or on location, but not for news.

**The Graflex Camera.** Over the years, cameras became smaller and handheld, so a small mirror was introduced into the camera construction. This enabled the photographer to view the subject without opening the back of the camera. The mirror blocked the light from the film when viewing. When the shutter was released, the mirror flipped up, allowing the film to be exposed.

The Graflex camera was an early mirror reflex camera, and a popular one for news photographers into the late 1920s. It was used for sports well into the 1950s. When mounted with a long lens, it was the "Big Bertha" for sports (Fig. 10.3).

The Graflex took some adapting to, however. The mirror gave the photographer a reverse image so everything looked backward. In sports, the runner going left looked like he or she was going right, and vice versa.

Today, the two camera types that use the reflex viewing system are the twin lens reflex (TLR) and the single lens reflex (SLR).

## TWIN LENS REFLEX (TLR)

The twin lens reflex camera has two identical lenses mounted one above the other. The top lens is equipped with a fixed mirror that reflects the image upward to a ground glass screen for focusing. The bottom lens is the shooting lens. When the shutter is pressed, the shooting lens records the image. Because they are in tandem, both lenses see almost the same and therefore focus together. Because the view image is reflected from a mirror, that image is reversed, which can prove awkward for fast-moving subjects (Fig. 10.4). Focusing with the TLR is simply a matter of viewing the image and turning the focusing knob until the image is sharp.

## SINGLE LENS REFLEX (SLR)

The single lens reflex viewing system overcomes the disadvantage of viewing a reversed image by allowing you to view and shoot through the same lens.

A prism atop the camera allows you to see the subject through the lens just as your eye sees it, rather than as a reverse, or mirror image. To do this, the SLR is equipped with two mirror sets. The first is a moveable mirror located directly behind the lens and pointed upward. This mirror reflects the image upward to a viewing screen in the same fashion that the TLR does. Atop this viewing screen, however, is a prism that reverses the mirror image one more time so that your eye sees the subject from a normal viewpoint.

This mirror system allows you to view through the lens as you shoot (Fig. 10.6). When you press the button, the bottom mirror flips up. This allows the image to pass through the open shutter and to make the exposure on the film. The viewing mirror is only up for the instant of the exposure, so only on long exposures is your eye greatly aware of an interruption of the image. The SLR camera is extremely popular today because of this convenience in composing directly through the lens. It is made in 120mm and 35mm sizes.

To focus the SLR you simply turn the lens barrel until the subject is sharp. One disadvantage in using an SLR is difficult focusing in low light. Another is the noise of the mirror as it moves. However, some SLR's add a split image rangefinder to the viewing screen to give you two systems to help focus.

Figure 10.3: The "Big Bertha" was the favorite long-lens camera for covering sports from the 1930s to the 1950s. Courtesy Ernie Sisto.

### RANGEFINDER

Viewfinder cameras are equipped with an eye-level viewer, usually built into the side of the camera. The viewfinder is made of glass to give a flat perspective of what the lens sees, and only frames the subject for composition. For focusing, those cameras incorporate a mechanical device called a *rangefinder,* which is coupled internally with the lens barrel (Fig. 10.7).

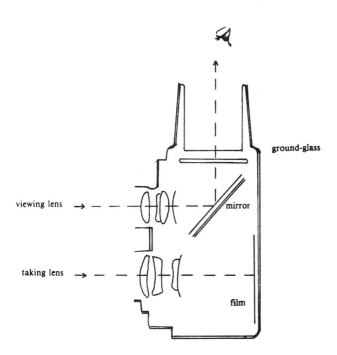

Figure 10.4: As the name implies, the twin lens reflex camera has two lenses, one to direct the image to the film, and another to direct it to the viewfinder (where it ends up reversed).

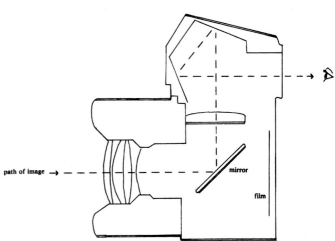

Figure 10.5: The prism in a single lens reflex camera overcomes the disadvantage of image reversal found in the twin lens reflex. It re-reverses the image.

Figure 10.6: The mirror inside a SLR reflects the image upward to a prism for correct through-the-lens viewing.

Figure 10.7: The rangefinder camera has been popular since the 1920s. It is easy to focus in weak light.

The coupled rangefinder is a double-prism mirror located within the camera. One prism is a fixed mirror located within the viewfinder. The other prism is located to the side of the lens and is movable (Fig. 10.8). It is coupled, or connected, to the lens so that it moves when the lens rotates. This dual prism produces two overlapping images when the subject is out of focus. To focus, you rotate the lens barrel. When the two images merge into one, focus is assured.

The main advantage of the rangefinder camera is its ease of focusing in low light conditions. It allows you to focus on a bright mirror rather than directly on the poorly lighted subject. The lack of a moving mirror also means quiet operation. However, the perspective of a flat glass viewer can be a disadvantage for composition.

# SHUTTER TYPES

All cameras operate by adjusting the relationship between the shutter and the diaphragm to make the right exposure on the film. Both shutter and aperture control light during exposure, but in different ways.

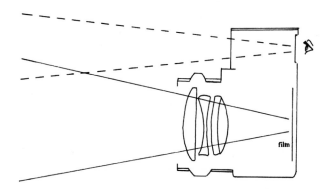

Figure 10.8: Dual prisms in the rangefinder produce a ghost image in the viewer when the subject is out of focus.

The shutter controls how long light strikes the film, adjusting measures of time. The aperture controls the amount of light by adjusting the size of its circular opening. In practice they work together. But here we will separate them for ease of discussion. Later we will discuss their interaction. The two types of camera shutters are leaf, or between-the-lens shutters, and focal plane shutters.

## LEAF OR BETWEEN-THE-LENS SHUTTER

This shutter has two names, and both aptly describe its operation. First, it is called a leaf shutter because it is made of many small, overlapping leaves operated by a spring. During exposure, the leaves open and close like the petals of a flower. Second, the spring mechanism is located between the lens elements, so it is also called a between-the-lens shutter (Fig. 10.9). Leaf shutters can be automatic, but most professional cameras of this type do not have an automatic mode, so

**Figure 10.9: Leaf shutters, or between-the-lens shutters, form an opening with overlapping plates, or leaves.**

**Figure 10.10: The introduction of the focal plane shutter made it possible to shoot faster than ever.**

you must select the *f*-stop for each picture. Leaf shutters can synchronize with any shutter speed from 1/500 second down.

## FOCAL PLANE SHUTTER

The focal plane shutter is located inside the camera directly in front of the film. Older focal plane shutters consist of a set of overlapping curtains that move across each other to form a slit or adjustable opening. When activated, the slit moves across the area in front of the film to expose the film in sections (Fig. 10.10). The width of these sections depends on what speed the shutter is set for. The faster the speed, the smaller the width of the section. Newer focal plane shutters consist of hinged metal curtains (Fig. 10.11).

The focal plane shutter has several practical advantages. First, there is no shutter within the lens mechanism itself, so it can remain open while you look directly through the lens. Second, being located at the film plane rather than between the lens, the focal plane shutter makes interchangeable lenses practical. Third, the focal plane shutter allows speeds as fast as 1/4000 second, whereas the leaf shutter can only work up to about 1/500 second. Although some new focal plane shutters synchronize with flash at up to 1/250 second, many still must be set at 1/60 second or 1/125 second.

## SHUTTER OPERATION

Shutters divide time into fractions of seconds. This allows you to expose the film at any one of a series of speeds ranging from 1/4000 second to 1 second or longer. Calibrated in steps that sequentially cut the ex-

posure time in half, the common shutter speeds for a focal-plane shutter might include 1/4000, 1/2000, 1/1000, 1/500, 1/250, 1/125, 1/60, 1/30, 1/15, 1/8, 1/4, 1/2, and 1 second. There is also a ''B'' setting that allows you to leave the shutter open for lengthy time exposures beyond 1 second; the newest cameras are capable of extending their exposures automatically beyond 1 second.

To set the shutter speed, all you do is turn the dial to the required speed. In the case of some automatic

**Figure 10.11: Newer focal plane shutters are metal and expose the film in a vertical movement.**

shutters, you place the dial settings to "A" (or "P" for program) and the camera adjusts the shutter speed or aperture automatically as the light changes.

The logical half/twice relationship between each shutter speed makes it easy to understand, but do this short shutter exercise.

1. Set your camera on manual and at 1/250 second.
2. Change the shutter speed for half as much exposure (1/500 second).
3. Reset your shutter dial to 1/250 second.
4. Now change the shutter speed for *twice* as much exposure (1/125 second).

## THE DIAPHRAGM

Regardless of type, each shutter is equipped with another device to control light striking your film during exposure. This device is a diaphragm with an adjustable opening, called the aperture. But, whereas the shutter controls light during exposure by increments of time, the diaphragm does so by adjusting the size of its opening.

## APERTURE

The diaphragm is constructed of overlapping leaves that open and close like a leaf shutter (Fig. 10.12). This opening is circular and is called the aperture. On leaf shutters, the diaphragm is located within the shutter. But on cameras with focal plane shutters, the shutter/aperture connection is severed. An outside ring allows you to turn the aperture and to adjust the size of its opening. This ring also contains printed numbers that correspond to the opening for your reference.

Like the shutter, the diaphragm adjusts light in a twice/half relationship in a series of standard numbers called *f*-numbers. Each *f*-number has a half/twice relationship with the numbers on either side of it, as with the shutter speeds. But the numbers assigned to each *f*-number are arrived at differently and can cause some confusion. The formula for this is,

$$f\text{-number} = \frac{\text{focal length (of lens)}}{\text{effective diameter (of lens)}}$$

For most lenses, the standard series of *f*-numbers are 1.4, 2, 2.8, 4, 5.6, 8, 11, 16 and 22. As Fig. 10.13 shows, each of these numbers corresponds to a different size opening. They range from the largest—*f*1.4—to the smallest—*f*22. Each *f*-number allows either half or twice as much light as its neighbors, depending on which direction you turn the aperture. For example, if you are set at *f*4 you can either close down to *f*5.6 or open up to *f*2.8 (Figs. 10.14–19).

**Figure 10.12: Like a leaf shutter, the aperture (or diaphragm) is composed of overlapping metal plates that form a circular opening.**

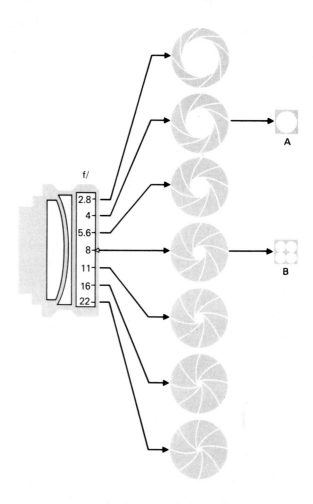

**Figure 10.13: Each numbered aperture opening, or *f*-stop, admits either twice or half the amount of light as the *f*-stop before or after it in the series, as this comparison shows. Turn to the next lowest number—you'll let in twice the amount of light. Turn to the next highest number—you'll let in half the amount of light.**

## UNDERSTANDING f-NUMBERS

Look again at the formula above. Each f-number represents an aperture size that is scientifically related to the focal length of the lens, so each is a consistent standard measurement. For example, f4 will transmit the same proportion of light whether the lens focal length is 50mm or 20mm. For now, just memorize the f-numbers and remember that they correspond to each other in a half/twice relationship.

To help you in this first step, study your lens. Take it off your camera and check the f-numbers. Hold the lens toward a light and slowly turn the aperture ring. On most lenses you can see the size of the opening change as you turn the ring.

Follow these steps as an aperture exercise:

1. To begin, set your lens at f5.6.
2. Change the setting to give you *twice* the light (f4, or open one stop).
3. Now reset your lens to f5.6.
4. Change the setting to give you half as much light (f8, or close down a stop).

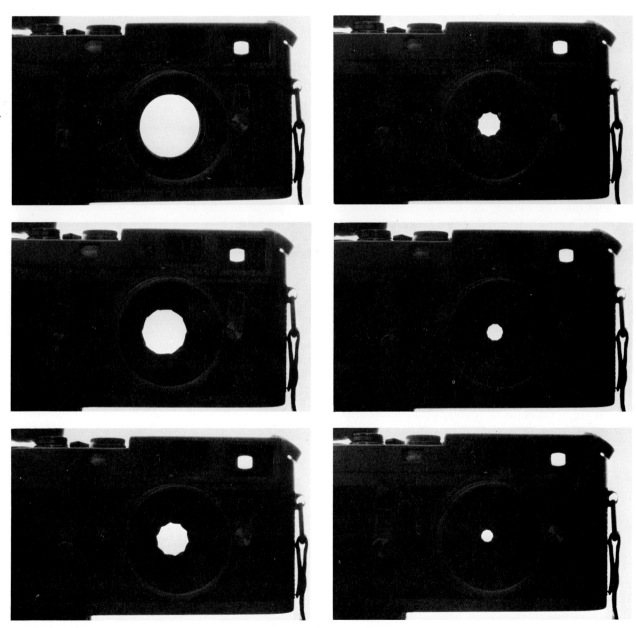

**Figure 10.14** *(top left)* **is a 50mm lens opened to** f2. **Figure 10.15** *(middle)* **is the same lens closed to** f4. **Figure 10.16** *(bottom left)* **is the lens closed to** f5.6. **In figure 10.17** *(top right)* **the lens is closed to** f8. **In figure 10.18** *(middle)* **the lens is closed to** f11. **In Figure 10.19** *(bottom right)* **shows the lens closed to** f16. **Note that as** f-stop numbers have gotten higher, the amount of admitted light has gotten lower.**

# THE SHUTTER/APERTURE RELATIONSHIP

In practice, you adjust the relationship between shutter and aperture to get the proper mixture of time and amount and just the "right" exposure. Usually, you only change one at a time because each gives a different effect on the final image.

As a general rule, change the shutter when you want to affect the motion of the subject. A slow shutter speed of perhaps 1/15 second will give a blur, whereas a fast shutter speed of perhaps 1/500 second will freeze the action for a sharper image.

Change the aperture when you want to affect an area of focus within the scene. In general, a small $f$-number, $f2$, will give you less area in focus and a larger $f$-number, $f16$, will give you more area in focus.

If you set the shutter/$f$-number relation at 1/500 second at $f2$ and change each in concert, you obtain a relationship that looks like this:

| 1/500 | 1/250 | 1/125 | 1/60 | 1/30 | 1/15 | 1/8 |
|-------|-------|-------|------|------|------|-----|
| $f2$  | $f2.8$ | $f4$ | $f5.6$ | $f8$ | $f11$ | $f16$ |

Each of these shutter/aperture combinations will yield the same exposure on your film (Figs. 10.20–26). A fast shutter speed of 1/500 second combined with a wide opening of $f2$ will mean a lot of light in a short time. By contrast, a slow shutter speed of 1/30 second and a closed-down opening of $f8$ will mean a little light for a longer period of time. However, like other combinations listed, each will yield equal exposure on the negative. Many other exposure combinations are available to you. Creativity in photojournalism comes from manipulating the shutter/aperture relationship for visual effect.

# FILM SIZE

Because film size dictates the size and construction of a camera, it greatly affects the other major camera differences. This in turn strongly affects a photographer's working methods, style, and even subject matter. No one camera can do everything, but in recent years the 35mm camera has become the standard for photojournalism.

Each camera type and size discussed so far has been used for photojournalism in the past, but the 35mm format is the overwhelming choice of today's photojournalists. As a matter of fact, the 35mm format is so pervasive that our brief discussion of other cameras is only background.

The 35mm format is so popular with photojournalists today because it is made for the fluid style of fast shooting on deadline. It has these characteristics:

- Small and easily carried
- Technically sophisticated but easy to operate
- Ruggedly built to survive "news" conditions in the field
- Uses long rolls of film: 36 and 72 exposure rolls
- Has a great variety of interchangeable lenses
- Has "fast" lenses for available light shooting
- It is an extremely popular amateur format, encouraging manufacturers to constantly improve it with innovative computer technology
- Lenses, accessories, film and replacement parts can be bought worldwide
- Can be equipped with motor drive

All of these attributes combine to make it likely that the 35mm format will remain *the* camera for photojournalism until the electronic still camera offers more versatility.

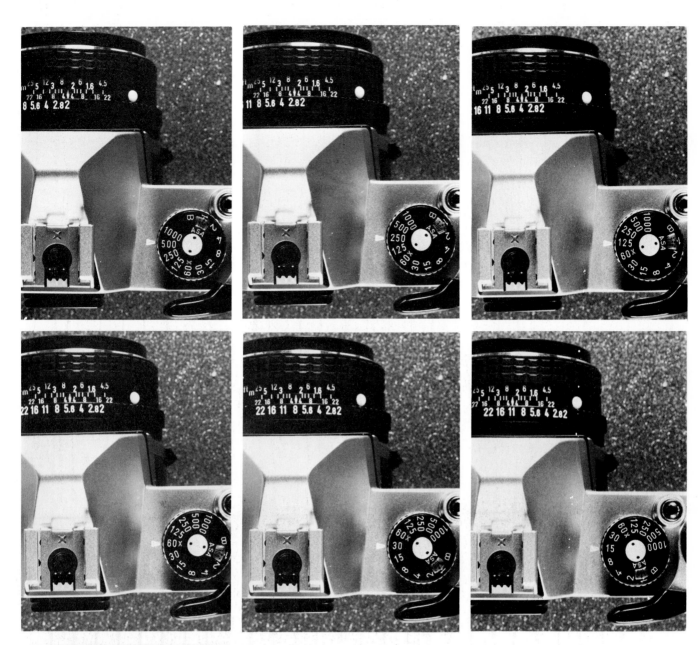

Figure 10.20: The following photos show seven shutter-speed and *f*-stop combinations that produce the same *exposure* on the film, but entirely different effects. For example, depth of field improves as f-stops get higher. This camera is set on ¹⁄₅₀₀ sec. at *f*2. (*top left*) In figure 10.21 (*top center*) the camera is set on ¹⁄₂₅₀ sec. at *f*2.8. In figure 10.22 (*top right*) The camera is set on ¹⁄₁₂₅ sec. at *f*4. In figure 10.23 (*middle left*) is set on ¹⁄₆₀ sec. at *f*5.6. In figure 10.24 (*middle center*) the camera is set on ¹⁄₃₀ sec. at *f*8. In figure 10.25 (*middle right*) the camera is set on ¹⁄₁₅ sec. at *f*11. In figure 10.26 (*lower left*) the camera is set at ¹⁄₈ sec. at *f*16.

# 11 · LENSES

*"I need an assortment of lenses for coverage of fast-breaking news stories. That's why I carry several camera bodies, each equipped with a different lens. I never know when I'll need one of them at a moment's notice."*

David Longstreath, Associated Press

A photojournalist needs a variety of lenses in the camera bag at all times. Within the same day, a sports assignment could require a telephoto lens to capture action or a news story might need a wide angle lens to show the whole subject. Often you need both on the same story to cover it fully. The pro's camera bag will contain extra camera bodies and enough lenses to handle the unpredicted situations.

Eventually, you might need a large assortment of lenses. But with understanding and a little imagination, you can produce professional work with the "standard" 50mm lens on your camera. As a matter of fact, it helps to use the 50mm lens to its full capacity before buying other lenses. You can cover every assignment in this book with your 50mm lens. It will also prepare you for effective use of the assortment of lenses later.

## THE BASIC LENS

Every lens from 50mm to exotic special lens operates on the same principles. A lens is an optical device that directs and focuses light rays by refraction into a pattern on the film emulsion during exposure (Fig. 11.1). After developing, this pattern forms a negative image.

The key word to understanding the lens operation is *circle*. The aperture is a circle. The lens form is a circle. Even the film image is a rectangle taken from the original circle of the whole image. And finally, the image itself is made by minute *circles of confusion* formed by lens refraction.

Light that reaches the film is far different from the light we have discussed so far. Raw light energy cannot form an image. To be useful in photography, this unharnessed light energy must be refracted and then focused onto film by the lens during exposure.

### CONVERGENT REFRACTION

Refraction makes the photographic image possible. In the case of the lens, glass elements refract (bend) a great number of light rays, as a prism does, as they strike the opening and direct them, point-by-point, to the film during exposure. The simple positive lens is made of two prisms; it refracts rays inward so that they *converge*. The result is a mosaic of circles that form an image on the film. (Fig. 11.2).

### LENS ELEMENTS

Light energy is too strong to be completely controlled by a simple lens. Some rays are "lost" when they enter

**Figure 11.1: The principle of photography is that rays of light reflected from a subject will project an image of the subject through a tiny hole and form the reverse images in circles of confusion.**

**Figure 11.2: A simple lens refracts light rays so that they converge within the camera to form the image.**

the lens and bounce around to cause problems. Because of flaws in the glass or due to the energy aspect of light, they converge at a different angle, or even diverge. These vagrant light rays cause aberrations that make the film image less sharp, the wrong color, or even foggy. The solution is the modern compound lens constructed of many elements juxtaposed in a *negative-positive* series of refractions that corrects for aberrations (Fig. 11.3).

A positive element is convex and curves outward, so is thicker in the center than on the edges to make light converge inward. A negative element is concave and curves inward, so is thicker on the outer edges to make light diverge outward. In series, these two opposite elements form a step-by-step distillation of the light to correct most aberrations.

## THE FOCUSED IMAGE

Such finely made lenses form an exactly focused image at a single focal plane where the most light rays converge. But to be practical, the lens must be able to adjust this focal plane for variable focus.

For all adjustable focus cameras, this means a mov-

**Figure 11.3: A lens focuses the image but also creates distortions which other lenses must correct. This cross-sectional view of a common 35mm camera lens reveals the combination of elements required for quality work.**

able lens. As the lens moves forward or backward in relation to the film plane, focus also changes until the image is sharp. On your camera focal points are translated into a footage scale.

# LENS CHARACTERISTICS

All lenses have similar characteristics:

RESOLVING POWER—the ability of the lens to record fine detail. This is effected by quality of glass and number of elements.

FOCAL LENGTH—the optical length of the lens measured from the approximate optical center of the lens to the plane (the film) at which an object is in focus when the lens is set on infinity. For 35mm camera lenses, focal length is expressed in millimeters.

LENS SPEED—determined by the widest opening of its aperture, this rates the ability of a lens to capture light (Fig. 11.4). An $f$1.4 lens would be "faster" than one that was $f$4.

DEPTH OF FIELD (DOF)—the range of acceptable sharpness in front of and behind the actual focal plane. The DOF varies depending on $f$-stop, focal length, and camera-to-subject distance.

**Figure 11.4: Lens speed is the $f$-stop of the lens when at its widest opening. This 50mm lens has a widest opening of $f$1.8.**

## FOCAL LENGTH

Today's 35mm camera lenses range in focal length
from the 16mm fisheye lens that covers 180 degrees of
view to the extremely long 2000mm telephoto. Be-
tween these two extremes focal lengths are divided into
three general categories: normal, wide angle, and tel-
ephoto, depending on their angle of view. Focal length
determines angle of view, image size, and depth of
field.

Everyone has a different focal length that he or she
considers "normal." Like many photojournalists,
freelancer Michael Okoniewski uses a wide angle lens
as "normal". He says, "If I had only one lens, I'd
keep my trusty *f* 2.8, 28mm. I keep it on the camera
all the time. Almost all of my noteworthy shots in the
past four years have been taken with the 28mm."

The generally accepted normal lens is the 50mm for
two reasons. First, the 50mm is the lens that normally
comes with the 35mm camera. It is not built for long
sports shots or for special "wide" shooting. In the list
of lenses, the 50mm is right in the center, a good place
to start with "normal" shooting (Fig. 11.5).

Second, the 50mm lens on a 35mm camera gives the
perspective and angle of view that approximates ef-
fective human vision. As a quick visual test, view a
scene through your 50mm lens and then view the same
scene with one eye closed.

Actually, "normal" varies with film size, so a focal
length that is normal for a 35mm camera would be
wide angle for a 120mm camera. A "normal" lens is
one that equals the diagonal of the particular negative
format. Because a 35mm negative measures 43mm di-
agonally, the real "normal" lens for a 35mm camera
should be a 43mm lens. However, the 50mm lens has
been the accepted standard lens on 35mm cameras.

## WIDE ANGLE LENSES

Any lens that offers a wider angle of view than the
50mm lens is considered a wide angle lens. Some wide
angle lenses are 35mm, 24mm, and 16mm (fisheye)
(Fig. 11.6).

Wide angle lenses are also called short lenses, be-
cause their focal length measures shorter than the film
diagonal. Because of this, they record more informa-
tion onto the film at a shorter distance than the normal
lens (Fig. 11.7). For example, a 50mm lens can record
a whole person standing from eight feet away, whereas
a 21mm wide angle lens can record the same person
from about three-and-a-half feet away. Some unique
characteristics of the wide angle lenses include:

- Greater angle of coverage
- Apparent alteration of space relationships by giv-
  ing the appearance of a diminishing subject with
  background and foreground appearing farther
  apart
- Wider depth of field than with other lenses at the
  same camera-to-subject distance
- Apparent change in perspective that leads to a
  feeling of distortion when used in a certain way
- Tendency to show less camera movement than
  either normal or long lenses

**Figure 11.5: The standard 35mm camera lens is the 50mm.**

**Figure 11.6: The wide angle lens is any lens shorter in
focal length than the "normal" 50mm. This is a 20mm
lens.**

**Figure 11.7: Wide angle distortion obtained when the lens is used up close and at a steep angle can be entertaining, as Bill Seymour shows in his book, *Knee High Goes to the Store*.**

### TELEPHOTO LENSES

Any lens that offers a narrower angle of view than the 50mm lens is considered a long or telephoto lens. Some telephoto lenses include 85mm, 200mm, 400mm, and 1000mm lenses (Fig. 11.8).

Telephoto lenses are also called long lenses because their focal length is longer than the diagonal of the 35mm film. It follows that these long lenses magnify the image and record less information on the film rectangle than the "normal" lens (Fig. 11.9). For example, a 50mm lens can record a face at 3 1/2 feet, whereas a 200mm lens can do it at about 18 feet. This gives the telephoto lenses certain characteristics:

**Figure 11.8: The long lens, or telephoto, is any lens longer in focal length than the "normal" 50mm. This is a 200mm lens.**

- More shallow depth of field than with other lenses at same camera-to-subject distance
- Foreshortening of background and foreground to make them appear closer together
- Alteration of space relationships
- Tendency to show camera movement more than normal or wide angle lenses

Wide angle and telephoto lenses seem to dramatically alter perspective. Wide angle lenses distort and telephoto lenses compress the image perspective when used in a certain way (these effects are actually optical illusions).

Lens focal length determines image size and angle of view, whereas perspective is determined by subject-to-camera distance. If you photograph a person from the same position with three lenses with different focal lengths, the image size and angle of view will change, but perspective will remain the same. However, a radical change in subject distance and shooting angle will produce dramatic changes in perspective, especially with wide-angle lenses, which exaggerate the size and shape of the closest objects, as compared to farther objects.

Generally, the most effective wide-angle and telephoto shots are those that do exaggerate perspective the most.

# DEPTH OF FIELD

Photographic seeing begins with understanding the optical phenomenon of depth of field. This characteristic of any lens is the basis of much photographic composition. Judicious use of the right depth of field is one of your most effective storytelling tools.

In order to get sharp photographs, you naturally need to focus right on the exact spot you want completely sharp. But all lenses produce a range of sharpness on either side of the focal plane. This gives you some leeway between what is optically sharp and what

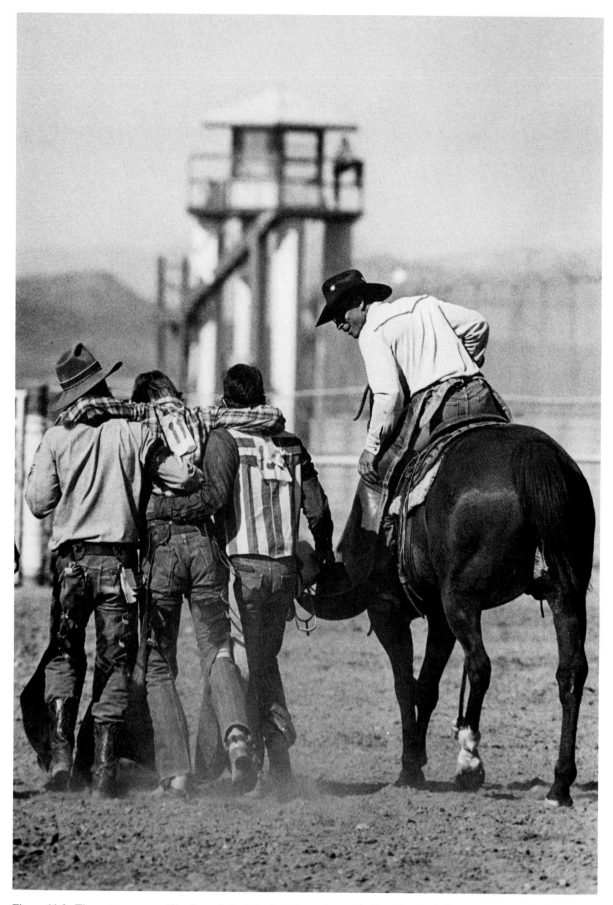

Figure 11.9: The extreme magnification of the telephoto lens gives a shallow depth of field when focussed for shorter distances. Here, a 300mm lens captures cowboys about 30 feet away, blurring the tower in the background. Photo by Brian Brainerd.

looks acceptably focused. Depth of field is a certain depth of image sharpness measured in front and back of the focal plane. This depth gives a visible range of acceptable sharpness to the negative or print (Fig. 11.10). Depth of field helps you direct the viewer's eye to any spot in your photograph, because the eye naturally seeks the sharpest point in a print.

The depth of field on any lens is affected by three factors: aperture, focal length, and camera-to-subject distance.

## APERTURE AND DEPTH OF FIELD

When you change the *f*-stop without changing camera-to-subject distance, you change the depth of field. Closing down to a higher *f*-stop increases depth of field. Opening up to a lower *f*-stop decreases depth of field. Most lenses have a depth of field scale printed on their barrels to give you an idea of the depth of field at any *f*-stop (Fig. 11.11).

Changing the *f*-number changes the diameter of the relative apertures. This manipulates depth of field by changing the size of the circles of confusion that form the image on the film.

## DEPTH OF FIELD AT *f*16

When you close the diaphragm down to *f*16, you make the aperture very small. This concentrates the converging rays of light; they are so tightly packed that they produce a sharp plane of critical focus.

But of course, other circles of confusion are being formed on the film from other points in the scene. These are not as sharp as the principal focal plane—how sharp they are depends on their distance from the focal point. Beyond the range of depth of field, they overlap to form blurs. At *f*16, this range is quite wide because the small aperture concentrates all the rays coming in to the lens, making everything on the scene sharper (Fig. 11.12). In other words, the circles of confusion are so small, they appear as sharp details.

**Figure 11.10: Because the focus in this photograph extends from the foreground to the background, it can be said to have great *depth of field*. Photo by David Fraker.**

**Figure 11.11: Between the thumbs is the scale for the depth of field for a 50mm lens focussed at 10 feet. At ƒ16 the DOF is from about 6½ feet away to nearly 30 feet away from the camera.**

For your 50mm lens set at 10 feet, these circles of confusion will not become apparent as blurs until an object is closer than 6 feet or farther away than 25 feet. In between is the approximate depth of field at ƒ16 under the described circumstances.

### DEPTH OF FIELD AT ƒ2

At the other extreme, with the aperture opened to ƒ2, the aperture and the circles of confusion are comparatively larger because opening up increases the angle between converging lines that form the image. Yet despite their relatively larger size, the circles of confusion are still so tightly packed at the focal plane that they are seen as details of the image. Like the comparatively smaller circles at ƒ16, they form a sharp image at the point of focus.

Beyond the focal point, the larger circles of confusion start to overlap more quickly then they did at ƒ16. The result is a more shallow depth of field than for ƒ16. For your 50mm lens focused at 10 feet at ƒ2, the depth of field is 9 feet to 11 feet. With such shallow depth of field, the amount of the scene that is in acceptable focus is greatly reduced (Fig. 11.13).

Between ƒ16 and ƒ2, you have a range of depths of field that create the right effect you want. On many

*Left*—Figure 11.12: Aperture affects focus. Here , a 50mm lens focuses on a woman 10 feet away. At ƒ16, foreground and background are in sharp focus. Books in foreground are 2 feet away; background photos are about 10 feet behind woman.

*Right*—Figure 11.13: An exposure of ƒ2, with the same lens still at a distance of 10 feet, now yields a shallow depth of field.

cameras, a "preview" button lets you see each effect before you snap.

## FOCAL LENGTH AND DEPTH OF FIELD

When you change lens focal length *with camera-to-subject distance unchanged,* you either magnify or diminish the effect of aperture on depth of field. A 50mm lens will have a physically smaller diameter of aperture at the same *f*-number as a 200mm. Thus, the 50mm lens will increase depth of field; the 200mm lens, with circles of confusion about four times larger at any *f*-stop, will decrease it.

## CAMERA-TO-SUBJECT DISTANCE AND DEPTH OF FIELD

You can change depth of field by changing the distance between your camera and your subject. The change in distance, *without a change in aperture,* affects the circles of confusion by changing the angle between the converging light rays.

When you focus on a close subject, light reflected off the subject enters through the aperture at an increased angle to form an image at the focal point. Even at *f*/16, a lens focused at 2 feet yields shallow depth of field because the angle between converging light rays only permits somewhat large circles of confusion.

But when you focus at a farther distance, the light rays reflected off the distant object enter at a relatively less steep angle. They naturally converge to form a sharp image at the focal point. Even at *f*/2, the decreased angle of entering rays allows for smaller circles of confusion, thus increasing depth of field.

Knowing depth of field is an advantage, because you know that for a given setting you have a zone of acceptable focus. Sports photographers use this principle by pre-setting the camera and shooting when the subject enters the zone of acceptable focus.

On assignment, photojournalists use all of the above approaches to manipulate depth of field. They use their experience to make the maximum use of *f*-stop, focal length, and camera-to-subject distance to change perspective and contrast between sharp focus and out-of-focus for storytelling effect. However, you should change only *one* of the three for the effect you want. If you change two or three, you could cancel your depth of field manipulation and the effect you want. In fact, a 200mm lens focused on a distant subject *could* give greater depth of field than a 50mm lens focused on a very close subject. Depth of field effects are relative.

# SPECIAL LENSES

There are a variety of special lenses that can produce effective storytelling photographs. Some of these are:

MACRO LENS—can focus at distances from infinity to a few inches. With an adapter, the close distance becomes less than an inch. This makes the macro lens excellent for taking storytelling details or in copying a small object. Although macros have relatively slow lens speeds (not more than *f*2.8), they can be used on many assignments (Fig. 11.14).

FISHEYE LENS—has an angle of view as wide as 16mm. This gives it a near-180-degree angle of view. The super-wide angle fisheye is not usually corrected for linear distortion, so it gives an exaggerated effect of curving surfaces and details. There are superwide angle lenses that are corrected for linear perspective and give an undistorted rectangular wide view, and so are more practical to use (Fig. 11.15).

MIRROR OR CATADIOPTIC LENSES—magnify the image with mirror optics within the lens barrel. These lenses reflect the image in two steps before it actually enters through the lens elements. This cuts the physical length of the lens in half and makes otherwise cumbersome lenses portable. For example, a 500mm mirror lens can be used on location with only a monopod

Figure 11.14: Here, a 55mm macro lens, focussed at about 10 inches, gives shallow depth of field even though the aperture is *f*11.

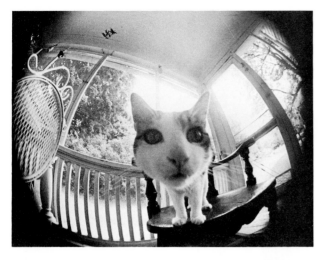

*Above, left*—**Figure 11.15: A fisheye lens produces a round image and a surrealistic distortion when used close-up. Photo by Nancie Battaglia.**

*Above, right*—**Figure 11.16: Mirror, or catadioptic, lenses magnify the image with an interior mirror and effectively reduce the physical length of the lens. Here, a 500mm mirror lens, focussed on the football players, produced a shallow depth of field.**

*Right*—**Figure 11.17: Zoom lenses can be used for a blur effect. This baby was photographed at ⅟₁₅ sec as the lens was "zoomed" to produce an illustration for a child abuse story.**

for support. However, mirror lenses have only one fixed lens speed (about *f*8 or *f*5.6) so you can't change apertures (Fig. 11.16).

ZOOM OR VARIABLE FOCUS LENSES—incorporate many focal lengths into one large lens. Zoom lenses are equipped with "floating" elements to allow a focal length adjustment. They are heavier and longer than conventional fixed focal length lenses and are usually slower. In the past, zooms have been less sharp than their conventional counterparts, but some are now much improved. One advantage to zooms is in composition. You can settle on the standard focal lengths or use one that is in between. Some zooms also have a macro feature (Fig. 11.17).

TELECONVERTERS—extend the focal length of a lens by extending the distance between the lens and focal plane. This effectively doubles, triples, or quadruples the focal length of any lens. With a 2x teleconverter, a 200mm lens becomes a 400mm. With a 3x, it becomes a 600mm.

Using teleconverters is one way to add longer lenses to your collection at lower cost. However, some teleconverters also reduce the lens sharpness, and all reduce effective lens speed by as much as three stops. But even with these disadvantages, a good teleconverter can be a valuable tool when you need extra focal length.

The main consideration in using any lens for photojournalism is how you use it for storytelling communication. With your increasing ability to think in terms of how a camera lens sees, you will use lenses in a photojournalistic way.

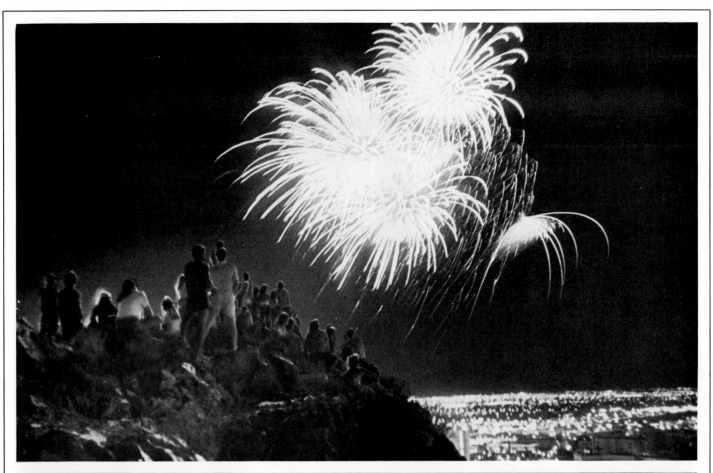

# 12 · THE LIGHT METER

*"What does your meter read?*

Photojournalist's refrain

By now, you are probably pretty adept at shooting and maybe even more adept at second-guessing your meter, so it is time to explore the light meter in detail.

Despite our emphasis so far on the exposure chart you do need a good light meter and confidence in using it accurately. When used right, it is a marvelous tool (Fig. 12.1). It assures correct exposures under nearly any lighting situation. Since it is built into many 35mm cameras, it makes them automatic. It sometimes seems that all you have to do is point and shoot to get an exposure.

But even the best light meter can be fooled by tricky light and give you a wrong exposure, so you have to use it with care. Your memorization of the exposure chart in Chapter 3 was the first step. The second step will be an educated use of the light meter itself.

A light meter is a photoelectric instrument that reacts to the energy of light and records that reaction on a scale of accurate exposure readings (or, if a built-in meter, a scale of *f*-stops).

**Figure 12.1: Photojournalists take a meter reading when they can. Here, prizewinner Bernie Boston of *The Los Angeles Times* uses two meters to check lighting on a Presidential assignment. Photo by MSG John Taylor, U.S. Army Band.**

# TYPES OF LIGHT METERS

Light meters read light in one of two ways: (1) *incident reading* of all ambient light falling on a subject, or (2) *reflected reading* of light reflected off a subject. There are three types of light meters. They are (1) *handheld meters* that can be used away from the camera, (2) *spot meters*—handheld meters that magnify to read small, far away areas, and (3) *built-in meters* built into the camera mechanism.

## HANDHELD METERS

Handheld meters are designed to read either incident or reflected light. They have the added advantage of offering a range of exposures for the same lighting condition. When the handheld meter is set for incident readings, a dome-shaped cone covers the sensor (Fig. 12.2), ensuring an even reading of light from all angles. The incident-reading meter is used at the subject rather than at the camera. It is best used on studio or controlled events when you can move around and take the reading.

## SPOT METERS

Spot meters are equipped with a magnifying fitting that is like a telephoto lens (Fig. 12.3). This narrow angle of coverage allows you to "read" a "spot," even from far away.

**Figure 12.2: This Minolta Auto Meter III reads both reflected light and incident light (all light falling on the subject). Courtesy The Minolta Corporation.**

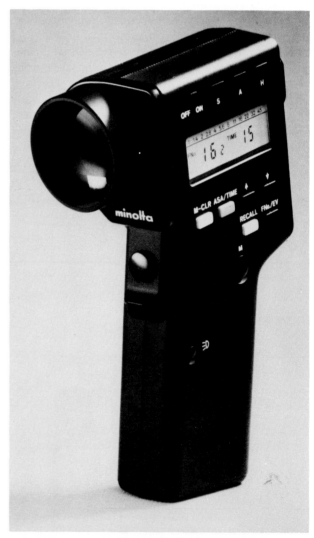

**Figure 12.3: Spot meters have a "long lens" that narrows the reading to one small area. Courtesy The Minolta Corporation.**

## BUILT-IN METERS

Built-in meters are the most common meters in photojournalism. They are coupled with the *f*-numbers and shutter speeds of the camera, and in the case of programmed cameras, automatically adjust to changes in light (Fig. 12.4). Even though many modern cameras have automatic exposure control, many photojournalists prefer the manual controls so they can double-check the built-in meter's accuracy with their own experience.

Figure 12.4: There are numerous types of built-in meters. One type reads two areas near the center of the image and provides a reading that is often more useful than that of either an overall or spot reading.

# USING THE METER

Most meters operate on battery power. These batteries are often very tiny, but are strong enough to supply the current for accurate and speedy meter readings, even at very low light levels.

## THE HANDHELD METER

When you turn the hand meter on, the light activates the meter's sensors and the light's power is converted into electric current. This current activates a *galvanometer* that moves an indicator needle across a scale containing a series of shutter speed–*f*-stop combinations. The result is a reading that matches the film ASA to the light and provides an accurate exposure (Fig. 12.5). The dial on the handheld meter provides a choice of exposure combinations for your convenience.

## BUILT-IN METERS

There are several types of built-in meters:

- Automatic shutter priority: you set the shutter speed, the camera indicates *f*-stops as the light changes. Shutter priority is preferred for sports or active subjects.
- Automatic aperture priority: you set the aperture, the camera adjusts the shutter speed as the light changes. Aperture priority is preferred when depth of field is important.
- Programmed: the camera adjusts both shutter and aperture as light changes.
- Center-weighted: the meter reads the light at the center of the scene.

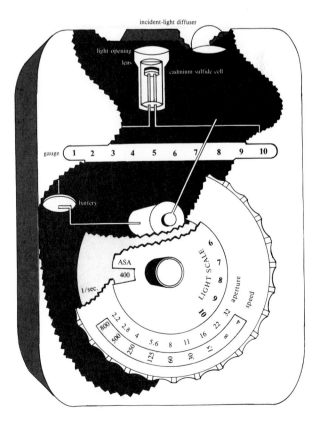

Figure 12.5: The amount of light entering the meter determines how much current flows from the battery to the needle of the meter's gauge, as this diagram shows.

• Averaging: the meter reads two areas and then takes the average for an overall reading.

Exposure readings for these meters usually show within the camera's frame. These are either a match needle reading or a LED reading that flashes as the exposure changes.

Most automatic meters are used in "point and shoot" work. But some have a handy feature called a *memory lock* that allows you to take more controlled readings. You can read the shadows in a scene, then press a lock button to retain that exposure when you shoot the overall scene. The exposure will be at the setting you selected instead of what the meter would have read on automatic.

## AVERAGED METER READINGS

The one word to remember when you use any light meter is *average*. The light meter is calibrated to read the average lighting of a scene. Most do not distinguish between various light intensities in the same scene.

Manufacturers arrive at an averaging system that treats each scene as though it were an average gray. New meters are calibrated against a surface toned middle gray that is 18 percent reflectant. This makes the meter good for reading evenly lighted scenes. But on scenes with high contrast or uneven lighting, the meter averages the brightest light and the shadows, yielding a middle gray. This can cause exposure problems, even with the best meter systems. One way to combat this is to bracket your exposures with the usual one-stop-over and one-stop-under procedure.

# PRACTICAL STEPS

Although the modern built-in meters are extremely accurate and reliable, they can be fooled, so follow these simple steps in their use:

1.  Check the battery.
2.  Set the correct ASA. This sometimes forgotten-step can cause problems. The meter must "know" the speed of the film it is reading for.
3.  Set the shutter–*f*-stop for the general lighting. Use "emergency exposure" to tell the meter what the light is by setting the shutter/aperture to an approximate exposure. For example, for Tri-X:

    • Outside—set exposure at 1/500 second at *f*/11 (or the automatic setting).
    • Inside—set exposure at 1/60 second at *f*/2.8 (or the automatic setting).

    This allows the meter to start off with an appropriate reading for the light. Often, people think the meter is broken when it is only set wrong. For example, it may really be trying to read the exposure for 1/500 second for weak inside light.
4.  Second-guess the reading (for black-and-white). Today's light meters are accurate and reliable, so you can use them with confidence. But they are only machines, so use that necessary ingredient: your second-guessing brain.

Remember that the meter is an averaging instrument, so decide how right its reading is for a particular lighting. If the light is not even, take control by manually adjusting for the light. Some ways to do this include:

• BRIGHT/HIGH NOON SUNLIGHT: Meter will read the highlights and produce a negative without adequate shadow detail. Remembering the old adage to "expose for the shadows" for black-and-white, first read the meter, then bracket one to two stops open. If possible, place the meter into the shadow and read that (Fig. 12.6).

• BACKLIT SCENE I: Meter will read the strong light coming toward it and will produce a negative without any shadow detail. If you can, actually place the meter/camera lens into the shadows and read that. This fools the meter into giving you a reading that amounts to a shady day (shadow) producing a negative with adequate shadow detail if you are not in the automatic mode (Fig. 12.7).

• BACKLIT SCENE II: SILHOUETTE: Meter can be followed here because you *want* contrast, by having it read the bright light and then exposing as it reads. The result will be a negative with no shadow detail and the effective silhouette you wished (Fig. 12.8).

• STAGE OR SPOTLIGHT: When the subject is in bright light surrounded by darkness, you have the opposite problem from backlighting. Here, read the meter, then close down one stop to overcome the meter's reaction to the darkness (Fig. 12.9).

• STRONG SIDE LIGHTING: Like the backlit scene, you can control this type of lighting. If you wish to have the dramatic, deep shadows, then follow the light meter exposure and allow the shadow to be underexposed. But if you want shadow detail, read and expose as backlit above, by reading the shadows and exposing for that detail (Fig. 12.10).

*Above*—Figure 12.6: When sunlight creates high contrasts, a meter can be fooled. Open up one stop farther to give the shadows some exposure. Photo by John Metzger, *The Ithaca Journal.*

Figure 12.7: Backlighting can fool your meter, so either read for the shadows or open up a stop or two more. This shot called for a three-stop adjustment for shadow detail.

**Figure 12.8: For a silhouette of a backlit subject, follow the meter reading and you will underexpose the shadows, as Jim Witmer did here. Courtesy** *Troy Daily News.*

**Figure 12.9: Stage lighting can be tricky. Here, spotlights on President John F. Kennedy during inaugural ceremonies were regarded as backlighting—with excellent results. Photo by Tom Hoy.**

Figure 12.10: Strong sidelight calls for some adjustment to the meter reading for a rounded exposure. Photo by Robert Hoy.

## METERING FOR COLOR

When you shoot color film, adjust your metering approach depending on whether you use negative color or transparency film. If you shoot negative color, you can follow the basic metering approach above, but make your adjustments with more care. For example, you may want to bracket your exposures one-half stop rather than one full stop.

When using color transparency film, you have to reverse the black-and-white approach. Over-exposure washes out the final color image on transparency film, and you can't just expose for the shadows and compensate when you print. Because they read the highlights and then average down, meters give more reliable "average" readings when used with transparency films.

So when metering for transparency color, "expose for the highlights" and then bracket one-half stop on either side for safety.

Although you can't compensate for shadow detail by exposing for the shadows, you still need to get better shadow detail on high contrast or backlit subjects. One answer to this can be flash fill. When you shoot color, think of flash or auxiliary lighting for important shadow detail.

# TESTING YOUR METER

Because the accurate use of your meter is so important, first test your meter by shooting a roll under a variety of lighting situations using the suggestions above. To do this, have a friend volunteer as subject for front light, sidelight, backlight, bright sunlight, flat "average" light, and other possibilities. Shoot in both black-and-white and color. As you shoot each set, take these steps:

1. take a "point and shoot" meter reading and shoot
2. open one stop and shoot
3. close down one stop and shoot

This simple test will do more for your confidence in your meter than a lot of meter readings. When you evaluate the finished film, choose the best negative and take that as the most realistic meter reading.

## TESTING PROGRAMMED/AUTOMATIC CAMERAS

The above test assumes that you can place your camera on manual and adjust the exposures. But even if you have a totally automatic camera and metering system, you can still test it. Just fool the metering system by changing your ASA setting to each test shot. For example, shoot the first shot at the normal ASA (400 for Tri-X) and then change the ASA setting, first to 200 for one stop overexposure and then to 800 for one stop underexposure. By evaluating the finished film, you will have the information for adjusting the program/automatic metering when needed.

# 13 · FILM

In this chapter you will learn about the image recording material of today's photojournalism: silver-base film. It is in many ways the most important tool of the photojournalism trade. Every other step in the photographic process depends on your skill and understanding of what makes film and exposure work.

Today's black and white films come in a variety of sizes, sensitivities, and contrasts to cover every type of photography from general assignment to high contrast copy. These films range from the fast 35mm film used on the vast majority of daily assignments to a large sheet film used for high-contrast copy work. Between these extremes is a range of special purpose films that gives you a palette of film effects.

## A GENERAL VIEW

A definition that fits modern black and white negative film is: "A material consisting of a light-sensitive gelatin emulsion bonded to a flexible, transparent plastic base. Silver halide crystals embedded in the emulsion record the latent negative image when light strikes the emulsion during exposure."

There are two basic attributes of these negative films. First, the image made by the light on the emulsion is a latent image. It must be developed and fixed in order to be seen and reproduced. Second, this image is in a negative form. It is a "mirror of nature" and must be printed to a positive for use. This negative/positive process has been the principle of modern photography since William Fox-Talbot's photographic process was announced in 1839. Unlimited copies from a single image is one of the foundations of photographic communication.

## FILM STRUCTURE

Film is so thin that it is measured in thousandths of an inch. Despite this, most films have six separate layers made with exact precision. These parts of a black-and-white film are the following:

- Topcoat: a thin, hard layer that protects the emulsion from scratches.
- Emulsion: the light-sensitive layer consisting of millions of microscopic crystals, or halides, of silver bromide suspended evenly in a thin layer of gelatin. This gelatin is impervious to water, but

allows the processing chemicals to reach the halides during developing and fixing.
- Subbing: an adhesive layer that helps bond the emulsion to the support material.
- Support: a transparent, flexible, but firm plastic-like base (made of either cellulose acetate or a polyester) that holds the emulsion. Roll film supports are about 1/1000 of an inch thick. Sheet film is somewhat thicker.
- Second adhesive layer: a glue that bonds the antihalation backing to the support.

• Antihalation backing: a gelatin dye that filters out excess light that can fog the emulsion if reflected off the support. This backing absorbs light inside the film layers that could cause "halos" of fog. This antihalation (or antifogging) dye is completely dissolved during processing.

# THE EMULSION

Six characteristics of the emulsion are: (1) color sensitivity, (2) contrast, (3) light sensitivity, (4) grain/granularity, (5) resolving power, and (6) acutance. Differences in these basic characteristics provide films with their special characters. In addition, exposure and developing controls can alter the inherent characteristics of general purpose films.

## COLOR SENSITIVITY

Color sensitivity refers to the ability of black-and-white films to reproduce colors in varying shades of gray. These films translate the world of color into degrees of brightness on a gray scale, depending on the degree of color sensitivity. During manufacture a film emulsion can be made to respond to all colors or to a limited number, depending on the film's ultimate purpose.

## PHOTOGRAPHIC COLOR

A black-and-white film is sensitive either to all of the primary photographic colors (red, blue, and green) or to only one or two. These three colors combine to produce any known color; there are four basic types of film for general use, based on color sensitivity. These are blue-sensitive; orthochromatic (blue and green sensitive); panchromatic (sensitive to red, blue, and green) and infrared (sensitive to red and some blue). A special screening filter is needed with infrared film.

**Blue-Sensitive Film.** Blue-sensitive film, also called ordinary film, is blind to all colors except blue. It is a very contrasty film. In a photograph with equal amounts of red, blue, and green, the blue areas will reproduce as highlights and print as strong white, while the red and green will reproduce as black (Fig. 13.1).

Until the 1870s, light-sensitive materials were sensitive to blue only. Early portraits and scenes had high contrast as a result of this limitation.

Kodak's Commercial 6127, is a blue-sensitive film. You would use this film to copy in black-and-white a color map or drawing. It would separate blue lines from red or green lines, resulting in a stark black-and-white print. Drawings, and line art work are copied on this type of film for newspaper and magazine reproduction. This film is also used to make copy negatives from black-and-white prints.

**Orthochromatic Films.** Orthochromatic films are sensitive to blue and green and are blind to red (Fig. 13.2).

Figure 13.1: Panchromatic film is sensitive to all colors and renders them in a range of values on a gray scale. Here, a stop sign's red, a street sign's green and the sky's blue have a normal black-and-white look.

Figure 13.2: Orthochromatic film yields contrasty negatives because it is so sensitive to blue and green while blind to red.

**Figure 13.3: Infrared film gives a ghostly appearance to a scene. Photo by Rick Wiley.**

Kodak's Tri-X Ortho and Contrast Process Ortho 4154, 4×5 sheet films with an Estar thick base, are such films.

You would use ortho film to copy both blue and green areas and to make the red "disappear." Ortho films produce a contrasty print, but not as starkly as the blue-sensitive film. Orthofilms can be developed under a red safelight.

**Infrared Film.** Infrared films are sensitive to the infrared portion of the color spectrum and to some blue. They are used for special purposes: anti-haze, aerial, medical, scientific, photomicrography, and other specialized areas. Kodak's High Speed Infrared Film is one such film.

In photojournalism, you use infrared film sparingly for special effect. For example, by combining a red filter with infrared film, you could produce eerie landscapes or graphic effects. When shooting infrared, you must use a red or black filter over the lens to get the infrared effect (Fig. 13.3).

**Panchromatic Films.** The invention of panchromatic films around 1875 gave photography the material to faithfully reproduce scenes in full tonal range of grays. They are almost equally sensitive to blue, red, and green. Panchromatic, or pan, films record various colors in approximately the same brightness range as you see them (although in shades of gray). The result is a wide tonal range in your print.

Pan film is used on most photojournalism assignments. The vast majority of films available are pan films, including Kodak's Tri-X and Ilford's HP-5.

## CONTRAST

Contrast is a film's ability to record values of gray among the closely related tones in a scene by recording white through various shades of gray and on to black. Contrast is directly related to color sensitivity. Ortho- and blue-sensitive films are contrasty films, whereas pan films, with the ability to record a wide range of colors into subtle gray values, are of medium contrast. Although pan films can have their contrast adjusted during development, in general, contrast is an inherent characteristic of a given film.

## LIGHT SENSITIVITY

Light sensitivity refers to a film's ability to record an image. Light sensitivity is also referred to as the "speed" of the film. "Fast" films can record an image faster than the "slow" films. Fast films have emulsions made of larger silver halide crystals that can capture the image with less light (and at higher shutter speeds and f/stops). Slow films require more light to activate the smaller grains of silver in their emulsions.

137

## MEASUREMENT OF LIGHT SENSITIVITY

A film's light sensitivity is rated numerically by an assigned film speed index. The standard system for designating film speed indices in the United States has been the ASA ratings. These ASA ratings (set by the American Standards Association*) gives a numerical rating based on each film's light sensitivity. The higher the ASA number, the more light-sensitive the film.

In Europe, the standard has been the DIN system (set by the Deutsches Industrie Norm, in Germany) based on a logarithmic reference. Film that would be designated ASA 100 would be DIN 21°. Both numbers have traditionally been printed on film boxes for information in the United States.

To complicate this a bit, Eastman Kodak Company adopted the ISO (International Standards Organization) film speed designations in 1979. ISO is a federation of all national standards bodies of the world. ISO standards combine the ASA and DIN references and rate them arithmetically and logarithmically. Therefore, the ISO value for a film rated at ASA 100/DIN 21°, would be ISO 100/21°. Kodak is continuing to use the ASA values as well as the ISO values until the public becomes familiar with the new system.

## GRAIN

Grain (granularity) refers to how the silver halide particles clump together during development to form the negative image in the emulsion. In all films, the grain

*This organization is now called the United States Standards Association.

clumps together to form a mosaic of the negative image. If the film is a fine-grain film with small grains of silver, you cannot see the grain as a mosaic. You see the image made of many blended grain clumps (Fig. 13.4). If the film is a coarse-grain one (or has been developed improperly) you can see the grain as a distinct mosaic.

A certain level of graininess is acceptable in 35mm work, and its effect is subjective. Often, under certain conditions, an excessively grainy appearance will even add to the storytelling effect of the final print. Riots, wars, or similar spot news events are often shot under extremely adverse conditions. The resulting granularity is often a part of the visual effect.

However, grain generally should not be seen. With proper handling and careful processing, you can produce fast-speed 35mm negatives that have surprisingly fine grain. But careful processing is the key. Four factors affect the granularity of film:

FILM SPEED—the faster the film, the larger (more visible) the gain clumps.

EXPOSURE/DEVELOPMENT—overdoing either (or both at once) increases graininess by increasing silver density.

DEGREE OF ENLARGEMENT—does not cause graininess, but emphasizes it

HEAT AND MOISTURE—fluctuating heat effects graininess by swelling the emulsion, as will the length of time the film is wet during development.

Usually grain is coarser in a fast film like Tri-X, but modern fast films produce excellent grain structure if proper exposure and development procedures are followed.

**Figure 13.4: The enlargement of a photo often determines the appearance of grain. Blowing up the Tri-X photo on the left results in a degree of graininess and some loss of sharpness.**

## RESOLVING POWER

Resolving power refers to the ability of film to record fine detail. During manufacture a film is tested by photographing a set of parallel lines of varying sizes, widths, and distance from each other. The negative is then examined under a high-powered microscope to determine the number of lines per millimeter that can be seen. A film with high resolving power can record more than six hundred lines per millimeter. Films with low resolving power can record about fifty lines per millimeter.

Resolving power is greatly affected by exposure and developing, just as granularity is. Often, poor resolving power is the result of poor processing techniques.

## ACUTANCE

Acutance refers to the film's sharpness, the ability to record sharp edges with a minimum of light diffusion caused by light *within the emulsion* at exposure. The test for acutance consists of placing a knife edge on the film emulsion, and then exposing by direct light. A film with high acutance records the knife edge as a sharp line with a minimum of diffusion. As in the case of resolving power and granularity, acutance is affected by exposure and development procedure.

### COMMON BLACK AND WHITE FILMS

| FILM | ASA |
|------|-----|
| Slow-speed (below 50 ASA) | |
| Panatomic-X (Kodak) | 32 |
| Pan F (Ilford) | 50 |
| High Speed Infrared (Kodak) | |
| | |
| Medium-speed (50–125 ASA) | |
| Plus-X (Kodak) | 125 |
| FP4 (Ilford) | 125 |
| | |
| Fast-speed (400 ASA) | |
| Tri-X (Kodak) | 400 |
| HP4, HP5 (Ilford) | 400 |
| | |
| Extra-fast-speed (above 400 ASA)* | |
| Royal-X Pan† (Kodak) | 1250 |
| 2475 Recording Film (Kodak) | 1000 |

*These films are sometimes used for special low-light situations in photojournalism when extra speed or grainy effect is desired.
†This is a 4×5 pan film.

# BASIC COMPARISONS

The above characteristics apply to a large variety of modern black and white films available today. The above table will help you make the more basic comparisons between them.

In certain situations, photojournalists manipulate exposure and development to "push" processing by either overdeveloping or using extra-active developers. In these cases, the official ASA numbers no longer apply and the film requires special handling. This subject will be dealt with in Chapter 14.

In an informal survey of 25 practicing photojournalists across the country, their overwhelming film choice was Kodak's Tri-X, with some Plus-X on special assignments, and some HP5, the Ilford counterpart to Tri-X. For our purposes, then, Tri-X can serve as the working example of film for photojournalism.

The characteristics of Tri-X are a relatively high speed, fine grain with very high acutance, medium resolving power and contrast, a cellulose acetate base, and an ASA of 400. It comes in both rolls and sheets in these sizes: 35mm; 120mm (2¼ × 2¼); 70mm; 4×5 sheet. Tri-X also has an ortho emulsion in 4×5 sheet size.

Ever since its introduction in 1958, Kodak's Tri-X has been the standard fast film in photojournalism. Tri-X can be used virtually anywhere and under any conditions. In going from indoor to outdoor assignments, or even mixing available light with flash, Tri-X is as close to an all-purpose film as photojournalists have. And it can be specially developed for low-light shooting on sports and news with excellent results.

A persistent myth is that such fast 35mm films as Tri-X and HP5 are inherently, even excessively, grainy. However, this myth started because of poor exposure and development techniques. These films will yield outstanding quality negatives and large prints, up to 16×20 inches, if you carefully follow high standards of exposure and development.

In the next chapter we will study in detail a method for producing quality work from 35mm films.

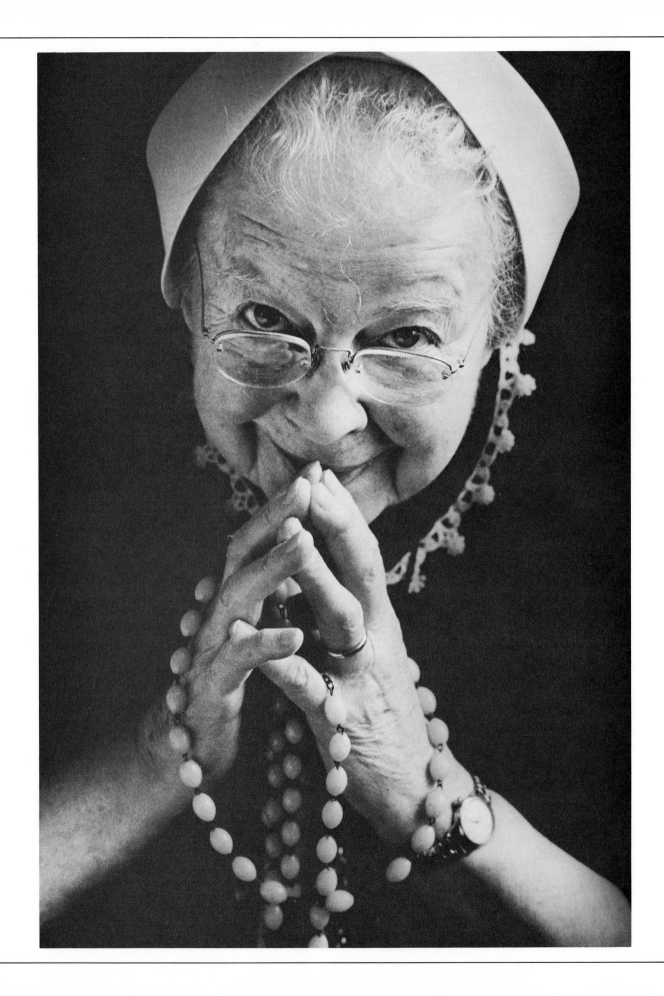

# 14 · BLACK-AND-WHITE EXPOSURE AND DEVELOPMENT

*"Quality printing begins with a good negative."*

William O. Seymour,
Professor of Photojournalism,
West Virginia University.

Most photojournalists gain a feel for good negatives by developing and checking hundreds of rolls of film. Randolph Routt, the retired sports photographer for the Washington *Evening Star*, was a master of available light shooting. When asked how long he developed his film for night sports, he answered, "Until it looks good." He wasn't joking. This practical approach is the test of a well-exposed negative or developing technique. Quality printing starts with a good negative.

## THE GOOD NEGATIVE

A good negative is a *full-range* negative: it has enough exposure in highlight, shadow, and gray areas to ensure that the print will reproduce the scene as the camera saw it. The negative image is built in silver levels: highlights have a dense build-up, shadows have minimum build-up, and gray areas have a range of intermediate build-up. A lighter gray tone is more dense, a darker gray tone is less dense.

Exposure occurs in the light-sensitive emulsion the instant you release the shutter. Light energy disrupts the molecular structure of the silver halides embedded in the gelatin of the emulsion. This exposure produces two phenomena: (1) a latent image is formed and (2) the light energy changes exposed silver halide crystals to metallic silver and makes them susceptible to the action of the developer.

The latent image, or mirror image of the subject, is produced when the silver halides that have been exposed to light blacken to form the image. This blackness is in proportion to the amount of light striking each silver halide. The more light that strikes the halide, the darker it becomes. When developed, these halides will form highlight areas. Where less light has struck, fewer halides will be blackened. When developed, these areas will form the shadow portion (Fig. 14.1). In a full-range negative, the density of the silver will range from practically none to heavy.

## PHOTOCHEMISTRY

This first step, the *photo* part, is called decomposition. The light energy has broken the silver halides down into a compound that will admit the action of the developer—the *chemistry* part. In the second step, the developer will amplify the light's effect millions of times.

### LIGHT DECOMPOSES SILVER

Photographic exposure is based on the property of unstable silver salts to decompose to metallic silver when light strikes them. The change is so slight and the silver atoms so tiny that the latent image cannot

**141**

**Figure 14.1: The good negative has been exposed and developed so that silver has formed the shadows, highlights, and gray areas of the image in correct amounts.**

be seen, even by the strongest microscope, until it is developed.

## SILVER BROMIDE

A popular silver compound in modern films is silver bromide, a chemical compound composed of silver salt crystals and bromine, a halogen. Halogens are chemicals that increase the emulsion's light sensitivity. This compound is held together by electrical attraction to form millions of silver bromide halides in the film's gelatin.

But this attraction is not perfect, otherwise there could be no exposure when light strikes the emulsion. Within the structure of the silver halides are impurities. These impurities, or "sensitivity specks," are three types of irregularities in the silver compound: free silver ions, free bromine ions, and cracks and imperfections in the halides themselves. These impurities are *not* held in attraction but are free to be jarred loose from the halides when light strikes them.

At the instant of exposure these three impurities are jarred from their locations in proportion to the amount of light that strikes them. They move and recombine into another compound: silver. In that fraction of a second, exposure creates millions of tiny clusters of metallic silver that form the latent photographic image (Fig. 14.2).

## DEVELOPMENT AND FIXING

Chemical development continues this process in two ways.

First, in a process called reduction, it changes more elements in these sensitivity specks into metallic silver. The original clusters act as "development centers" for the developer to expand the image.

Second, developer works inside the halides themselves. It draws more silver bromine atoms from the exposed halides by chemically supplying the electrical attraction that light had given at exposure. In the developing process these original clusters grow, greatly amplifying the primary effect of light's force that formed the latent image.

When the process is complete, the developer has changed the exposed silver bromide halides into a permanent image made of minute particles of metallic silver. Development has very little effect on unexposed halides.

A fixing process removes these unexposed, undeveloped silver halides and makes the image permanent (Fig. 14.3). Fixer is made up of sodium thiosulfate and other ingredients that dissolve unexposed silver halides. Fixer has no appreciable effect on the metallic silver image, but penetrates the gelatin and enters the molecules of the unexposed halides. There it chemically neutralizes them so they can be later washed away.

## THE IMPORTANCE OF EXPOSURE

Although each of the above steps must be carried out correctly to get a good negative, you can see the importance of good exposure. It is the first step in the

*Above left*—Figure 14.2: The latent image is represented here by an underdeveloped paper negative. Where this image is dark, imagine that millions of sensitivity specks have been formed, but are not yet developed.

*Above, right*—Figure 14.3: After development and fixing, the negative image is fully formed of silver where this image is black and of little or no silver where this image is white. During fixing, all the unexposed silver crystals dissolve. What remains is a negative image formed by millions of silver molecules.

*Left*—Figure 14.4: The positive print reproduces an image in black and white as the camera recorded it. This film has been severely overdeveloped to illustrate graininess (so it is *not* from a good negative).

process, and the developer cannot work until the light "opens" the silver halides. In a way, this is an explanation of the old photographic saying, "Expose for shadows and develop for highlights." Exposure must be enough to give the developer a "development center" to work with. (These development centers show up in a print as the pebbly effect called *grain*. See Fig. 14.4). No amount of overdeveloping will salvage an area of film that had insufficient exposure. This is especially important in so-called "push" processing, or in manipulation of exposure/development in any way.

# PUSH PROCESSING

Your elementary "feel" for the important equation—no exposure = no development—is crucial to produce high-quality negatives consistently. The best negative has correct density in all areas of the silver emulsion so that development can work for optimum print quality later.

But photojournalists seldom work in perfect conditions. Often, though the light is too weak, you still must get an exposure. In such cases, you can change the exposure/development relationship with a special technique called "push processing."

In push processing, you manipulate the manufacturer's ASA rating of the film. You purposely underexpose the film, but then overdevelop to compensate for it. On assignments like indoor basketball games, night football, or poorly lighted areas, you sometimes must shoot at a higher shutter speed than a normal 400 ASA meter reading calls for. For example, the meter reading of light in a stadium at night is 1/125 second, f2.8 at 400 ASA. But you know you will get blurs if you use such a slow shutter speed. You can adjust the ASA indicator to 1600 (two stops underexposed) and take a reading (Figs. 14.5–14.13). (ASA technically applies to the manufacturer's one designated film speed. Reference to higher film speeds is by an Exposure Index (E.I.) number. This designates speeds other than the official ASA. For example, Tri-X "pushed" to 1600 would be 1600 E.I. and exposed at 200 would be 200 E.I.). The meter now reads 1/500 second at f2.8, so you can stop the action.

However, that means you have underexposed by two stops, and you must now overdevelop the equivalent number of stops or the negative will be too thin (not enough silver exposed or developed). You can do this by increasing the time in your normal developer, or you can use a special developer that compensates for the overdevelopment.

## EXTENDED TIMES FOR NORMAL DEVELOPER

Usually, when you push film you get a higher contrast negative than normal, which can be difficult to print. As the degree of overdevelopment increases, so does the contrast. Unless you want extreme contrast, pushing film is not recommended for normal developer beyond 800 E.I. For 800 E.I., you can overdevelop in D-76 by adding 50% to normal time. If normal time is 10 minutes, use 15 minutes for 800 E.I. (This is a start. Adjust after you see results.) You will get a higher contrast negative that lacks some shadow detail, so decrease agitation by 50% (Fig. 14.15).

*Left*—Figure 14.5: Any variation in either the exposure or development steps will produce a different look to the negative and final print. The photojournalist manipulates the two steps as often as is necessary. Print is from negative of Figure 14.6.

*Right*—Figure 14.6: The negative was underexposed by 2 stops and developed normally, so it is flat, lacking detail in highlights and shadows.

*Left*—Figure 14.7: The negative was overexposed by 2 stops and developed normally. It lacks contrast; excess silver has built the shadows almost to the density of the highlights.

*Right*—Figure 14.8: The negative was given normal exposure and received normal development. This is a "good" negative with shadow and highlight detail and proper gray tones.

*Left*—Figure 14.9: The negative was exposed according to the meter reading, but overdeveloped by 50 percent. The silver received proper exposure, but since the developer was allowed to work longer, the result is a slightly contrasty negative. Overdevelopment almost leaves shadows alone, but makes highlights "heavier."

*Right*—Figure 14.10: The negative was exposed normally, but underdeveloped by 50 percent. Curtailed development did not allow the image to reach full strength. The result is a negative with thin shadows and highlights.

## COMPENSATING DEVELOPERS

For a two-stop push it is best to use a compensating developer such as Acufine, HC110, FG7, Diafine (a two-solution developer), or others. All are excellent for pushing film because they chemically compensate for increased contrast.

As you recall, developer works on exposed halides, so underexposure will affect fewer silver halides in both highlights and shadows. But because some exposure has occurred, the developer will work more on the sil-

ver halides in the highlights. The shadows, where few or no halides have been exposed, will remain underdeveloped. This exaggerates contrast between highlights and shadow in proportion to the overdevelopment. For extreme cases, highlights are blocked up (opaque) and shadows are thin (no density).

A compensating developer chemically slows highlight development and allows shadow development to "catch up" *somewhat*. But remember the no exposure = no development rule.

*Left*—Figure 14.11: The negative was underexposed 2 stops, then underdeveloped by 50 percent. The result is a disaster: inadequate silver exposure and inadequate development.

*Right*—Figure 14.12: The negative was overexposed by 2 stops and underdeveloped by 50 percent. The result is a slightly flat negative with adequate detail in shadows and highlights. This is the way to avoid the harsh contrast that sunny days produce.

Figure 14.13: The negative was overexposed by 2 stops and overdeveloped by 50 percent. Too much silver was exposed and with overdevelopment the result is a "heavy" negative with increased contrast.

## FG7 AND SODIUM SULFITE

Compensating developers such as Acufine and FG7 are popular with photojournalists who shoot night and indoor sports. Here is a formula for using FG7 and sodium sulfite.

To develop Tri-X or HP4 to 1600 E.I. (at 70°F), dissolve 1 oz sodium sulfite in 15 oz water (a four-roll tank; for fewer rolls, reduce amounts). Make sure sodium sulfite is thoroughly dissolved. This takes some time (at least 20 minutes) because it is a powder.

Add 1 oz of FG7 liquid developer to the solution. When both are thoroughly mixed, bring developer to temperature and develop. Developing time can be calculated by the number of stops pushed. A guideline is that for each stop pushed beyond normal 400 ASA increase the time by half. Try these times:

400 ASA—6 minutes (70°F)
800 E.I. >—9 minutes
1600 E.I.—13½ minutes

Some photojournalists develop in this solution for 1600 E.I. up to 17 minutes with excellent results. You should experiment for best results.

Remember to mix FG7 before each development, then use it once and dump it. You must always have fresh developer. Acufine can be reused if replenished.

## AGITATION

When you increase agitation during development you increase contrast. You decrease agitation to decrease contrast. It is best to agitate minimally for push processing. For FG7 this means rapping the tank with your hand to dislodge air bubbles, then agitating gently the first minute, then halfway through development. The result is a slightly flat negative that prints well.

Push film only when you must. It always adversely affects the quality of your negative, but if it is the only way to get that extra film speed then use it. A good print can be made from a carefully pushed negative, but you may have to do more dodging than normal to hold the shadows.

*Above*—Figure 14.15: "Pushing" film just *one* stop in regular developer, adding 50 percent to the time, produces a good, rather contrasty negative, but a printable, effective one. Photo by Mark Damon, *The Ithaca Journal*.

*Left*—Figure 14.14: Pushing film to 1600 E.I. can be quite effective, especially if the action and the light are right. The negative was underexposed 2 stops (rated at 1600 ASA) and then developed in acufine to compensate. Photo by Jim Bryant, Courtesy *The Jacksonville Journal*.

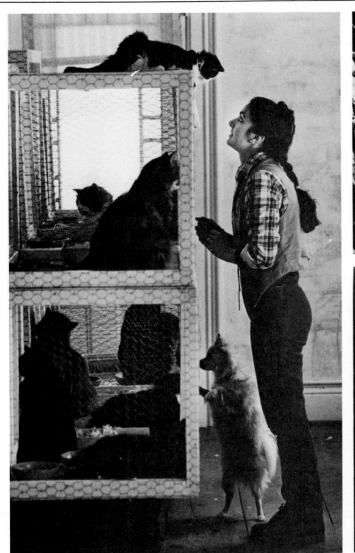

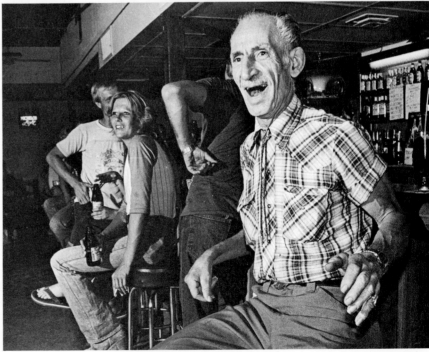

# 15 · FLASH

*"When I use flash I use it any way I can. I try to bounce it off something to soften the light, but when I can't, I just use it straight on the camera. . . . You have to adapt to what the situation calls for."*

Wally McNamee, *Newsweek*

Photojournalists carry a small electronic flash in the camera bag and use it when existing light is unsuitable for the story or too weak for a proper exposure. Often this means using one flash for many situations. Many assignments are so rushed there is no time to set up more than one flash.

Wally McNamee states it this way:

I shoot a great deal under existing light conditions. A lot of this is television lighting, because of the nature of po-litical coverage. But when necessary, I "push" the black and white to 1600 ASA. I have color pushed one or two stops.

But if I'm covering news and I find I have to shoot slower than 1/60 of a second, I just put a strobe on the camera. There is no way you can cover news by working at a slow shutter speed. In news work, you *must* get the picture. If someone shoots at the President or someone else shoves into a person under weak light at, say 1/60 of a second, the result will be a blur . . . that's why, under low light conditions, I have a tiny strobe (electronic flash) as big as a pack of cigarettes that I carry with me all the time. But if I know before hand I'm going to need flash, I take along a Vivitar. It's comfortable. I always have a strobe in the bag for emergencies.

## BASIC FLASH LIGHTING

Generally, you should think of flash when:

- a sure exposure is needed on fast breaking news work and light is inadequate.
- control of the lighting effect is desired (available lighting gives wrong effect).
- you are on tight deadline and "pushing" film will take extra time.
- creative lighting is needed for illustration or story-telling detail.

Of course, flash photojournalism today is the in-stantaneous light of electronic flash, or, as it is some-times called, strobe. This flash is produced by a charge of electrical energy into a gas-filled tube. The gas in the sealed flash tube lights up for a fraction of a sec-ond. It is usually xenon, an inert gas that will light without exploding when struck by the electrical cur-rent. Tiny cadmium batteries are the power source for much location photojournalism flash, but color and studio flash are often powered by large dry cell bat-teries or an AC adaptor.

As early as 1851, William Fox-Talbot, credited as one "inventor" of photography, used an electrical spark to light a stop-action photograph. But it was not until the 1930s that a practical method of electronic flash was devised by Dr. Harold E. Edgerton of the Massachusetts Institute of Technology. Before then, photographers often relied on explosive flash powder.

Originating in Germany, *blitzlichpulver* (flashlight powder) was an explosive mixture of powdered mag-nesium and other ingredients. It went off with a bang, lasting about 1/40th of a second, and left a smoky room and often a black ring on the ceiling.

Flash bulbs, also from Germany, were introduced to American news photographers in the late 1920s and replaced powder by the early 1930s. These bulbs looked like regular electric bulbs, but contained oxygen and

tin foil containing a tiny amount of flash powder and combustible wire filament. When an electric current passed through this wire, it ignited the powder in the foil and flashed at about 1/200 second. (This is essentially the operation of a modern flash cube or "peanut" bulb.)

Edgerton was experimenting with stroboscopic light at this time. Today's gas-filled flash tube and electrical circuits are basically smaller, lighter versions of Edgerton's early units, which were heavy and required large batteries to operate.

Today's typical hand-held electronic flash unit includes seven fundamental parts: (1) a power source that provides electrical energy that goes through (2) an inverter circuit that converts the battery's low voltage to high voltage, and then to (3) a control board that directs the energy to (4) one or more electrical storage capacitors, which hoard this energy until (5) a triggering circuit, activated by the camera shutter, spills all the stored power through (6) a gas-filled flash tube, which converts the electrical energy into light, which a reflector directs toward the subject (Fig. 15.1).

The stored charge flashes through the gas-filled tube and gives a powerful light for a fraction of a second. The duration of the light from most portable electronic flash units will be in the range of 1/1000 to 1/2000 of a second. After each firing, the electronic flash unit needs a brief period to recharge the capacitor. This is usually referred to as the recycling time and can vary from under 1 second to 12 seconds. Many units have an indicator lamp that glows when the unit is ready to fire again.

The design is basic to all electronic flash units, but flashes with these basic features must be operated manually. The photojournalist must adjust the lens aperture for the amount of light that reaches the subject. The aperture must be opened wider as the distance from flash to subject increases because the intensity of the light decreases as distance increases. These manual flash units have built-in calculators (Fig. 15.2) on the back or side to help you find the correct *f*-number for each flash-to-subject distance.

## MODERN AUTOMATIC FLASH

The newer units, however, do this for you by turning off the flash automatically when the film has received enough light for a correct exposure. To do this, a light-sensitive cell or sensor is added to the basic design circuit. When the unit fires, this sensor reads the light reflected back from the subject and shuts off the light

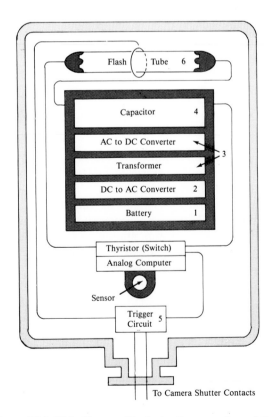

Figure 15.1: This diagram illustrates the operation of the hand-held electronic flash unit.

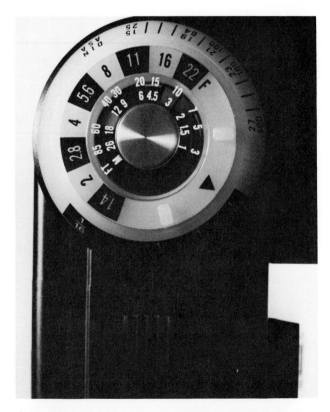

Figure 15.2: The dial on an automatic flash unit tells you exactly what *f*-stop to use. But always shoot a test roll before using the unit on assignment.

at the proper moment, usually after only part of the energy stored in the capacitor has been used.

When using one of these automatic units, you simply follow the instructions to select the proper *f*-number for a range of distance, and then fire away. As distance to subject increases, the sensor keeps the light on longer, so separate shots of subjects at 4 feet, 8 feet, and 12 feet are all correctly exposed. Thus, you can concentrate on the subject, with no worries about getting the right aperture for different distances.

## THYRISTOR

Another improvement was the addition of a thyristor circuit. This circuit preserves unused energy in the capacitor instead of dumping it. This means not only a savings in energy, but the possibility of more rapid firing. If the capacitor is only partially empty, then it takes much less time to refill it. So the thyristor-equipped electronic flash units, when used for shots of subjects at distances of 3 to 5 feet, recycle in only a second or less. The thyristor circuit also makes it possible to select different light outputs (full, half, quarter, etc.) when the flash is switched to manual operation.

A *dedicated* flash unit is essentially part of the camera metering system because it gives automatic through-the-lens exposure control. This unit automatically sets the shutter speed and aperture, so it works on the same principle as an automatic metering system, but it reacts to the light of the flash instead of to other light sources. When the flash goes off, the meter in the camera reads the amount of light that reaches the film plane. When enough light to make the exposure is reached, the in-camera circuit cuts off the light in the flash.

# FLASH WITH DIFFERENT SHUTTERS

You are familiar with the shutter operations on cameras, but here we will review some important flash/shutter relationships. Using flash with focal plane shutters, you should take a few precautions.

Even though the newest cameras' shutter speeds will synchronize with the flash up to 1/250 second, many of the older ones still must be set at 1/60 second or 1/125 second for full coverage of the duration of the flash. Since the focal plane shutter exposes the film in sections, a speed higher than the "synch" speed will record only part of the image.

## LEAF SHUTTER

If your camera has a leaf shutter, you can use the flash at any shutter speed. The leaf shutter, which opens like a series of leaves, does so evenly from the center outward and then closes again the same way. Because of this, the film is exposed the same at any shutter speed from 1/500 to 1/60 of a second or slower. This can be a great advantage when shooting outdoors and using flash for fill with sunlight. However, leaf shutters are used rarely on 35mm cameras for photojournalism today.

All leaf shutters have *M* and *X* synch modes. *X* is for strobes and some quick-firing flashbulbs, while *M* is for flashbulbs that need 20 milliseconds to reach their peak of brilliance.

## FOCAL PLANE SHUTTER

It is much more likely that your camera has a focal plane shutter, so the synchronization problem is a bit more complex. The focal plane shutter exposes the film in slices, depending on the speed of the shutter setting.

Higher shutter speeds expose the film in narrow strips, in sequence, as the curtain travels across the focal plane (Fig. 15.3). This means that in order to synchronize properly, the shutter speed must be set to ensure full coverage of the film when the flash lights. On most older 35mm cameras in photojournalism today, this means that your shutter must be at either 1/125 or 1/60 of a second, and no higher. You can set the shutter slower if you wish. At this writing, some of the newest cameras will synchronize with flash at a speed of up to 1/250 of a second, but it will always be safe to use 1/60 on any focal plane camera. Check your camera for the proper synchronization setting. This setting is usually of a different color than the other as a reminder.

# ELECTRICAL CONTACTS

With the shutter set at the proper speed setting, the next important step is to make certain that the PC cord is connected to the right electrical contact (Fig. 15.4). On some cameras, you will find two tiny contacts where the cord will plug in. It is vital to use the *M* (or *FP*) or the *X* setting along with the proper shutter setting.

The contact marked *M* (or *FP*) ensures synchronization with flashbulbs. This contact starts the flashbulb firing 20 milliseconds before the shutter is fully

Figure 15.3: Only a strip of the image will be exposed if you set the shutter speed too high for synchronization with the flash. This illustration shows an approximation of that effect.

Figure 15.4: An X setting assures flash synchronization when a focal plane shutter speed is either 1/60 or 1/125 sec.

open so the flash has reached full brilliance when the shutter is fully open. However, flashbulbs are rarely used in photojournalism today, so the contact marked *X* is the important one for photojournalism. This contact ensures that the shutter will not delay, but will

open along with the instant light of the electronic flash. The *X* setting and the proper shutter speed for your camera work together to give you the right synchronization for your flash photos. A mix-up will produce what you see in Fig. 15.5.

# JUDGING EXPOSURE

Despite all the automation in flash and cameras today, you will still find it useful to know how to calculate exposure for manual flash.

### THE GUIDE NUMBER

There are several ways of measuring light output, but the most common and easiest to understand is the guide number approach. The guide number is *only* a guide, as the name implies, but if handled correctly, it can give you a fairly accurate measure of your electronic flash output.

The guide number is very useful if you have a manual flash. Basically, the guide number relates the power of a flash unit to distance and to the aperture that will

give the right exposure. Most flash units have the guide number (or a chart based on it) on them (Fig. 15.6).

The formula for arriving at the right aperture when guide number is known is:

$$\frac{\text{Guide number}}{\text{Distance}} = f\text{-stop number}$$

Using this formula to get the *f*-stop at 10 feet, with a flash guide number of 110, you get:

$$\frac{110}{10} = f/11$$

Your starting *f*-stop in this case would be *f*/11. But remember this is only a guide, so you should *bracket*,

**Figure 15.5: A strip of the scene is the result when your shutter speed is too high. Here, at 1/250 sec., the curtain only exposes part of the scene.**

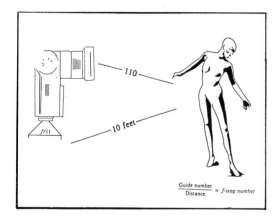

or shoot from $f/8$ to $f/16$—that is, shoot at the $f$-stops in this range—to be safe. Dark subjects, night lighting, and surrounding walls of various colors all affect the exposure, so it is best to test your flash by shooting a roll in the same way you tested your meter.

If you shoot bouncing the flash off one surface onto the subject, you must compensate in your computation. If the bounce surface is 10 feet from the flash, then another 10 feet from the subject, while the subject is 10 feet from the flash, take the total of 30 feet and divide it into the guide number in the formula.

## FLASH-TO-SUBJECT DISTANCE

As with other artificial light, the distance the light travels is critical in flash. Obviously, the light will be weaker the farther it is from the subject. A person 5 feet away will naturally receive more power from the flash than one 10 feet away. Of course, this will require an adjustment of the $f$-stop when set on manual. Just how much of an adjustment is determined by the inverse square law of light. As discussed in Chapter 10, this law says that light's power decreases at an inverse ratio to the square of the distance. This means that if you double flash-to-subject distance, you reduce the intensity of the light striking the subject by one-fourth. Thus, if the subject moves twice as far away as your first shot, it would require a two–$f$-stop adjustment. If the $f$-stop for the first shot was $f/16$, then the second shot would require $f/8$. Of course, automatic flashes adjust such differences without your help.

**Figure 15.6: The guide number formula will help you to arrive at the correct $f$-stop for a flash exposure.**

# ON ASSIGNMENT

With the overwhelming preference for existing light in photojournalism, flash is normally used only when the existing light is found wanting. If the light is too weak, or from the wrong direction, or the assignment takes place outside at night, flash can supply the light. In general, when the meter reads 1/60 at $f2.8$, you should think about using flash.

Kent Sievers is a freelance photojournalist who is typical of photojournalists who use a lot of flash. Kent uses an insurance system. He says:

> Even when I have decided on flash use, I still shoot some available light as insurance. Of course, when I am shooting available light, I reverse this and take a few with flash, also for insurance. It's good to have that choice to show the editor.

## A FLASH SYSTEM

Another approach Kent uses is to use several flash techniques on the same subject. He says, "I almost always take a few straight, on-camera, flash shots, even though I am setting up multiple flashes. The straight flash is 'one for the bag' but, like the available light back-up, it is insurance."

You can extend Kent's approach by developing a systematic approach to flash. Try all of the techniques listed below in succession and on the same subject.

1. Straight Flash: With the flash right on the camera, you can't miss. There are no shadows, just front lighting (Fig. 15.7). You are assured of a

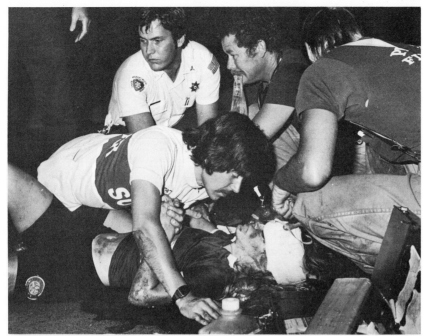

*Left*—Figure 15.7: Photojournalist Kent Seivers shot the following three flash examples for *The Arizona Republic*. In this one, straight flash for a night shot made the difference between a useful photo and no photo at all.

*Below*—Figure 15.8: For this shot, Kent used a slow shutter speed to pick up ambient light and positioned the flash almost at arm's length to give the impression of light from the field.

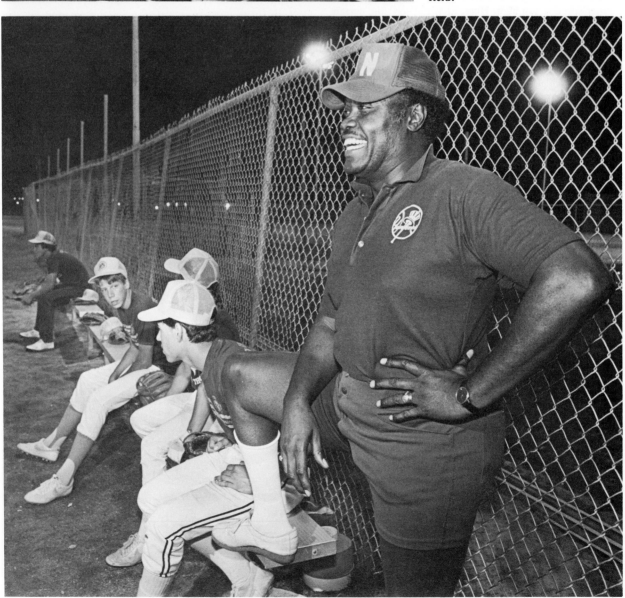

picture. With this assurance, you can then be confident in trying the next step.

2. Off Camera: This is a bit more tricky. With the flash held at arms's length (Fig. 15.8), your aim can be off and throw harsh shadows. This should not deter you though. Knowing that the straight flash shot is done, hold the flash high, at arm's length, carefully aim down at a 45-degree angle, and shoot. After you have shot off-camera at arm's length, try achieving 90-degree lighting using a flash-to-camera extension cord.

3. Bounce: This can be trickier still. With such a variety of surfaces, the exposure for bounce can be a real challenge. As a matter of fact, bounce should never be attempted without the back-up described here. The natural, diffused look that is so appealing with bounce is worth the effort (Fig. 15.9), but you need this fail-safe system before trying it.

In practice, you will take about three frames with each flash type and then settle into shooting many shots with one approach. You are experimenting with proper back-up, so when the time comes to print, you can choose the best one from the three approaches.

## DIRECTIONS OF BOUNCE

Once you decide to use bounce flash, you have many choices of direction. You can bounce it from any reflecting surface that faces the subject and can produce studio-like lighting with only one flash. To succeed with bounce flash, you just have to be willing to take a chance and to practice until you have the right exposure and effect for a variety of surroundings. It can be both creative and effective. A few of the choices are the following:

- bounce flash directly to the side for a 90-degree effect
- bounce toward the ceiling for soft top light
- bounce into the corner of a room for an "umbrella" effect
- bounce for fill light indoors (Fig. 15.10)
- bounce for fill light outdoors—backlit subjects lend themselves to flash fill (Fig. 15.11).

## MULTIPLE FLASH

On many assignments, you stop experimenting with flash when you reach bounce flash. But, if you have the time, or if you need special lighting, the three approaches above prepare you for off-camera flash uses that take more time and cooperation from your sub-

ject. With an extension cord that allows you to place the flash in a wide number of creative positions, off-camera (especially multiple) flash gives you unlimited lighting effects (Fig. 15.12). When you arrive at this stage of a flash session, you have such a selection of all flash effects that you can be as imaginative as you wish without fear of failure.

- Multiple Flash: This is the logical step when you want to fill in shadows or light two separate areas. Two or more flashes are extremely useful for black-and-white situations where there is no light, and is often necessary in color shooting.
- Two-Light Flash: This set-up is reasonably easy to control. The most convenient setup is with a

**Figure 15.9: A 45-degree bounce flash can look like natural light; it is diffused. Here, one flash was bounced off the corner between ceiling and wall.**

*Left*—Figure 15.10: Flash bounced off a card filled in the shadows on this National Guard airman during a training flight. Photo by Bob Miles, *The Phoenix Gazette.*

*Below*—Figure 15.11: Flash can "fill" with natural light. Here, the desert sun would have made a silhouette if it were not for the flash. Photo by Peter Schwepker, *The Arizona Republic.*

*Left*—Figure 15.12: Kent Seivers used a flash on a long cord to light the machines in the background while early morning sunlight took care of the man.

*Below*—Figure 15.13: For this multiple flash shot, Kent put one off camera to the right on a cord, the other with a slave unit behind the subject for backlight. The flash stopped the action and gave a sharpness that available light could not.

*Bottom*—Figure 15.14: A slave-equipped flash allows you to shoot multiple flash with a minimum of bother. The slave unit (open plastic unit below flash) fires when your on-camera flash fires.

second flash and a "slave" unit (Fig. 15.13). The slave unit is an electronic sensor that attaches to the off-camera flash and fires in synch with the on-camera flash (Fig. 15.14).

A two-flash setup is easier than you think, because you are really combining two lighting directions you already know. For example, you might set the off-camera flash for 45-degree lighting and have straight flash on camera for fill. Naturally, you can combine any other directions, but usually the on-camera flash is for fill. Just remember that one flash must be dominant, so make certain that the main flash is closer than the fill. The relation is flexible, depending on what effect you want, so bracket as you work.

In many of the photos in this chapter, Kent Sievers used this two-flash setup, with one flash on-camera and a flash-with-slave off-camera. One basic set-up is to have the 45-degree light at 3 feet and the on-camera fill at 6 feet and set the *f*-stop for 45-degree light. This will ensure that the 45 degree is approximately twice the intensity—enough to be dominant.

In this age of fast films and lenses, it's easy to ignore flash and even to try every trick not to use it. But flash is a valuable and necessary tool for the modern photojournalist. With only a little practice and a few rolls to test your flash, you will become comfortable with it. In particular for shooting color, but of great use also for black-and-white shooting, flash should be a part of every photojournalist's equipment bag.

# 16 ▪ COMPOSITION

*"Compostion is the strongest way of seeing."*

Edward Weston

This chapter will cover the why and how of compositions that were taken naturally through uncomplicated EDFAT seeing. From now on you can be more selective and careful in composing. It's time to give a deeper dimension to your arrangement of elements to tell a story in a photograph.

Composition can be defined this way: It is the selection and arrangement of subjects within the frame of the photograph to assure effective communication. Any composition that accomplishes effective communication is a "success"; one that does not is a "failure." (Fig. 16.1) In photojournalism, effective communication tells a story. This makes photographic composition an active and constantly adaptive approach that has defied most academic rules. Accepted composition rules are no substitute for a sense of design based on imaginative seeing.

## CONTENT

Content supercedes all aesthetic considerations in photojournalism composition. Imaginative compositions contain only those elements that tell the story. Choosing the right composition requires a high degree of visual perception.

Visual perception is the quest for meaning in what you see. As Richard Whelan writes in his photo book, *Double Take*:

> The more creative the mind the greater the ability in seeing correspondence between disparate people, objects and situations. Such perceptions are the soul of wit and metaphor. Our discoveries of connections are surely among the intellectual and artistic pleasures, for similes, affinities, sequences and even puns all give us a sense of underlying order and fraternity.

You practice visual perception when you question the significance of what you see with: "What does it mean?" and then answer that question with strong, storytelling pictures.

Visual perception requires an awareness of every element in the scene. Only when you see details as the camera sees them can you choose the best composition.

In beginning EDFAT you concentrated on your subject alone. Now relationships between elements in the foreground, background, and middle ground become equally important. You analyze other elements in the frame to produce various levels of design. Elements previously not seen or cropped out to simplify composition now become secondary design elements that add to the photograph.

## APPLYING PERCEPTION

There are two methods of applying your visual perception. The first is EDFAT, the free association approach that is a fluid reaction to the subject or scene. This "trial and error" method gives extreme freedom to improvise.

As you learned in Chapter 4, EDFAT is the detailed seeing for a choice of storytelling photographs. The acronym stands for Entire (observe the entire subject in its environment); Details (dissect it into specific details); Frame (strong compositions); Angles (shoot

**Figure 16.1: Breaking a "rule" can work, if done right. Here, Mark Damon centered the man, but added a barn and mules for a strong composition. Courtesy *The Ithaca Journal.***

from a variety of angles); Time (build visuals by using slices of time). By taking these steps, you explore even the most familiar subject in rich detail and shoot in a systematic way.

The second is a "rules" approach that is in reality a memorization approach. You memorize accepted rules of composition and then make photographs that conform to the rules laid down by teachers or successful photographers.

Each method alone can limit your development toward confident, visual perception. Free association becomes too random and self-absorbed, while the "rules" approach locks you into preconceived compositions and discourages experimenting.

## A COMBINED APPROACH

You can combine these two methods into a sophisticated approach by applying the EDFAT II method: This extends EDFAT towards a conscious use of foreground, middle ground, and background elements and towards selectivity. EDFAT II leads to more skillful compositions and builds that selective "feel" of principles used by working photojournalists.

Like EDFAT, EDFAT II is based on the belief that you have the ability to find just the right photographic composition to tell the story. It will be your own, so will be different from what another photographer might take of the same subject. Belief in your own

strong sense of design and seeing in detail will naturally lead to your own "right" composition.

This corresponds to what photographer Paul Strand wrote:

> Composition and design mean nothing unless they are the molds you yourself have made, into which you pour your content, and unless you make the mold, . . . respect your materials and have mastery over them, you have no chance to release that content.

And Cartier-Bresson said, "there is nothing new in the world . . . only a reconstructing of things," and he added that we must be "always trying to be more lucid . . . keeping on and on. . . . " It is this creative, individualistic refining of what has been done before that makes much new composition effective. In photojournalism, imagination is always in the service of clear communication.

# PRINCIPLES OF COMPOSITION

For the EDFAT II method, it is better to speak of principles than of rules. There are few unbreakable rules, but there are some strong principles of photographic compositions that photojournalists have used in the past, especially on deadline. These include the following.

- Know the story. Content is the constant preoccupation of photojournalists. Your aim is to tell a story. Once you know what you are trying to say through photographs, compositional approach follows.
- Never center your subject. The centered image tends to make a static photograph (Fig. 16.2). In photojournalism, with the need to place other elements in the frame, very few compositions will call for exact centering of the subject. The exception is if you want to communicate a static effect.

- Use the "rules of thirds" (Fig. 16.3) for placing your subject in the frame. First divide your frame into horizontal and vertical thirds by imagining four lines as shown in Fig. 16.3. Then place your center of interest where two of the four lines intersect. This begins your search for the "right" placement.
- But the rule of thirds is only a start. Try placing the subject at all 4 intersections on four consecutive frames of film. Then shoot other compositions, away from these intersections. Remember that you can place your subject anywhere you want, provided it communicates what you want.
- Question each element in the frame. Is it relevant? Can it be removed by cropping or using a different angle? If not, can it be used to better effect by different placement (Fig. 16.4)?

**Figure 16.2: As a rule, never center your subject. Here, the subjects are perfectly centered to produce the "bull's eye" effect, while other elements draw the eye away.**

**Figure 16.3: A "rule of thirds" composition produces a strong design in which roughly one-third of the picture contains the dominant element.**

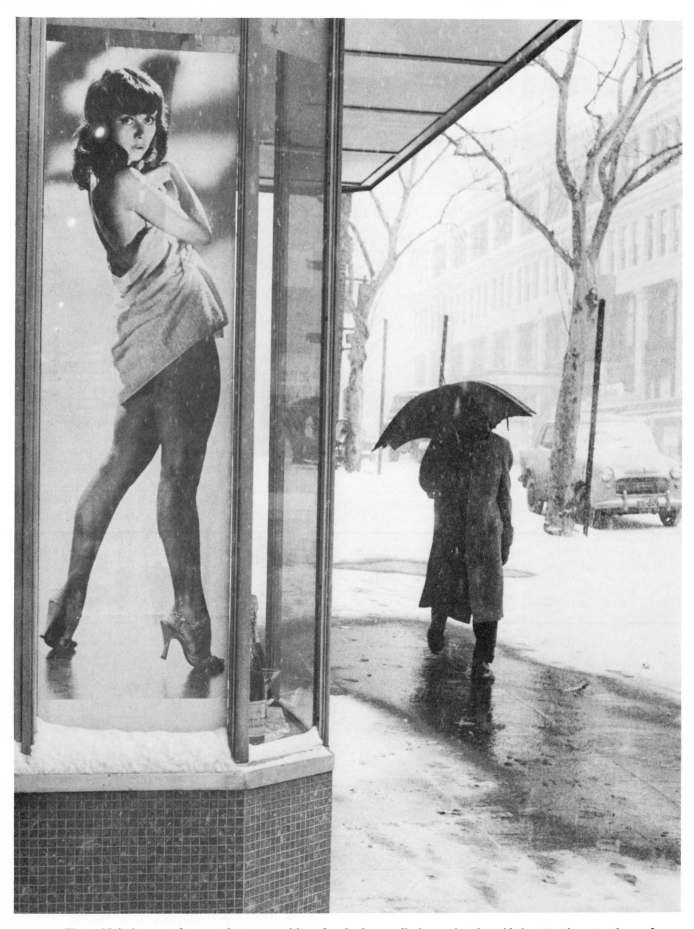

**Figure 16.4: A personal approach to composition often leads to radical cropping that aids in attracting attention and communicating forcefully. Courtesy** *The Washington Post.*

• Always simplify the composition. Either by strong design of many elements or by concentrating on a detail of a single element, make the composition communicate at a glance.

There are other basic principles you can use for more sophisticated compositions. Originator of the EDFAT approach, John Szarkowski of the Museum of Modern Art, New York, describes composition as "the photographer's task to order and simplify our perceived sense of life."

Four characteristics of the sophisticated composition are (1) simplicity of design, (2) a strong center of interest, (3) conscious use of the camera to recreate relationships between elements in the frame, and (4) the use of background and foreground as environmental design elements through selective focus or selective detail.

## SIMPLICITY OF DESIGN

Simplicity of design is the aim of every photojournalist. Even when reporting a complex idea or scene, your design should be simple and effective. This does not mean including only a few elements. The design should lead to one emotional effect no matter how many elements are included. Feel free to try any angle, lens or framing that communicates simply and immediately to the reader (Fig. 16.5).

Phil Dougliss, who teaches visual communication nationally through his Dougliss Visual Workshops, writes: "Simplify. . . . Composition is just another word for organizing the elements within the photograph for maximum coherence and meaning."

Over the years, this feeling has led to the general rule of "move in and fill up the negative." When slavishly followed, this "rule" will cause you to miss important elements that may add to the story. But when used well, this close-up approach leads to strong, simple photographs and is an effective way to emphasize a subject. In the early days of the Speed Graphic, photographers had only a single lens and therefore had to move in to simplify their photographs. Even today, with our wide assortment of lenses and long rolls of film, simpler is still better (Fig. 16.6).

## STRONG CENTER OF INTEREST

The best way to make a simple design is to concentrate on a strong center of interest. This often means making one person stand out from a crowd or environment. But even with more complex designs, compose so the viewer never doubts who or what your center of interest is.

The simplest way to manage a strong center of interest is to make certain that a person is in every photograph. Even in a striking pictorial, a person lends scale and contrast, whether the rest of the photo is of a tiny object or a towering mountain. When a person is present in the photo, he or she automatically draws the reader's attention. Even when the aim is to show other parts of the scene, the person enhances and complements it (Fig. 16.7).

## CONSCIOUS USE OF FRAMING

The act of placing the camera to your eye does more than make you a photographer. The frame of the cam-

**Figure 16.5: Brian Drake framed the center of interest, the accident victim, and cut out almost every inessential element. Courtesy** *The Longview Daily News.*

Figure 16.6: Tightly cropped close-ups are a simple, enduring type of composition, but they can omit important environmental elements. Photo by Walter Calahan.

Figure 16.7: A person in your photo provides a strong center of interest because a story is implied.

era that surrounds your subject can reestablish spatial relationships within the frame. By "cropping in the camera" you gain control over the elements. A shift to the left or right, up or down, can reestablish these relationships between people or things to make a series of compositions, each different in effect.

Framing gives you the means to control perspective and content. Generally, photojournalists have been conservative in using the frame as a creative tool. But when a photojournalist tries "radical" framing, the effect can be striking (Fig. 16.8).

## USE OF BACKGROUND/FOREGROUND

When you first began shooting, you concentrated on the subject so closely that you probably barely noticed background or foreground elements. As a result, they may have shown up on the final print as distracting elements. A captivating smile may have kept you from seeing a tree, car, or passing pedestrian in the background. Now that you can see these other design elements, you can use them to make stronger statements. There are two ways to use the background or foreground elements for composition: selective focus and selective detail.

### SELECTIVE FOCUS

Selective focus is pure photographic design. By consciously making one element sharply focused to stand out from the rest of the composition, you are drawing the viewer's eye to the focused point (Fig. 16.9).

*Above*—Figure 16.8: Compositional framing can draw the eye through a complex image that communicates on several levels.

*Left*—Figure 16.9: Selective focus guides the viewer's eye to the center of interest. Here, Robert Townsend shot over the onlooker's shoulder to frame the woman with the monkey. Courtesy *The Pittsburgh Post-Gazette.*

*Above*—Figure 16.10: A formally patterned background echoes the human pattern in this council meeting, producing a strong composition. Photo by Mark Damon. Courtesy *The Ithaca Journal*.

*Right*—Figure 16.11: Words can almost create a caption-within-a-photo. Photo by Mike Rynearson. Courtesy *The Phoenix Gazette*.

## SELECTIVE DETAIL

Selective detail takes advantage of depth of field. Both background and foreground are kept in focus so each can help tell the story. Sharply focused elements convey information rather than act as masses of negative space (Fig. 16.10).

Selective detail is used in environmental portraits when a sign, a building, a symbol, or another person can be seen in great detail. Selective detail can yield a more complex message than the selective-focus photograph with fewer elements (Fig. 16.11).

## UNLIMITED COMPOSITIONS

Composition using these categories results in virtually unlimited composition effects. Nearly every other compositional device fits into the list. To take advantage of them you need an alert and imaginative approach to visual perception while shooting. Often only a subtle move of the camera will result in just the right effect that makes your photograph appear fresh or new.

You can elaborate on these four broad areas of composition by introducing some equations for further photographic composition. The following equations might lead to some guidelines for you:

simplicity of design = visual impact
visual impact = action or possibility of action
close-up = intimacy or emphasis
long shot = isolation or aloneness
subject facing into frame = leads to object of gaze
subject facing out of frame = mystery
sharpness of detail = reality
softness of focus = mystery or nonreality
lightness of print = happiness
darkness of print = sadness, foreboding
facial expression = best for showing emotion

## ENVIRONMENTAL ELEMENTS IN DESIGN

You can go beyond immediate elements to use environment as a frame for your subject. Environmental lines, shapes, and forms can lead the viewer's eye to the center of interest, frame the center of interest, or act as symbols to enhance meaning.

## LEADING LINES

Roads, fences, walkways, even lines of people or patterns serve as leading lines. They strengthen composition by literally pointing to the center of interest.

Leading lines are often more definite than mere sweeping lines. They can be definite shapes and forms that give fuller meaning to your composition. Some lines form shapes that surround the subject. Some shapes to look for are C's, L's, T's, S-curves, +'s, and radials. By placing the subject in a spatial relationship to such forms, you contain the viewer's eye. The remaining area of the frame then serves to counterbalance what amounts to a self-contained composition within a composition (Fig. 16.12). However, unless you adapt this recognizable shape to your own composition, it can look like a cliché, and will draw attention to itself rather than to your message. To avoid this, you can begin with any of the traditionally recognizable forms and recrop, even radically, to make a new relationship of form to subject.

This means starting with an awareness of the definite shape in the environment. Then shift perspective, changing your lens or point of view by careful cropping to use just enough of the shape to present a fresh view. Some part of an S-curve, for example, could be-

*Right*—Figure 16.12: John Metzger's environmental portrait of a man and his cat uses the arch to frame and add appeal to the shot. Courtesy *The Ithaca Journal*.

*Below*—Figure 16.13: Leading lines and definite shapes can direct the eye and enhance the shot. Here, the curve of the elephant's trunk leads right into the keeper. Photo by John Metzger, *The Ithaca Journal*.

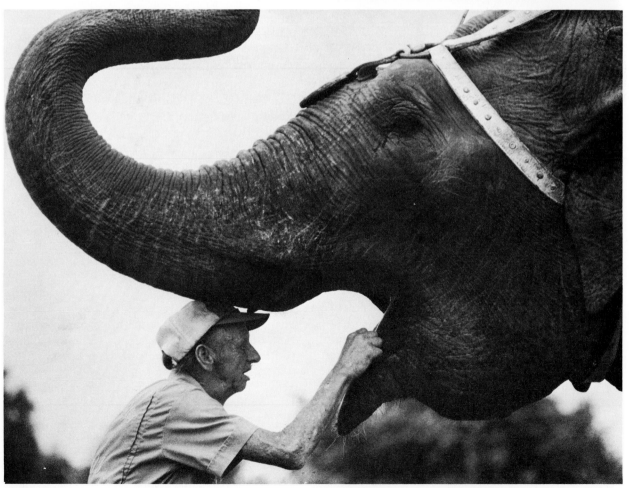

*Above*—**Figure 16.14: Selective detail helps tell the story. The double flag motif here says: Olympics hopeful. Photo by Jim Bryant, Courtesy *Florida Times Union*.**

*Below*—**Figure 16.15: Mark Damon produced a poignant photo of retirement by allowing the subject to "speak" for himself. Courtesy *The Ithaca Journal*.**

come a legitimate leading line or shape that is strong enough to lead the eye without being seen as a cliché (Fig. 16.13).

## FORMS AS SYMBOLS

Mountains, rivers, huge trees, signs, roads, flags (Fig. 16.14), or even massive buildings or bridges can make a statement by themselves. Even smaller pieces like crosses or similar symbols can be used to convey your message (Fig. 16.15).

The question "What does it mean" is one sure way to decide what portion of an environmental shape should be used. A second consideration is whether the shape helps tell the story or whether it works against it.

Beyond such obvious shapes, forms, and symbols, many patterns can enhance your message by either repeating the subject's form or contrasting with it. Either way, the patterns form a strong part of the composition.

## A PRACTICAL TEST

The practical test of any composition device is whether the viewer can understand the content. When the viewer notices a form or composition, it has called attention to itself at the expense of the message. Content must communicate with the viewer so clearly that the viewer doesn't even notice the compositional device.

# 17 · HISTORY AND TRADITION

*"Too many photographers . . . try to lift photography into the realm of art, because they have an inferiority complex about their craft. You and I would see more interesting photography if they would stop worrying and instead apply horse sense to the problem of recording the look and feel of their era."*

Jessie Tarbox Beals, early news photographer

On Sunday morning, June 28, 1936, the photo in Fig. 17.1 appeared on the front page of *The Washington Post*. Taken in Philadelphia the day before, it shows President Franklin D. Roosevelt and Vice President James N. Garner at that year's Democratic convention. It had been received by wire transmission shortly after it had been shot. It is an excellent news photograph. It gives the reader a "look and feel of an era." Smiling and grasping hands, two politicians are caught in a moment of history. This was one of 75 news photos that covered the five days of the convention. It combined with the text of the President's acceptance speech and many stories to produce a words-and-pictures reflection of history as it occurred.

By 1936 news photographers could spontaneously record people in action instead of posing them. News photographers had the equipment to cover events speedily and well. They were using 4 × 5 Speed Graphics with film and flash bulbs instead of glass plates and dangerous flash powder. Picture magazines (and some

newspapers) used 35mm cameras with no flash. Even the engraving process was greatly improved. Editors could depend on wire machines to transmit photos from around the world, 24 hours a day. News photography was beginning to be what Helmut Gernsheim calls the "historian of our time." By 1939, on the centennial of its invention, photography was a medium of mass visual communication.

The 1930s were typical of a series of eras during the 150 years since the invention of photography in 1839. During such eras, technical innovations led to complete technical and aesthetic change within a few years. Few eras of change were as extensive as the 1930s, but each generation of photographers adapted to change as the new replaced the old.

For example, the 1850s were a time of change from the metal base daguerrotype to the collodion wet plate process. That was followed by the change from wet plates to dry plates in the 1880s, and for the public, the beginning of the roll film snapshot era. The 1880s also introduced the halftone for photographic reproduction of photographs on the printed page.

The 1930s bridged the gap between the glass plate era of the 1880s and the 35mm approach of the 1950s and prompted the birth of modern photojournalism. But to understand the significance of its role, we must return to the 1880s for historical perspective.

## BEGINNINGS: 1880-1919

In America between 1880 and 1919, the spirit of Manifest Destiny sent the country beyond its borders for the first time. This engendered a sense of progress based on great capitalistic success with mass production of items for the millions. Increasing population supplied customers for such inventions as Ford's automobiles, Bell's telephone, and a host of mass-produced mechanical devices.

This interest in mechanical things provided a natural atmosphere for the rise of photography, itself a product that owed its appeal to the mechanical reproduction of an image. Like other commodities of the era, photography succeeded partly because it was a mass instrument.

Although it required some 40 years for them to be fully accepted, four innovations of the 1880s laid a

foundation for modern photojournalism. These included:

GELATIN BROMIDE DRY PLATES: Photography was made easier with the mass production of the gelatin bromide dry plate. Dr. Richard Leach Maddox had laid the foundation for mass manufacture of film in 1871 when he replaced the messy wet plate collodion with the reliable gelatin emulsion base. The resulting gelatin-bromide dry plate could be stored for later use and ushered in the modern era of photography. The emulsions and chemistry introduced then remain in use today.

KODAK FILM: In 1888 George Eastman's Kodak roll film system brought photography a step beyond the dry plates. Kodak's camera used flexible roll film and made snapshot photography popular in America (Fig. 17.2).

Eastman employed the capitalistic principles of the time: mass production at low cost, high volume international distribution, extensive advertising, and a product that satisfied the needs of many customers. He made photography an overnight success. His first camera was a simple box camera with one speed (1/60 second); took 100 exposures on a flexible roll of film; and required no experience to use; also, the film was developed and printed by Eastman's staff in Rochester, New York.

VISUALLY AWARE AUDIENCE: The Kodak and its close cousins, detective cameras, made the public intimately aware of photography. Soon everyone was taking "snaps" of picnics, trips, and countless small events.

This democratization of photography by the ubiquitous "snapshot" formed the beginnings of a visually literate audience. Having themselves taken pictures the public could appreciate photographs when they saw them reproduced in newspapers and magazines.

HALFTONE PROCESS: The introduction of the halftone made photographs on the printed page possible. Printing had always been able to reproduce continuous white or black tones, but the photograph, with its range of black, white, and grays, required a different method of reproduction. The photograph had to be rendered in subtle shades that showed clear details in all tones. Until the 1880s the black-and-white photograph could not be reproduced directly onto the printed page. The photograph had to be hand-copied by an artist.

The introduction of the first halftone for use on rotary presses by Stephen Horgan of the New York *Daily Graphic* solved that problem. The photo was a general view of New York City's Shantytown and was published on March 4, 1880. Photos were used increasingly in newspapers and magazines, between 1880 and 1919. Magazines like *Collier's* and *McClure's*, among others, used photographs lavishly. However, editors in

Figure 17.2: George Eastman himself was snapped with a Kodak by friend Fred Church. The first snapshots were circular. Courtesy of the International Museum of Photography at George Eastman House.

Figure 17.1: Flashbulbs synchronized with the shutter allowed photographers to capture spontaneous action indoors for the first time on a regular basis in the 1930s. Courtesy *The Washington Post.*

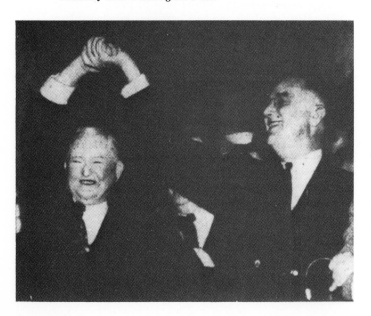

general distrusted the halftone and the handheld cameras, so it was not until the era between 1919 and 1930 that their cumulative effects were seen.

In the halftone engraving process, the original photograph is copied through a dot-patterned screen onto a plate to produce an engraving of a mosaic of various-sized dots.

In black areas, the engraving dots are large and equidistant from one another. During printing this produces heavy inking. In the white areas, engraving dots are smaller and farther apart, resulting in little or no inking during printing.

But most importantly, in the gray areas of the photograph the engraving dots are a variety of sizes and distances apart to print a variety of shades. Where the area is dark gray, the dots are large; in light gray areas, the dots are extremely small. This varied screening allows for subtle shades of black, gray, and white to be reproduced on the printed page. Halftone engraving, in use today, has been improved, but is still based on the same principles.

Examine the pictures in this book with a magnifier or a lupe; you'll see they were printed using the halftone process.

# PHOTOGRAPHERS AS SOCIAL DOCUMENTARIANS

Two reformers introduced the photographic documentary tradition in the United States between 1880 and 1908. Jacob Riis and Lewis Hine used glass plate cameras and halftones to produce some of the most effective social documentary in photojournalism history.

## JACOB RIIS—REFORMER WITH A CAMERA

Jacob Riis was more of a reformer with a camera than a news photographer. His stories and photographs helped reform the environment of some of the tenement slums in New York City. In the spirit of Lincoln Steffens and the muckrakers of the era, Riis used his camera to show the social problems of the era (Fig. 17.3). As a reporter for the *New York Sun* he saw the problems up close. Thanks in great part to his photographs, abuses in public health, sweatshops, and child labor were beginning to be corrected by the mid-1890s.

Because Riis did much of his work at night, he used magnesium flash powder as a light source for his large tripod-mounted dry plate camera. Wandering the tenement slums alone or accompanied by a police officer, Riis would set up his camera, flash his picture, and disappear, leaving a puff of smoke and the startled inhabitants behind.

In 1890 Riis published his illustrated book, *How the Other Half Lives,* a strong indictment of tenement conditions. About a dozen halftones were used in the book, along with drawings taken from his photographs. The halftones were ill-produced in a nascent halftone process, but they were graphic proof of social abuses. The book was an immediate success and is still in print today.

Riis never lost his zeal for reform. He personally covered the openings of parks, schools, and nurseries built as a result of his stories. He was an original in the tradition Cornell Capa has named "concerned photographers."

## LEWIS HINE—CONSCIENCE WITH A CAMERA

"There were two things I wanted to do. I wanted to show the things that had to be corrected. I wanted to show the things that had to be appreciated."

Lewis Hine was a trained sociologist and a New York school teacher when he discovered photography in 1903. He taught himself to use the Graflex, dry plates, and flash powder, and then gave up teaching to devote full time to photography.

Like Riis, Hine was inspired by the reform atmosphere of the time. His photographs of immigrants at New York's Ellis Island and their subsequent settling in tenements are masterpieces of photo reporting.

By 1908, acceptance of the halftone allowed the magazines *Charities* and *The Commons* to publish Hine's photos as "photostories." Between 1908 and 1919, Hine produced his heart-rending photostories for a variety of publications to show the plight of child laborers (Fig. 17.4). He used his considerable persuasive powers, and often a disguise, to enter cotton mills, canneries, and sweatshops where he photographed children as young as eight years old working long hours at dangerous machines.

Hine was more than a photographer. He was a sociologist and an investigator for the National Child Labor Committee. He combined photography with pertinent information of the children's age, size, health, and family history. His notes of the children's conversations added poignancy to shocking visual evidence.

Such photos and facts were instrumental in forcing Congress's Child Labor Committee to enact stringent child labor laws.

Unlike the feisty Riis, who devoted his entire life to reform work, Hine included "the things that had to be appreciated," while retaining his strong social conscience. After 1920 he chose the general theme "Men

Figure 17.3: Using dry plates and flash powder, Jacob Riis depicted the plight of New York tenement dwellers in his now-famous documentary style. From the collection of John Faber, NPPA historian, with the permission of Dover Publications, Inc.

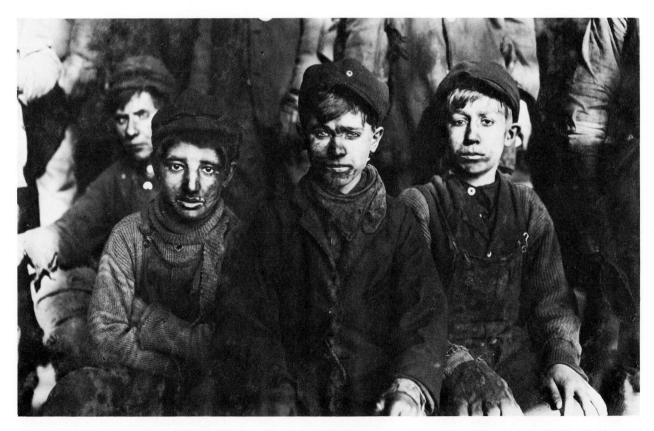

Figure 17.4: Lewis Hine showed the public the injustices of child labor around the turn of the century. He found these young coal miners working in Pennsylvania in 1911. From the collections of the Library of Congress.

at Work" and produced hundreds of photographs showing workers building the nation. His photo essay on the erection of the Empire State Building was indepth photojournalism.

## JIMMY HARE—NEWS PHOTOGRAPHER EXTRAORDINAIRE

For pure news coverage, between 1880 and 1919, one person stands out. Englishman Jimmy Hare was one of the few professional news photographers of the era to take advantage of handheld roll film cameras. A photographer for *Illustrated American*, a magazine that used halftones regularly as early as 1896, Hare was a news photographer extraordinaire.

Hare arrived in America in 1889. In 1898 he covered the Spanish-American War for *Collier's* as special correspondent. Using his folding hand camera and roll film with 12 exposures, Hare traveled all over the Cuban battlefront. He worked with such writers as Stephen Crane and photographed Teddy Roosevelt and his Rough Riders.

Hare was a one-person staff. He was a true photojournalist, initiating stories as well as photos. Using the hand camera he traveled light and covered stories in the same style as a modern photojournalist.

# THE ROARING TWENTIES

Between 1900 and 1919, there was steady improvement in printing, engraving, and photographic equipment, and there was excellent work being done. At the end of World War I, another major era began in America: the newspaper era.

The 1920s have been romanticized as the era of the lost generation of Ernest Hemingway and F. Scott Fitzgerald. In Europe, in the years following the slaughter of millions in the war, disillusionment and escapism reigned. In an era with few inherited rules, intellectuals sought new means of expression, from nihilism and surrealism to experimentation in the Bauhaus School. In photography, the spirit of experimentation led to a flowering of the 35mm "candid" camera aesthetic.

In the United States escape took more frivolous avenues. The country had joined the war in Europe late in 1917, so its armed forces had suffered relatively light casualties. The 1920s in the United States was what historian Frederick Lewis Allen calls the "age of ballyhoo" and "jazz journalism." Heroes and heroines were made overnight by extravagant press coverage of "wonderful nonsense," flappers, and bathtub gin.

It was also the era of photos in newspapers.

In 1919 the new *New York Illustrated Daily News*— "the picture newspaper"—gained a circulation of millions and helped lay the foundaton for photojournalism in the 1930s and the rise of picture magazines. But in 1919, news photographers covered assignments using virtually the same equipment and materials that their counterparts in the 1880s had used.

Through the 1920s, newspapers were the mass medium that delivered the daily news to a waiting public. With radio still in its infancy, a newspaper's "extra" generated street sales of hundreds of thousands of copies in large cities.

News photographers depended on getting a scoop that often made the extra. Every aesthetic consideration was superceded by the race to be the first to get the picture in print.

Competition for scoops and the extra edition led to sensationalized news coverage. New York tabloids like the *Mirror, Graphic,* and *Daily News* appealed to subway commuters and many immigrants because they were easily held and had a simple writing style enhanced by explicit photos. These newspapers were anything but subtle, and they prospered.

## SENSATIONALISM

Sensational photographic coverage mainly relied on gruesome crime and scandalous news that editors knew would titillate readers. But the New York *Daily Graphic* deliberately set out to invent photos. Emile Gavreau, editor of the *Graphic*, invented a form of illustration called a "composograph." When the details of the divorce trial of "Daddy" Edward Browning and his 15-year-old bride, Peaches, needed illustrations, the *Graphic* invented them. Testimony in the trial quoted the antics of "Daddy" and Peaches as cavorting on a bed with "Daddy" saying "Woof, woof, don't be a goof," so Gavreau had models pose as the pair, altered the photo, and ran it as a "composograph." Faked photos soon became Gavreau's forte (Fig. 17.5).

However, most other tabloids preferred their sensations straight and relied on content to shock readers.

For example, in 1928, when Ruth Snyder was electrocuted for her part in the murder of her husband, the *New York Daily News* photographer covered her demise on film. News photographers were forbidden at the execution but *Chicago News* photographer Tom Howard was present with a miniature camera strapped to his leg. Howard had been brought from Chicago

*Above*—Figure 17.5: Composographs were faked by *The New York Daily Graphic,* a tabloid. Here, models posed as "Daddy" Browning and his teenage bride "Peaches," as described in court testimony. From the collection of Prof. Robert Lance, Arizona State University.

*Right*—Figure 17.6: The electrocution of Ruth Snyder made the front page of *The New York Daily News* in 1928. The photo was taken with a hidden camera by Tom Howard.

because the prison officials might have recognized the New York photographers. His sneak photo ran on the front page of the *New York Daily News* (Fig. 17.6). It sold 250,000 extras plus 75,000 additional copies of the front page later.

## STAFF PHOTOGRAPHERS

Not all photographs were sensational, and straight coverage saved photojournalism from total disrepute, so photographs grew in popularity. More photographers were hired to staff newspapers. These were the first generation of news photographers who learned to cover assignments in a narrowly news-oriented style: to scoop the opposition with the first shot to "hit the front pages." A front-page photo was a prize rewarded by a bonus, particularly if it was an exclusive.

Training was haphazard at best, but one that trained generations of excellent news photographers. A teenager could get a job in the photography department by accident. Ernie Sisto, *New York Times* staff photographer, recalls that as a teenager he went to the *Times* to apply for a job as an artist. He got off the elevator on the wrong floor and was asked "Hey, kid, you want to work in photo"? He took the job and stayed 50 years. Other photographers who began careers in the 1920s are representative of the era.

### HUGH MILLER

Hugh Miller was Chief Photographer of the *Washington Post* for nearly 50 years. He recalled:

March 1920 was the date I came to the *Washington Post*. . . . My salary increase was $5 to $35 a week with syndication rights to the negatives I made.

Well, in the 1920s, training was usually in association with an older, seasoned photographer. It was real on-the-job-training. A youngster would help carry cameras and learn by observing. There were few schools for photography. . . . Early training was mixing chemicals. At that time, chemicals started from scratch. . . . Days were long—six days a week and few days less than 12 hours. No overtime nor compensation for callbacks at night. . . . We all used glass plates until the late 1920s when cut film became available in smaller sizes. . . . I can recall my best negative slipping through wet fingers to shatter on the floor.

### BUCK MAY

Andrew "Buck" May covered the Washington scene in the twenties for Harris and Ewing Photos, which had a syndication of more than 70 clients in those days. Buck was a founder of the White House News Photographers Association in 1921 and was among 15 photographers who founded the National Press Photographers Association in 1945. He has photographed

*Left*—Figure 17.7: Andrew "Buck" May used existing light and a Speed Graphic camera to capture President Calvin Coolidge reviewing the U.S. fleet aboard the presidential yacht in 1927. Courtesy Harris and Ewing Photo.

*Above*—Figure 17.8: Photographer Harry Rhodes demonstrated how flash powder was ignited in the twenties. From the collection of John Faber, NPPA historian.

13 Presidents (Fig. 17.7) beginning with Woodrow Wilson, and recalls covering Washington news in the twenties with flash powder. He says:

> When flash powder was used for stories concerning Cabinet members or other set-ups, it was a cooperative affair. Because the flash powder created so much smoke, we could only get one shot indoors. We'd have only one photographer pull [set off] the flash, while the rest of us would take a time exposure.
>
> When everyone was set, with the shutter on open and our dark slide over the lens, the photographer with the flash gun would yell "Open!" or "Caps off!" and we would all uncover our lenses as the flash powder exploded. . . . It took some time to clear the room of smoke afterwards (Fig. 17.8).

## TONY BERARDI

Anthony Berardi began his career as a teenager in the twenties for Hearst's Chicago *Evening American*. Ber-

ardi found a mentor in the photo department who helped him greatly—Merwyn Breton:

> [Chief photographer] Merwyn would come into the darkroom and teach me to print, step by step. He would also take me into the studio and show me the techniques of the camera from flash powder to time exposures. All this time, of course, I was mixing chemicals and running errands, making prints—everything that had to be done in a photo department.

Newspapers in prohibition Chicago competed vigorously for scoops. It was before wire transmission, so news photographers used any means of transportation to get photographs back for deadline.

> For us, the most important thing, beside the picture itself, was making the deadline. A picture in your grip is no good unless you can get it in the paper.
>
> Merwyn Breton would send two or three photographers

on local news and have one pick up the plates from the others and rush back to make deadline. Other times, we used motorcycles, cab drivers, even a few bucks to a passing motorist would get the film back in time when we needed it.

And if it was an out-of-town assignment on deadline, one of the greatest things was to flag down a man on the railroad and give him two dollars so he'd give the plates to a messenger waiting at the station in Chicago.

Berardi photographed crime often in those Prohibition days. He photographed mobster Al Capone and covered gangland in all of its aspects. He says, "if it was a murder story you could work 24 or 36 hours straight. You would catch a little sleep in the police station but stay ready to go when the news break came. It was your story."

One of Berardi's most famous photos was the scene after the infamous St. Valentine's Day Massacre, one of the notorious Chicago gangland slayings (Fig 17.9).

Using flash powder, glass plates, and time exposures with their Speed Graphics, the news photographers cooperated to photograph the grisly scene. Lighting in the dark garage was by flash powder; they used the open flash method, with one photographer setting off the powder. They pictured the sprawled bodies of the seven gangsters who had been gunned down at close range by Al Capone's mob.

### FRANK GEBMAN

Frank Gebman, a news photographer for Acme News Photos in the 1920s before wire transmission, recalls how Acme used an ambulance to get the photos back from the Max Schmeling–Jack Sharkey fight in Yankee Stadium:

> We hired an ambulance and made it into a traveling darkroom. The plates were developed in the ambulance as it raced back to the office. The guy who developed in the racing darkroom was Arthur Fellig, but everyone called him Weegee. He later became famous. That night we went through Times Square blowing the siren—and with cops holding traffic for us we whizzed right through everything.
>
> Other times, we used motorcycles, cars, anything that would get plates back to the office the fastest.

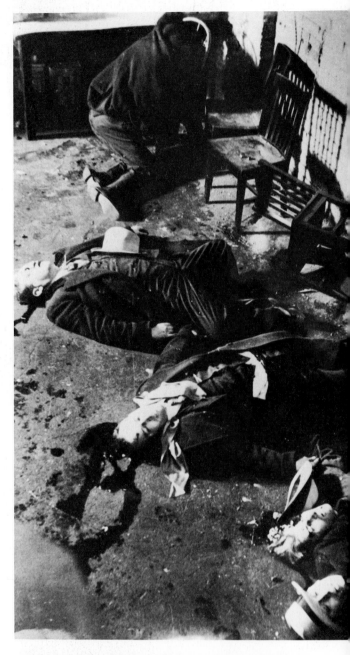

**Figure 17.9: This photo from the St. Valentine's day massacre, taken by Tony Berardi in Chicago in the 1920s, remains a classic. Courtesy *The Chicago Tribune*.**

# THE BIRTH OF MODERN PHOTOJOURNALISM

The birth of modern photojournalism occurred when the world was in the Great Depression. The stock market crash of 1929 abruptly ended the "Roaring Twenties" and plunged the world into a decade of economic chaos. The fear and suffering from the worldwide economic instability led to totalitarian regimes in Germany, Italy, and Japan and eventually resulted in the global catastrophe of World War II.

## TECHNOLOGICAL CHANGES

Despite economic hard times, the 1930s were a time of vast changes in the technology of photojournalism. Between 1930 and 1939 more important journalistic innovations occurred than in any previous era, including the following:

- Flexible gelatin film replaced the fragile glass plates for the large press cameras.
- The mobile 4 x 5 Speed Graphic camera replaced the 5 x 7 Graflex for newspaper work.
- Flash bulbs replaced the dangerous flash powder for inside lighting. These flash bulbs were synchronized with the shutter to make indoor action photos possible.
- The 35mm camera was used for special, available light assignments.
- Kodak's Kodachrome 35mm color transparency film was introduced in 1935.
- The Associated Press network of coast-to-coast wire transmission bureaus was established in 1935.
- United Press introduced its Telephoto network of transmission bureaus in 1936 to rival AP's, doubling the number of photos available.
- *Life* magazine published its first issue on November 23, 1936.
- Documentary photography became viable on a large scale when Roy Stryker organized a staff of outstanding photographers for the Farm Security Administration.
- In printing, dry-plate engraving replaced the wet-plate process.
- Look magazine in 1937

Photojournalism became a 24-hour-a-day reporting profession. Of these innovations, the four most important for photojournalism were: the Speed Graphic camera style, photo magazines, wire photo transmission networks, and use of 35mm cameras in news work.

## THE SPEED GRAPHIC STYLE

Compared with the tripod-mounted glass plate cameras, the Speed Graphic camera was a mobile, hand camera. Film was lighter and more light sensitive than glass, and flash bulbs made indoor action photos possible.

The Speed Graphic dominated news photography for the next 25 years. Carrying it and a bag filled with flash bulbs and film holders, press photographers rushed from event to event (Fig. 17.10).

The Speed Graphic style of the mid-1930s, which lasted into the late 1950s, usually meant posing the subject engaged in a characteristic storytelling activity and moving in close to "fill up the negative." This style of report, with caption, became the staple on wires and in newspapers.

### WEEGEE

The Speed Graphic flash-on-camera style, was epitomized in the work of Arthur Fellig, nicknamed Weegee. The same fellow who developed the plates in the racing ambulance for Acme had become "Weegee the Famous" by 1938—a freelancer in demand for his murder photos.

Weegee was a cigar-chomping, rumpled-clothes news photographer who developed coverage of happenings on the night shift into an art. He made murder and feature news in the seamy part of New York City his beat. His flash bulb style produced the harsh, shadowed lighting that was its own mood. A Weegee photo *is* the Speed Graphic flash-on-camera style of the 1935–1955 news photography style (Fig. 17.11).

Weegee described his approach in his book *Weegee on Weegee*: "Things back to normal. The cops and reporters were happy, and I was happy. Gang wars, shootings, stickups, kidnappings . . . I was in the chips again. My pictures . . . with my by-line: Photo by Weegee . . . were appearing in papers every day."

He was a master of self-promotion and produced several books. One, *Naked City*, was made into an early TV serial. In recent years his photos have gained attention from the art world, and have been exhibited in museums.

## WIREPHOTO

Transmission of photos over telephone lines was probably the most dramatic innovation of this era. It made photojournalism a truly mass medium. Starting in 1935, newspapers across the country received approximately 100 photos a day from Associated Press and another 100 from United Press.

Editors had been trying for years to find a photographic equivalent of the telegraph to transmit photographs as speedily as word stories.

One photographic device using leased telephone lines was demonstrated in 1920 at the New York *World*. The editors were impressed by the Telastereograph, but they thought that "news pictures of sufficient worth to warrant the cost were not numerous enough to make it worthwhile." Wire transmissions were made only for special occasions, and extensive wirephoto transmission was not tried on a continuous basis. According to Charlie Payne, who worked for Acme News Photos, there were wirephotos "in 1926 and '27, [but] you had to transmit from the ATT Building and it took about an hour for one transmission." In 1935, ATT introduced an improved method; AP agreed to try it.

### THE NATIONAL WIRE NETWORK

On January 1, 1935, the first transmission was sent over the improved system to 47 newspaper offices in 27 cities. By January 4, over fifty photographs were sent by wire in less than 18 hours. From then on, news photographs from across the country fed continuously into the network.

Coming into the city rooms, these photos made editors more picture-conscious, and they began to use

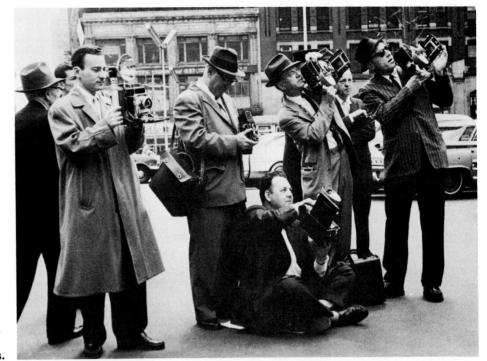

*Right*—Figure 17.10: The Speed Graphics with their trusty flash bulbs and large negatives, were the workhorses for the news photographers of the forties. Courtesy Charles Payne.

*Below*–Figure 17.11: The Speed Graphic approach was epitomized by Weegee's style. This is "The Critic," one of his most famous photographs.

fresher news photos. Pictures arriving almost hourly from AP and UP bureaus could be published with late-breaking stories. Editors began to use larger photographs for news rather than for features. After January 1935, the picture page became a regular feature in most newspapers.

Picture page subjects ranged from Hollywood marriages to disasters and wars. They were predominantly national events, but there was an attempt to keep a balance between national, international, and local pictures (Fig. 17.12).

## THE RISE OF PICTURE MAGAZINES

The increased supply of photographs made the public picture-conscious and helped lay the foundation for the picture magazine era.

Unlike the newspapers with their emphasis on daily deadlines and news content, picture magazines could devote time to the layout of the pictures on a page.

This called for a rationale to organize this new, multiple-picture medium that came originally from Europe, where publications like *Munich Illustrirete Presse* and *Berlin Illustrirete* had gained circulation in the millions in the 1920s.

In the Wiemar period in Germany, there was a flowering of mass circulation picture magazines using the realistic, unposed, "candid camera" approach. A staff of photographers produced realistic photo essays that were as good as anything done later. Stefan Lorant, editor of *Munich Illustrirete* and later of England's *Weekly Illustrated* and *Picture Post*, set high standards for later editors. His picture editing was totally visual. He varied size, shape, contrast, key, and mood to introduce visual organization and continuity in the picture page. He used sequential photographs; natural, unposed fashion photos, and showed an overall respect for the photograph.

## CANDID CAMERA AESTHETIC

Many excellent photographers practiced this new style in the 1920s and 1930s in Europe, but the urbane German lawyer Dr. Erich Salomon had a magical way with the Ermanox camera and existing light (Fig. 17.13). Dr. Salomon, who spoke seven languages fluently, gained entrance to social and diplomatic events by disguise and charm. He became famous for his unposed, available light photographs. Equipped with the small glass plate Ermanox camera and a fast *f*/2 lens, Dr. Salomon made exposures of one-half to a full second to capture people in what he called the "unguarded moment."

The great interest in Salomon led others to use candid photographs. Books and magazines began publishing photographs taken with the miniature cameras, and there developed a new aesthetic. This followed Lorant's criterion for a new realism: "the camera should be like the notebook of the trained reporter to record events as they happen, without trying to stop them to make a picture."

## THE 35MM LEICA

The desire to photograph without manipulation had been present since photography's early days. But the candid style did not become practical until the 1920s. The first candid camera to gain approval by the public

Figure 17.12: Picture pages became popular and frequent during the 1930s as more photographs from more places were made available by wire transmission. Courtesy *The Washington Post.*

was the 35mm roll-film Leica, developed by Oskar Barnak at the optical works of E. Leitz in Wettzlar, Germany, before World War I. It was improved by the Leitz company and put on the market in 1924; this was followed by the Contax camera in 1932. The era of "new realism" in photography expanded.

By 1936, this realism had reached the United States, where the 35mm candid approach and the European influence combined in a new type of visual medium: *Life* magazine.

## LIFE MAGAZINE

*Life's* first issue hit the newsstands on November 23, 1936, and from the first followed this statement of purpose:

> To see life; to see the world; to eyewitness great events; to watch the faces of the poor and the gestures of the proud; to see strange things—machines, armies, multitudes, shadows in the jungle and on the moon; to see man's work—his paintings, towers, and discoveries; to see things thousands of miles away, things hidden behind walls and within rooms, things dangerous to come to; women that men love and many children; to see and take pleasure in seeing and to be instructed.

*Life's* first issue contained a photo essay by Margaret Bourke-White: a cover photograph and inside

layout on the frontier-like atmosphere of workers and scenes of Fort Peck, Montana (Fig. 17.14). The photographs showed Bourke-White's skill with industrial subjects as well as her ability to capture the spirit of people.

Bourke-White's essay was not shot with the 35mm camera, but its strong visual organization set the stage for three decades of in-depth photo essays on every subject.

## THE DOCUMENTARY APPROACH

Documentary photography introduced in this era was neither daily reporting nor essays, but an extension of the realistic approach into something different.

Photojournalism reached a special level when Roy Stryker in the government's Farm Security Administration (FSA) reintroduced photography for documenting social conditions. Seldom before or since has photography reached such involvement and influence as in the work of the FSA documentary photographers.

Talented and socially aware photographers like Dorothea Lange, Arthur Rothstein, Russell Lee, Walker Evans, Marion Wolcott, Ben Shahn, Gordon Parks, and others traveled the United States to document the effects of the Depression on rural and small town America. Their photos were in the tradition of Riis and

Hine and showed social ills, so it was not entirely new. The 1930s documentary photographers showed the public the farm problem created by farm policies of the 1920s and exacerbated by the Depression (Fig. 17.15). But this documentary approach was highly organized. The FSA style was developed by a government team under the strong direction of Stryker, who instinctively understood how to use documentary photographs as persuasive evidence. The FSA images were direct photographs of great detail that had the look of objectivity. These strong images seemed to say "This is the way things are."

## THE FSA APPROACH

Without daily or weekly publication deadlines, FSA photographers had freedom beyond most photojournalists of the time. Each became a strong photographer with a unique style.

The FSA photographers blended sociology with journalism to persuade the public that a problem existed. The FSA approach showed the relationship between displaced farmers and their land and, by extension, the result of past unwise land use.

FSA photographs were initially dismissed as government propaganda, but the realistic documentary style produced strong emotions and believability. By the late 1930s, FSA photographs were being used widely by wire services, newspapers, and magazines.

## THE WAR YEARS: 1940-1945

Between 1940 and 1945 the United States concentrated on the "war effort." For civilian news photographers this meant shooting scrap metal collections for war material enlistments, training exercises, and other news connected with daily life in wartime.

Figure 17.14: The first issue of *Life* appeared in 1936 and Margaret Bourke-White created its first photo essay. Courtesy *Life* magazine.

**Figure 17.15:** Dorothea Lange's "Migrant Mother" has become a classic documentary photo. The FSA photographers were dedicated to making strong, visual social comments. From the collection of the Library of Congress.

News photographers joined the armed forces to report news of millions of men and women at war to people back home. When the war ended in 1945, the photographers came home. But even with the end of the hostilities, the aftermath of the war dominated photographic assignments. Many stories reported on the population readjusting to peacetime.

# PHOTOJOURNALISM SINCE THE 1950s

News photographers who began a career in the 1950s were working in an atmosphere of dramatic technical changes. Technology introduced in the decade between 1950 and 1960 laid the basis for today's approach to photojournalism. It might be said that in 1950 the photographer was a news photographer and in 1960 he or she was a photojournalist.

Three important innovations occurred. The 35mm Nikon camera was introduced, Kodak's Tri-X film was introduced, and electronic flash replaced flash bulbs.

## 35MM CAMERA

The changes wrought by acceptance of the 35mm were as significant and wide-reaching as those made by the Speed Graphic in the 1930s. In 1950, the 4 × 5 Speed Graphic with flash bulbs was *the* newspaper camera. But by the mid-sixties, 35mm and available light (or with electronic flash) had taken over that position. Even by the late 1950s 35mm was the preferred camera for younger newspaper photographers. The mobile 35mm brought a different photographic style.

The popularity and availability of 35mm cameras in the 1950s encouraged regular newspaper experiments with 35mm style to replace the Speed Graphic. In particular, publicity about magazine photojournalists like David Douglas Duncan and war correspondents like Marguerite Higgins and others in the Korean War led to a rebirth of interest in the small camera.

But equally important was the faster and improved 35mm film Tri-X introduced by Kodak in 1954. At ASA 200, Tri-X was much faster than other films. But Tri-X was not excessively grainy and was the perfect match for the 35mm format. By 1960, Tri-X was improved and its speed increased to 400 ASA to make available light shooting even easier.

Along with this, Kodak's fast Royal Pan 4 × 5 film (200 ASA and, later, 400 ASA) was introduced. This encouraged existing light shooters with the larger camera (Fig. 17.16).

In these years, flash bulbs were replaced by the electronic flash or the strobe light. Repeated flashes without changing bulbs, a softer tone to the light, and the action-stopping (upwards of 1/1000 of a second) burst of light made the strobe light a perfect companion for the 4 × 5 Speed Graphic still in use on newspapers. The electronic strobe was a great boon to indoor action shots. When used with 35mm, the strobe became a handy light source.

Editors were against 35mm cameras, and often photographers used bounce flash to simulate the look achieved with the small camera (Fig. 17.17). Despite editors' objections, the 35mm camera became a part of the newspaper photographer's equipment by the mid-1950s. It was common practice for younger photographers to carry a 35mm in the camera bag and to use it candidly after a few shots with the Speed

**Figure 17.16: In the mid-1950s, Fast Royal pan 4x5 film could be pushed and then developed in "Dektol" for a long time.**

*Right*—Figure 17.17: Bounce flash with the Speed Graphic simulates the "natural" 35mm look in this society-page shot of painter Salvador Dali. Courtesy *The Washington Post*.

*Below*—Figure 17.18: The 1960s saw a disturbing series of political assassinations. The murder of Senator Robert F. Kennedy, as he was campaigning for the presidency in 1968, is shown in this *Los Angeles Times* photo by Boris Yaro.

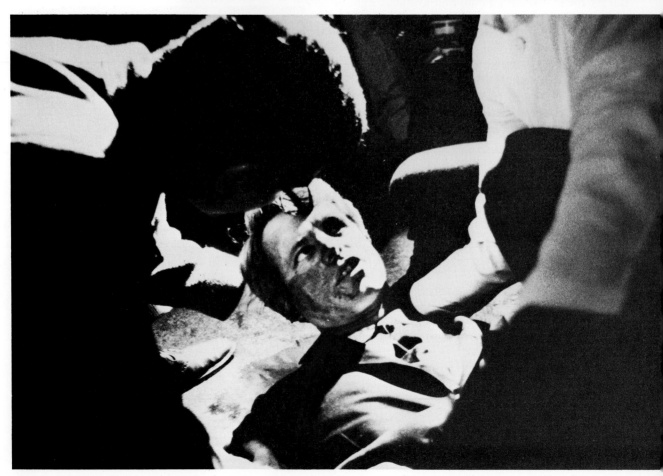

Graphic. They began to develop a new style based on these guidelines: (1) pose only if you must; (2) allow subjects to be themselves; (3) use available light; flash only when absolutely necessary; (4) move around and shoot candidly; and (5) use longer lenses, rather than move in.

Most photographers of the 1950s combined the old and the new styles, using each when it seemed right; some used the 2¼ x 2¼ format, as a compromise, but by the 1960s, 35mm was predominant.

## THE 1960s

This decade was one of inspiring technological achievement mixed with disturbing social upheaval caused primarily by an unpopular war. At one extreme, the United States placed a man on the moon. At the other, the Viet Nam war and political assassinations also dominated the news.

Television coverage brought the Viet Nam war into the nation's living rooms. Nightly news, daily newspapers and news magazines covered the Viet Nam war in more bloody detail than any war in American history. Increased color coverage heightened the visual effect of an already gruesome conflict.

In addition to such confrontation, the era included political assassinations, with victims ranging from President John F. Kennedy, in 1963, to civil rights leader Martin Luther King, and Senator Robert Kennedy in 1968 (Fig. 17.18). By 1973 the country was in the Watergate period of political scandal, which saw the resignation of President Richard M. Nixon.

### THE 35MM ERA CONTINUES

By 1965 the 35mm camera was predominant in photojournalism. There was little difference between magazine and newspaper photojournalists in equipment, shooting style, or aspiration. Photographers on newspapers and magazines, as well as advanced amateurs were using the same size camera.

On assignments, photojournalists with two, three, or even four camera bodies, each with a different lens, covered an event in the 35mm style. Motorized cameras became standard equipment and photojournalists would shoot many rolls on each assignment.

During this era, equipment was being improved. There was a proliferation of newer, faster, and more versatile lenses. Mirror lenses, improved zoom lens, and lenses with improved glass and as fast as $f1.2$ were introduced. Canon introduced its 0.95 35mm Rangefinder. All combined with improved and faster films to produce flexible coverage of fast-moving events.

For the first time in photojournalism history, new photographers were added to the staff without training time in the darkroom lab. Some were still learning the old way, but by the late 1960s graduates of journalism schools were being hired as staffers. The number of women and minority photojournalists also increased.

### MULTIPLE-PHOTO APPROACH

Changes led to a new style of photojournalism. The 35mm camera led to the multiple-photograph approach, even on newspapers. Having the basics from outside instead of from older staffers, the college-educated photojournalists approached assignments with a more personal view. They often shot for layout beyond a single picture. On newspapers, this led to a broader interpretation of "news" and a more liberal approach. Also, the ideas these new staffers brought led to fierce competition and an era of progress.

These attitudes resulted in an increase in single-subject picture pages. At its best, and particularly in the late 1960s and early 1970s, there were many successful attempts to transfer the photo essay to the newspaper picture page.

### TODAY

In recent years, 35mm cameras have been automated, computerized, miniaturized, and made completely electronic. Through-the-lens metering, totally automatic cameras including autofocus, digital read-outs of exposures in cameras, and automatic flashes have kept pace with the computer age. Perhaps the major sign of this age is AP's Electronic Darkroom, a step toward total electronic photojournalism. Using lasers to transmit, edit, and store images makes the AP a leader in computerized photojournalism.

Many observers predict the end of the 35mm film-generated image and the beginning of the electronic era. Nearly every day we learn something new about electronic cameras. Like so many eras in the past, today's photojournalist is using the familiar equipment to cover news while anticipating new equipment.

# 18 · EDITING

*"The team most likely to achieve the happy blend of words and pictures consists of an editor who thinks visually and a photographer who thinks editorially."*

Gerald D. Hurley and Angus McDougall,
*Visual Impact in Print*

To discuss editing fully would take a whole book, but in this chapter we can introduce you to some editing fundamentals from the perspectives of photojournalist and editor. The photojournalist's perspective is familiar to you by now, so let's turn to the editor's perspective.

Even though their jobs are separate, photojournalists and editors follow the same logic to edit photo-

graphs; the only difference is that one does it in the camera and the other does it on the printed page.

At its best, Hurley and McDougall's "happy blend" is more than words and pictures. It is teamwork between two supportive people with one purpose: effective visual communication (Fig. 18.1). The photojournalist is the "outside person" on the scene, and acts as the eyes of the picture editor. The editor is the "inside person" who organizes photos to communicate to the reader. This calls for a delicate balance between responsibilities (and egos) of strong-willed people. When they cooperate, full coverage is assured.

## EDITORIAL THINKING

Editorial thinking by the photojournalist on the scene requires that:

- You be a reporter—not an artist with a camera.
- You communicate to the public.
- Your pictures are sharp, uncluttered statements.
- You shoot to give your editor a choice.
- You think layout when shooting: long, medium, close-ups; horizontals; verticals; subject from left, right, front.
- You get all written information to complete the photo message.

Of course, you have been your own editor since you shot your first roll with EDFAT, so editing is not new to you. As you chose a frame to print for past assign-

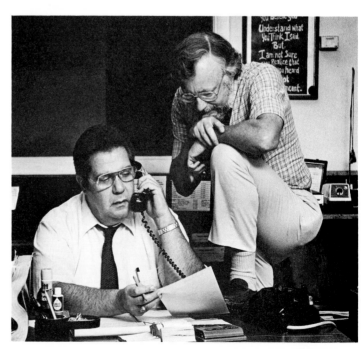

Figure 18.1: Graphics Director Bob Lynn (right) and Chief Photographer Bill Abourjilie consult on the distribution of assignments in a team effort. Courtesy *The Virginian Pilot* and *The Ledger-Star.*

**Figure 18.2: A contact sheet shot by Brian Brainerd now of the *Denver Post* shows editorial thinking at work. The editor back in the office has a choice among establishing to medium close-up shots.**

ments, you were editing your work in the same way (and sometimes with the same complaints) an editor would.

Many photojournalists print what they feel tells the story and often work without direct supervision by an editor. On deadline, this saves time and strain on the editor. But these photojournalists make several prints so the editor can make the final choice.

Remember: the editor has the final say on which picture is used. This is *partly* because it is often difficult for photojournalists to edit their own work. They are sometimes too attached to individual photos, and need objective judgment not tied emotionally to the story. Photojournalists have to ask themselves, "What does the editor need based on the story and space available?"

## WORKING FROM CONTACT SHEET OR FILM

Contact sheets (or, on most daily newspapers, film) are where you start editing. Contact sheets or film are the photojournalist's rough notes and the editor's raw ma-

terial. Even a fast search through film or contact sheets will show how thoroughly a photojournalist has shot full coverage by providing a choice of establishing shot, medium, and close-up, plus different angles.

Imagine that you are the editor and turn to the partial contact sheet (Fig. 18.2) shot by Brian Brainerd. First you would cross out all out-of-focus frames, bad exposures, or photos that don't interest you. You'd choose one photo you think is best.

Next, in looking for full coverage to tell the story, you would ask these questions:

- Is there a good establishing shot to show the scene?
- Are there enough good medium shots that move in closer?
- Are there enough close-ups to add impact to the story?
- Do striking or unusual compositions give a different view?
- Was a variety of lenses used for effect?
- Are there exciting, natural, and storytelling expressions?

- Are there possible sequences?
- Is there one photo that tells the story, or sets the mood?

A *yes* answer to all of these questions would mean that the photojournalist was thinking editorially and was concerned with full coverage.

## THE EDITOR—THINKING VISUALLY

For an editor who thinks visually, the question, "Which is the best single photo to use?" contains these considerations:

- Can you run it full frame?
- Will cropping improve the message?
- How big can you use it?
- How can it be improved?

And then the final question: "Are there so many good shots that you can make a picture page?"

The best modern photojournalists offer a picture editor "too full coverage" even on a single picture assignment (Fig. 18.3). As Angus McDougall writes: "The editor's best friend is the photographer who provides full coverage."

**Figure 18.3: The choice from the contact sheet was a feature shot that captures young musicians as they wait for what seems like hours. Photo by Brian Brainerd.**

# THE PICTURE EDITOR

A working definition of a picture editor is offered by Bob Lynn, Graphics Director of the *Virginian-Pilot* and *Ledger-Star,* Norfolk, Virginia. Lynn says:

> Picture editors need to be full members of the editorial team, acting as the communication link between the photo department and the other editorial departments. They also should be the link between the editorial department and the production departments. In this capacity, picture editors must be the champions for good picture use and good picture reproduction. To be so, they must have responsibility for initiating as many assignments as possible and for monitoring all other assignments (approve, disapprove, improve); and for the selection, cropping, sizing, and display of pictures (Fig 18.4).

> The good picture editors I have known all have a passion for pictures. They have a good understanding of picture assignment potential. They have sound knowledge of what makes a successful picture, plus they have sound

news judgment. They have a good sense of how to integrate pictures and typography on a page, be it a page with a single picture or a full picture page. They work effectively with others . . . photographers, reporters and editors.

## PHOTO DEPARTMENTS

In the past, photo departments were often service-oriented. Photographers would wait for a story to be written and then illustrate it. Otherwise, he or she would wait for spot news to happen and then rush out to cover it. At its best this approach produced excellent spot news photographs. But today's newspaper and magazines are expected to provide commentary on community affairs plus breaking news pictures. Today, TV often gets the scoop, reporting events live, while newspapers and magazines are secondary news sources.

**Figure 18.4: The picture editor gives out assignments, sizes photos, and creates page layouts. Courtesy *The Virginian Pilot* and *The Ledger-Star*.**

Lynn's approach to picture editing adapts successfully to this reality. He notes:

> The photo operation at the *Virginian-Pilot* and *Ledger-Star* is an initiating department, . . . we are not simply a service department. We often originate photo–story assignments for the newsroom, feature department, and sports department. Our photographers are constantly looking for stories to tell through photos and words. We also encourage them to initiate in-depth picture stories and to get involved with layouts of these stories.
>
> With this "initiating" atmosphere, the photo department and other editorial departments are equal partners in putting out the most informative and visually interesting newspaper we can each day. It is not pictures or words,

and certainly not picture versus words, but two complementary ways to report stories to our readers. We encourage our photographers to shoot, edit, and write in-depth picture pages, and they do it regularly.

## WEEKLY NEWSMAGAZINES

The picture editor on a weekly newsmagazine faces a slightly different situation, but retains the fundamental visual approach. Max Desfor, former Photo Director of *U. S. News & World Report,* offered his ideas on the newsmagazine picture editor:

> The picture editor on a newsmagazine doesn't just look at a bunch of pictures and make selections. Picture editors must read the stories assigned to them. They must be in constant liaison and discussion with writers, editors and art director concerned with a story.
>
> The picture editor must be able to conceive ideas suitable for illustrative material and must know how to get that material. He does so by assigning photographers who produce what is needed. To do this he or she must have a close working relationship with photographers and lab staff; be able to talk to photographers in their own language; and convey the idea, meaning, or purpose of the story and suggest suitable and obtainable pictures.

## ASPECTS OF THE EDITOR'S WORK

In photojournalism many people with the title "picture editor" have little authority beyond processing photographs and writing captions. But when the title carries strong management authority, the editor is a manager, a coordinator, executive, and assignment editor, in addition to an arranger of words and text on a page.

### THE MANAGER

Organizing and overseeing a staff of photojournalists covering diverse and changing assignments calls for strong management skills. Mary Ann Nock, Picture Editor of the Phoenix *Gazette*, describes the management part of her job:

> Managing a photo editor's job takes equal amounts of diplomacy, patience, and organization . . . the ability to get things done even though you never have enough time. You make coherent decisions in two minutes while answering phone calls, talking on the radio, and monitoring police scanners at the same time. You must like dealing with diverse personalities (photographers, reporters, editors) who are usually strongly committed to opposing philosophies.
>
> But you shouldn't even think about photo editing unless you are unequivocally committed to photojournalism . . . for you may be the only one in the newsroom who is. An ability to do constant battle for the cause of photos is perhaps your most valuable asset.
>
> As far as "managing" the photo staff, I approach that

job with a light touch. I consider myself not so much their boss as their spokesman in the newsroom. They start the job, I finish it. In a job like ours, where professionals are working together, it is difficult to place one person's responsibilities above another's.

It is true, as photo editor, I determine salaries and raises, set schedules and deal with other personnel matters concerning our staff of 11 photographers. But the bottom line is getting the best possible photos in our newspaper on a daily basis. Without dedicated, responsible photographers in the field, my job becomes harder, if not impossible. And, without a dedicated, responsible photo editor in the newsroom, the best photographs in the world won't see the light of day.

In hiring, I make sure this relationship is clear to potential staffers. I count on them to get me the best photos out of every assignment. They count on me to get them the best photo play, and make sure photography remains an important part of our newspaper. They make me look good, and I make them look good.

## THE COORDINATOR/EXECUTIVE

As the representative of the photo department to other departments, the picture editor must coordinate the photo needs with the overall direction of the publication. Rich Clarkson discussed this part of the picture editor's job when he was Assistant Managing Editor of Photography of the *Denver Post*. Clarkson (now with *National Geographic*) said:

The effective picture editor must always have a sense of the role of pictures in the overall journalistic product—and on the particular newspaper or magazine for which he or she works. There must be an understanding of combining pictures and words, of the "personality" of the publication, and a feeling for the readership.

The best picture editors—the most effective ones—are those who have a sense of overall journalistic taste, who have an appreciation for fine writing, who are intrigued by the news and subject matters, and who have a sense of originality in the bringing together of all of these facets.

When they argue strongly for a picture, other editors respect their opinions because they are good journalists overall.

## ASSIGNMENTS

Perhaps no other aspect of picture editing is as difficult as distributing assignments to a staff of photojournalists. This requires a system that is fair but produces the best work. Bob Lynn says:

At the *Virginian-Pilot* and *Ledger-Star,* myself and the assignment editor, chief photographer Bill Abourjilie, try to make sure that everyone gets a share of the "good" assignments. That doesn't mean everyone gets an absolutely equal share of them, because we try to match assignments to the photographer's ability, interest, and past performance. Much of it is a matter of balancing the morale of individual photographers with expectations of department editors making the photo assignment.

# PICTURE EDITING PRACTICES

The actual selection, cropping, sizing, and layout work by a picture editor takes a surprisingly small part of his or her time. That time is often sandwiched between the other duties and calls for a sure visual sense of what is good or not good. Each editor has a system, even a philosophy on how to lay out words and pictures for the particular publication, so there are many styles. But the general picture editing process is in three areas: (1) selection and judgment; (2) cropping, sizing, and scaling photos for reproduction; and (3) make-up and layout of pictures onto the page.

## SELECTION AND JUDGMENT

The photojournalist who thinks editorially has a great deal of freedom on assignment. Often the picture editor publishes the photo as it is submitted by the photojournalist (Fig. 18.5). Editors use the criteria for judging a photograph that was discussed earlier and then fit photographs into the overall layout on the printed page.

## CROPPING

Naturally, the editor does more than select photos as they were shot by the photojournalist. Photographs can sometimes be improved with judicious cropping by a visual-minded editor. McDougall defines the art of cropping as "to trim a picture down to its essentials." An editor with the confidence to crop to essentials can make a strong visual statement. In general, cropping is the editor's chance to improve a photograph, and is a powerful and creative tool. But the editor has to be flexible. Knowing when and how to crop for the best visual effect depends on realistic circumstances (Figs. 18.6–8).

An editor who thinks visually will try to use the photograph as composed by the photojournalist. Lynn says that at the *Virginian-Pilot* and *Ledger-Star,* the philosophy is to "place the pictures, cropped to make them as effective as possible, on the pages *first* . . . and *then* lay out the stories. According to Lynn, "there is a lot of negotiating as to size, but not too much

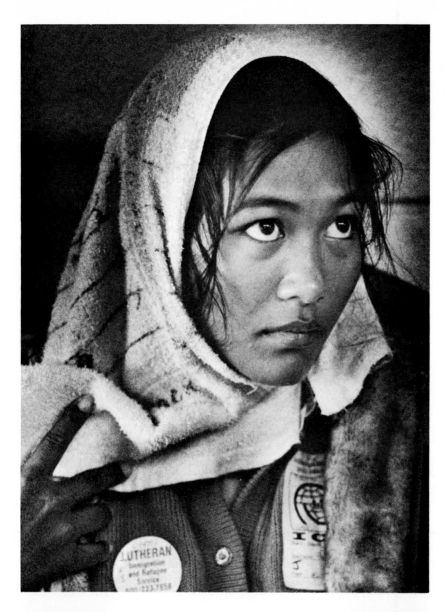

*Left*—Figure 18.5: Photos are often used just as the photojournalist printed them. The composition of this affecting portrait of a refugee is a product of darkroom enlargement, with publication in mind. Photo by April Saul. Courtesy *The Philadelphia Inquirer.*

*Below, left*—Figure 18.6: Cropping may completely alter the effect of a shot, not just make it fit a space. Knowing how to improve a shot or how not to lose its best qualities through cropping is a skill of a good picture editor. This photo is the photographer's full frame.

*Right*—Figure 18.7: The photo has been cropped to include only two of the children.

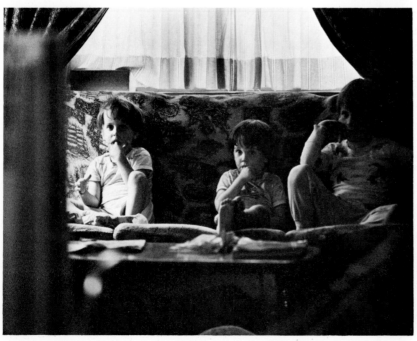

about the shape, as cropped. As for size, our approach is to run the photograph *impact size.*"

This emphasis on photographs leads to some special handling on deadline. Lynn says, "of course, if the picture comes in right on deadline, it is made to fit— but with even a little time before deadline, we go into the darkroom to size from a wet print, enlarge image, or even estimate size and shape from the negative. On tight deadline, a "must" picture can even be sized from the photographer's advice while the film is enroute to the office."

## CROPPING APPROACHES

When cropping is called for, there are four basic approaches:

- Crop slightly to improve the original.
- Crop to create a visual storytelling effect.

- Crop to fit a space.
- Crop to "save" an otherwise confusing or busy photograph.

**Crop To Improve the Original.** It is a pleasure to crop a photograph only enough to improve it. Cropping to "clean up" extraneous details on an otherwise effective photograph leaves essentials of the original and is appreciated by the photojournalist. The picture editor is respecting the basic idea while improving it (Fig. 18.9).

**Crop for Storytelling Effect.** But if the picture editor sees a chance to improve on the original composition by making a drastic crop he or she shouldn't hesitate to do so. A long, narrowly shaped shot or a perfectly square cropping can make the photo more visually exciting, communicating more to the reader than a straight photo. Even cropping a face down to the eyes from a full portrait can make a striking effect (Fig. 18.10).

**Crop To Fit a Space or Save a Photo.** Sometimes limited space forces the picture editor to crop the photograph; for example, trying to fit a wide horizontal photograph into a two-column space. Of course, there could be another photo that fits, but if not, the editor must crop creatively. The aim is to crop but retain as much of the original content as possible.

A photograph that turns out badly, whether from technical mistakes, an amateur source, or just plain lack of thinking by the photojournalist should not be used. But if it must run, it can be saved in the hands of an imaginative picture editor. It takes some work (and a sense of humor) if the photograph is a real disaster, but often severe cropping can make it useable (Fig. 18.11).

## SCALING AND LAYOUT

The next editing step is to match the dimensions of the original to the scaled down proportions of the layout sheet. Scaling the photograph places it right where it belongs in photojournalism: on the printed page. There it will combine with type and white space to create an attractive, informative design.

Successful page design requires a person with a thorough knowledge of photographs, graphics, type, and design principles. Full discussion of these are beyond us, but we can offer some basic layout principles.

More and more, today's newspapers are designed rather than just "made up." Dr. Mario Garcia, author of *Contemporary Newspaper Design,* describes the present atmosphere:

**Figure 18.8: In this cropping, the original photo becomes a vertical of only one child.**

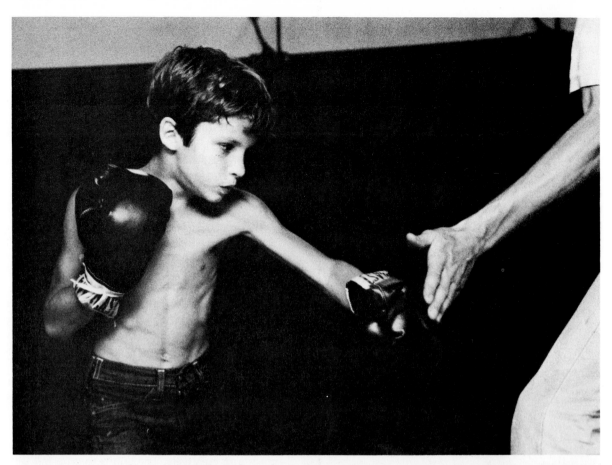

**Figure 18.9: Cropping to improve an already good photo is a pleasure for both the editor and the photojournalist.**
196

Figure 18.10: Cropping drastically can result in more visual impact, as with this narrow third of the original frame. Photo by Jim Bye, *The Virginian Pilot* and *The Ledger-Star.*

Figure 18.11: Cropping to "save" a photo is a last resort measure, as when it has met with some technical accident. In such a case, the editor usually crops down to the bare essentials.

The look of the American newspaper is rapidly changing. Better packaging, more white space, new typefaces, larger photographs, more organized positioning of advertising, and a new surge of graphic creativity are all part of the new look.

This new look relies on photographs to reach a visual audience raised on television. Photographs are larger, more graphic, and carefully integrated into the total "package" of the page. According to some research the reader "reads" the photograph first and then the caption or story, so strong photographs are important.

Dr. Garcia writes, "If properly integrated, photographs help pull a design together. The designer's primary task is to create order through the placement of photographs on a page."

For the single photographs on a page, this means grouping them so they are not scattered around the page merely to break up the text.

## BEYOND THE SINGLE PICTURE

Of course, this visual emphasis often calls for more than one picture on the same subject. When a multiple photo layout is used, the picture editor has many options, a sort of lexicon of visual designs, from which to choose. These designs are comparable to a writer's choice of words, sentences, and paragraphs and give a structure to the picture editor's approach. In *Visual Impact in Print,* Angus McDougall offered some of the design options:

- Picture group or series—a cluster of related or unrelated photos
- Picture sequence—photos in sequence to simulate movement (Fig. 18.12)
- Picture story—a narrative with beginning, middle, and end
- Picture essay—a layout with a strong editorial point of view

197

**Figure 18.12: A picture sequence simulates movement, or "flows," if run in a row at the same size. Photos by Don Stevenson,** *The Mesa Tribune.*

198

- Newspaper picture page—any of the above on one page creating theme or mood story, or an essay

Each category has its uses and allows the editor to adjust the subject matter to the photos available. For example, photos from several different locales, without any relationship, could be grouped together for visual coherence, but could not be made into a coherent photo essay or story. Photographs shot at differing angles, perspectives, and subjects would not make an effective *sequence,* but could be used as a *series.*

## EDITING FEATURE PICTURE PAGES

Perhaps the most satisfying aspect of picture editing in newspapers is the picture page. The feature picture page gives photojournalist and picture editor a chance to do a story that relies heavily on visual design.

A visual approach should be flexible, so there are few hard and fast rules. But follow the logic of photos and try to use them without cropping (Fig. 18.13). Try these fifteen "guidelines" suggested by Bob Lynn, Mary Ann Nock, and other sources:

1. Start by emphasizing photos, with complementary text.
2. Have an establishing shot, a medium shot, and a close-up to structure a coherent message.
3. Photos all need to make statements—*separate* statements.
4. The layout should have a dominant photo 50% larger than the next largest photo. It should be the most compelling one that best defines the story.
5. Group photos so that the eye goes to the dominant one and then to the other pictures. Cluster the dominant picture with smaller support pictures.
6. To start, apply the "50% rule" further. Make each photo *approximately* 50% smaller than the next, in descending order of importance. (Example: 6 columns wide, then 3 columns, and then 1½ columns.)
7. Make sure the smaller photo's image sizes are large enough to read.
8. Maintain equal interior margins. Spacing between the inside elements should normally be consistent (1 to 1½ pica is a good range).
9. Follow the photo's line of force, or the direction the photo carries the eye, as a strong design element.
10. Pictures, headline, cutlines, and text need to work in harmonious composition. Make sure the headline is large enough to "carry" the page. Remember, extra large, bold headlines can be

toned down by printing them gray instead of solid black.

11. Use white space to balance the page (for example, if the upper left-hand corner of the layout has a certain amount of white space, a somewhat similar amount of white space might work well in the lower right-hand corner).

12. Put the entire page in a box.

13. Give the pictures borders.

14. Avoid lining up the *outer* edges of too many elements. The visual line that results may be too strong and might distract from the content of the pictures. For example, lining up sides of three pictures results in a "2 × 4 effect" (look

like boards nailed together by a carpenter). It is better to design the page with a minimum of lining-up, even though some lining-up is desirable and/or necessary. Also, avoid "stair stepping" elements (three or more elements "stepping" down).

These guidelines can help you in page layout, but remember Lynn's advice that "designing a well composed, visually attractive picture page is not a matter of mathematics or hard and fast rules, but a matter of visual sensitivity. Laying out a page is not a science, it is an art. Attention to detail will make the difference

**Figure 18.13: Picture essays are designed for visual effect rather than narrative order. Photos by Karen Kamenski, courtesy *The Virginian Pilot* and *The Ledger-Star*.**

between an 'okay' layout and an 'outstanding' layout'' (Fig. 18.14).

Finally, don't try to show too much. Less is better. A pile of contact sheets can look overwhelming, but edit them down to five or six strong photos and you have the makings of an effective page. You are usually trying to present the visual *essence* of a mood, a spirit, a theme. The essence—presented in a well-composed, visually attractive way—is what you want to present to the readers.

## WORKING WITH AND FOR AN EDITOR

Working with and for an editor calls for teamwork and cooperation. The editor has the final responsibility of putting it all together, so he or she often needs a photo of specific size or shape. In other cases, he or she has special ideas for coverage.

Remember you work both with and for a picture editor. This calls for a delicate balance between "orders" of the editor and "free enterprise" of the photojournalist. When you have a specific order from the editor, carry it out in the spirit of teamwork and then go one step further—give the editor what he or she asks, and then create. That's what full coverage means.

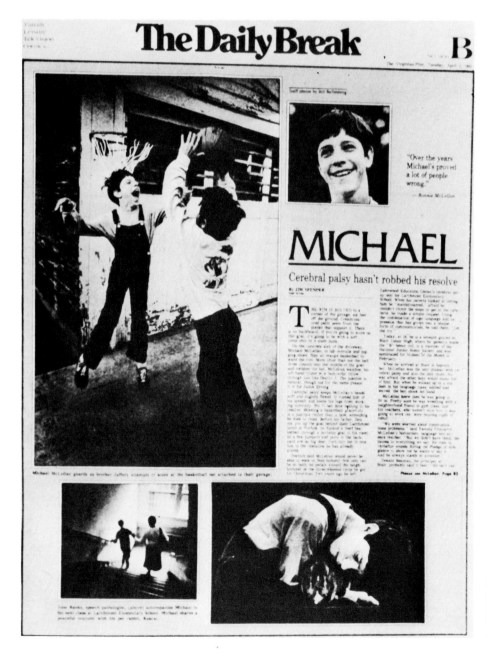

**Figure 18.14: This picture page follows the rules listed by Bob Lynn, who designed it. Courtesy** *The Virginian Pilot* **and** *The Ledger-Star.*

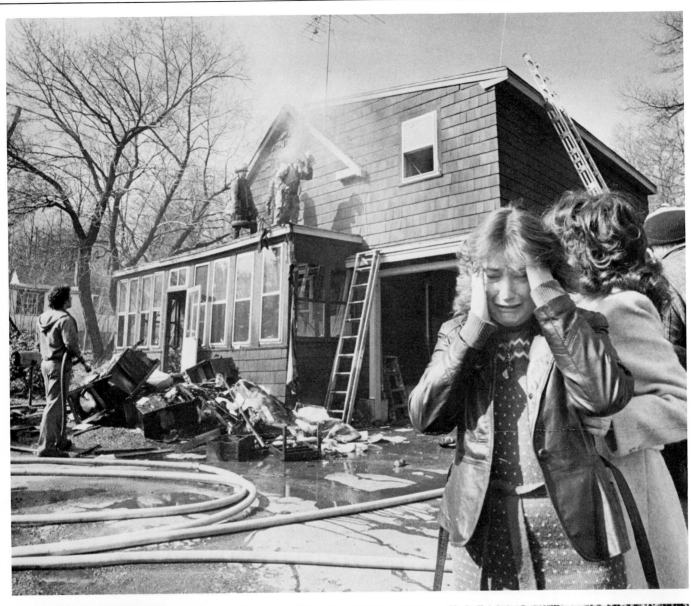

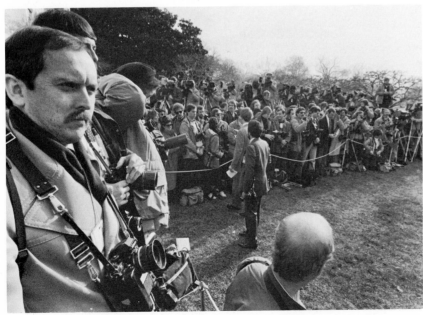

# 19 · PHOTOJOURNALISM AND THE LAW

*"We believe the agencies of mass communication are carriers of public discussion and information, acting on the Constitutional mandate and freedom to learn and report the facts . . . journalists will seek news that serves the public interest, despite obstacles . . . "*

Sigma Delta Chi Code of Ethics

To do their job, photojournalists must get the picture despite obstacles so the editor can publish it (Fig. 19.1). Photojournalists act almost instinctively on their obligation to report. Their first consideration is to report "without fear or favor." They have more rights than restrictions on their activity.

## THE LEGAL BOUNDARIES

But these are not unqualified rights. In *Contemporary News Reporting,* Dr. Douglas A. Anderson wrote:

The reporter's lot when dealing with controversial stories would be secure if the First Amendment meant precisely what it says: Congress shall make no law abridging

freedom of speech or press. That, of course is not the case. Only seven years after ratification of the First Amendment, Congress passed the Alien and Sedition Laws of 1798, the latter designed to stifle criticism of the government. Those laws expired when Thomas Jefferson took office in 1801, but more than a century later, in 1918,

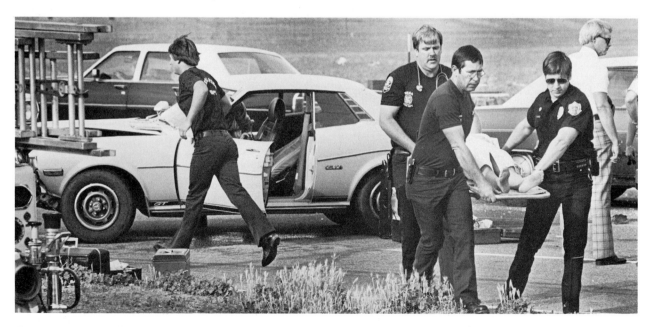

Figure 19.1: Police, fire, and rescue personnel have an important job to do and the photojournalist should not interfere. Don Stevenson used a telephoto to cover this accident. Courtesy *The Mesa Tribune.*

Congress approved another Sedition Act for basically the same reason.

The Supreme Court, in *New York Times Co.* v. *Sullivan* (1964) essentially put to death the concept of seditious libel in this country, but the courts repeatedly have held the First Amendment is not an absolute. Very simply, there are exceptions to its seemingly ironclad language.

The courts constantly are called upon to decide whether actions taken by the press are legally permissible. As the courts consider issues on a case by case basis, journalists are obligated to stay abreast of significant decisions.

Today, photojournalists have great freedom in their activities, but they can still violate subjects' rights. Often in pursuit of a hot news story they can violate those rights without knowing it. If the photographs are used for advertising or commercial purposes without the subject's permission, this could violate their right to privacy. Photojournalists must know the boundaries within which they work when photographing people. Those boundaries are of two kinds: the law, or what they *can* do, and the ethics of journalism, or what they *should* do.

In many cases, ethics and law coincide when judgment can be made clearly from both perspectives. This chapter will discuss how the law applies to photojournalism. Chapter 20 will discuss ethics.

## THE RIGHTS OF SUBJECTS

In the United States, the courts often must decide when subjects' and photojournalists' rights are at odds. In their case-by-case decisions, the courts try to create a balance between the public's right to know and the individual's right to be left alone. Thus, law applies to

**Figure 19.2: Photographing spot news on the public street is not restricted. Photo by Robert Townsend. Courtesy** *The Pittsburgh Post-Gazette.*

photojournalism by protecting members of the public against harm by false reporting or unwanted invasion of privacy.

## THE RIGHTS OF PHOTOJOURNALISTS

For news coverage, photojournalists have more protections than restrictions. However, just how much protection depends on certain circumstances. First, it depends on whether you photograph in a public or a private place. Second, it depends on whether your subject is a public official or figure, or is a private citizen.

### IN PUBLIC PLACES

Photojournalists have the right to photograph in a public place as long as no local ordinance prohibits it and they are not creating a hazard or interfering with the public's right of way. The streets, public parks, the zoo, sidewalks, municipal property and airports, public areas of schools, and similar locations open to the public are also open to photojournalists (Fig. 19.2); they can photograph public or private citizens there without permission.

Public activities of public and private citizens are the staple "people pictures" we see in newspapers and magazines (Fig. 19.3). But such excellent photo opportunities demand sensitivity. In these cases, the admonition to get full caption information must be followed. Photojournalists do not have the right to embarrass their subjects. By letting them know they have been photographed and asking for names, the photojournalist gives subjects a chance to demur if they feel the photograph might place them in a compromising or embarrassing position.

Problems can occur in public places when people try to interfere with a photojournalist. This is especially so when friends, family, or even bystanders object to photos of tragedies. However, unless photojournalists are unduly harassing someone, they have the right to photograph.

Police and fire officials do have the right to regulate photojournalists on public property. Photojournalists must not interfere with rescue operations or other activities of police or firefighters. Normally, good police relations allow photojournalists to have ready access to any public scene (Fig. 19.4). Working photojournalists are issued press passes that identify them and

**Figure 19.3: Photographing in public is allowed if local ordinances permit it and the photojournalist doesn't harass the subject. This was shot in a public park by David Longstreath. Courtesy *The Daily Oklahoman*.**

smooth the way for coverage of even the most hectic news scene.

Even if you are a freelancer (or beginner) without a press pass, you can cover public occurrences. A lot depends on the locality, but if you stay out of the way, you probably will have no problem with the police.

## IN PRIVATE PLACES

Any citizen in his or her own home is protected by law from intrusion. A citizen has the right to keep the press, or anyone, out of a home. If you photograph there, it is with the person's permission. This naturally raises problems and issues of public debate—sometimes heated debate—when news happens in a home or on private property.

Generally, public figures, by the nature of their office, fame, or by overt efforts to gain publicity, have voluntarily relinquished some of their rights to privacy. When such personages are present in a public place, or even in some private places, photojournalists have the right to photograph them.

Such personages usually don't object to photographic cover. But if they consider your conduct harassment, they may object strenuously, One example is the 1973 *Galella* v. *Onassis* ruling. Ron Galella, a freelancer specializing in celebrity photos, became obsessive in his coverage of Jacqueline Onassis. He photographed the former First Lady at all hours of the day and night. He hid in hallways and behind bushes, and

followed her and her children in cabs to photograph them in schools, on tennis courts, and even out on the water.

After years of such attention, Secret Service agents assigned to protect the former First Lady interfered with Galella. The result was a suit by Galella for interference with his trade, protected by the First Amendment. Mrs. Onassis countersued to keep Galella from photographing her and her children.

In 1973 the Second U.S. Court of Appeals rejected Galella's defense that the First Amendment protected him from any liability for his *personal* conduct while covering the news. After several appeals, Galella was found guilty of harassment and invasion of privacy, among other charges. He was ordered by the court not to approach Onassis or her immediate family closer than 50 feet (later changed to 25 feet). The courts made it clear that they were restricting Galella's personal conduct, not his right to photograph Onassis.

## PRIVATE PLACES OPEN TO THE PUBLIC

Restaurants, cafes, hospitals (Fig. 19.5), or similar private locations that cater to the public fall somewhere in between these private and public guidelines. Also, courts and government buildings have their own restrictions, although they do serve the public. The restrictions that apply to these locations are set by law, but the photojournalist can usually photograph with permission. A number of states today allow some form of photographic coverage of courtroom proceedings if the presiding judge decides to allow it (Fig. 19.6).

# ISSUES OF LIBEL AND INVASION OF PRIVACY

Each time we photograph a person, we risk possible suit for certain ways published photos are used.

## LIBEL

*Libel* is a malicious publication by writing, printing, or picture, which exposes a person to hatred, contempt, ridicule, or causes him or her to be shunned or to be harmed in business or personal reputation. *Slander* is the term used for spoken words that have the same effect.

For libel to exist, three conditions are needed: (1) the material must be published; (2) the subject must be identified, if only by inference, and (3) the material must lead to proven harm of reputation, etc. Libel *per se* is a special condition wherein a publication is so clear in its meaning that the law presumes damage must have occurred.

In most circumstances, news coverage by photo-

journalists is protected by First Amendment right of freedom of the press to report to the public. If libel is charged, truth is a defense in most cases. If the report or photograph and caption prove untrue, it must be proved that the photojournalist, editor, or publication printed the untruth knowingly, deliberately, and with malice. This protects the press from being sued for honest mistakes or even typographical errors.

Even though photographs usually depict reality and so are considered "truthful," they can place a subject in a bad light or can be made false by retouching. However, usually when published photographs are the subject of a libel suit, it is in connection with accompanying words that add a libelous tone to the photo. Such instances include:

- Captions misidentifying the person in the photograph.
- A person's photograph located on the page so as to be connected with a headline or a story that

*Above*—Figure 19.4: Shooting in private places requires owner permission. Here, a women's rugby club celebrates after a game. Photo by April Saul, courtesy *The Baltimore Sun*.

*Left*—Figure 19.5: Hospitals require permission before photographs can be taken. With minors, parents' or guardians' written permission is also required.

*Above*—**Figure 19.6: Court photography is done at the behest of the judge. Photo by David Longstreath, *The Daily Oklahoman*.**

*Right*—**Figure 19.7: Suppose that, without the subject's permission, the caption here read: "Women who have large families often lead unhappy lives, neglect the children, the husband, and the home, and turn to alcohol." That would be libelous!**

reports on some injurious or even criminal activity.

• News photographs used after they are no longer news, as illustrations for photo features. The problem arises when a derogatory headline libels the person pictured (Fig. 19.7).

## INVASION OF PRIVACY

*Invasion of privacy* is unwanted intrusion on another person's life. Many states protect this privacy by law and define it as the right of the person to live a life in seclusion, if desired, without unwanted or undue publicity.

News photographs are protected to a large extent by the First Amendment and other laws. If your photographs are used in advertising, trade endorsements, or some commercial media beyond strict news coverage, however, you need the subject's written permission. Read the sample model release from the American Society of Magazine Photographers (ASMP) (Fig. 19.8).

A model release tells how and where photos will be used, so the person who signs it is giving written consent to the conditions. It is a generally effective defense against invasion-of-privacy suits, particularly when it specifically explains how and where photographs are to be used. However, even a model release will not be a protection if the photo is retouched, distorted, or used in a manner not mentioned in the re-

# Minor Release

In consideration of the engagement as a model of the minor named below, and for other good and valuable consideration herein acknowledged as received, upon the terms hereinafter stated, I hereby grant _____, his legal representatives and assigns, those for whom _____ is acting, and those acting with his authority and permission, the absolute right and permisssion to copyright and use, re-use and publish, and republish photographic portraits or pictures of the minor or in which the minor may be included, in whole or in part, or composite or distorted in character or form, without restriction as to changes or alterations from time to time, in conjunction with the minor's own or a fictitious name, or reproductions thereof in color or otherwise made through any media at his studios or elsewhere for art, advertising, trade, or any other purpose whatsoever.

I also consent to the use of any printed matter in conjunction therewith.

I hereby waive any right that I or the minor may have to inspect or approve the finished product or products or the advertising copy or printed matter that may be used in connection therewith or the use to which it may be applied.

I hereby release, discharge and agree to save harmless _____, his legal representatives or assigns, and all persons acting under his permission or authority or those for whom he is acting, from any liability by virtue of any blurring, distortion, alteration, optical illusion, or use in composite form, whether intentional or otherwise, that may occur or be produced in the taking of said picture or in any subsequent processing thereof, as well as any publication thereof even though it may subject the minor to ridicule, scandal, reproach, scorn and indignity.

I hereby warrant that I am of full age and have every right to contract for the minor in the above regard. I state further that I have read the above authorization, release and agreement, prior to its execution, and that I am fully familiar with the contents thereof.

Dated: _____

_____      _____
(Minor's Name)          (Father) (Mother) (Guardian)

_____      _____
(Minor's Address)          (Address)

_____
(Witness)

**Figure 19.8: Any use of a minor's photo for commercial purposes requires a written consent form from parents or guardians. Courtesy ASMP.**

**Figure 19.9: A photo for a feature on the first day of school does not require written permission. But if it were used in an ad for this child's brand of clothes without written permission, it could lead to an invasion-of-privacy suit.**

lease. Think of a model release as a contract that assures your subject that he or she will not be exploited. The release is one way to protect a subject's right of privacy. It is also a way to protect the subject from commercial exploitation by the photographer (Fig 19.9).

## BACKGROUND

United States law has great respect for the rights of individuals, but it was not until the turn of the century that the concept of privacy as a right of law was presented, in reaction to some of the excesses of the so-called "yellow press" of that era. In an 1890 *Harvard Law Review* article, attorneys Samuel D. Warren and Louis Brandeis (who later became a Supreme Court Justice), argued that the abuses of the press called for the courts to recognize citizens' right of privacy. They

argued for legal and governmental defense for private citizens against invasion of privacy by the press. Up to that time, no right of privacy law had existed.

## ROBERSON v. ROCHESTER FOLDING BOX CO. CASE

It took a court decision against privacy to lead to laws guaranteeing privacy. In 1902, the case of *Roberson* v. *Rochester Folding Box Co.* was heard by the Supreme Court of New York. The case involved the reproduction of a likeness of a celebrity, Miss Roberson, on posters and magazine advertisements for Franklin Mills Flour. Roberson sued for damages against the unwanted publicity.

In its decision, the New York court denied that a right of privacy existed and held that no legal right had been violated. The decision evoked great criticism by the public and even by the press itself.

Controversy over implications of this decision led to enactment of a New York law of privacy. In the ensuing sixty years other state legislatures followed New York's lead and enacted similar right-of-privacy laws against using a person's likeness or name for "advertising or trade" without written consent. Also, in some thirty other states without a law of privacy, the courts have said that right of privacy is enforceable by courts on a case-by-case basis. In these states, the courts base their decisions on whether the use offends the sensibilities of an ordinary person. Either approach uses the power of the courts to protect people against commercial use of their photograph without their express permission.

## LANDMARK GUIDELINES

It is impossible to get a model release from everyone, and in news coverage a release is not needed, so exactly when is it necessary, and under what circumstances?

A general answer to this question was provided in the 1937 *Lahiri* v. *Daily Mirror* decision in New York. This decision gave specific guidelines for judging invasion of privacy cases in New York that have been followed on a case-by-case basis ever since.

The case grew out of a right-of-privacy suit by a Hindu musician, Lahiri, against the New York *Daily Mirror*. The *Mirror* had published a story illustrated by a photograph of Lahiri as he performed his "rope trick." He sued for invasion of privacy under the New York statute.

New York Supreme Court Justice Shientag decided that Lahiri's privacy had not been invaded because the photograph was published "in connection with an article of current news." But Justice Shientag went further than the particular case and provided four specific rules for recovery of damages. These rules have been applied to such cases involving photographs ever since in New York and in some other jurisdictions:

1. Recovery under the statute may be had if the photograph is published in or as part of an advertisement or for advertising purposes.
2. Recovery may be had if the photograph is used in connection with a work of fiction.
3. No recovery may be had if the photograph is published in connection with an article of current news of immediate public interest.
4. No recovery may be had, as a general rule, if the article is educational or informative in character.

Justice Shientag clarified rule 4 by stating: "Such article includes, among others, travel stories, stories of distant places, tales of historic personages and events, the reproduction of items of part news and surveys of social conditions . . . as a general rule such cases are not within the purview of the statute." In the years since, the courts have said that rules 3 and 4 may constitute invasion of privacy if the photograph has only a tenuous connection with news or educational items or if it might "outrage common ordinary decency."

Other jurisdictions have patterned decisions on New York's four rules. This gives photojournalists working in the news or educational fields a great deal of latitude.

# LEGAL PRECEDENTS

Our discussion so far has been general enough to give you some basic background. However, there are still many unanswered questions regarding photojournalism and law. And the situation changes as new court decisions refine the important balance between the public's right to know and the right of the individual subject to his or her own life (and often to a fair trial).

Stuart Kahan, co-author of the book *Photography: What's the Law?* says, "If legal advice is required or when in doubt as to what law applies in your locale, the services of a competent professional should be sought."

## RIGHT OF PRIVACY RULINGS

According to Kahan, there are only six states that have a right-of-privacy statute. To a photojournalist working in those states, this means that the photojournalist will be guided by the wording of the specific statute when it comes to whether or not an invasion of privacy claim would be successful. The states without such a statute have court-enforced regulations. Privacy actions in these states are generally guided by the rules of good taste; in other words, the use of the photograph shouldn't shock one's sensibilities. A good barometer would be to determine if the use of the photograph tended to ridicule someone.

However, each state operates differently. For example, in New York, the law depends on whether the photograph is being used to advertise or for purposes of trade. In any case, the use of a person to advertise a specific product must be accompanied by a release. In the Galella-Onassis case, Galella had been sending out Christmas cards to many of his clients that included a picture of Mrs. Onassis on one side and Galella's name, address, and phone number on the other. The court ruled that this amounted to advertising for Galella and, therefore, Mrs. Onassis had grounds for an action under the New York statute.

A photo used for advertising or for purposes of trade is primarily used in a strictly commercial way. In *Dallesandro* v. *Henry Holt & Co.,* the court found that a dockworker's photograph was being used without his permission on the cover of a book of nonfiction and as such did not fall within the advertising purview of the New York statute, nor within the parameters set forth under the statute respecting purposes of trade. However, if the book had been *fiction* and the same photo of the dockworker had been used in exactly the same way, it would have been actionable because it would have been seen as the commercial use of a person's picture pursuant to the statute. There would have been a connection between the picture and the theme of the book.

In the matter of photography used in current news or immediate public interest, Kahan cites the recent Arrington case in New York. A freelance photographer was sued for invasion of privacy because of a photograph that was used on the cover of a New York *Times Sunday Magazine* issue. The court cleared the *Times,* but found that the photographer was guilty of invasion of privacy notwithstanding the editorial use of the photograph. The court reasoned that the photographer was selling the photograph and therefore had a commercial purpose. But this decision was corrected by the New York Legislature which passed a law bringing the right-of-privacy statute back to where it was prior to the court's decision.

Thus, photographs used for illustration of a newspaper or magazine article are protected under "immediate public interest" and press privilege. However, *Graham* v. *Daily Times* is a prime example of a rule of the court application. The photo showed a woman's dress being raised by a gust of air, so the court decision turned on the question of humiliation, ridicule, and scorn, stating that the public was not entitled to see under the woman's dress.

Essentially, rule-of-court decisions are guided by

# Assignment Confirmation/
# Estimate/Invoice Form

**FROM:**            **TO:**

Date:
Subject:
Purchase Order No:
Client:
A.D./Editor
Shooting Date(s)
Our Job No:
☐ Assignment Confirmation
☐ Job Estimate
☐ Invoice

## Expenses

**ASSISTANTS** ———
**CASTING**
  Fee/Labor ———
  Film ———
  Transportation ———

**FILM & PROCESSING**
  Black & White ———
  Color ———
  Polaroid ———
  Prints ———

**GROUND TRANSPORTATION**
  Cabs ———
  Car Rentals &/or Mileage ———
  Other ———

**INSURANCE**
  Liability ———
  Other ———

**LOCATION SEARCH**
  Fee ———
  Labor ———
  Film ———
  Transportation ———

**LOCATION/STUDIO RENTAL**
**MESENGERS & TRUCKING**
  Local ———
  Long Distance ———

**SETS/PROPS/WARDROBE**
  Set Design Fee ———
  Food ———
  Materials ———
  Props ———
  Set Construction ———
  Set Strike ———
  Surfaces ———
  Wardrobe ———
  Other ———

**SPECIAL EQUIPMENT**
**SPECIALIST ASSISTANCE**
  Electrician ———
  Hairdresser ———
  Home Economist ———
  Make-up Artist ———
  Stylist ———
  Other ———

**TALENT**
  Adults ———
  Children ———
  Extras ———
  Animals ———

**TRAVEL**
  Air Fares ———
  Meals ———
  Hotels ———
  Overweight Baggage ———

**MISCELLANEOUS**
  Gratuities ———
  Shoot Meals ———
  Toll Telephone ———
  Other ———

**EXPENSE TOTAL** ———

## Photography Fee(s) & Totals

                 $

**PRINCIPLE PHOTOGRAPHY (BASIC FEE)** ———
($_____ per day or photograph, if applicable)

**DESCRIPTION**

**SPACE &/OR USE RATE (IF HIGHER)** ———
($ per page: $ per cover: $_____ per photo)
**TRAVEL &/OR PREP DAYS** (at $ per day) ———
**PRODUCT OR SUBSIDIARY PHOTOGRAPHY** ———
($ per photograph)
**POSTPONEMENT/CANCELLATION/RESHOOT** ———
( % of orig. fee)
**WEATHER DAYS** (at $ per day) ———

**TOTAL FEE(S)** ———
**TOTAL EXPENSES** (see 1st column) ———
**FEE PLUS EXPENSES** ———

**SALES TAX** (if applicable) ———

**TOTAL** ———

**ADVANCE** ———

**BALANCE DUE** ———

## MEDIA USAGE

| ADVERTISING | | EDITORIAL/JOURNALISM | |
|---|---|---|---|
| Animatic | ☐ | Book Jacket | ☐ |
| Billboard | ☐ | Consumer Magazine | ☐ |
| Brochure | ☐ | Encyclopedia | ☐ |
| Catalog | ☐ | Film Strip | ☐ |
| Consumer Magazine | ☐ | Newspaper | ☐ |
| Newspaper | ☐ | Sunday Supplement | ☐ |
| Packaging | ☐ | Television | ☐ |
| Point of purchase | ☐ | Text Book | ☐ |
| Television | ☐ | Trade Book | ☐ |
| Trade Magazine | ☐ | Trade Magazine | ☐ |
| Other | ☐ | Other | ☐ |

| CORPORATE/INDUSTRIAL | | PROMOTION & MISC. | |
|---|---|---|---|
| Album Cover | ☐ | Booklet | ☐ |
| Annual Report | ☐ | Brochure | ☐ |
| Brochure | ☐ | Calendar | ☐ |
| Film Strip | ☐ | Card | ☐ |
| House Organ | ☐ | Poster | ☐ |
| Trade Slide Show | ☐ | Press Kit | ☐ |
| Other | ☐ | Other | ☐ |

Subject to all Terms on Reverse Side—Which Apply in All Cases Unless Objected to in Writing by the Sooner of the First Shooting Day or Ten Calendar Days. Usage Limited to Reproduction Rights Specified

Client Signature: ————————————

**Figure 19.10:
A written agreement is the professional way to contract for photographic work. Courtesy ASMP.**

rules of good taste. This is a broad criterion, especially in today's permissive society. Since each state operates on its own, one has to be careful not only in the photograph itself but in the way it is used with the copy that accompanies the picture. Also, each of these rules is interpreted differently depending on whether a subject is a "public" or a "private" person. Public persons get shorter shrift than private persons, although this is an extremely tricky area that changes almost daily. Basically, as Supreme Court Justice White stated, the interest of privacy fades when information appears publicly.

Kahan also discusses questions about *specific* actions of the photojournalist: "You can't march into a private place and photograph without consent. That is trespassing." If a story involving an accident, fire, or shooting takes place in the backyard of a private home within public view, a photojournalist can photograph the scene from the street, over a fence, or with an extremely long lens. Yet, the photographer must still be careful as to *what* is photographed. For example, it is unlawful to photograph defense installations without prior approval and, of course, one must obey local ordinances.

If the news event occurs inside a private home, the news photojournalist must be invited in to take photographs—and you must be careful how you use them. State laws govern such usage notwithstanding what may appear to be a "current newsworthy event."

## LIBEL

Kahan stresses that libel and invasion of privacy "frequently join hands in the same action." Libel is deemed an injury to one's reputation, while invasion of privacy is an injury to one's right to be left alone. The best way to protect yourself from liability for libel is to caption every photograph and print that you make. Then, if the ultimate user of the photograph miscaptions or deletes your caption, you will not be responsible for any libel which may eventually occur, unless the photograph is libelous *per se*.

## SELF-PROTECTION

It is important to know who owns your photographs. If you are a staff photographer, your work is automatically owned by the employer. If you are a freelancer, you own your work unless there is a signed agreement to the contrary. You should have the signed agreement before you do the work (Fig. 19.10). Any work that is initiated by a freelance photojournalist is also owned by the photographer. "Only you, the photographer, have the copyright on what you create and only you, the photographer, can determine how you will dispose of it," says Kahan.

Currently, on works created after January 1, 1978, the term of copyright is the life of the author plus 50 years. It covers all areas and serves to protect you against the copying of your work without permission. A copyright exists from the moment you snap the shutter, but you can also formally register the work at the Library of Congress in Washington, D.C. Registering a copyright is simple; all you need do is request the copyright kit from the Copyright Office, Library of Congress, Washington, D.C., 20559.

Having considered these general points about the law, let's turn to the matter of *ethics*.

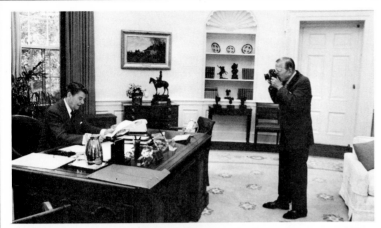

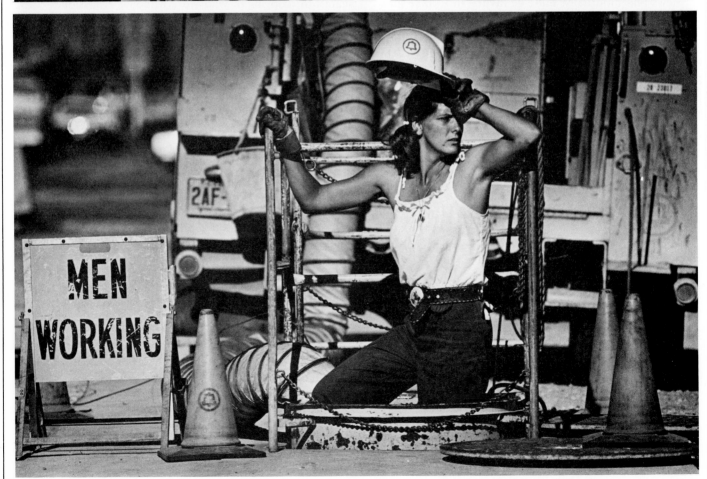

# 20 · ETHICS

*Ethics the discipline dealing with what is good and bad and with moral duty and obligation. . . . the principles of conduct governing an individual or a group. . . . "*
Webster's New Collegiate Dictionary

If court decisions set some bounds on what photojournalists can or cannot do, then journalistic ethics set personal bounds for what photojournalists should do under certain circumstances.

Readers often perceive certain photographs as morally "good or bad"; as shocking, distasteful, or unneccessary intrusions into private lives. They often judge photojournalists as wrong for covering tragic or shocking stories.

However, photojournalists perceive the taking of these same photographs as within their professional ethics. Principles of conduct governing their work make such coverage a necessary part of news that informs the public. With this attitude photojournalists can decry the tragedy while seeing a duty to picture it. In this chapter we will discuss this dilemma of photojournalistic ethics on assignments where these two views conflict.

Given the adversary role of the press in the United States, there are times when law and ethics conflict. When this happens on specific cases, members of the press may face the choice of either breaking the law or reporting the news. Such dilemmas are very special cases; we are dealing here only with general principles. Also, the ethics of special interest publications that cater to scandal, sex, or other topics are not considered here.

So far we have emphasized the photojournalist's job to "get that picture, no matter what." This assumes that we do so professionally, with sensitivity to our subjects' feelings. There is little problem when the subject is of the "happy news" variety and subjects allow, even welcome, us to photograph them. But the reality is that much news involves violence, suffering, death, and the photojournalist must cover it.

This type of news is unpredictable at best and happens so fast that photojournalists have to react by instinct. There is often no time to decide what the law says or to overtly sympathize with subjects. This leads photojournalists to intrude on the grief of subjects and to get photographs that can shock readers when they see them in print. On assignments such as fires, accidents, drownings, and similar tragedies, photojournalists can feel, and indeed be treated, as unwelcome intruders who are exploiting tragedy.

Indeed photojournalists *are* outsiders picturing the private grief or suffering of others, and at tragic scenes the photojournalist's sensitivity is tested (Fig. 20.1). In many instances, the law says we have the right to photograph a suffering, even dying, human being as he or she lies in public view as long as we don't interfere with police and rescue officials or harass the subject.

Our own feelings or ethics, and possibly the verbal or physical barriers of bystanders, often cry to refrain from taking pictures. Many photojournalists have covered such scenes with tears in their eyes, and have asked themselves the question, "Why am I here?" The responsibilities of the press and the rights of the subject seem to conflict.

What is the right thing to do? Would it be better (or more ethical) not to take the photograph in tragic situations? Or are professional privilege and ethics so sacrosanct that we always take the photograph regardless of personal feelings or tragic circumstances? Once the photograph is taken, do we always publish it? Does the public have to know so much detail about a tragedy? Every day, photojournalists and editors have to decide story-by-story the answers to these basic questions.

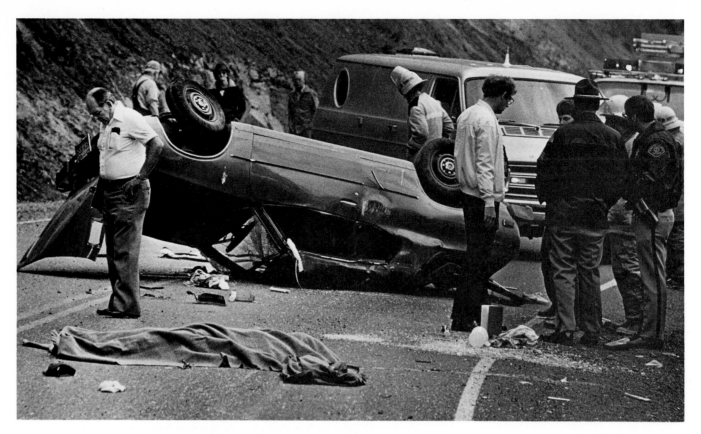

**Figure 20.1: When tragedy strikes, the photojournalist, while still feeling for the subjects, goes on working. Photo by Brian Drake. Courtesy *The Longview Daily News*.**

# THE TRAGIC PHOTO

A photograph by C. W. McKeen of the Syracuse *Herald-Journal* that won third place in the monthly NPPA Clip Contest illustrates the range of opinions aroused by the publication of a spot news photograph (Fig. 20.2). The caption accompanying the photo and story in News Photographer Magazine is reproduced here.

> Rescuers cradle a Syracuse, N.Y., utility worker, Howard Root, after pulling him from a flooded water main access hole where he had been trapped for about 30 minutes. Root was no longer breathing and his heart had stopped. Rescuers revived him using cardiopulmonary resuscitation and artificial ventilation enroute to the hospital. Root had been removing bolts from a faulty valve on a 48-inch main about 12 feet below the surface. A valve cover blew off and the hole instantly filled with near-freezing water.

McKeen and another staff photographer covered the rescue operation. While the other photographer stayed close to the rescue operation, McKeen crossed a creek to shoot from the other side. As he ran to the other side, he worried that he might miss the rescue. He was convinced that Root was dead and wondered whether he should even take a picture, because his newspaper did not use body pictures. He decided to photograph the scene anyway.

Back at the office, McKeen turned in a photo showing water gushing out of the broken pipe. He also put three prints of the rescue into an envelope with instructions not to open unless Root was going to live.

The morning paper ran the photo of the water main. The next day, at deadline for the afternoon paper, Root was still alive. The decision was made to run the rescue photo in the second section of the *Herald-Journal* to avoid the appearance of sensationalism.

Meanwhile, McKeen says he is still trying to decide whether he made the right decision:

> The bottom line is geography. If it's in Beirut, that's OK. But if it's in Syracuse, that's sensationalism. I'm just photographing what's going on in the community. Just because [the photo] gives you a twinge doesn't mean you shouldn't use it.

However, many readers felt it *was* sensationalism. "All you people care about is the God-almighty dollar," one caller said. She insisted that the paper had run the picture just to sell papers. Root's cousin wrote

that the *Herald-Journal* and two television stations, WTVH and WIXT, "chose to sensationalize the whole story." Another writer, urging that the paper "show a little more sympathy," said publication of McKeen's picture had a "devastating effect on Root's relatives." McKeen himself said he feels guilty about "messing up the family."

Yet a Syracuse University dean supported the newspaper, writing:

There was a constructive, hopeful element of people trying to help in that photograph. When people criticize the press, it's frequently because they read or see something they don't like, or which upsets them. . . .

Intelligent, vigorous and independent journalists should be honored in our society as vital supporters and implementers of the democratic way of life.

In a "View from the Newsroom" column, the newspaper's managing editor, Timothy Bunn, described the photo as a "most vivid and dramatic image of humankind at its best. In it we saw our firemen and policemen working frantically to save a fellow human being. . . . And we did what professional news editors do. We presented it to our readers."

Bunn said he was sorry if the family's pain ran deeper because of publication of the picture. A caller's question, "How would you like it if it was one of your relatives?" still haunts him. "I hope," Bunn concluded, "it haunts all the editors I work with. If it doesn't, they have no place in this business."

## WHO IS RIGHT?

The reaction to McKeen's photograph is typical. When a newspaper or newsmagazine publishes such a photograph, the result is a spate of pro and con letters to the newspaper. Readers who decry such photographs of news happenings are right to sympathize with the victims. However, they seem to impute nefarious motives to the press for doing its job. Photojournalists and editors are right, too, within legal bounds, to publish what happens. The photojournalist who covers such a "horrible" story and captures it graphically is acting professionally and within the ethics of photojournalism.

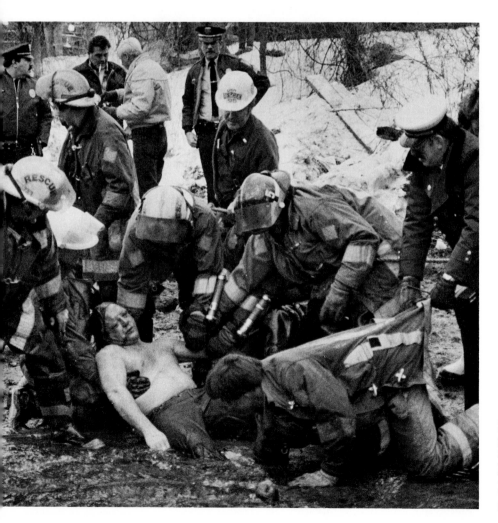

Figure 20.2: A rescue photograph can evoke strong reactions in the question of photojournalistic ethics. Photo by C. W. McKeen. Courtesy *The Herald Journal*, Syracuse Newspapers.

# THE HAPPY PHOTO

In a similar news situation with a happy ending, the public response was laudatory. When Tim Rogers, of *The Arizona Republic*, pictured a firefighter cradling an infant in his arms after an automobile accident, (Fig. 20.3), one letter-writer wrote:

> Firefighter Bill Shields of Station 1 cuddling tiny Cassandra Serna after an auto accident is a portrait of tenderness and compassion rarely captured on film. Tim Rogers, *Republic* photographer, is to be congratulated for recording this poignant moment.

By now you can see that there is no absolute answer to how ethics are applied. Photojournalists and editors know that their obligation is to report what happens. They can't protect the readers from the tragic realities of life, but they know that the tragic photographs will cause shock and perhaps add misery to the family of those depicted. It is not an easy decision and each story is judged on its own merits. The primary decision about how to cover tragedy is made on the scene, by the photojournalist.

# THE PHOTOJOURNALIST : ON THE SCENE

The photojournalist's role on the scene is dictated by the cornerstone of photojournalistic ethics—to get the picture despite any obstacles.

In general, it is not the photojournalist's job to decide whether to photograph or not. He or she is just too close to the drama and tragedy to know whether the photograph is in bad taste or is in reality an important news story that the public should know about. McKeen's action at the rescue site was a perfect example of this. Later, the editor (or the publication's attorneys, if need be) can decide on whether the photo is invasion of privacy, libel, or even "in good taste."

Yet, often the first thought of the beginning photojournalist—and rightfully so—is to sympathize with the subject and to decide not to photograph. But the responsibility is clear—if it is news, a photojournalist has the obligation to report it regardless of personal reaction. Here the old adage "shoot first and question afterwards" is a good policy.

Max Jennings, Executive Managing Editor of the Mesa *Tribune*, says:

> Yes, I expect photographers to shoot the pictures when they roll on a story and leave it to the editors whether to print them. This does not mean I want the photographer to be insensitive to what he or she is shooting.
>
> For example, if the carnage at the scene is awful, obviously too rough to print, the photographer should think of other ways to tell the story. Sometimes a sheet-draped figure has to be printed instead of the mutilated body. But I certainly wouldn't want the photographer to come back and say he or she didn't shoot the picture because it couldn't be printed.

The history of photojournalism is filled with examples of photographs of sensational subjects, violent scenes, or suffering. The photojournalists who shot these scenes acted instinctively on the obligation to report to the public. Other photojournalists, who may

have hesitated or backed away because of interference by others, or even their own sensibilities, were simply not doing their job. The fact that photographs can often be shocking is part of the burden of being a pho-

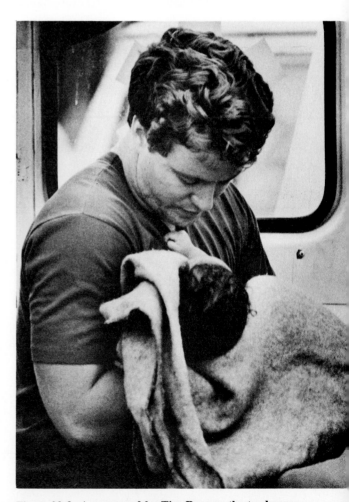

**Figure 20.3: As captured by Tim Rogers, the tenderness shown by firefighter Bill Shields drew praise from readers. Courtesy *The Arizona Republic*.**

tojournalist. There are many such assignments where events happen so fast that the photojournalist acts on instinct. It is not until later that they can show emotion over what has been photographed.

## COMPASSION OVER COMMUNICATION

It is rare when a photojournalist decides not to shoot a photograph. But when it does occur, there is usually a very strong and emotional reason.

One strong reason not to photograph is that you are the first to arrive, or when rescuers need help. Then it is more important to help victims—and forsake photographing—until the victims are safe or fire and rescue personnel arrive.

This situation was addressed when a young photojournalist, Michael Okoniewski wrote an open letter to *News Photographer* magazine:

I was driving home at night when I heard a call over the scanner about a personal injury auto crash. Upon arriving at the scene, I decided not to take photos since it was "just another one." Instead I began to watch the Syracuse (N.Y.) Fire Department Rescue Company workers to see in detail the little things that go on at an accident scene [Fig. 20.4]. . . .

About 10 minutes after the crash, the first ambulance left with a victim. Another was en route for the other victim. Suddenly, rescue worker Joey Singleton grabbed my arm. Pointing up the street, he said "Mike, what's that up there? . . . "

I ran the two blocks along with a city cop. When we arrived, I couldn't believe my eyes. It was an Eastern Ambulance rig on its side burning. It had been rammed by a car at the intersection. The cop and I both thought it was the rig from the first scene and that the driver, medic and patient were still inside.

We checked and no one was in the rig. The medic was crawling away from the wreck. We grabbed the driver

**Figure 20.4: Helping instead of photographing, Michael Okoniewski helps rescue workers. Photo by Carl Single. Courtesy Syracuse Newspapers.**

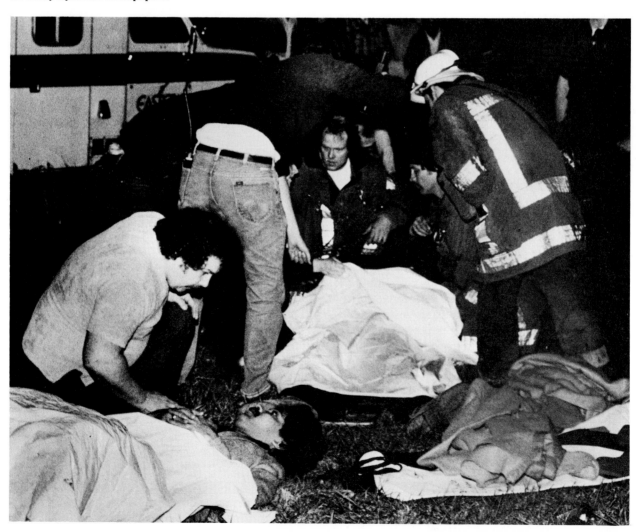

while another cop helped the medic. Right then I thought, "I can't believe this is happening. I should be photographing all of this. . . . "

Then the rig exploded. The telephone pole with a transformer caught fire and next the transformer exploded with the wires burning. The cop, the driver, and I were underneath the wires. I honestly thought, "This is it. . . . "

Again, I thought I should be taking pictures. But it seemed like there was so much to do. I was still listening to my scanner (cranked up as far as possible). The only two other rigs available were 10 to 15 minutes away. Again I said to myself that I wasn't going to take any pictures, that it wouldn't be right because the rescue workers were extremely short-handed at the scene. . . .

When another off-duty photographer, Carl Single, showed up to take photos, for a moment I wanted to punch him. "Who would want to take photos of this?" I thought. Yes, these thoughts went through my mind. The proverbial shoe was on the other foot. Only briefly, but it was there. . . .

What do you do when you are "first in"? When do

you stop and back off? I really hope it never happens to me again. I like having that shield we refer to as a camera in front of my face. I really wonder what other photographers have done or would do.

Okoniewski added a postscript after he talked the situation over with members of the rescue squad. He found that his reaction had been typical of their reactions, even to wanting to hit the other photographer. One rescue worker added, "How can you fault yourself for not taking a picture when you also have to help another human being? I think what you did was right, in being human first. So you missed recording the event. There will be others. At least you helped. . . . "

Of course, when someone is already at the scene delivering the needed help, the photojournalist can proceed to cover the story. But he or she must be prepared to be regarded as taking advantage of the misfortunes of others.

# SHOOTING TRAGIC SCENES

It is often very difficult to take pictures where people are suffering or mourning. Few photojournalists enjoy such assignments. The best feel a great degree of compassion for the people they photograph. But they still must get the shot, even at the expense of personal feelings, or the record is lost forever. The solution to this delicate situation is to shoot, but to do so as unobtrusively as possible. You can use the entire-to-detail approach or the snapshot, or sneak-shot approach, or a combination of the two.

## ENTIRE-TO-DETAIL APPROACH

As soon as you come within a block or so of the scene, take an entire shot. Then continue to shoot every few yards until you are at the scene. This gives you a shot to use in case something, or someone, stops you from photographing closer. It also prepares you psychologically. You are already covering the scene, and so are not just starting when you arrive close. In addition, this gives you a series of photographs in ascending order of shock.

On a neighborhood shooting story, this approach gives you (1) the street where it happened; (2) the house where it happened showing people and police around; (3) the victim and others; (4) closer shots of the victim. This allows you to have full coverage in an ascending order of shocking details, and gives the editor a choice of photographs.

## SNAPSHOT APPROACH

When you arrive at the scene, it is often enough to take a few photographs without raising the camera to your eye (Fig. 20.5). Guess the distance and shoot "from the hip." With these few "sneak shots" as a back-up, you can then decide whether to take more photographs.

A combination of these two approaches, or the use of a long lens (Fig. 20.6), are compromises between the ethics of photojournalism (to get the photograph) and your personal feelings of sympathy for the subjects of a tragic scene. Most situations can be covered with one or two shots. More shooting is often visible intrusion on the grief of the subjects.

# THE EDITOR'S VIEW

The editor naturally views photographs of tragedies, violence, or suffering from a different perspective than the photojournalist—as a gatekeeper between the pho-

tojournalist and the public. Especially concerning tragic stories the editor asks: "Does the public need to know this much?" Each publication has its own un-

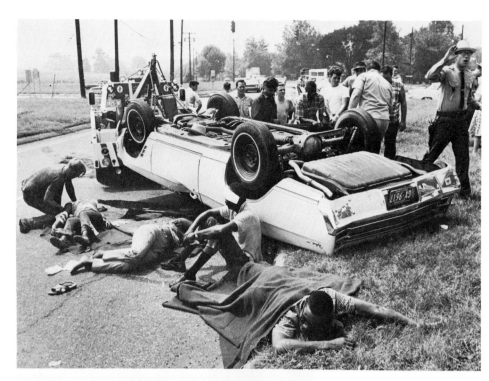

Figure 20.5: This ''from the hip'' shot was made on arrival at the scene, without the camera being raised to the eye. Courtesy *The Washington Post*.

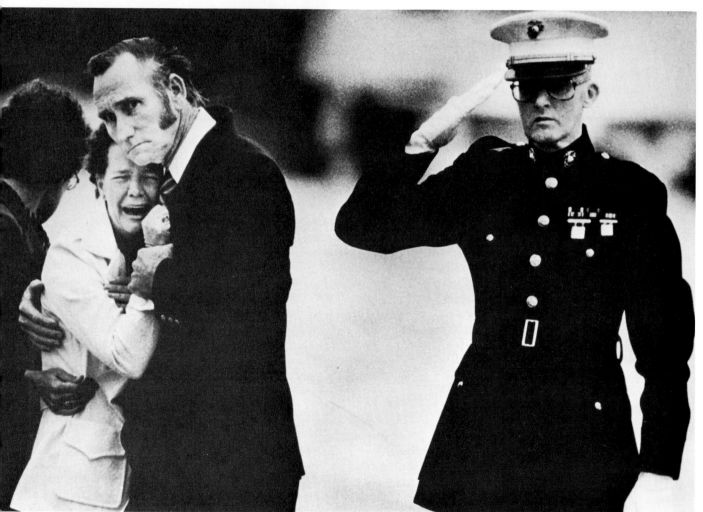

Figure 20.6: Parents grieve over the body of their son, a marine killed in Beirut. Photo by Jim Bryant. Courtesy *The Florida Times-Union*.

written policy to guide editors and staffers on the ethics of day-to-day decisions on news such as suicide, drowning, rescue efforts, shootings, and survivors of a tragedy.

Max Jennings addressed some of the questions surrounding such news. He concentrated on the *Tribune*'s approach to suicide coverage, but his remarks apply to other tragedies. He writes:

On suicides, we try to apply the same broad standards of news judgment we apply to other stories, but with special considerations.

For example, there's a big difference between one person hanging himself in his bathroom and another jumping from the freeway bridge onto a crowded highway. . . . In the first instance, we elected not to cover the story, and in the freeway case, we ran a picture of the covered body on the freeway with investigators on the scene. Our reasoning was that the event was witnessed by hundreds of passersby; it disrupted freeway traffic; it was news.

We had another instance of a double suicide in Mesa, however, which was not as easy to call. An elderly couple in failing health carefully prepared all paperwork and financial records, left notes to loved ones and took sleeping pill overdoses. Our city desk elected not to use the pictures of the bodies being removed. I disagreed with that judgment call. . . . I think that particular story was news because they chose to die together, and because society had not taken care of them. . . . My judgment was if that's the kind of community we have, or if that's the way we treat our elderly, then we need to say so. . . .

The most controversial picture we have used since I have been an editor was of a 19-year-old youth who hanged himself from a tree on a public school playground on the weekend. . . . A decision was made to print the picture of the police officers looking at the body, and to show the body from the waist down. The head was not shown (Fig. 20.7).

Again, the decision to run the picture was based on the idea that the event had attracted public attention because it was in a highly public place and had been witnessed by probably more than 100 persons. The photograph told the story but did not reveal objectionable detail.

**Photo 20.7: A subject of horror was reported with a minimum of graphic detail when *The Mesa Tribune* cropped to hide the suicide's face. Photo by Don Stevenson.**

There are times when suicides are news and when they are not. If the mayor kills himself, that's news; if an unknown person kills himself in the privacy of his home, that may not be. These kinds of judgments are made every day on other types of stories, and deciding whether to carry pictures relating to suicides requires the same kind of judgment as that used in most other types of news coverage.

# STAYING OUT OF THE WAY

David Longstreath once responded to a police call on a car accident. A teenage boy had driven his new car into a lake and had drowned. When Dave arrived at the scene, a young woman, a friend of the victim, was crying over the tragedy (Fig. 20.8). Dave says:

I immediately got out my 400mm lens and started shooting. The car was still submerged in the lake, so there were no photos of that, so I decided to focus on the girl and

show her reactions. Thanks to the long lens, I was never in the way or involved physically in the scene.

Don Stevenson was called out to cover a shooting in a tavern in Mesa and arrived just as the paramedics did. The police on the scene kept Don out of the front door because there was still an armed suspect in the vicinity. So Don entered through a side door where another officer allowed him to remain. Don recalls:

**Figure 20.8: A 400mm lens captured the shock of a young woman who watched her boyfriend drown. Photo by David Longstreath. Courtesy** *The Daily Oklahoman.*

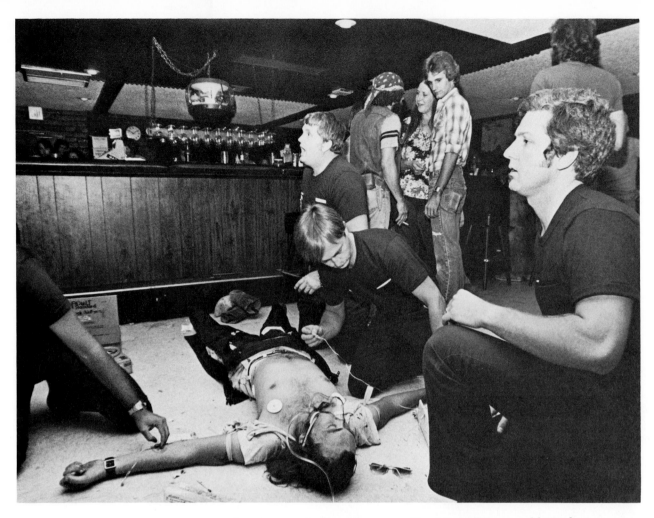

**Figure 20.9: A tavern shooting was covered on the scene by Don Stevenson with some persistence and know-how. Courtesy *The Mesa Tribune*.**

I spotted my photo immediately in the dark bar. A wounded man was spread out on the floor surrounded by paramedics [Fig. 20.9]. I also wanted to show that there were still bar patrons sipping their drinks as though nothing had happened. Although I had a few choice words from friends of the victim, I was not stopped from photographing. I continued to shoot as the victim was carried out to the waiting helicopter.

Covering spot news sometimes requires staying out of the way, to avoid either showing insensitivity to people in distress or endangering oneself—as Longstreath's and Stevenson's stories illustrate.

## "PACK" PHOTOJOURNALISM

When some major happening gathers large numbers, even hundreds, of photojournalists to the scene, the situation is quite different. The crowds of photojournalists literally become a "pack" and compete with each other for a photograph. This can lead to chaos.

But more importantly, when the news is of a tragic nature, the behavior of at least some in the "pack" can override the feelings of the subjects and turn the scene into a brawl that embarrasses many press professionals.

In 1984, a heavily armed man went on a 90-minute rampage, slaughtering some 20 people and wounding 17 others. Its coverage is a classic case of the ethical problems presented by "pack" coverage of tragic news.

The shooting was the worst by a single individual in United States history. The story made the front pages of most United States newspapers, and millions of readers around the world followed the story in words and photographs. The perennial question applies to this shocking story: "How much should the photojournalist show and how much should the editor publish?" The story was really in two parts: the shooting itself, and the subsequent funerals of victims.

The coverage of the shooting scene itself naturally posed problems, but wakes and funerals of the victims posed even more. The shootings had been covered by

relatively few photojournalists. But in the days after, the story drew crowds of press to the scene. Coverage became "pack" photojournalism.

Coverage of the wakes and funerals of the San Ysidro victims clashed with the private grief of family and friends (Fig. 20.10). The number of photojournalists grew to as many as fifty or more at the graveside three days after the shootings. Pushing, crowding and the general chaos of the pack made the ceremonies undignified public events.

AP's Dave Longstreath tried to make the best of the situation by using two approaches. First, he tried to suggest some ground rules for the still photographers. Second, he used a long, 400mm lens and stayed back. This worked well at uncrowded services, but the situation eventually got out of hand. The worst scenes occurred inside the churches during funerals and at the graveside. Longstreath says:

Any 'ground rules' we had established were off, and it was chaos. When an older woman mourner fell on the steps, she was immediately surrounded by a pack of photojournalists. I saw what we looked like . . . here was an accident

not connected with our story, and it turned into a circus. . . . At graveside, it became worse as press competed with family and friends for space.

Longstreath felt he had to be in the crowds of photographers to record this news. However, he showed compassion for the mourners by staying back, using a long lens, and not using a motorized advance. His photos still had emotional impact and told the story.

Longstreath covered the San Ysidro event with the same courtesy he showed the woman in Figure 20.8. Of the "pack," he says: "It will take a long time to forget the agony and grief of the subjects of my camera. It will also take a long time to forget the lack of sensitivity some photojournalists showed."

Ethical questions have no absolute answers, but this discussion introduces you to some opinions on covering tragedy. In their work, photojournalists must cover the news and see and photograph sights that shock, but they should never lose feeling for the subjects. To balance news coverage with sensitivity for people is the meaning of photojournalistic ethics.

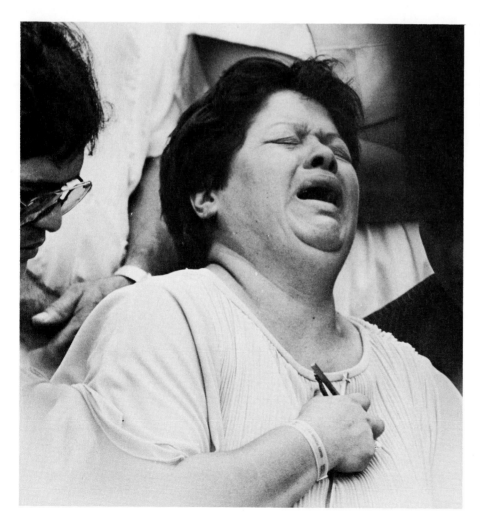

**Figure 20.10: Grief in the aftermath of random murders at San Ysidro in 1984 was captured amid the chaos and pressure of "pack" photojournalism. AP/Wide World photo by David Longstreath.**

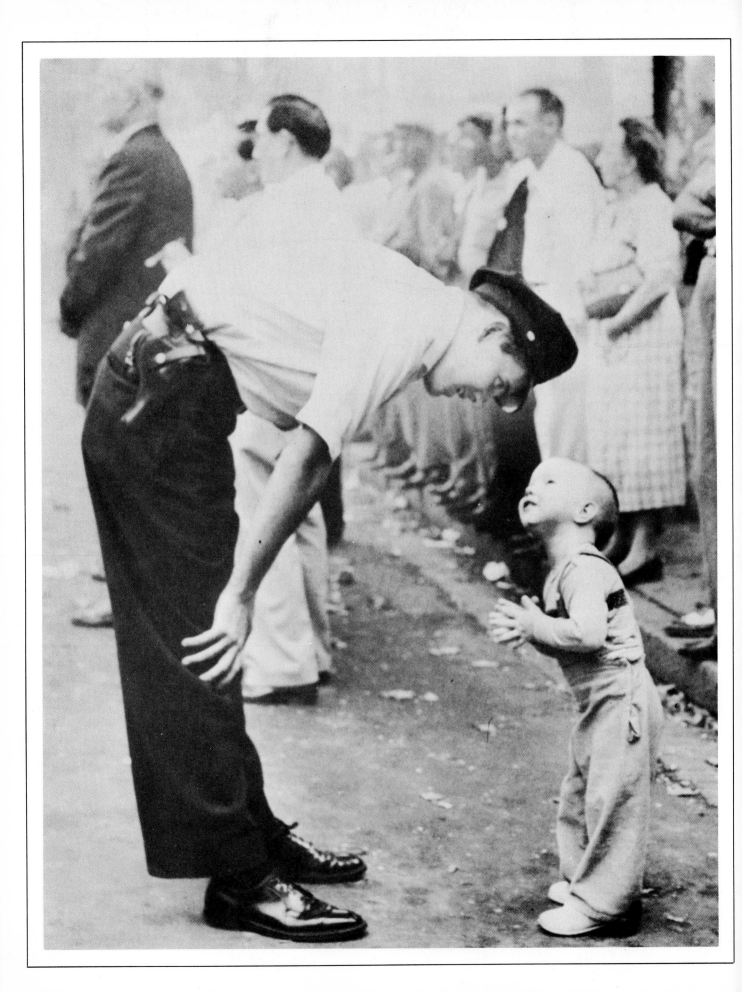

# 21 · THE FUTURE

*As you saw in the history chapter, change is a fundamental ingredient in photojournalism. Rooted as it is in technology, photojournalism in every era has always been one half the "old" and the other half the "new."*

*According to most observers, in the next ten years change will be from the "old" silver chemistry process to a "new," totally electronic photojournalism. Thus, this final chapter is written by Dr. John W. Ahlhauser, Associate Professor of Journalism at Indiana University and a specialist in electronic cameras.*

*Dr. Ahlhauser worked 24 years as a photojournalist on the* Milwaukee Journal. *He comes to the study of the future with a thorough grounding in photojournalism history—as a well-respected photojournalist. He covered stories with the Speed Graphic and flash bulbs, shot color photos in its pioneering days, and then adapted the 35mm to news work in his prize-winning career.*

Some people would say that photographers are already using electronic cameras today. If we were to remove the casing from current models, we'd find a maze of wires and printed circuit boards with cells and sensors that automatically (electronically) control shutter speeds, *f*-stops, flash sync and flash output, and even focusing, film advance, and rewind.

But for all the wizardry of photography today, we really aren't far from the technology introduced by Daguerre, Niepce, and Talbot in the 1820s. We still record negative images on silver, develop them chemically, and repeat the process in reverse to get a positive image on paper.

Engineers and manufacturers have given us more sensitive and faster emulsions, much finer grain film and paper, and truer color rendition. Electronic controls have removed guesswork and even the "work" of taking pictures, and all the parts have been miniaturized to be compact and convenient to operate. But we still use the silver chemistry process.

## ELECTRONIC PHOTOGRAPHY

"Electronic camera" means something radically different. It bypasses the silver emulsion on the film base and receives the light image on a permanent, light-sensitive plate or chip. That plate is in fact a fine screen, each compartment of which is called a picture element (pixel or pel). Unlike film which records continuous varying tones in an analog, each pel measures the amount of light within it precisely and records that amount digitally.

From that recording, a TV image or a photo print could be made. The print could be "processed" just like a film negative. An editor could also prepare and place a picture on an electronic page along with type. With the entire page composed on a video display screen, the page can be directly converted into a laser-etched printing plate, bypassing the page paste-up technique that was considered a tremendous shortcut less than 10 years ago!

Another advantage to electronic images is the ability to store them digitally—no fading, no loss of sharpness in copying, easy access, and thousands of images stored on a single videodisk. While this recording technique is too new to have proven the permanence of the actual recording material, the printed newspaper itself has been shown to be too fragile, too bulky, and too easily faded for storage. Few libraries retain bound newspaper volumes. Microfilm may be finer for text but almost worthless for photos because of its very high contrast. Original prints defy library filing and are not durable.

Therefore, costs of processing, difficulties of storing prints, and the economics and speed of using digital images to make up pages all make an electronic camera desirable.

## ELECTRONIC BREAKTHROUGHS

Technological breakthroughs have been occurring so fast that even this textbook would have to be "delivered" on a video screen in order to be current.

The giant film manufacturers have been reminding us that today's electronic images come nowhere near the fine resolution of conventional film images. The light-sensitive chips on the early electronic cameras resemble poor-quality television; instead of American television's 525-line screen, they have only 388 lines. At first scientists were fearful that making the pixels smaller (more pixels in the same area, meaning finer resolution), or making the area larger (again, increasing the number of pixels and resolution) would result in so much circuitry that the heat generated within the camera would be impossible to absorb. But miniaturization continues in the electronics industry and higher resolution in electronic imagery seems assured—as does the growing capacity to store images (a good quality full-screen photograph requires about 10 million times the computer storage that the same screen filled with text requires).

## STANDARDIZED DISK

Another major hurdle was crossed recently when more than thirty worldwide manufacturers of cameras and electronic devices voluntarily standardized the 2 ¼ inch disk format to be used for recording images within all cameras (Fig. 21.1). This was comparable to the in-

Figure 21.1: This "Mavipak" magnetic disk holds 50 images and has a built-in counter (lower right circle). Photo by John Ahlhauser.

dustry agreeing on width, sprocket-spacing, and cassette size for 35mm film. Now we can be sure the same disk will fit *all* makes of cameras.

Each disk can record 50 frames and each frame will contain frame number, date, and time recorded with it—even space to record location of the shot or abbreviated subject matter. Camera disks, like computer disks and cassette tapes, can be erased and re-recorded. Of course, other features of the competing electronic cameras can be quite different from each other, but the standardized disk size is a step that frees the industry for competitive development.

# PROTOTYPE CAMERAS

The Mavica by Sony (Fig. 21.2) was the first practical, still-frame electronic camera to be demonstrated. Introduced in March 1982, it was called "only a prototype." Many changes would be made before it was sold to consumers. At this time, no electronic camera by any manufacturer is available to consumers.

The Mavica was produced by television manufacturers and was basically a small television camera that used a closed circuit device (CCD) chip instead of a cathode ray tube (CRT) and could capture single frames on a separate recording disk within the camera. In size and shape, it resembled a 35mm single lens reflex camera. It weighed 1¾ pounds, just a shade more than most SLRs, and appeared to be a bit "off-center" because there was no film transport from side to

side and the recording disk and power pack were on the right-hand side. It did, however, balance well in the user's grip.

The CCD chip in the focal plane was somewhat smaller than a standard 35mm frame: in fact it was about one-fourth the size, so a "normal" lens length on the camera was 25mm.

The lens could be that of any manufacturer, fitted with an adapter. The viewing system was SLR with a prism on top, but the mirror was a permanently fixed, semi-transparent mirror that transmitted 20 percent of the image light to the prism and viewfinder and 80 percent directly to the "film" plane (Fig. 21.3). Further, the aperture setting was fully manual (no presetting, no automatic stop-down). This meant there were no

**Figure 21.2: Sony's Mavica was the first practical still-frame electronic camera. Introduced in 1982, it is basically a small TV camera that records the image on a disk. Photo by John Ahlhauser.**

"blind" moments at picture-taking time. It also meant the user saw only a very dim image in the finder, making for very painstaking framing and focusing.

There was no mechanical shutter on the prototype Mavica. The camera simply recorded electronically a single field (tracing) of the television picture. The action captured was what was seen in that 1/60th second tracing. Fast action was blurred by the original Mavica, much like it would be blurred by shooting 1/60 second with a mechanical shutter on film. But Sony engineers say that a mechanical or electronic shutter could be added to permit exposures as brief as 1/2000 second (Fig. 21.4). The operating procedure follows:

1. The operator depresses the shutter button which starts the tiny motor for the recording disk.
2. A built-in meter checks to be sure the manual aperture setting will yield the correct exposure. If aperture is not set right, the motor won't start and the aperture must be readjusted to the precise setting.
3. The motor will then start and when the disk has reached the correct speed of 60 revolutions per-second (which takes about one full second), *then* one rotation of the disk automatically records all the pixels of the image at the moment—which

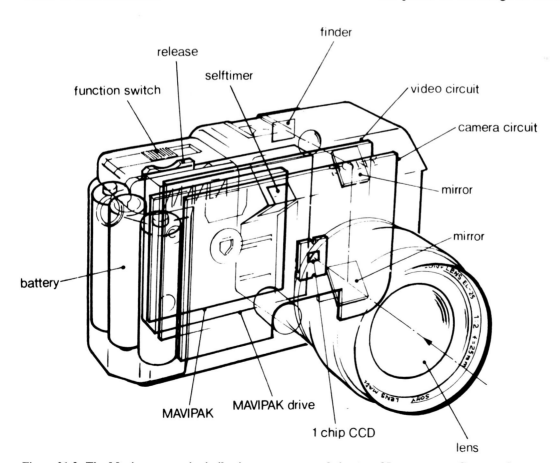

**Figure 21.3: The Mavica camera is similar in appearance and size to a 35mm camera. Courtesy Sony.**

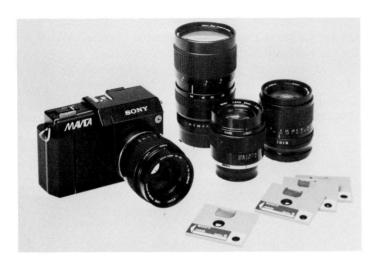

**Figure 21.4: Like the 35mm, the electronic camera will have interchangeable lenses. Courtesy Sony.**

may not be the same image that was there when the button was pushed.

As in commercial television, the image is retraced 60 times every second.

## IMAGE DISKS

The disk is slipped under a spring-loaded flap in the rear of the camera in much the fashion of the old cut-film holders on Graflex or Graphic cameras. A small round opening in the back plate allowed the user to see which number frame was ready. The first Mavica also had exposure adjustments for single frame, con-tinuous, or repeating frame or time-lapse, and a method for getting multiple exposures on one frame.

With the tiny disks, several hundred frames could be smoothly carried in each jacket pocket. Moreover, these disks can be completely "erased" and reused after individual frames have been transferred to other electronic storage. In the future, selected frames will be able to be erased and used again. With only the better frames kept on the disk, the likelihood of running out of frames while in the field will be far less than with 35mm film.

After shooting a session, a photographer can take the disk to a video viewer (in the photo car or truck or the nearest office), review all the frames on a TV screen, select the frame that best tells the story, and transmit it back to the office by connecting the viewer to a telephone, microwave sender, or conceivably, a satellite.

The Mavica system could also bypass the disk recording in the camera and be wired directly to a transmitter sending the *continuous TV picture* back to the newspaper office. The editor could record the entire TV sequence in action on tape and review it. Then, by touching a "shutter button" whenever he or she "saw" a picture, the editor could make selections for further editing, cropping, and cutlines.

If a print is needed, color-printing machines (Fig. 21.5) can make either 3½ x 5 or 5 x 7 prints using thin sheets of dyed paper. The dye tissues are discarded in the process and the print may be treated with a gelatin to make it more permanent and to strengthen the colors. It takes about five minutes to produce a print and costs about 25 to 50 cents.

# THE ELECTRONIC PHOTOJOURNALIST

Electronic cameras can be both boon and threat to to-day's photojournalists. There will certainly be change; whether it will be helpful or damaging will depend on how we humans use it.

We've already considered the advantages of electronic imaging. But what happens to our roles as visual journalists?

## IN THE FIELD

Of what value is the photographer's technical skill if the camera's computer can make all the adjustments and the electronic darkroom can easily alter any discrepancies?

Actually this question should not apply in any greater degree to a truly electronic still camera than to a conventional 35mm film camera. The shooting technique should be very similar, but the 50-frame disk and its compactness should free the photographer by giving more opportunities to shoot an assignment.

The ability to transmit the photo immediately back to an office probably means that photographers will not go back to the office but will stay more in the field. Transmitting pictures does not allow the photographer to add his or her personal vision to the "printing" process, which will be done by the editor in the office electronic darkroom. Even if the photographer were to "print" the picture, electronic darkrooms do not allow the subtleties or range of chemical printing techniques.

So, with burning and dodging severely restricted, much of the print quality control will be removed from the photographer.

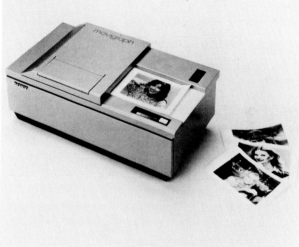

**Figure 21.5: Electronic cameras, used in conjunction with a TV screen, will provide the option of making prints with a video printer. Courtesy Sony.**

## PHOTOGRAPHER/EDITOR RELATIONSHIP

"Prestigious, glamorous, ego-satisfying," are different adjectives that have described the role of the photographer on assignment. The shooter has been very much on his or her own, taking a viewpoint and saying, in effect, "This is the way *I* saw it." The photographer has had something of star status and a lot of identity. Most photographs are credited to individual photographers—not to teams or groups. A written story, however, might be compiled and credited to several reporters and editors. Hardly ever has a desk person been given a credit line for editing a picture.

With electronic photography—and editing—we are reaching the point where picture reporters and picture editors are forced to work as a team, and, indeed, as a team with word reporters and editors. And in that process, they become more an integrated part of the journalistic operation. This requires that the field photographer be in constant contact with the coordinator of a story or news event coverage.

It may not be as glamorous as being a photographer out there on one's own, but it should lead to more coordinated news communication.

## THE PICTURE EDITOR'S ROLE

Picture editor status is considerably enhanced by this new capacity and relationship. On many papers, picture editors have really been picture clerks, taking the prints offered them or selected by senior editors, scaling them to fit holes, and writing cutlines.

The new technology demands a picture editor who is as skilled as any photographer in technical and visual abilities and who can work constantly with others in editorial judgment as stories develop. If this editor can see a story occurring, either live or in video recording, he or she must have the same sense of timing as the photographer on the scene. Indeed, Mike Tatem, a revered technical adviser, recommended in the early 1950s that beginners shoot pictures of movie screens in order to develop a good sense of timing.

Traditionally, photographers have complained that they've been considered apart from the news oper-

ation, considered secondary. Now, more photographers (or editors with photo training or knowledge) will be needed on city room desks, and will necessarily have more voice in the editorial process. It breaks with the tradition of photographers as a "distinctive breed," but it should elevate their position in journalism.

## ETHICAL QUESTIONS

Isn't there grave danger that ethics will be easily violated, or at least disregarded with the clever manipulations that can be accomplished with the electronic darkroom? Aren't we in trouble if someone can alter a picture so deceptively?

Harry J. Coleman, a photographer for the *New York Journal* around 1900, told in his biography that staff artists regularly altered stock photos by adding beards, glasses, and wigs so they would resemble individuals in the news that day. Altering pictures with electronics is not a new danger.

Artists of various types have always been able to falsify images. But the danger is compounded now because electronics and computers make it much more difficult to determine *who* did the altering.

To sum up, electronic cameras present attractive features in speed, flexibility, convenience and, ultimately, in cost. But they also offer a sharp challenge in changing the work form and status of photojournalists.

Electronic cameras seem inevitable. We should anticipate them by watching their development, considering the challenge, and taking it on.

# ASSIGNMENT 1

## A VIEW OF YOUR WORLD

### PURPOSE

This assignment will introduce you to shooting for communication. Your photograph should reveal an interesting aspect of your surroundings. You can shoot any subject, but try to make it reflect some important part of "your world."

You will send the film out for processing, so you will not need to know how to develop or print. Just shoot what you want to show.

### APPROACH

Use any of the approaches discussed in Chapter 1—from the snapshot approach to the photojournalistic approach, depending on your photographic background. The photographs you produce needn't be great statements. Just relax and shoot a whole roll with a single idea: to show others, in a significant, entertaining way, what you see in the every day world around you.

### FORMAT

Use a 400 ASA negative color film and shoot either inside or outside. Drop the film at any fast photo lab and tell them to *develop only.* Don't worry about the color of the negatives you get back; just choose what you feel is your best shot. Then have a 3 × 5 color print made.

Submit the print with a typed caption. Write the caption with enough information to make certain the reader knows your photo is about "your world." See the example below, a photo and caption by a student photojournalist.

### EXAMPLE

Kevin Elliott, of Tempe, Arizona, spent nine months in 1983 touring on his motorcycle. "I covered fourteen states, Canada, and Mexico," Elliott said. He is currently planning a road trip through northern California and Oregon. Photo by D. Kevin Elliott.

# ASSIGNMENT 2

## EDFAT

### PURPOSE

This assignment will introduce you to practice of EDFAT as outlined in Chapter 4.

### APPROACH

The detailed seeing of EDFAT leads you to produce general, medium, and close-up shots. Relax and shoot a whole 36-exposure roll.

### FORMAT

Use 400 ASA black and white film. You will develop this roll yourself.

Submit a set that consists of:
- a contact sheet
- a test strip
- a 5 × 7 black-and-white print
- a caption attached to print (use tape)

### EXAMPLE

EDFAT assures full coverage of a fire in Oklahoma City, shot by David Longstreath. Using two cameras and starting from far back (top left), David ended up with close-ups of a firefighter (right). This contact sheet is a combination of frames from a 24mm lens and a 300mm lens. Courtesy *The Daily Oklahoman*.

235

# ASSIGNMENT 3

## CLOSE-UP PORTRAIT

### PURPOSE

The close-up portrait is one of the most frequently used in photojournalism, so this assignment will introduce you to the step-by-step making of good "people pictures."

### APPROACH

The portrait will be taken within 3 feet of your subject. Remember that you are always trying to shoot to show a person's personality. Let your subject relax, and shoot a whole roll as you talk. Just enjoy making a good portrait. You can shoot a stranger or a friend, but either way, produce a photo that shows personality. Experiment with compositions to produce a contact sheet that shows horizontal, vertical, and creative croppings of the subject in the frame.

### FORMAT

Use 400 ASA negative color film for this assignment and again have it sent out to a fast photo lab. Tell them *develop only*. Choose the best of your closest shots to have printed. As with assignment 1, you might have two or three prints made and then choose your best.

Submit one 3 × 5 color print with a typed caption.

### EXAMPLE

Years of experience show on a bartender's face in this horizontal portrait by Jim Bryant.

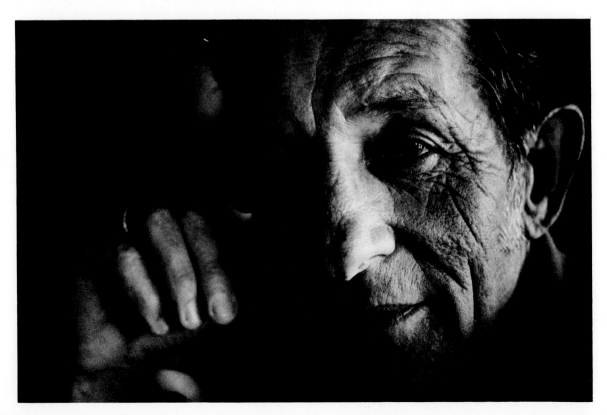

# ASSIGNMENT 4

## LIGHTING

### PURPOSE

This assignment will introduce you to the basic lighting directions for portraits. You will shoot for seven different lighting directions and then choose four to print.

### APPROACH

This assignment will be straightforward, for lighting purposes, but you may wish also to capture the personality of your sitter as you did in assignment 3.

### FORMAT

You will use 400 ASA 35mm black and white film and set up the lights as outlined here:
- front lighting—straight onto the subject from camera position
- 45-degree lighting—from the front at 45-degree high angle
- 45-degree lighting with fill—additional reflected light on the opposite side of the subject to offset strong shadows
- 90-degree side—at right angles to camera for half-lit face ("hatchet light")
- backlighting—at 45-degree angle from back of subject
- silhouette—on white background, with subject in shadow
- bottom lighting—from below the subject ("monster light")

Shoot each of the above lighting setups in vertical format from about 4 feet away.

Submit any four of the above shots in 3 × 5 prints. You may wish to mount them on cardboard in a row, as in the student example below. In your caption, identify each lighting direction and your subject.

### EXAMPLE

In another example from a student, Nancy Wiechec, a photojournalism major at Arizona State University, poses for portraits designed to demonstrate four basic lighting techniques. From left to right: front lighting; 45-degree lighting; 45-degree lighting with a fill; side or "hatchet" lighting. Photos by Brian O'Mahoney.

# ASSIGNMENT 5

## DOCUMENTARY I

### PURPOSE

This assignment will introduce you to the documentary style—shooting in a straightforward manner to show details of your subject. You will also use depth of field to emphasize your subject. You will shoot an entire roll on the outside of a building (and in the next assignment you'll shoot another roll on the inside).

### APPROACH

You can shoot any landmark building in your area. Preferably, this will be one that has historical or local significance. In effect, this is EDFAT applied to a building and its details, both outside and inside.

When shooting, start from far back, perhaps 50 feet away, to show the entire building. Frame the building with another building, a tree, or even a person by having that framing element closer than three feet from the camera (see the student example below).

Then in succession and from the same position, shoot your building:
- in focus, foreground out of focus
- foreground in focus, building out of focus
- at $f$/16, so that foreground and building are in focus

Now move toward the building and shoot the same succession of shots (as above) stopping every ten feet or so to reframe and reshoot. As you get closer to the building, concentrate on details of the architecture until you are at the base of the building. Shoot upward to make close-ups of the building against the sky.

Submit 8 × 10 black and white prints of your two best shots, with typed captions.

### EXAMPLE

Starting from far away, you can frame your building with any object in the foreground. Here, a student started far away and also chose a high angle to emphasize the pattern of building, sidewalks, and people. He added a sense of depth by framing the entire scene with the trees in the left foreground. Photo by Brian O'Mahoney.

# ASSIGNMENT 6

## DOCUMENTARY II

### PURPOSE

This assignment will apply the documentary approach to the inside of the same building. Choose a room, hallway, or similar location and shoot a depth of field series as you did the outside of the building.

### APPROACH

If a person is to appear in the inside photo, make a straight posed shot. Remember this is a documentary exercise as well as an exercise in depth of field, so straight records of significant details are more important than "personality."

Submit one 8 × 10 black and white print with a typed caption.

### EXAMPLE

Student photojournalist Rick Wiley made this shot in the documentary style, using a shallow depth of field to heighten two major elements: the books and the long shelves. Note also his use of the blurred, posed human figure.

# ASSIGNMENT 7

## STOP ACTION

### PURPOSE

This assignment involves you in making a good, sharp, stop-action photo, using a high shutter speed. You can choose any activity in which action is visually exciting. Perhaps the best subject would be an athlete in action, but you could also shoot a dancer or even a fast-moving animal.

### APPROACH

Because you are trying to stop action, make sure you:
- shoot at least 1/500 second shutter speed.
- use a long lens if possible.
- get as near to the action as possible.
- shoot at the peak of the action.

When shooting, remember these tips:
- prefocus or follow-focus the action.
- hold the camera still when shooting.
- position yourself in front of the action to get facial expressions.
- concentrate on the unfolding action so you get a significant shot.

If you have only a 50mm lens, sports may not be appropriate, so choose any subject with a lot of physical activity.

### FORMAT

Shoot outdoors using 400 ASA black and white film and remember to expose for shadows.

Submit one 8 × 10 black and white print with a typed caption.

### EXAMPLE

Classic sports action photos are usually like this one, a stop-action shot that freezes movement at a climactic moment. Photo by Rob Schumacher.

# ASSIGNMENT 8

## BLUR OF ACTION

### PURPOSE

This assignment will introduce you to another type of action photo—the deliberate blurring of the subject to create the effect of motion rather than to stop the action. As with the stop-action assignment, choose a subject that involves strong movement.

### APPROACH

When shooting, you are trying to be creative with the blur, so you consciously break the rules. For example, you:
- shoot slow shutter speeds to assure a blur (try 1/60, 1/30, or 1/15 second).
- deliberately move or shake the camera during exposure.
- shoot indoors to assure a slow shutter speed to create blur.
- try for a shot that gives the feeling of motion, *not* necessarily a high point in the action.

You can shoot blur-of-action photos in one of three ways:
- remain stationary and shoot the subject as it passes.
- move along with the subject and shoot in motion.
- remain stationary and pan your camera as the subject moves parallel to you.

You should try shooting all three ways if you can, then choose the best effect and print it.

## FORMAT

If shooting indoors, use 400 ASA black and white film. If shooting outside, use Panatomic-X film (32 ASA), so you can shoot at a slow exposure even in sunlight (try 1/30 second at $f$/16).

Always bracket your shutter speeds instead of your aperture (1/60, 1/30, and 1/15 seconds, all at the same aperture, for example).

Submit an 8 × 10 black and white print with a typed caption.

## EXAMPLE

There's no mistaking the impression that the photographer wanted to create in this blur-of-action photo of a runners' marathon—the sense of flowing and furious movement. Photo by Mike Rynearson.

# ASSIGNMENT 9

## SINGLE NEWS PHOTO

### PURPOSE

This assignment will introduce you to the basic coverage of a news event. You will cover a local news event and report it in a single photo with a complete caption. Shoot an event that would be considered news; a happening that is of interest to the general public and publishable as news in a newspaper.

Because we view "news" broadly, such events as a lecture by a visiting professor, a concert, an accident, a sports event, a demonstration by students on campus, strikers at a local plant, or even a meeting of a local organization can, at times, furnish suitable subjects if they are topical.

### APPROACH

Choose an event you can cover in available light. When shooting, follow the EDFAT approach and then choose one angle or distance for most of your shots. Remember that you need strong visual clues to show exactly what the event is. For example, for a speaker, try to get props or signs in the photo to show the subject of the talk.

Remember these tips when you cover the event:
- start back and shoot an entire, or general, view.
- move in to a medium shot.
- try for a close-up, if possible.
- watch for facial expressions of speaker, audience or subjects in general.
- make the report clear and sharp by using simple compositions.

### FORMAT

Shoot a whole roll of 400 ASA black and white film.

Submit an 8 × 10 black and white print with a typed caption. (And if you actually do this for a newspaper, make certain to get the film or print and caption to them *within the day* and on deadline!)

### EXAMPLE

A 50mm lens was used by a student photojournalist to cover firefighters during a training exercise. Of course, an assortment of lenses is handy, but you can often make excellent news photographs with your "normal" lens. Angle and simple composition can compensate for a beginner's lack of a "bag of tricks." Photo by Susan Taylor.

# ASSIGNMENT 10

## ENVIRONMENTAL PORTRAIT

### PURPOSE

This assignment will introduce you to one of the most interesting areas of photojournalism: the portrait that reveals the occupation, interests, or background of your subject by revealing his or her environment. You will combine two important elements:
- a portrait that shows the character, expression, or the strength of a personality
- an environment that adds strong visual information to the portrait

### APPROACH

Because it is a portrait the subject's full cooperation is essential. Also, face, clothing, and even hands are important, as in any portrait. This is not a working shot or a fast portrait, so don't hesitate to pose the subject and arrange the lighting exactly the way you want.

The environment can be extremely simple or very complex, depending on the subject and your approach. Remember that the more obvious and dramatic the surroundings, the more effective the shot. Some effective environmental elements are tools of the trade or uniforms that immediately identify your subject, easily identifiable surroundings (a lighted stage for an actor) and unusual details emphasized by lighting (see the straw hat in the example below).

### FORMAT

Use 400 ASA black and white film and try for a small aperture (*f*/8 or even *f*/16) to catch details. You may need extra lighting and a tripod. Shoot a whole roll on the same subject.

Submit one 8 × 10 black and white print with a complete typed caption.

### EXAMPLE

Eric Yeater's portrait of artist Linderman sets the man among several finished works, tools of his profession, and that almost mysterious straw hat. Notice that the "at-work" pose is so subdued that it does not interfere with the portrait aspect. This is a good practice to follow, for the portrait is the goal.

# ASSIGNMENT 11

## NEWSPAPER FEATURE

### PURPOSE

This assignment sends you in search of a newspaper feature. This category is so broad that it includes almost any subject, as long as it is interesting. A feature can run days, even weeks after being shot. Many photojournalists shoot features going to and from assignments or on their days off.

### APPROACH

Look for everyday spontaneous events. Children in parks, games of touch football, animals at the zoo, these and similar "slices of life" are feature material. The aim is to make a natural photo. You should not pose or rearrange. Just let it happen and be ready for the unexpected.

### FORMAT

Use 400 ASA black and white film and any lens you have. A long lens is often the best for taking feature photos without the subject being aware of you. But do make certain you get names and information for a caption. Make the photo and caption saleable to a local newspaper, the wire service, or college newspaper.

Submit an 8 × 10 black and white photo and a typed caption.

### EXAMPLE

In this feature photo, Michael Okoniewski snapped New York Governor Mario Cuomo caught off guard when a 13-month-old child was suddenly handed to him during a radio interview. Okoniewski got this one-time shot with a 28mm lens.

# ASSIGNMENT 12

## PICTORIAL

### PURPOSE

This assignment introduces you to another type of feature—the pictorial photo. Concentrate on outdoor scenery but include a person in the photo for scale or human interest. The main attraction in pictorial shots is the scenery—or, very often, the weather.

### APPROACH

The pictorial style is really that of a scenic photographer, but it is tied to a topical interest to appeal to a newspaper or magazine reader. You often see good pictorials that report some feature of the news through an esthetic approach. For example, heavy storm clouds can be beautiful in themselves, but can also show the storm that flooded an area. Other weather-style subjects include:
- snow, when the world seems to become all black and white images
- rain, with its myriad reflections
- clear, sunny days with their appearance of heat or cheerfulness
- foggy mornings with their mysterious light effects

You can photograph subjects under any of these conditions and tie them to the news, if only in a slight way. Pictorials give you a chance to publish your artistic work.

Submit one 8 × 10 black and white print with a typed caption that ties your artistic shot to the news in some way.

### EXAMPLE

The pictorial often combines artistic vision with the human figure in a striking composition revealing nature's beauty. Photo by Brian Drake. Courtesy *The Longview Daily News*.

# ASSIGNMENT 13

## SEQUENCE

### PURPOSE

This assignment will introduce you to the use of more than one photo in an order that gives the stills a sense of motion. The sequence is now normal to 35mm shooting, so you can often use the three photos to express what a single photo can't.

### APPROACH

Be conscious of a sequence when shooting. Choose an active subject that naturally lends itself to a sequence. Such subjects as sports and "how-to-do-it" demonstrations are good for sequences, provided that they have the following characteristics:
- they show motion.
- all are of the same subject.
- all are from the same or nearly the same perspective.
- all have equal emphasis, so reader's eye sees them each as steps, as units in a whole.

### FORMAT

Use 400 ASA black and white film. A motorized or winder-equipped camera is perfect for sequence shooting, but you can also produce very effective sequences with a regular 35mm if you think "motion" when shooting. Remember, you are attempting to give the *appearance of motion,* so even photos not in strict 1-2-3 order (as a motor would enable you to get readily) can still be put together into an effective sequence.

Submit a three-photo sequence, all three 3 × 5 prints, mounted 1/4 inch apart in proper order with a typed caption.

### EXAMPLE

Student photojournalist Brian O'Mahoney recorded this football player's progress down the field and maintained the perspective for a single-vision effect in this three-photo sequence.

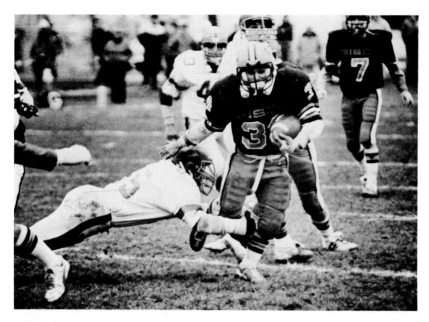

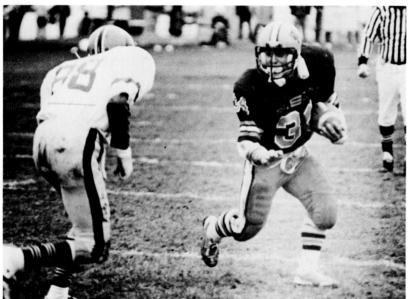

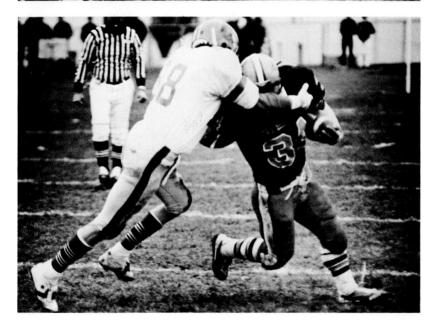

# ASSIGNMENT 14

## YOUR VISUAL AWARENESS

### PURPOSE

This assignment is a free choice of any type photograph you want to make. You may wish to return to the discussion of the single picture and caption in Chapter 7 and try one of the categories that you have not yet tried. The result of this assignment should be a photograph and caption of your choice, but also one that especially demonstrates the visual awareness you have developed.

### FORMAT

Use either black and white or color negative film and any lens and compositional approach you choose.

Submit one 8 × 10 black and white print or a 3 × 5 color print (as in assignment 1) with a typed caption.

### EXAMPLE

Detailed seeing and an ongoing attention to the play of light and shadow led the photographer to the poetic qualities in this glimpse of a window shutter latch.

# BIBLIOGRAPHY

The serious photojournalism student must read and study broadly. All manner of literature from fiction to non-fiction, from documents to poetry should be part of the well-rounded photojournalist's reading program.

The following will get you started in gaining some necessary background.

## HISTORY OF PHOTOGRAPHY

American Heritage, *An American Album.* New York: American Heritage, 1968.

Bettmann, Otto, *The Bettmann Archive History of the World.* New York: Picture House Press, Random House, 1978.

Faber, John, ed., *Great News Photos and the Stories Behind Them.* New York: Dover Publications, 1978.

Freund, Gisele, Photography and Society. Boston: David R. Godine, Publishers, 1980.

Gernsheim, Helmut, Creative Photography: 1939–1960. New York: Bonanza Books, 1962.

_____, *A Concise History of Photography.* New York: Grosset & Dunlap, 1965.

_____, *The History of Photography.* New York: McGraw-Hill, 1970.

Gilbert, George, *Photography: The Early Years.* New York: Harper & Row, 1980.

Horan, James D., *Mathew Brady, Historian With a Camera.* New York: Crown Publishers, 1955.

Newhall, Beaumont, *The History of Photography: From 1839 to the Present Day.* New York: New York Graphic Society, 1982.

Norback, Craig, and Melvin Gray, eds., *The World's Great News Photos 1840–1980.* New York: Crown Publishers, 1980.

Pollack, Peter. *The Picture History of Photography.* New York: Abrams, 1970.

Rosenblum, Naomi, *A World History of Photography.* New York: Abbeville Press, 1984.

Taft, Robert. *Photography and the American Scene.* New York: Dover Publications, 1938.

## TECHNICAL

Adams, Ansel. *Natural Light Photography* (1965); *Camera and Lens* (1968); *Artificial Light Photography* (1968); *The Negative* (1968); *The Print* (1968). Dobbs Ferry, N.Y.: Morgan & Morgan.

Davis, Phil. *Photography.* Dubuque, Iowa: William C. Brown, 1975.

Eastman Kodak Co., Rochester, N.Y. Catalogue of Books, including the "Here's How Book of Photography" series, plus many booklets on every aspect of photography.

*Encyclopedia of Photography.* New York: The Greystone Press, 1971.

Feininger, Andreas. *The Complete Photographer* (1966); *Successful Color Photography* (1969); *The Creative Photographer* (1975). Englewood Cliffs, N.J.: Prentice-Hall.

*Focal Encyclopedia of Photography.* New York: McGraw-Hill, 1975.

*Life Library of Photography.* New York: Time-Life Books, 1970.

*Petersen How-to Photography Library.* Los Angeles: Petersen Publishing Company.

Cavallo, Robert, and Stuart Kahan: *Photography: What's the Law?* New York: Crown Publishers, 1976.

Swedlund, Charles. *Photography: A Handbook of History, Materials, and Processes.* New York: Holt, Rinehart and Winston, 1974.

## GENERAL INTEREST AND PICTURE BOOKS

Abbott, Berenice. *Berenice Abbott, Photographs.* New York: Horizon Press, 1970.

Adams, Ansel. *Images 1923–1974.* Greenwich, Conn.: New York Graphic Society, 1974.

_____, and Nancy Newhall. *The Eloquent Light.* San Francisco: Sierra Club, 1963.

Ahlers, Arvel W. *Where and How To Sell Your Photographs.* New York: Amphoto, 1975.

Anderson, Sherwood. *Home Town: Photographs by Farm Security Photographers.* New York: Alliance Books, 1940.

*The Best of Life.* New York: Time-Life Books, 1973.

Capa, Cornell. *The Concerned Photographer.* New York: Grossman Publishers, 1972.

Cartier-Bresson, Henri. *The Decisive Moment,* New York: Simon & Schuster, 1952.

_____, *The Works of Henri Cartier-Bresson,* New York: Viking Press, 1968.

Cunningham, Imogen. *Photographs.* Seattle: University of Washington Press, 1970.

Davidson, Bruce. *East 100th Street.* Cambridge, Mass.: Harvard University Press, 1970.

*Dorothea Lange.* New York: Museum of Modern Art, 1966.

Duncan, David Douglas. *This Is War!* New York: Bantam, 1967.

_____, *Picasso's Picassos.* New York: Ballantine, 1968.

_____, *Yankee Nomad: A Photographic Odyssey.* New York: Rinehart and Winston, 1966.

_____, Goodbye Picasso, New York: Grosset & Dunlap, 1975.

Eisenstaedt, Alfred. *The Eye of Eisenstaedt.* New York: Viking Press, 1969.

*The Family of Man.* New York: Museum of Modern Art, 1955.

Fusco, Paul, and Will McBride. *Photo Essay.* (Text by Tom Moran.) Los Angeles: Alskog/Petersen Publishing Company, 1974.

Frank, Robert. *The American's Millerton,* New York: Aperture, 1969.

Gutman, Judith M. *Lewis W. Hine* (Text by Judith Mara Gutman). New York: Grossman Publishers, 1974.

Haas, Ernst. *The Creation.* New York: Viking Press, 1971.

_____, *In America.* New York: Viking Press, 1975.

Hurley, Gerald D. and Angus McDougall. *Visual Impact in Print.* Chicago: American Publishers Press, 1971.

Kane, Art, and John Oppy. *Art Kane: The Persuasive Image.* New York: Alskog/Thomas Y. Crowell, 1975.

Kertesz, Andre. *Sixty Years of Photography: 1912–1972.* New York: Viking Press, 1972.

Lange, Dorothea, and Paul Taylor. *An American Exodus.* New Haven, Conn.: Yale University Press, 1969.

Lartigue, Jacques Henri. *The Photographs of Jacques Henri Lartigue,* New York: Museum of Modern Art, 1963.

Lesy, Michael. *Wisconsin Death Trip.* New York: Random House, 1973.

Lieberman, Archie. *Farm Boy.* New York: Random House, 1973.

Lucie-Smith, Edward. *The Invented Eye: Masterpieces of Photography 1839–1914.* New York: Two Continents/Paddington Press, 1975.

Lyons, Nathan, ed. *Photographers on Photography.* Englewood Cliffs, N.J.: Prentice-Hall, 1966.

Marcus, Adrianne. *Photojournalism: Mary Ellen Mark and Annie Leibovitz.* Los Angeles: Alskog/Petersen Publishing Co., 1974.

McCullin, Donald. *Is Anyone Taking Any Notice?* Cambridge, Mass.: M.I.T. Press, 1973.

Muybridge, Eadweard. *The Human Figure in Motion.* New York: Dover, 1957.

_____, *Animals in Motion,* New York: Dover, 1955.

Newman, Arnold. *One Mind's Eye.* Boston: Little, Brown, 1974.

Newhall, Beaumont and Nancy. *T. H. O'Sullivan, Photographer.* Rochester, N.Y.: George Eastman House/Amon Carter Museum, 1966.

Penn, Irving. *Worlds in a Small Room.* New York: Grossman Publishers, 1974.

_____, *Moments Preserved.* New York: Simon & Schuster, 1960.

*Photography Year.* New York: Time-Life Books. Issued annually.

Pratt, Davis, ed. *The Photographic Eye of Ben Shahn.* Cambridge, Mass.: Harvard University Press, 1975.

Rothstein, Arthur. *Photojournalism.* New York: Amphoto, 1965.

Sander, August. *Men Without Masks.* Greenwich, Conn.: New York Graphic Society, 1973.

Smith, W. Eugene, *Minamata.* New York: Holt, Rinehart and Winston, 1975.

_____, *W. Eugene Smith: His Photographs and Notes.* Millerton, N.Y.: Aperture, 1959.

Steichen, Edward. *A Life In Photography.* New York: Doubleday, 1963.

_____, *The Bitter Years: 1935–1941.* New York: Museum of Modern Art, 1962.

Stern, Bert. *Photo Illustration*. (Text by Jim Cornfield). Los Angeles: Alskog/Petersen Publishing Company, 1974.

Szarkowski, John. *Looking At Photographs*. New York: Museum of Modern Art, 1973.

_____, *The Photographer's Eye*. New York: Museum of Modern Art, 1966.

Tucker, Anne, ed. *The Woman's Eye*. New York: Knopf, 1973.

Whiting, John. *Photography Is a Language*. New York: Ziff-Davis, 1946.

## CAMERA GUIDES

*All of these guides were published by Amphoto, New York.*

Nikon-Nikkormat Handbook, Joseph D. Cooper (loose-leaf)

The Minolta Book, Clude Reynolds

Minolta System Handbook, Joseph D. Cooper

The Canon Manual, Paul Jones

The Canon Reflex Way, Leonard Gaunt

The Honeywell Pentax Book, Clyde Reynolds

The Honeywell Pentax Way, Herbert Kappler

Leica and Leicaflex Way, Andrew Matheson

Olympus Camera Guide, Lou Jacobs, Jr.

## PERIODICALS

*American Photographer Magazine* (monthly)

*Camera 35*. Popular Publications, 420 Lexington Avenue, New York, N.Y. 10017.

*Color Photography Annual*. Ziff-Davis Publishing, 1 Park Avenue, New York, N.Y. 10016.

*Modern Photography*. ABC Leisure Magazines, 130 East 59 Street, New York, N.Y. 10022.

*News Photographer*. National Press Photographers Association, Box 1146, Durham, North Carolina 27702.

*Petersen's Photographic Magazine*. Petersen Publishing Company, 8490 Sunset Boulevard, Los Angeles, Calif. 90069.

# INDEX